Happy Birthday Diana

We are really looking forward. to being with you and Jim for two weeks — celebrating our 60th !!!

fondly

Vic and Marilyn

TURKEY

FROM THE AIR

TURKEY

FROM THE AIR

YANN ARTHUS-BERTRAND

JANINE TROTEREAU

THE VENDOME PRESS

First published in France by Editions de la Martinière as
"La Turquie vue d'en haut"

Published in the USA in 1998 by
The Vendome Press
1370 Avenue of the Americas
New York, NY 10019

Distributed in the USA and Canada by
Rizzoli International publications
through St. Martin's Press
175 Fifth Avenue South
New York, NY 10010

ISBN 0-86565-151-5

Printed and bound in France

INTRODUCTION

Janine Trotereau

From the air, the diversity of Turkey's powerful past civilizations is dramatically brought to life; the magnificent landscape, still largely untouched by the country's continuing economic and demographic expansion, is spread before us. An aerial view is able to encapsulate the history of this region where so many paths meet, linking the two continents – Europe and Asia – that it straddles. It has been a land accustomed to constant change, where so many flourishing cultures have taken root, matured and then disappeared, destined to reign over these vast domains for a while, before retreating in the face of an invader or absorbing his culture.

The most powerful conquerors in the world have ruled these lands, from the legendary Agamemnon to Alexander the Great, from Darius and Tamerlane to Mohammed II Fatih, from Genghis Khan to Suleiman the Magnificent. A battle ground and focus for territorial ambition, without doubt; but it was equally importantly a mystic and religious land. Here, it is said, Noah's Ark came to rest on Mount Ararat; the Didyma oracle, which attracted thousands of pilgrims, was here; St John the Evangelist settled with the mother of Christ at Ephesus to write the Book

of Revelation, Paul of Tarsus came here to preach, and St John Chrysostom – a Doctor of the Church – to chastise adulterers; Jalal-ud-din Rumi founded the order of the Whirling Dervishes at Konya, and anchorites came to take refuge in the remotest places, meditating on the world's vanity and worshipping their God.

The most ancient cities in the world took shape in this region, among them Homer's Troy; the Greece of Asia Minor, Byzantium, the Seljuks and the Ottoman Empire all flourished here; groups from many different cultures still attempt to live together: Turks and Armenians, Kurds and Circassians, Georgians and Bosnians, Tatars, Lazis and Macedonians.

All these are elements in the rich mosaic wonderfully captured in these aerial photographs, a viewpoint which makes it possible to show particularly well the amazing complexity and brilliance of this land in all its individuality and diversity.

THE EARLIEST TIMES

From evidence found at the cave of Karain, not far from Antalya, we know that man existed here a million years BC, and that Neanderthal man lived here around one hundred thousand years BC.

Humankind was from the very beginning nomadic, and the first substantial settlements were based in Anatolia: here people began to produce their food by cultivation and the rearing of cattle. Çatalhöyük and Hacilar are the most ancient known urban settlements in the world; others are to be found at Çayönü, Suberde, Yümüktepe, Koskhöyük and Becesultan.

From the dating of foodstuffs found buried in the ground, we know that agriculture was established at Hacilar, a village not far from the present-day Burdur, as long ago as 7040 BC, while Çatalhöyük was established five centuries later. In this town to the southeast of Konya, covering nearly thirteen hectares (thirty-two acres), twelve layers of settlement have been found (from 6500 to 5500 BC). The dwellings were arranged around a large courtyard and built of adobe, with the only entrance in the flat roof. There were no doors or windows, so that it was easier to keep out intruders and wild beasts.

The first settlement at Troy was built in the early Bronze Age, long before Homer's Troy; it is known to archaeologists as Troy I (3000–2600 BC), where the first bronze objects were found, followed by Troy II (2600–2300 BC) in the layer above. The famous 'Priam's Treasure' discovered in 1873 by the German archaeologist Heinrich Schliemann belongs to this distant period; he wrongly attributed these magnificent gold pieces to the supposed era of the *Iliad*.

Another remarkable culture, that of the Hattis (2500–2000 BC), was taking root farther east, at the same time as the development of Troy II. Sumptuous objects in gold, silver, electrum and bronze showing great skill and unity of style survive, and are perhaps even more remarkable than the finds at Troy. Most of them come from the royal tombs at Alacahöyük.

A FORGOTTEN CIVILIZATION

However, the most extraordinary civilization of prehistoric Anatolia was that of the Hittites (probably lasting from 2000 to 1180 BC), which has been almost forgotten until modern times. All record of their powerful empire was eradicated by the time of Herodotus (5th century BC): the great historian of antiquity, describing their sculptures, grouped them with the art of the Egyptian pharaohs.

Archaeological discoveries reveal that the Hittites were nomadic Indo-European horsemen, probably arriving in Anatolia in successive waves, assimilating the indigenous population while beginning to lead a more settled life themselves. Five city states originally ruled the country, among them Hattushash (Bogazköy) and Kanesh (the modern Kültepe). Large-scale buildings and monumental sculptures were apparently features of all of them. The high point of this civilization was between 1680 and 1180 BC; a centralized administration was introduced, roads were built, horses were bred and trained; cuneiform characters were borrowed from the neighbouring Mesopotamians and a hieroglyphic script of their own was created. The Hittite king Murwattali waged an inconclusive war against the Egyptian pharaoh Rameses II; their eventual peace treaty of 1269 BC has come down to us, and is the earliest known written agreement between two rival great

powers. The massive fortresses, colossal temples and shrines with huge relief panels carved directly into the rock face date from this period of strength.

After a thousand years of domination of central Anatolia, the Hittites, an essentially land-based race, were brutally wiped out by what the Egyptians called the Sea Peoples. These may have been the predecessors of the Thracians and the Phrygians, being also responsible for the destruction of Troy VIIb at the same period.

THE HELLENIC INFLUENCE

What would the history of Greece have been like if it had not included Asia Minor? Probably one of much less significance. At Gordium (the modern Yassihöyük) in Anatolia, Alexander the Great famously cut the knot binding the yoke to the shaft of the king's chariot (the Gordian knot) – a symbolic gesture which gave him power over a whole empire. Some claim that the most revered of the Greek bards, Homer, may have been born at Izmir (Smyrna). Innumerable Anatolians helped to make Greece famous all around the Mediterranean, from the historian Herodotus, born at Halicarnassus, to the mathematician Thales of Miletus, with his abstract geometry, and the architect Sostratus of Cnidus, who built the lighthouse (Pharos) at Alexandria – one of the Seven Wonders of the World. Others include the fable writer Aesop, who, according to tradition, was born in either Thrace or Phrygia; the geographer Strabo from Amasya; and the philosopher Anaxagoras, Pericles' tutor, born in Clazomenae. One of the greatest physicians of all time, Galen, was born at Pergamum and practised there at the Asklepieion; his work influenced Western medicine for many centuries. Undeniably, Western philosophy and sciences had their beginnings here.

Greeks from every part of the country came to Asia Minor and succeeded in Hellenizing the local population. Some had been hounded out of Thessaly by the Dorians around 1000 BC and colonized the coastal region of Aeolia; Ionians had come to settle first on the shores of the Dardanelles, then by the Sea of Marmara and the Black Sea, moving on to the area around Miletus before penetrating further into the Anatolian peninsula; immigrants from Crete came to live in Phrygia and Lycia; and, according to Herodotus, Dorians founded the city of Cnidus.

These Greek arrivals were responsible for two of the Seven Wonders of the World, the Temple of Artemis at Ephesus – the biggest temple in the Greek world – and the Mausoleum at Halicarnassus. Many of their myths were identified with this part of the Empire: for instance, Mount Olympus (Ulu Dagi), where the god Pan frightened the nymphs, is in Mysia; the rock which Pausanius thought was Niobe turned to stone is at Manisa (ancient Magnesia ad Sipylum); and Ovid recounted the story of Midas, the legendary king of Sardis, whose wish was granted by Dionysus, causing everything he touched to be turned to gold, including his food; in order to reverse the wish, he had to bathe in the river Pactolus, which ever since has flowed with gold-bearing sand.

Rome assumed control over the destiny of Anatolia after Attalus III of Pergamum bequeathed his entire kingdom to the Roman Empire. The great Roman conquerors came here one after another, from Sulla to Pompey, from Lucullus to Caesar and Mark Antony – Rome continued to stamp its influence on Asia Minor until it too became a beneficiary, like the rest of the Empire, of the *Pax Romana*.

THE SPLENDOUR OF CONSTANTINOPLE

Constantinople was built on seven hills, just as Rome had been. On 13 May 330, the Emperor Constantine inaugurated his capital city, named Constantinople in his honour. It had been built on the twin shores of the Bosphorus, incorporating the ancient city of Byzantium, founded by the Greek Byzas around 658 BC.

Sixty-five years later, Theodosius divided the Roman Empire into two. When in AD 476 Rome fell into the hands of the barbarians, Constantinople automatically became the single capital of a Roman Empire reduced to its eastern half, with Christianity as its religion, and whose culture and language were Greek. From then on it was called the Byzantine Empire and endured for a thousand years, until in 1453 Mohammed II Fatih ('the Conqueror') seized its capital city, which was the largest in the East, the most important, and the most culturally advanced.

Its grandeur and opulence had reached their peak under the Macedonian dynasty, during which the Oriental Schism (1054) separated Rome from Constantinople for ever. The Empire was weakened under the Comneni and gave way for a time to the

Crusaders, but after a brief recovery under the Paleologi, was unable to resist the force of the Ottoman warriors. The sultans in their turn revived the power and splendour of Byzantium under the new name of Istanbul.

THE TURKS IN POWER

Nomads from the steppes of central Asia, the Seljuk Turks, arrived in the Near East during the 11th century in search of new grazing lands, and from their base in Isfahan made incursions into the Byzantine Empire. They gradually took over almost the entire Anatolian peninsula; they prospered through trade, establishing secure lines of communication interspersed with caravanserais every thirty kilometres (about twenty miles), building bridges and mausoleums, and, as Muslims, providing themselves with mosques and madrasas (Islamic colleges). It was under the Seljuks that the great Persian mystic Jalal-ud-din Rumi founded the order of the Whirling Dervishes in the capital, Konya. In the 13th century, at the height of their power, the Seljuks were overthrown by the sheer force of the Mongol hordes of Genghis Khan, and were dispersed to live in various little emirates as vassals of the khan.

One of these fiefdoms in the northwest of the peninsula, near Bursa, was in the hands of Osman (1290–1326), who gave his name to the empire of the Osmanlis, or Ottomans, which was established by his successors in Anatolia and which was to dominate Turkey until 1922. In the 16th century, Suleiman (known as Kanunî, 'the Law Giver', to the Ottomans, but as Suleiman the Magnificent to the West) was the most powerful ruler in Europe. The overall extent of his empire included the Holy Places of Islam (Mecca and Medina) as well as Iran, Syria, Azerbaijan, Iraq, Yemen, Egypt, North Africa from Tripoli to Algeria (but not Morocco), and Bulgaria, Hungary, Greece and of course the whole of Anatolia. The army, spearheaded by the janissaries, and the invincible fleet of corsairs scouring the seas as far as the shores of India, were the mainstay of his rule. In spite of all this, the Ottoman Empire was notable for its great tolerance, basing legislation on the laws already in place in subject countries, respecting all religions and persecuting none, supporting poets and writers and encouraging the arts.

So this great power became also one of the outstanding civilizations of its time: Sinan was perhaps the greatest architect of the 16th century, the outstanding mosques he built, such as the Süleymaniye in Istanbul and, above all, the Selimiye in Edirne demonstrating his genius; while the multicoloured glazed tiles from Iznik, the silk, velvets and brocades which were traded all over Europe, the carpets, the finely chased metal objects, the miniature painting and calligraphy were the fruits of creativity at its finest.

THE MAKING OF TURKEY

The Ottoman Empire gradually declined, however, to the point of being, at the beginning of the 20th century, 'the sick man of Europe'. The Young Turks' revolution of 1908 failed, though not before they had committed genocide against the Armenians (1915). The abolition of the sultanate on 1 November 1922 opened the way for the nationalist leader Mustafa Kemal (later to assume the name of Atatürk) to proclaim the Republic on 29 October 1923.

Atatürk set in motion a complete social revolution. The sultanate and caliphate were suppressed; Koranic law and religious education were abolished and religious orders were dissolved; Sunday became the day of rest instead of Friday; men were barred from wearing the fez, while women were discouraged from wearing the veil and were given the vote in 1935; secular, free, obligatory and mixed education was introduced and the Latin alphabet was adopted; the capital was transferred to Ankara, a small town with no Ottoman history, and a bi-cameral National Assembly was instituted; lastly, all were obliged to use a family name, or surname. This liberalization did not prevent the establishment of a rigid one-party state, which lasted until the death of Atatürk on 10 November 1938. Since then, there has been a succession of democratic or repressive military governments: the democracy advocated by the 'Father of the Turks' has not so far been able to establish itself with any real solidity or permanence.

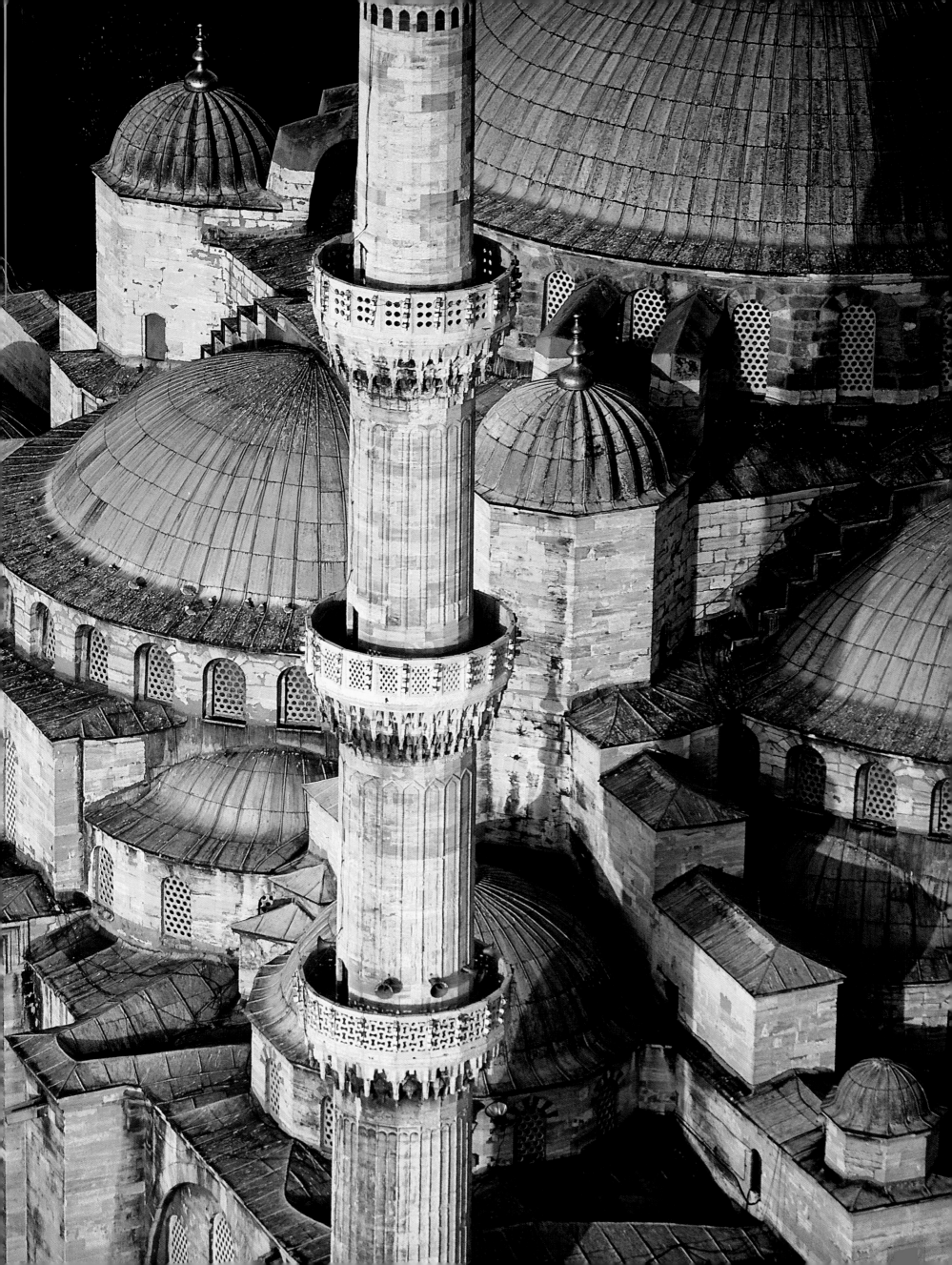

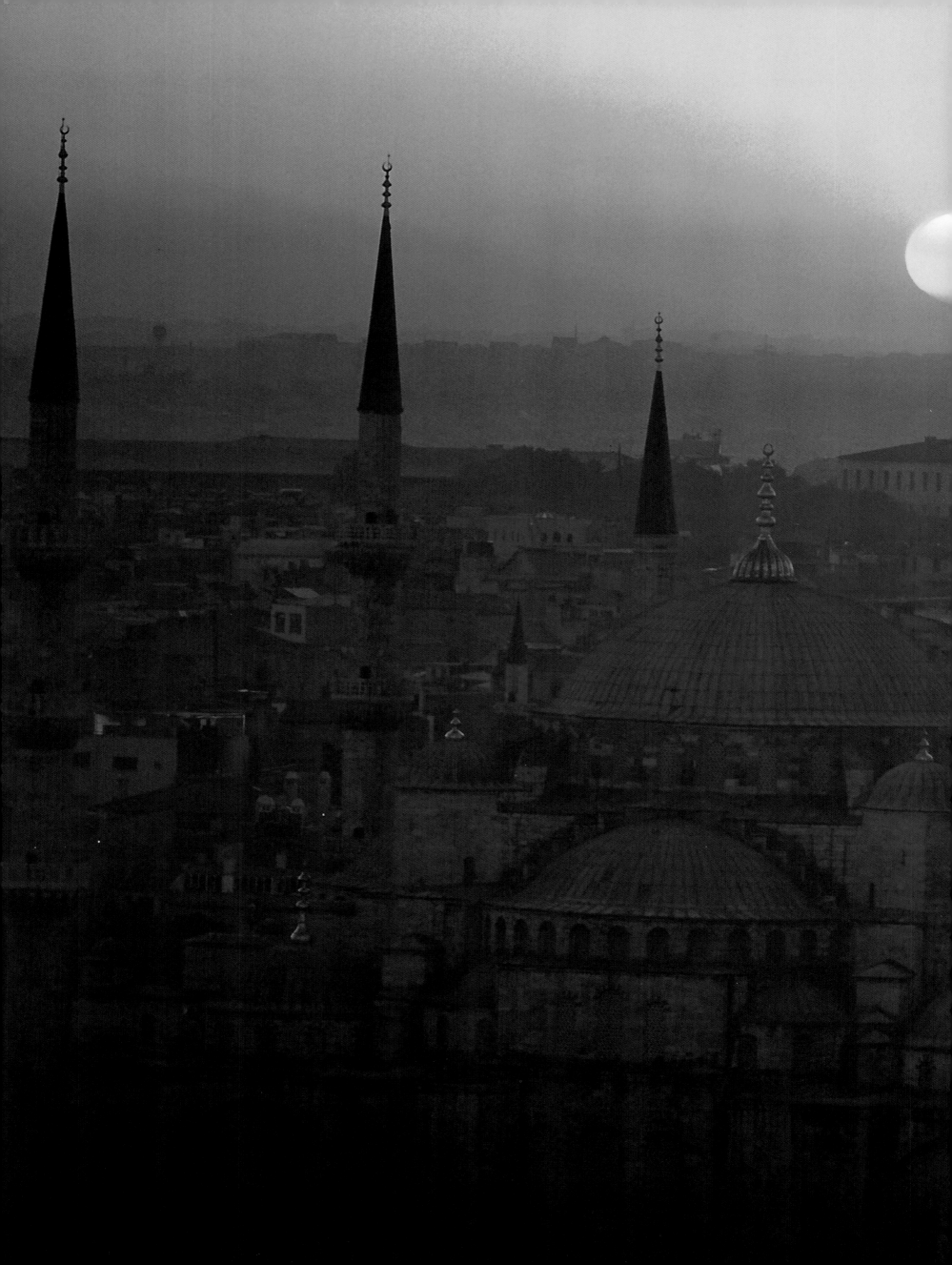

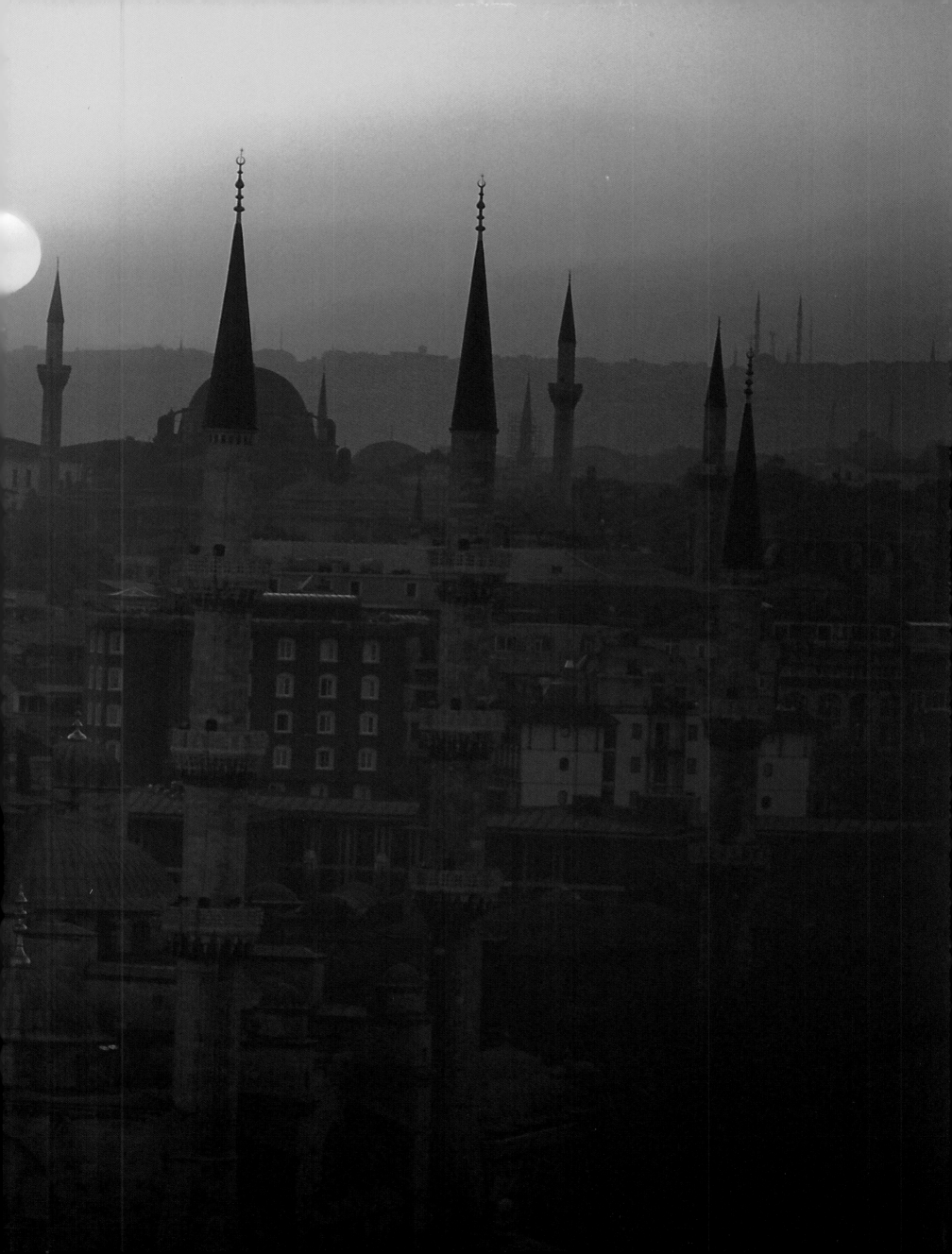

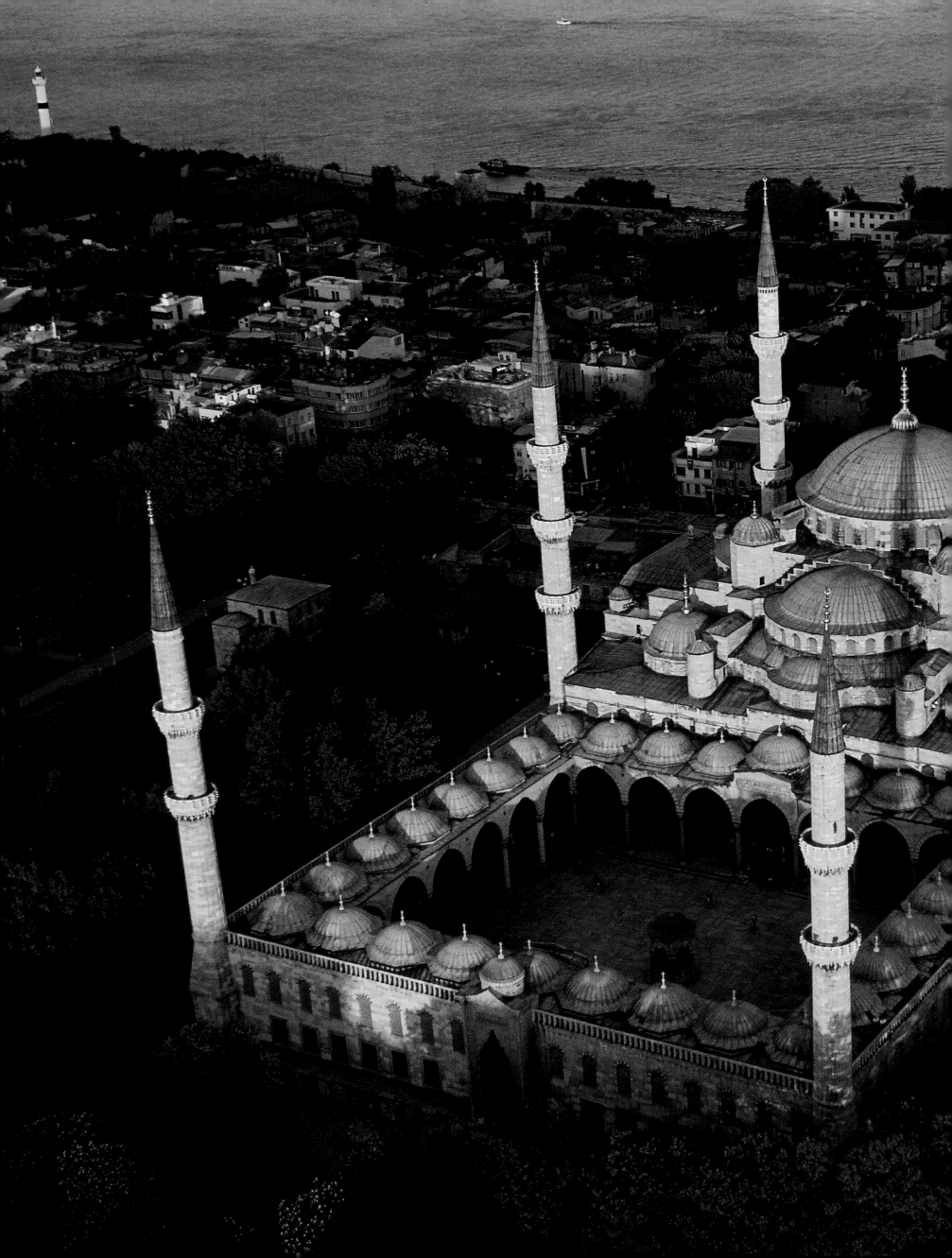

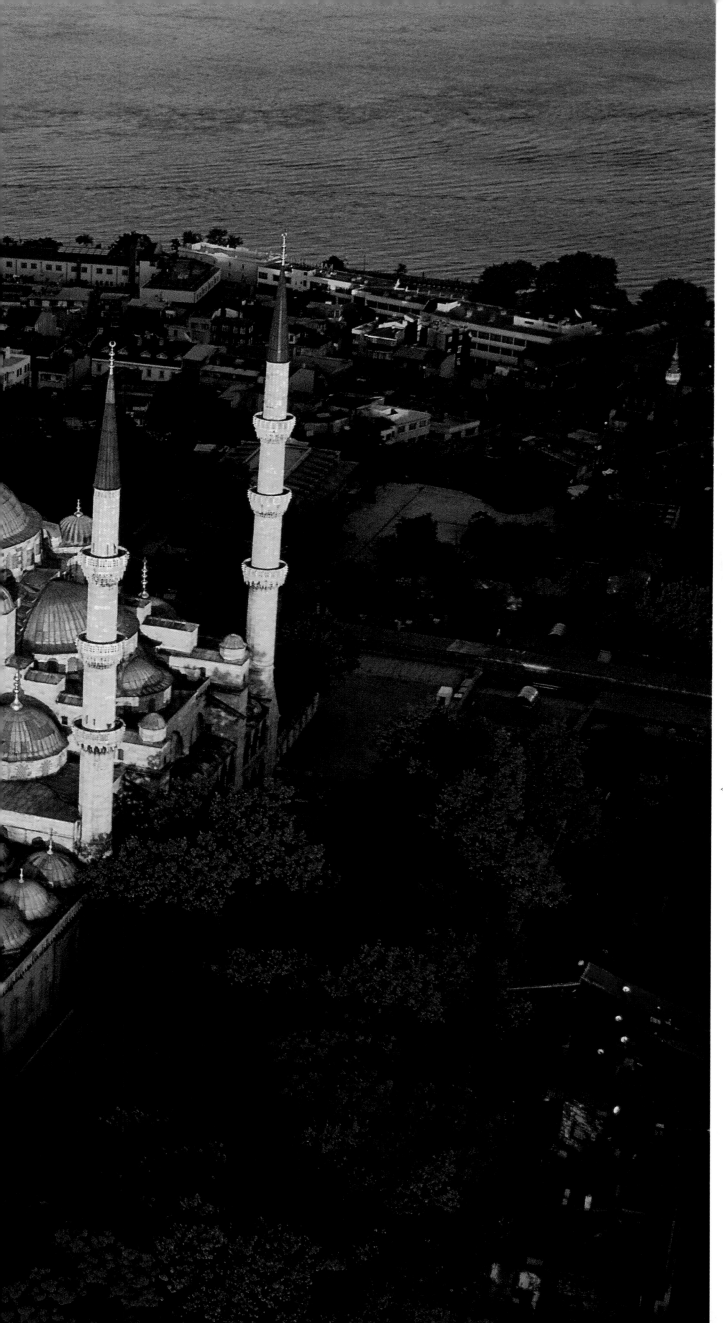

◁ ◁ **ISTANBUL**

SULTANAHMET CAMII
(BLUE MOSQUE)

The Sultanahmet Camii, or Blue Mosque, was built by the architect Mehmed Aga for Sultan Ahmed I. Its popular name derives from the exceptional light and atmosphere created by the turquoise tiles that cover the interior. It was built between 1609 and 1616 not far from Santa Sophia, on the site of Constantine's palace and the Hippodrome. Its soaring silhouette is unusual in having six minarets, and is surpassed only by the Great Mosque at Mecca, which has seven. A fragment of the Kaaba, the black stone revered at Mecca, is preserved in the white marble *mimbar*. Until the 19th century, the caravans of Turkish pilgrims gathered here before departing for the Muslim world's holiest city.

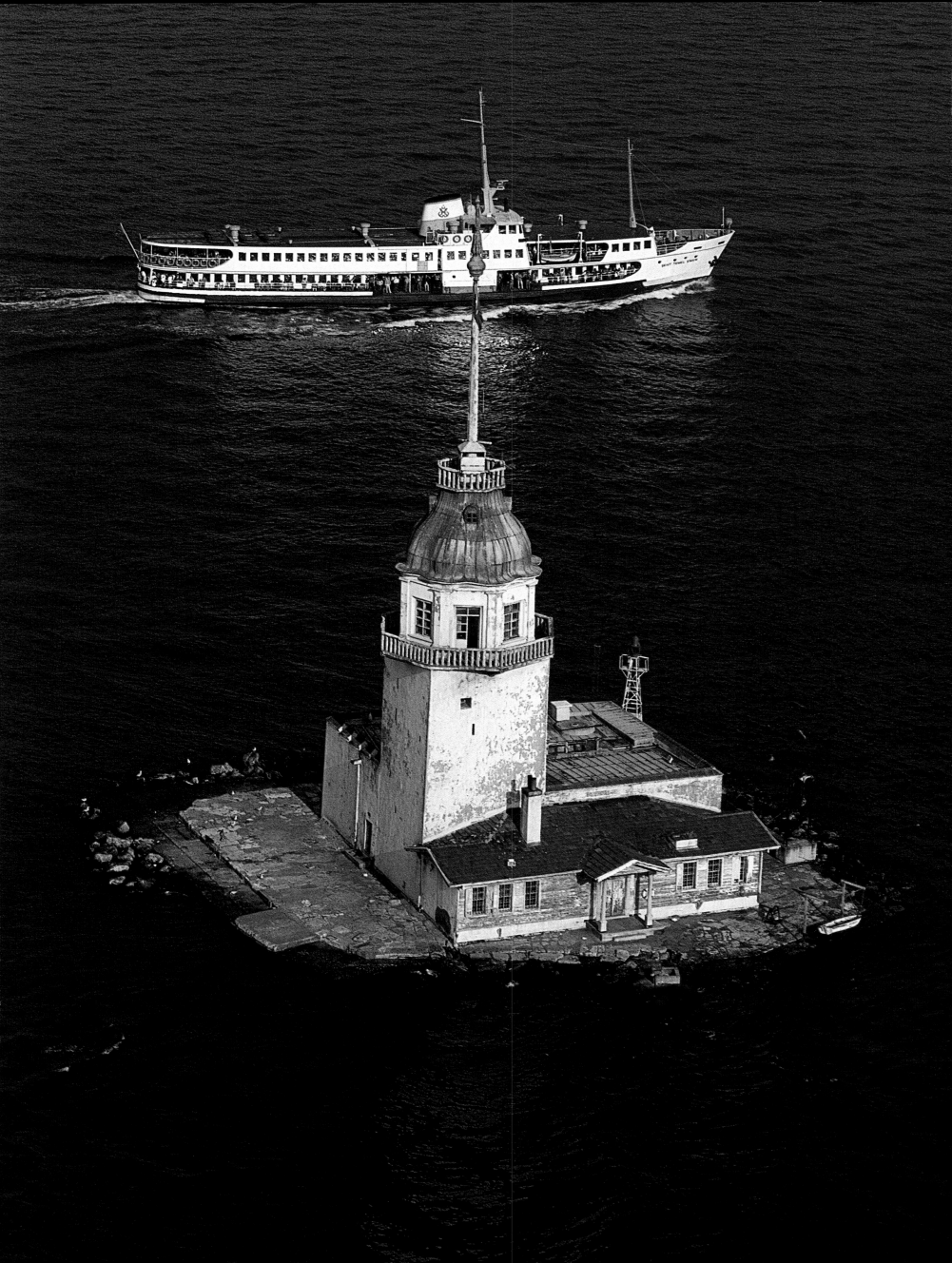

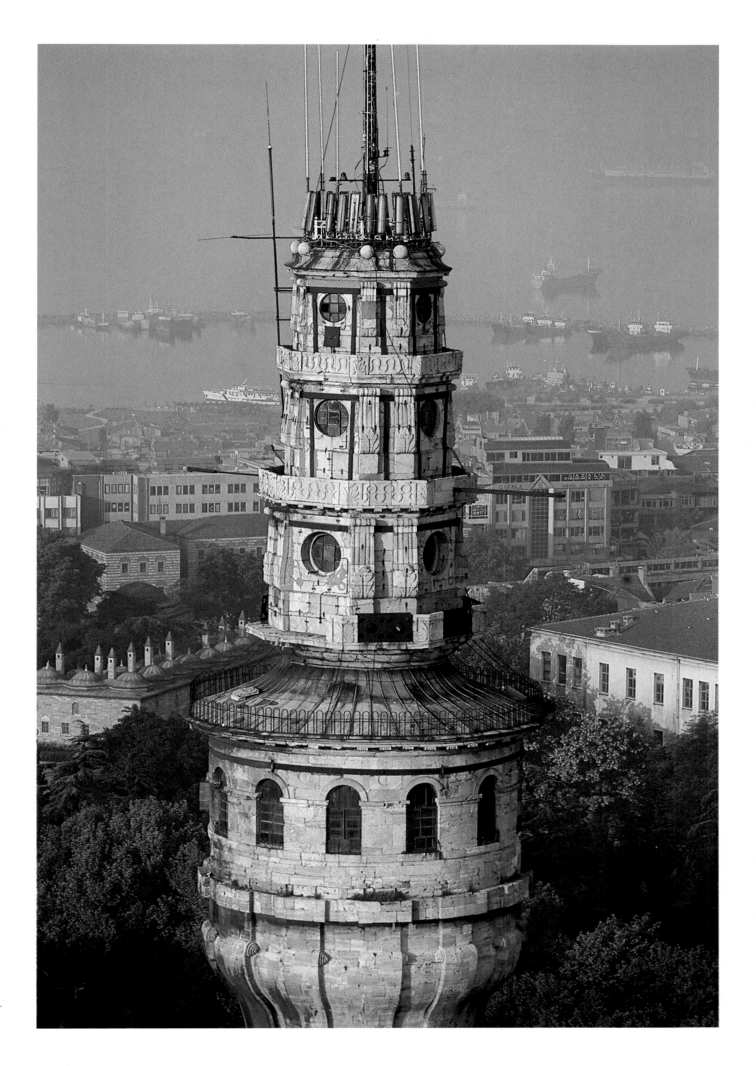

ISTANBUL

KIZ KULESI (VIRGIN'S TOWER)

The Virgin's Tower is built on a small island off Üsküdar, on the Asian shore of Istanbul. It stands as an important landmark opposite the Golden Horn as ships enter the Bosphorus. Long ago, it was linked by a chain to a tower on the European side, closing off all access to the Bosphorus, or 'Cow's Ford', so named in reference to Io, the priestess of Hera who was changed into a heifer by Zeus and who, according to the myth, was chased by a horsefly and crossed the water to escape it.

Alcibiades established a toll on the island after he had vanquished the Spartans at Cyzicus in 410 BC: from then on, all ships coming from the Black Sea had to obtain permission to proceed to the Sea of Marmara by paying an amount equal to a tenth of the market value of the goods they were carrying. A long time later, a lighthouse was built there, and then a semaphore.

The name of the Kiz Kulesi tower comes from the legend of a sultan's daughter who took refuge there alone because of her fear of the snakes on the mainland. She nevertheless died after being bitten by a snake concealed in a basket of fruit. The tower is known to westerners as Leander's tower, to commemorate his drowning while attempting to swim the Bosphorus to join his beloved Hero. However, there is strong evidence that the myth of Hero and Leander refers instead to the strait of the Dardanelles, or the Hellespont, as it was called by the Ancient Greeks.

ISTANBUL

BEYAZIT KULESI (TOWER OF BEYAZIT) ▷

The Tower of Beyazit, behind the University, was built on the instructions of Mahmud II in 1823 as a watch-tower for fires in the city. Nowadays, the residents of Istanbul can look at it at night for a weather forecast: its neon lights indicate the next day's weather by their colour – blue for fine weather and green for rain.

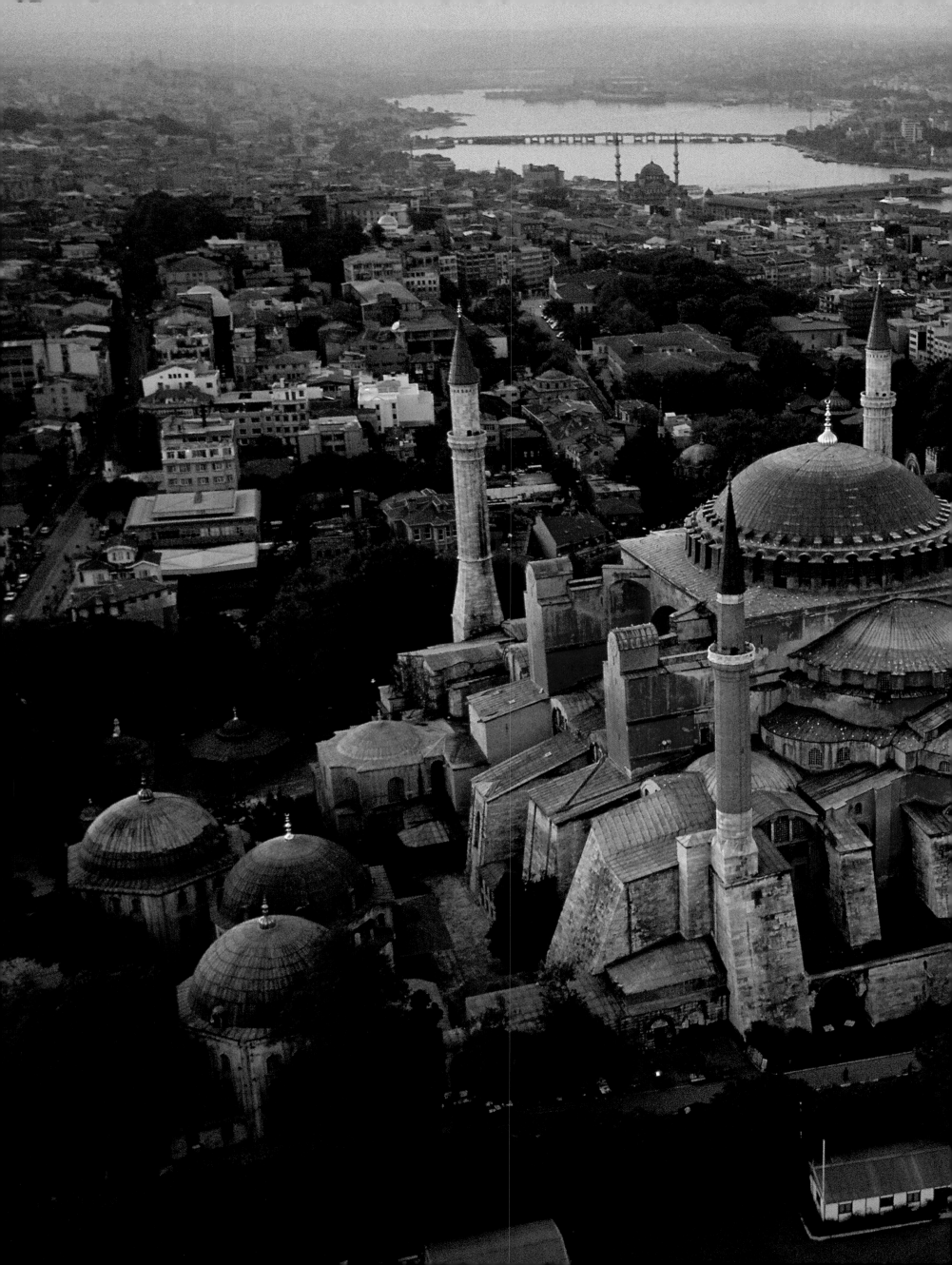

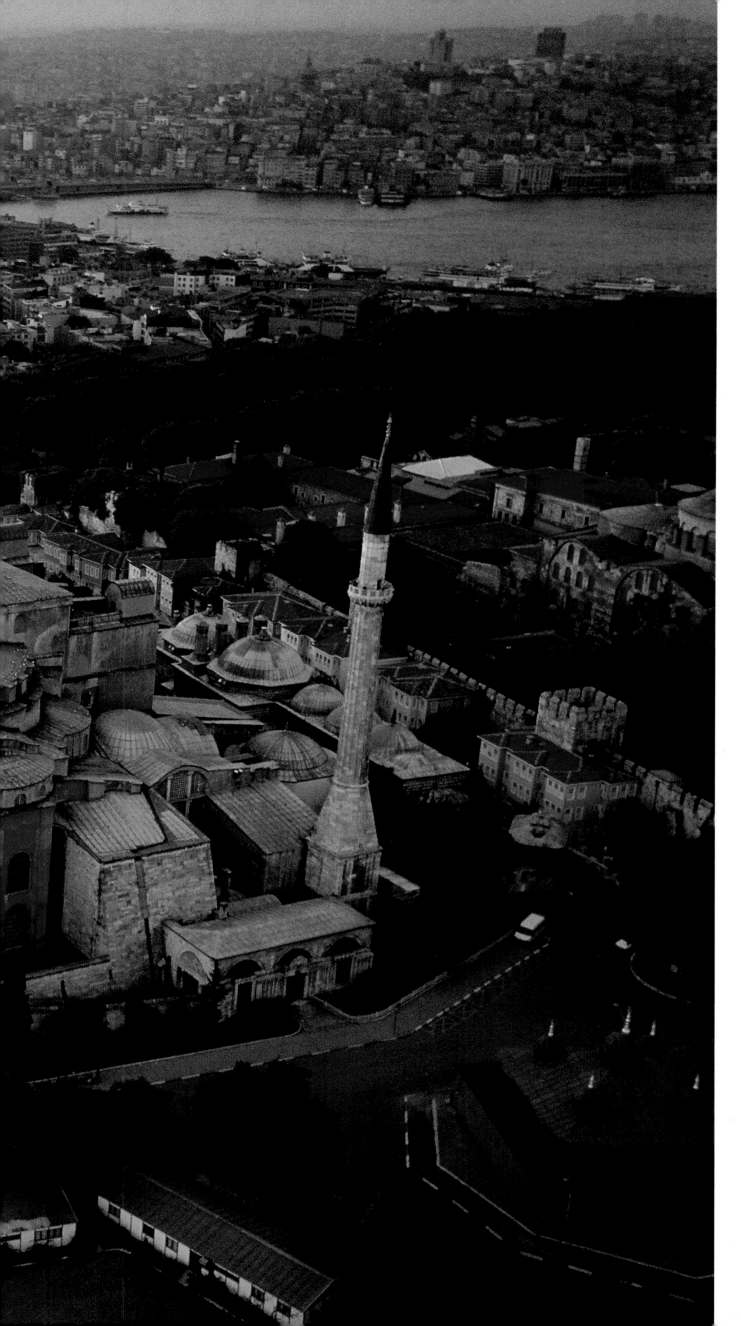

◁ **ISTANBUL**

BASILICA OF SANTA SOPHIA

The Emperor Justinian was responsible for
the building of the church of Santa Sophia,
dedicated to Divine Wisdom (Hagia Sophia) –
according to legend, an angel descended from
the sky and provided him with the plans and
the money necessary for the construction.
More prosaically, it is the work of two
architects, the Lydian Anthemius of Tralles and
the Ionian Isidorus of Miletus; they built the
church in brick, on foundations strengthened
with piles, apparently to protect the building
from the frequent earth tremors in the area. Its
huge scale and ungainly buttresses give no hint
of the extraordinary power of the interior and
the splendour of the dome, whose breathtaking
span was not equalled in Europe for nearly
ten centuries. This architectural masterpiece
was promptly converted into a mosque by
Mohammed II Fatih (the Conqueror) when
he entered Constantinople on 29 May 1453.

ISTANBUL

BASILICA OF SANTA SOPHIA ▷ ▷

'Glory to God who has judged me worthy
of completing this work. Solomon, you are
vanquished!' the Byzantine Emperor Justinian
proudly exclaimed at the opening of the
church, the work of ten thousand men, on
26 December 537: its magnificence surpassed
even the fabled Temple of Jerusalem itself.
The colonnades of some of the greatest temples
had been ransacked to build it: Ephesus,
Delphi and even Baalbek, from where eight
columns were taken. The Byzantine historian
Procopius described the dome at the time as
'appearing to be suspended from the sky by a
golden chain'. It certainly seems to stay up by
a miracle; it is constructed from light bricks
made in Rhodes, and was originally covered
with golden mosaics, though only fragments
survive today. They were not lost when the
building was turned into a mosque, but were
ripped out by the Crusaders during the orgy of
destruction that followed the seizure and sack
of Constantinople in 1204. They turned the
basilica into a place of wild entertainment.
However, the sultans respected it as a religious
building, and enriched it with many works of
art when it became a mosque. They added four
minarets, of which the two western ones are
attributed to Sinan, and undertook several
restorations before it was made into a museum
in 1935 by Mustafa Kemal Atatürk.

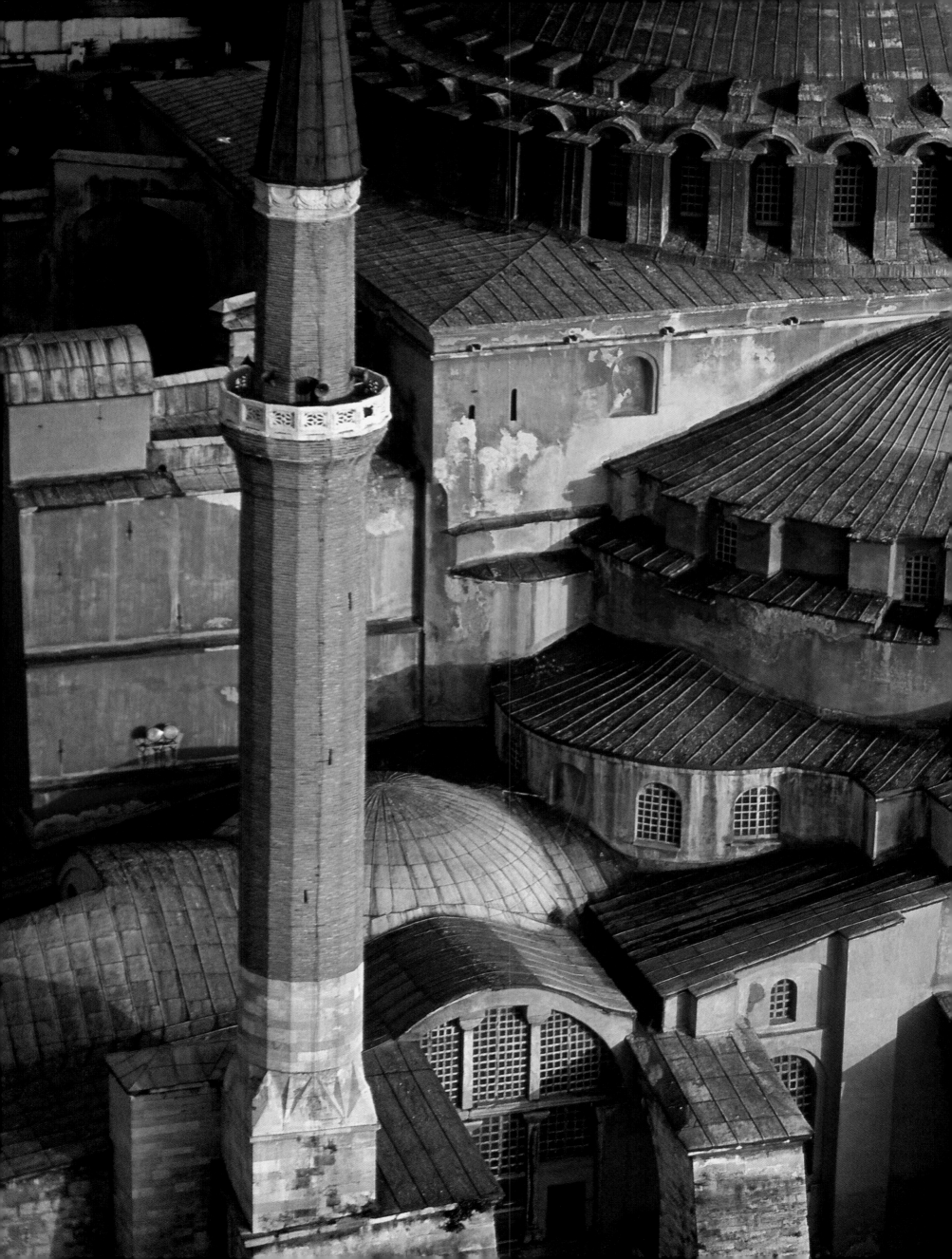

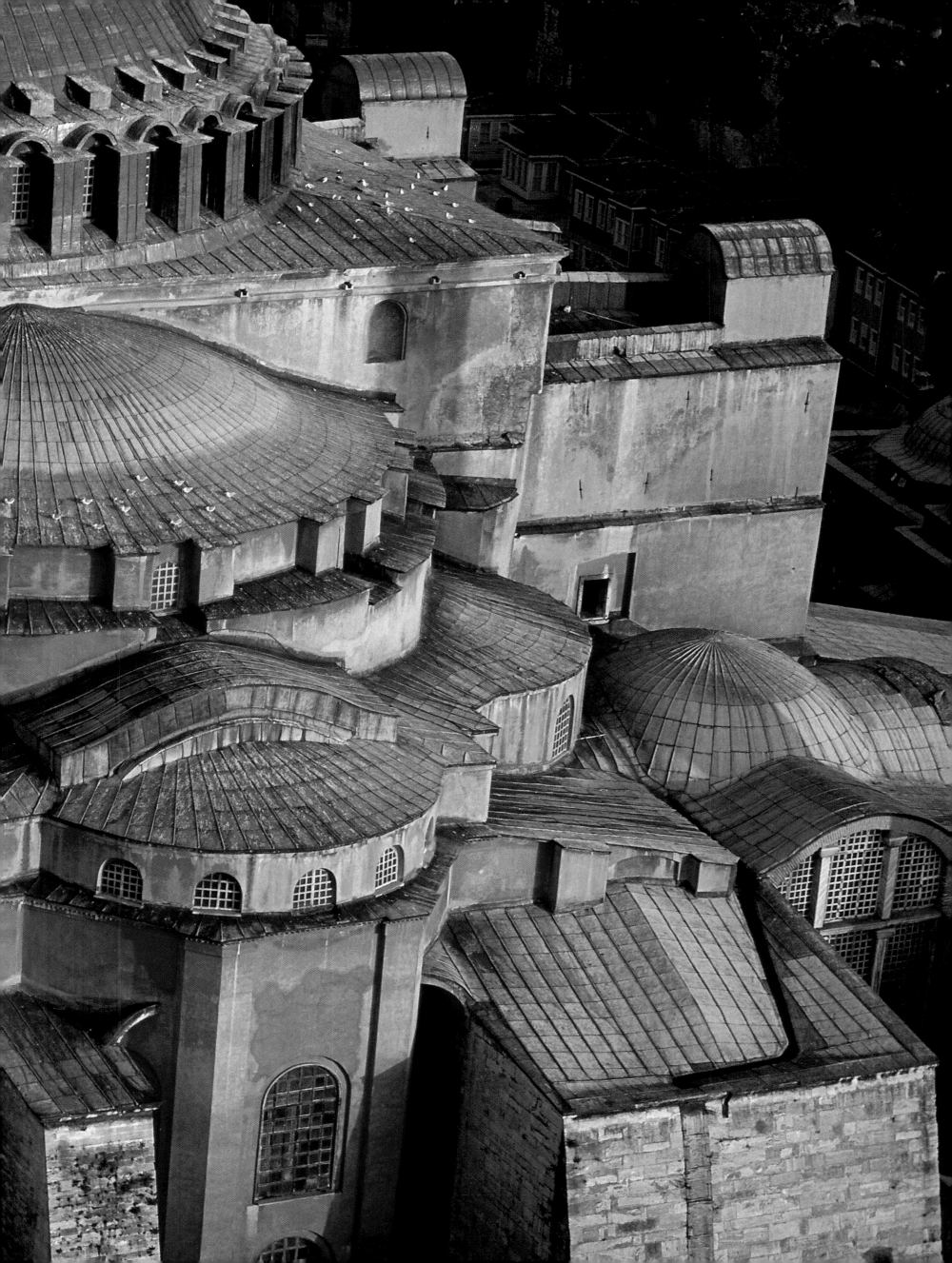

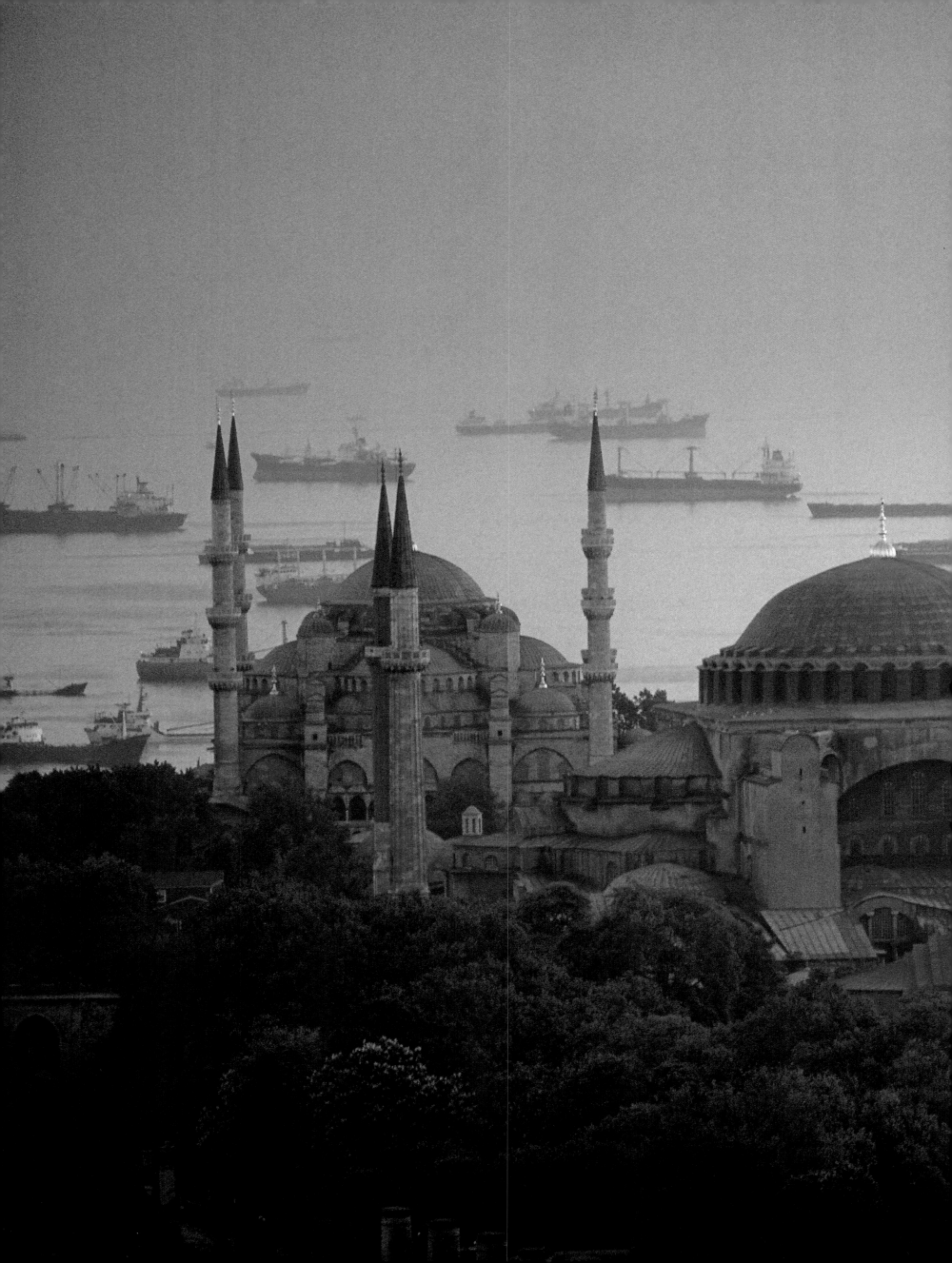

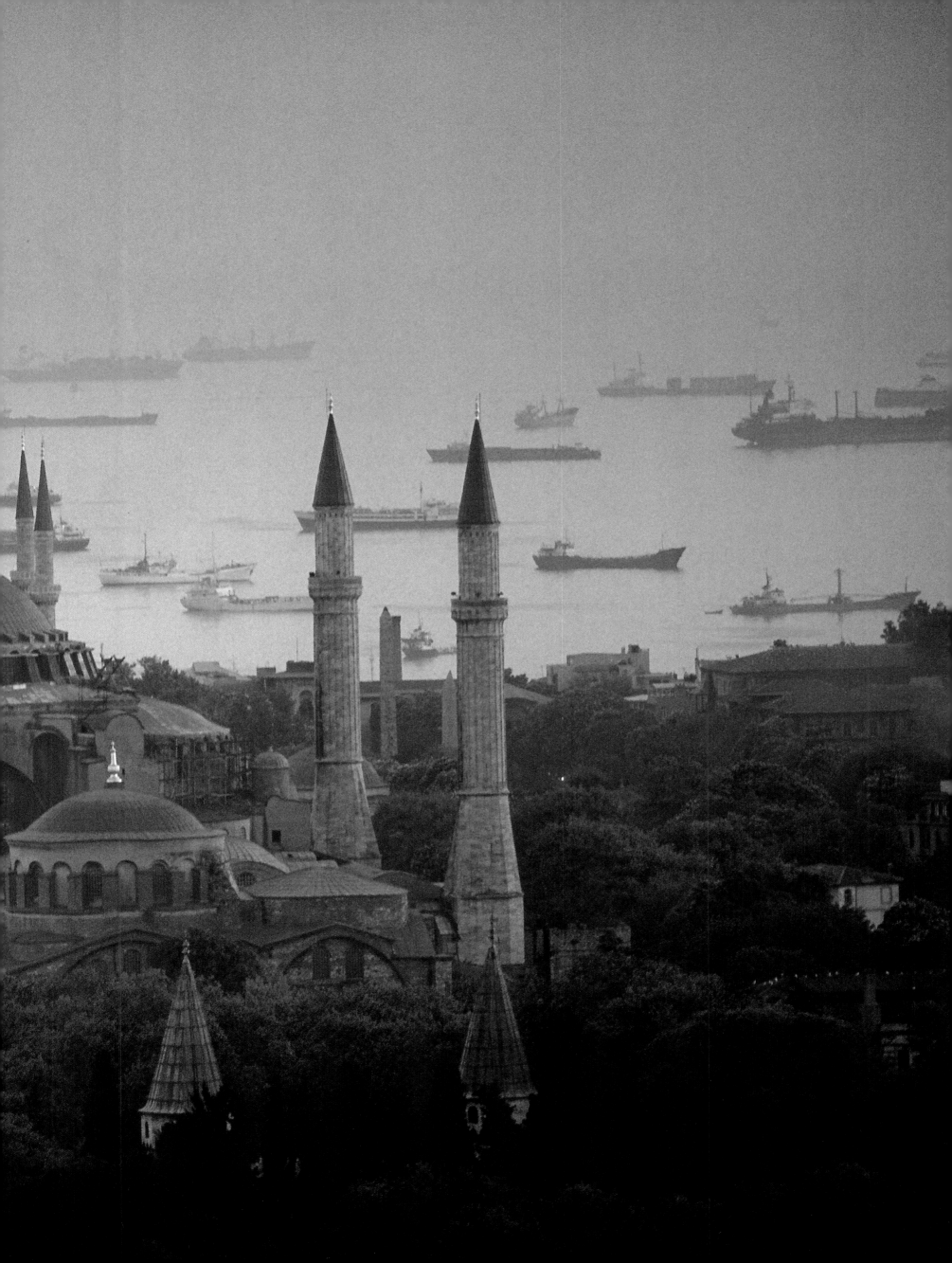

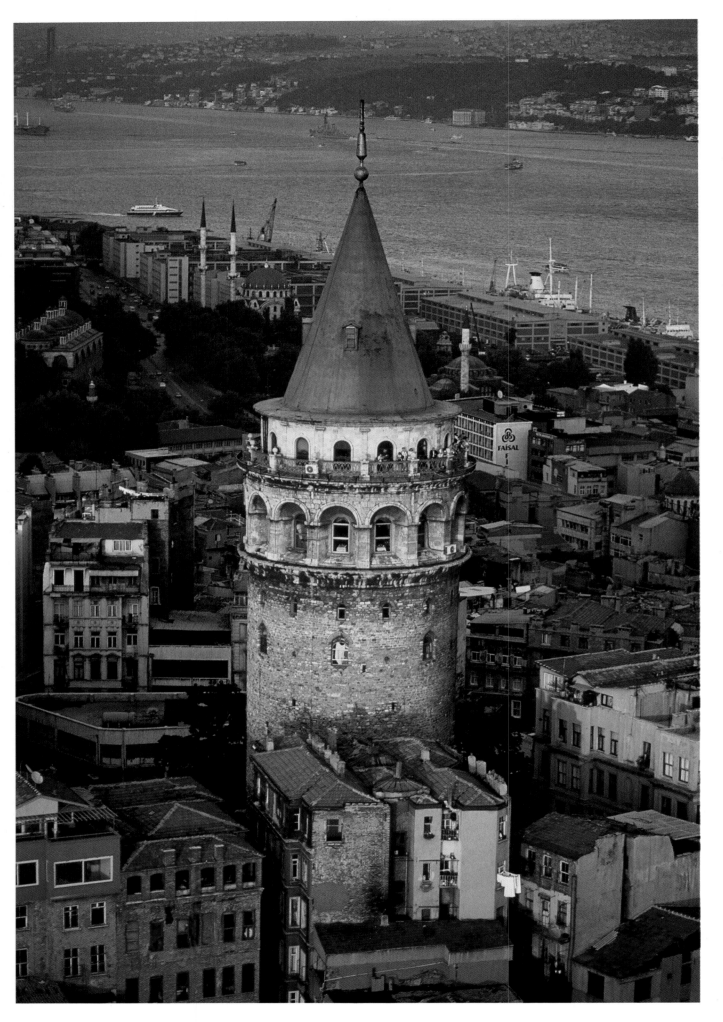

GALATA KULESI (GALATA TOWER)

The tower stands on the opposite bank of the
Golden Horn at Beyoglü, looking across at the
Süleymaniye Mosque. The first tower to be
built on this spot, in the time of the Emperor
Anastasius I, was called the Tower of Christ.
Demolished and rebuilt several times, notably
by the Genoese, the present structure dates
from the 15th century. It was part of the town's
defences, and was later used as a prison during
the reign of Suleiman the Magnificent; more
recently it served as a look-out post for fires in
the city. It is still one of the most important
sites to visit in Istanbul, offering wonderful
views from its outside gallery of the Golden
Horn, Suleiman's mosque and the Yeni Camii,
Topkapi Sarayi and Santa Sophia.

ISTANBUL

**NURU OSMANIYE CAMII (MOSQUE
OF THE SACRED LIGHT OF OSMAN)** ▷

The Nuru Osmaniye was built opposite the
entrance to the Great Bazaar between 1748 and
1755 at the instigation of Sultan Mahmud I.
It commemorates the founder of the Ottoman
Empire, but has a Western feel. There are
European Baroque and French Rococo
influences in the Greek architect Simeon Kalfa's
design for the building: it is even regarded
as the first genuinely Baroque Ottoman
construction. Religious representatives at the
time were disturbed by this, and put pressure
on Mahmud I and then on Osman III to water
down its foreign character. A notable feature of
the mosque is its semicircular courtyard shaded
by plane trees, which is popular with street
traders.

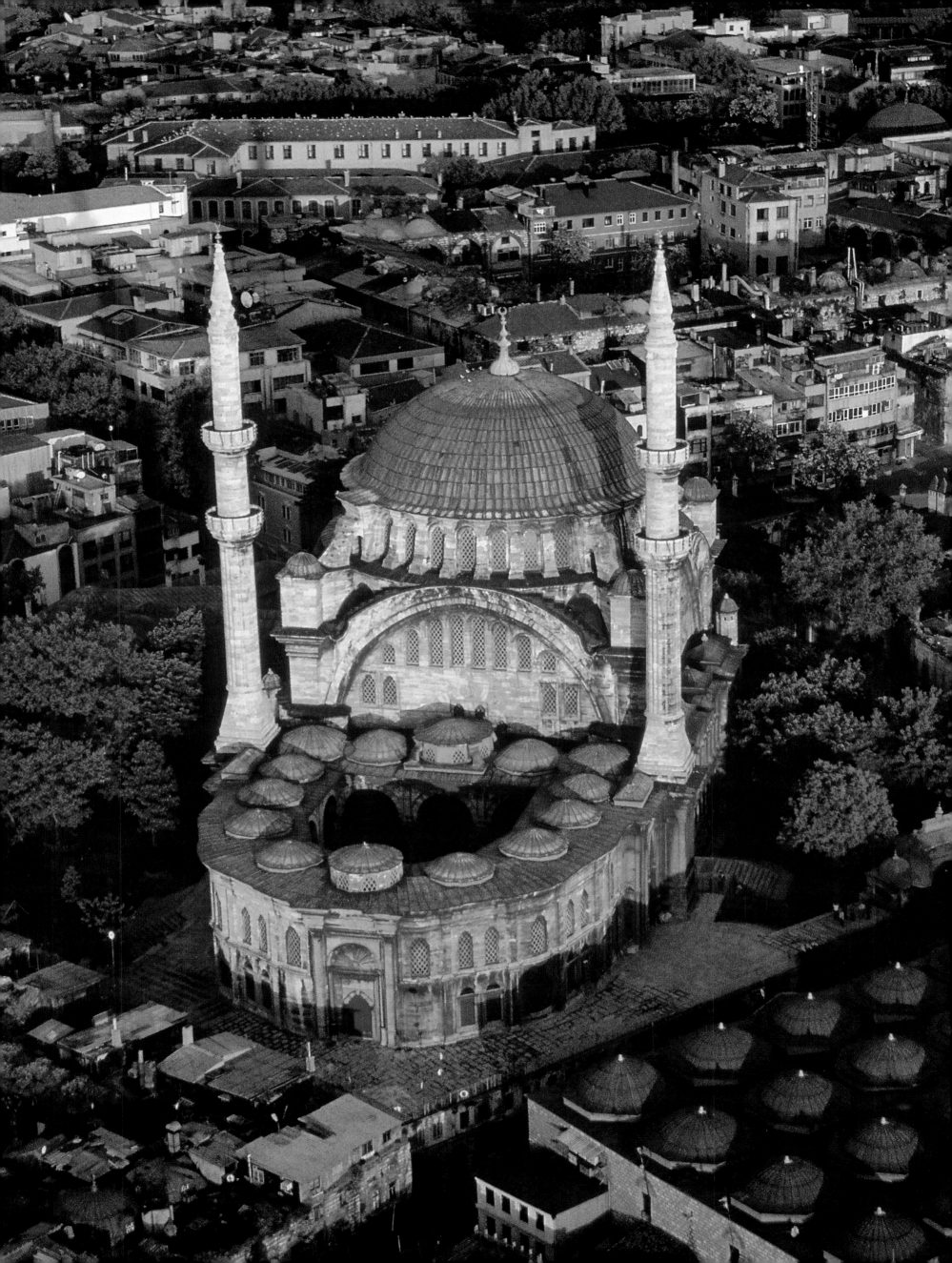

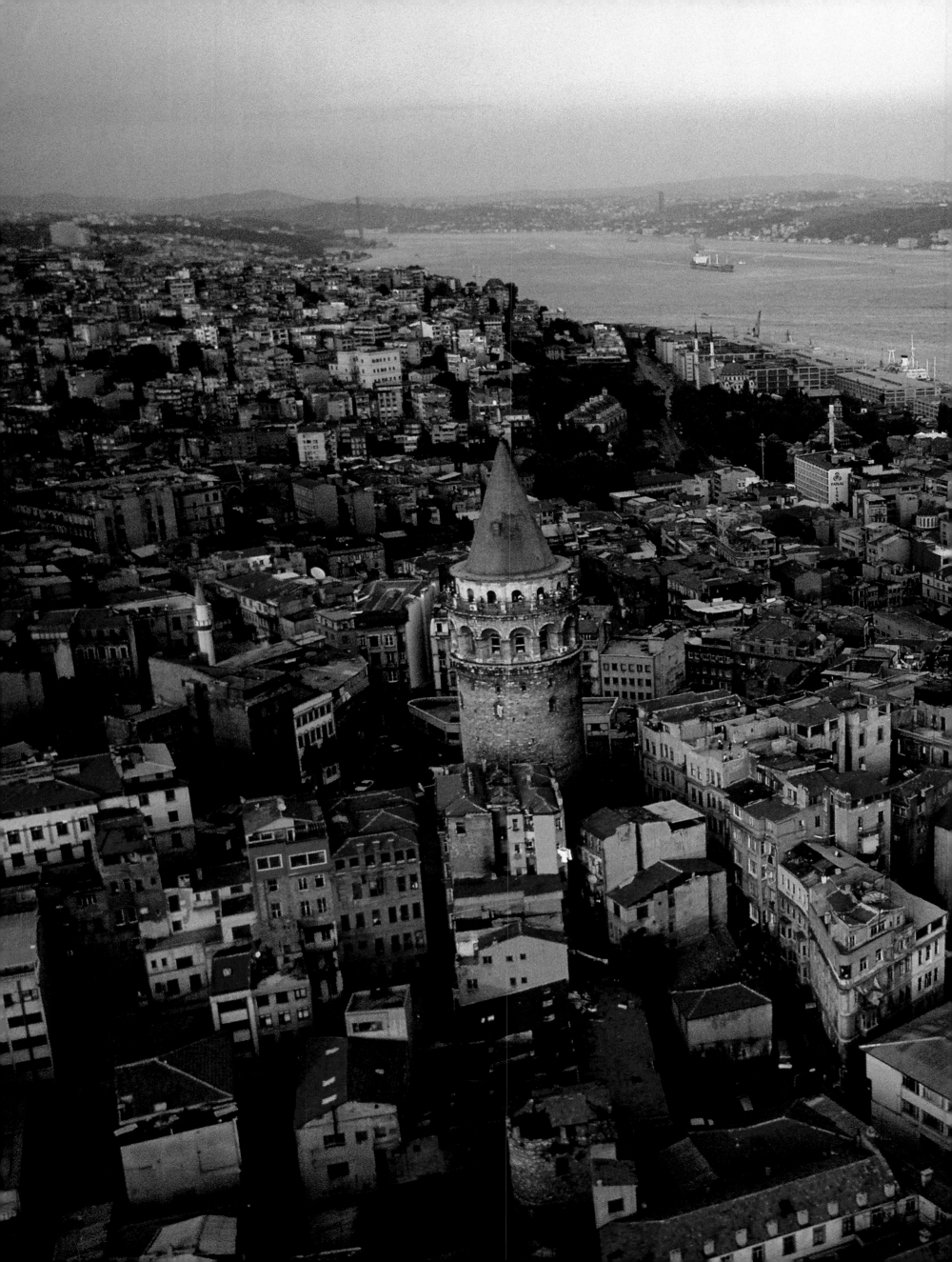

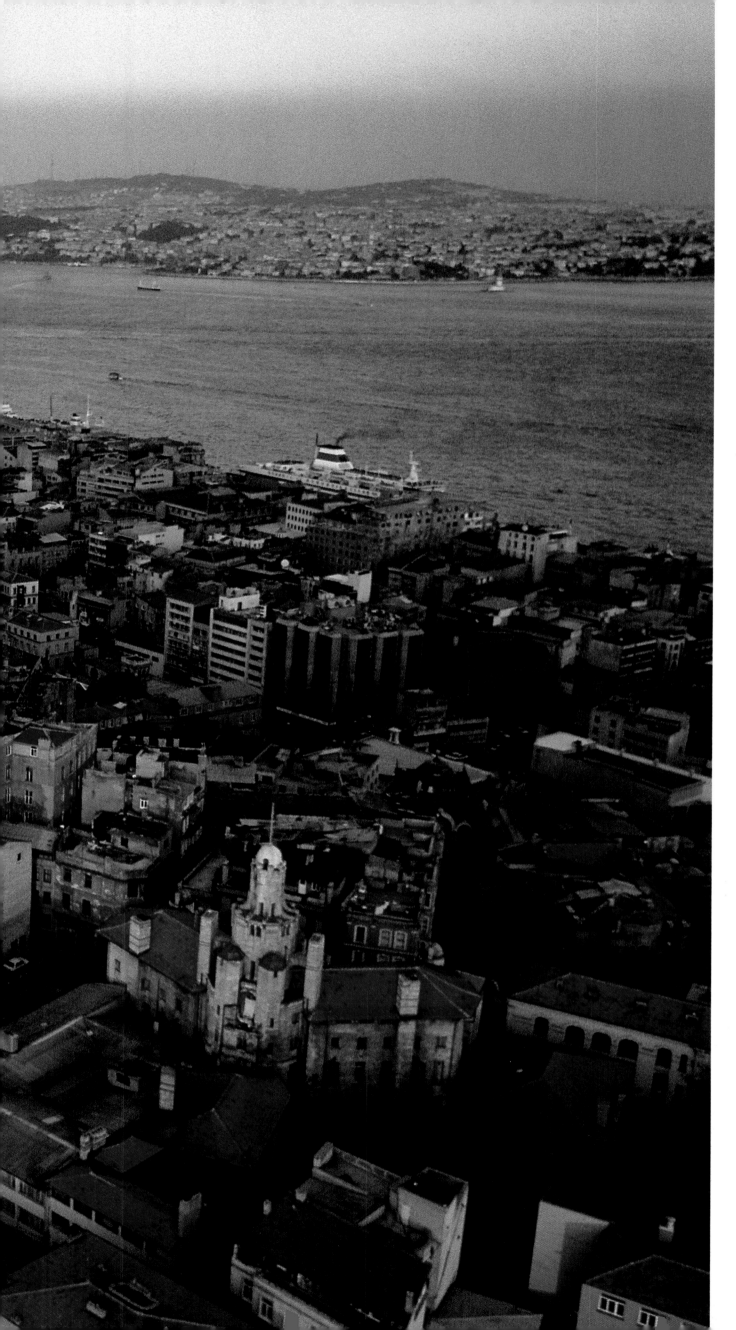

◁ **ISTANBUL**
VIEW OF THE GALATA TOWER
DISTRICT

ISTANBUL
TOPKAPI SARAYI (TOPKAPI PALACE) ▷

The Topkapi Palace is built on the site of the ancient acropolis of Byzantium, on one of the city's seven hills, and covers the whole of the Seraglio headland. It is made up of a great variety of buildings, the oldest of which were erected soon after the conquest of the city to house the sultans and their families. However, the name Topkapi Sarayi only dates from the 18th century, when the sultan called it 'The Palace of the Cannon Gate' after the cannons that he had positioned at the entrance to his private wing. The buildings of the imperial palace are enclosed within a fortified wall, and arranged around several courtyards. Among them, the monumental kitchens built by Sinan in the reign of Selim II stand out, still with their twenty tall, graceful chimney stacks. At that time, at least a thousand cooks were employed there, capable of providing food for five thousand people, since, beside the inhabitants of the Seraglio, all the sultan's subjects were entitled to come to eat there every day; the first courtyard of the palace was always open to them, day and night. The Topkapi Palace was the residence of the sultans continuously for four centuries, until 1855, when Abdul-Medjid moved to the Dolmabahçe Sarayi, a luxurious western-style residence that he had recently built on the shores of the Bosphorus.

33

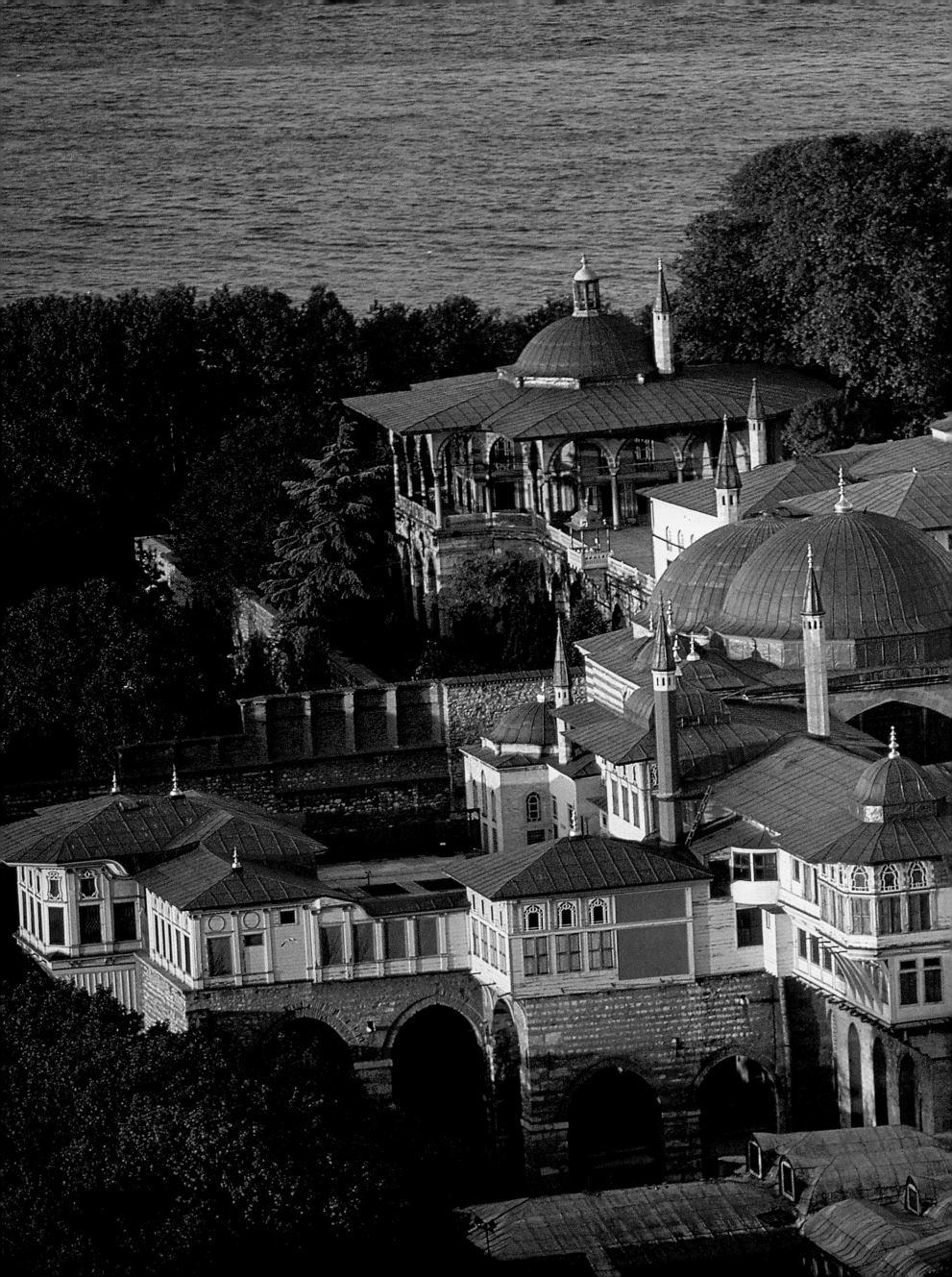

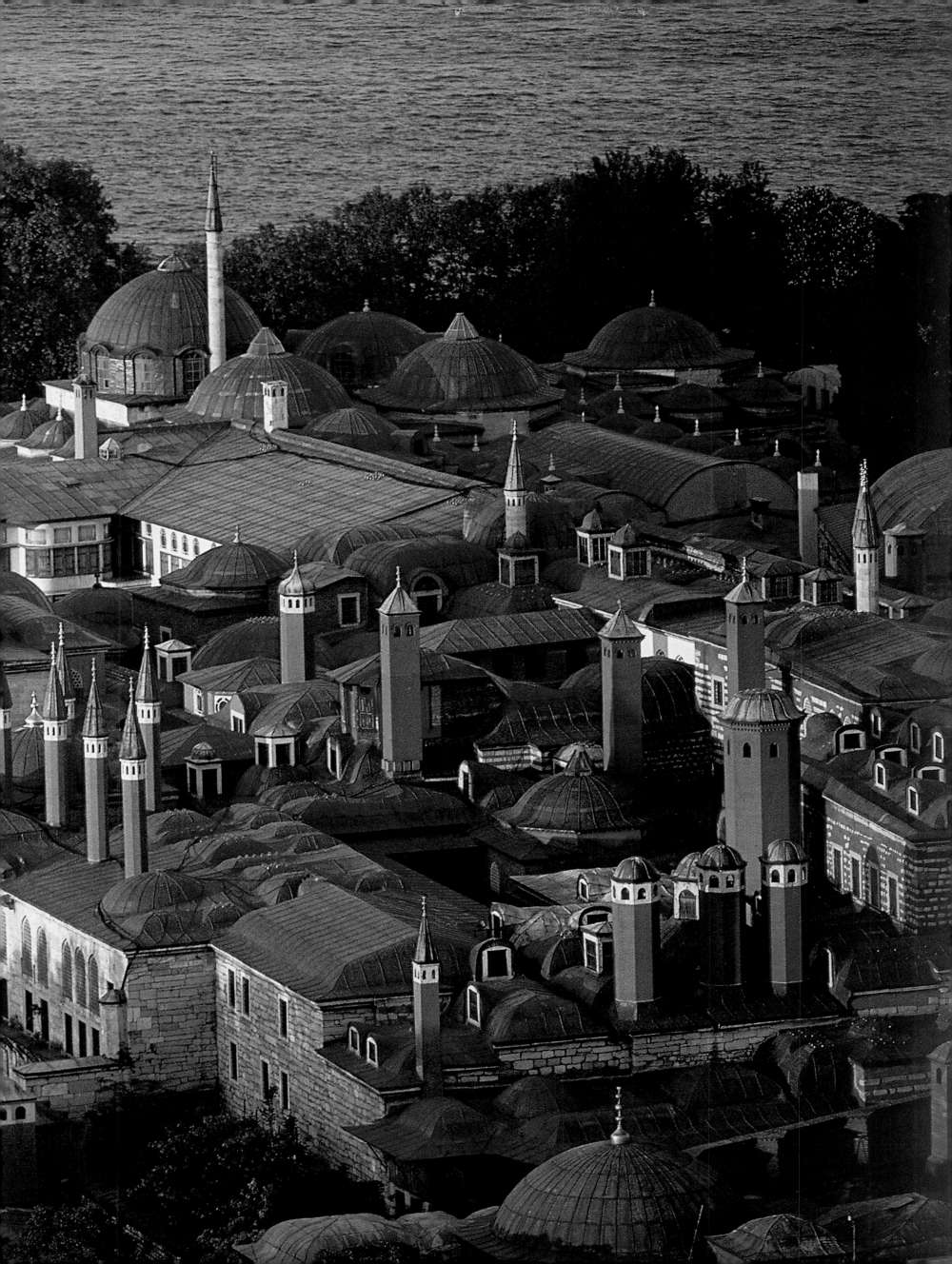

ISTANBUL

ORTHODOKS PATRIKHANESI
(ORTHODOX PATRIARCHATE)

The Greek Orthodox Patriarchate was established in the Fener district when it ceased to occupy the Theotokos Pammakaristos church: this became the Fethiye Camii, or Mosque of the Conquest, under Murad III. The main door of the Patriarchate, Orta Kapi, has been painted black since the execution in 1821 of Patriarch Gregory V at the time of the Greek uprising against the Ottomans. The church dates from 1720, and houses both the patriarchal throne – which, according to tradition, was that of St John Chrysostom – and the column of the Flagellation. At one time spiritual leader of the Orthodox world, nowadays the Patriarch of Constantinople only has authority over the Orthodox Greeks of Turkey, Mount Athos, Crete and the islands of the Dodecanese ceded back to Turkey.

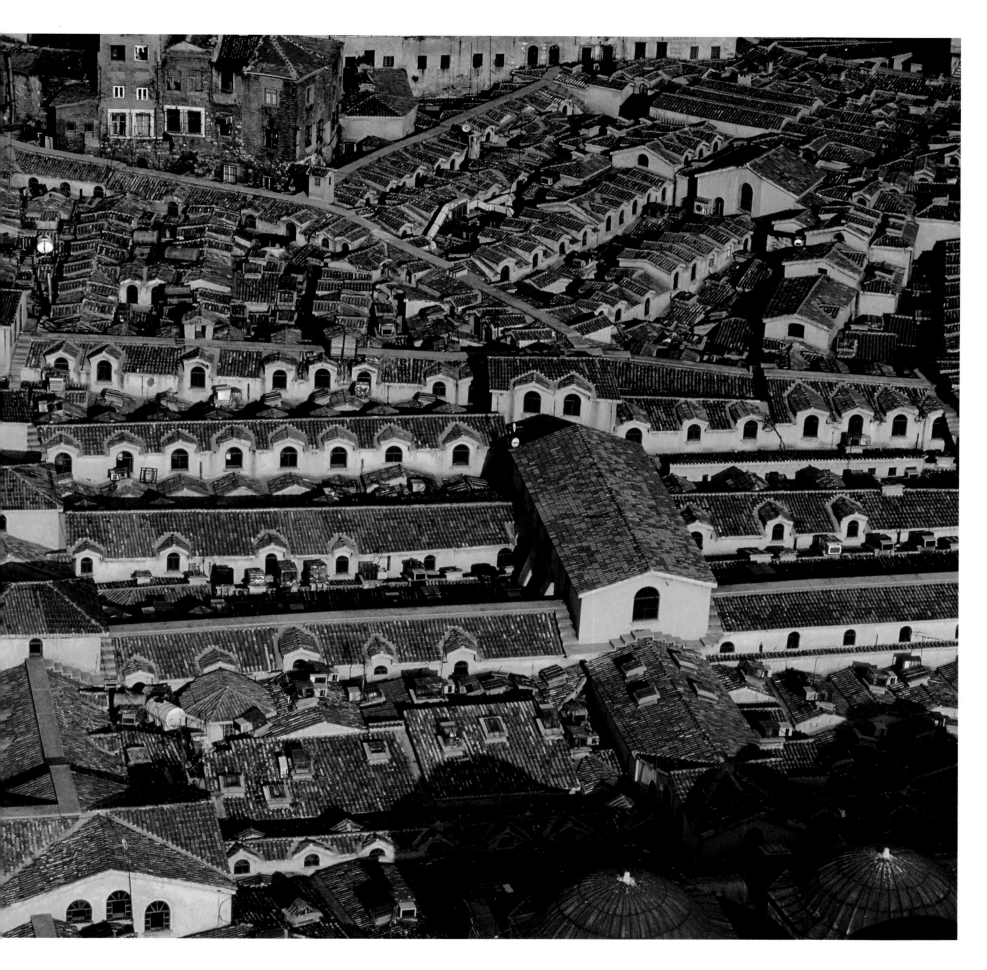

ISTANBUL

KAPALI ÇARSI (GREAT BAZAAR)

It appears that the Conqueror himself, Mohammed II, built the first Kapali Çarsi (literally, covered market) in wood, probably on the site of an earlier Byzantine market. It was damaged by fire several times, before being rebuilt for the last time in stone. It did not, however, avoid destruction in the earthquake of 1894. From the beginning, the different trades have occupied well-defined areas, and are still grouped together according to their merchandise. Nowadays, the bazaar is a vast maze composed of around sixty alleyways with some four thousand booths, as well as some banks, mosques and hammams. The central area, the Iç Bedesten (Old Warehouse), and the Sandal Bedesten (Satin Warehouse) are the oldest parts of the bazaar; they are roofed with cupolas and ringed with thick walls. Around the edges, the *hans*, or workshops, are alive with the bustle of traditional craftsmen. Here they make the merchandise for sale in the passageways of the Great Bazaar, which is regarded as the oldest covered market in the world.

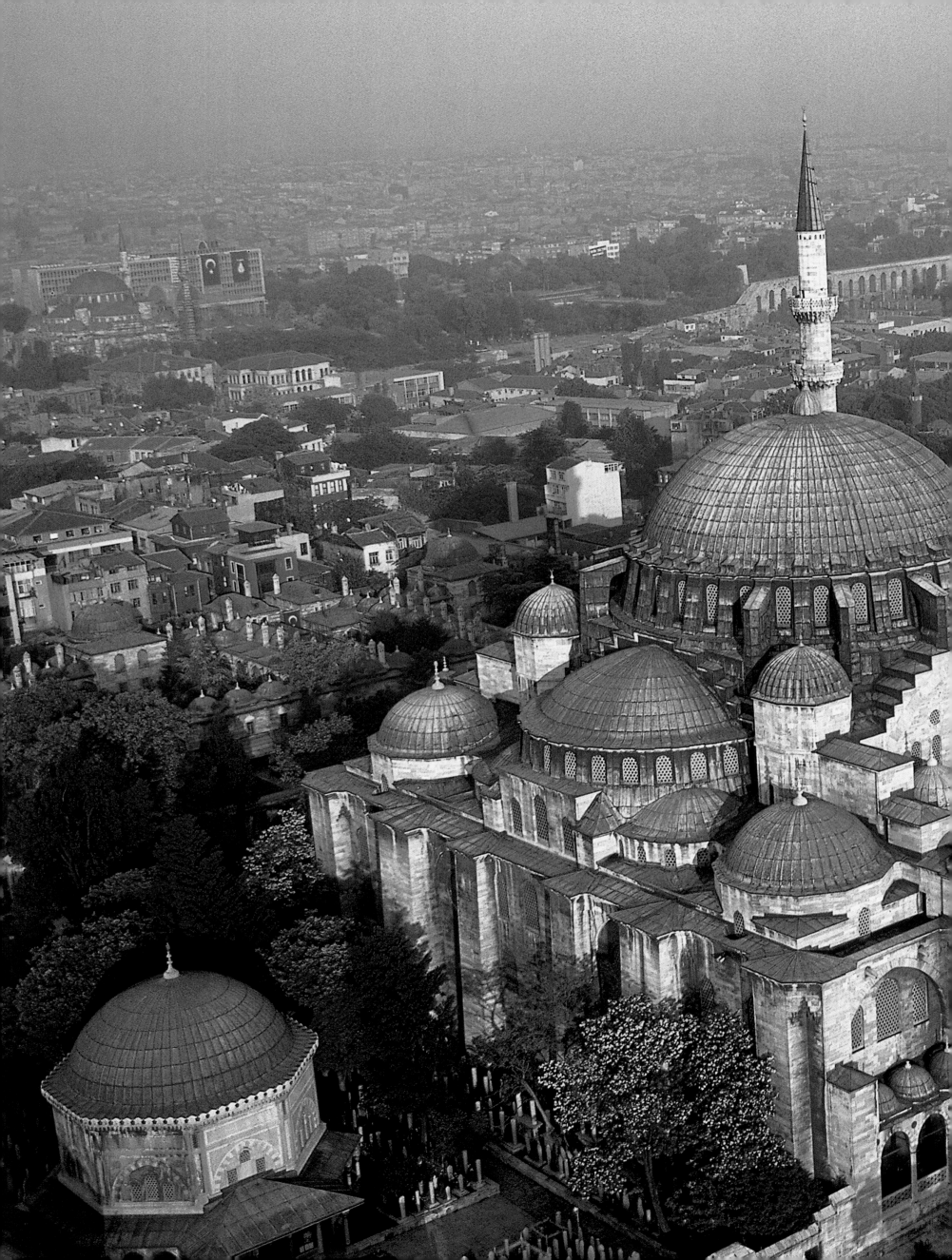

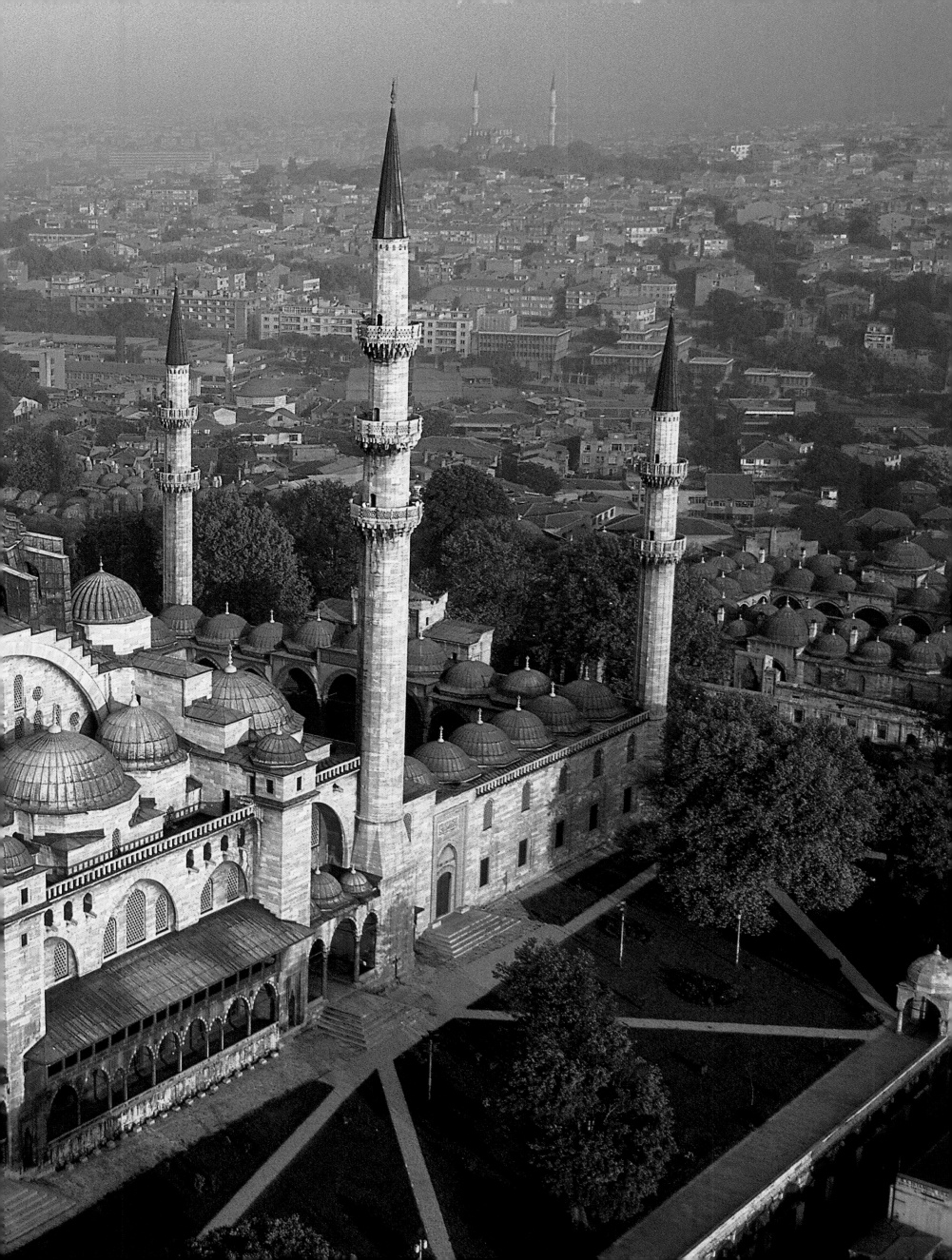

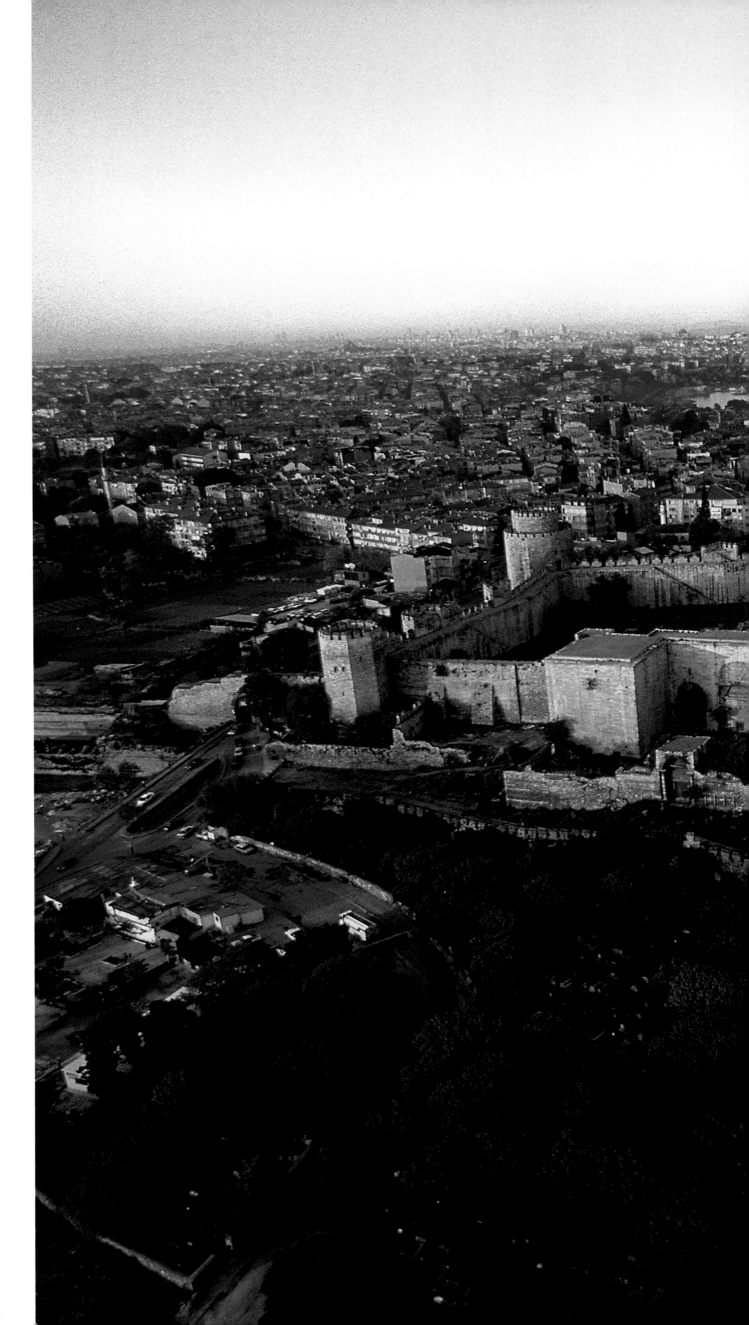

SÜLEYMANIYE CAMII

(SULEIMAN'S MOSQUE)

The Süleymaniye, or Mosque of Sultan
Suleiman I (better known in the West as
Suleiman the Magnificent) stands on one of
the seven hills of Istanbul. Its cascade of domes
dominates the Golden Horn, the narrow
channel of water which separates the old city
from the newer districts – it was once the
sultans' private lake, for which Leonardo da
Vinci designed a bridge with a span of more
than three hundred metres (one thousand feet).

The mosque is the work of the greatest
architect of the Ottoman world, and one of
the greatest of the whole Renaissance period,
Mimar Sinan. Little is known of his life, except
that he was born in about 1489 at Agyrnas
near Kayseri in Cappadocia, to Armenian
parents. Other historical sources claim that
they were Greeks from western Anatolia, or
even Austrians or Albanians. We do know,
however, that he was abducted around the age
of twenty-one and taken to Istanbul to join the
janissaries (*yeniçeri*), an elite Ottoman infantry
corps, in which he became a military engineer.
After returning to civilian life, Sinan became
architect-in-chief to the sultan when he was
in his fifties, and was put in charge of the
construction of the building which symbolizes
the reign of the most powerful of the Ottoman
rulers. He died in 1588, at the age of ninety-
nine; his modest mausoleum, or *türbe*, is not
far from the imperial mosque that he built.

ISTANBUL

YEDIKULE

(CASTLE OF THE SEVEN TOWERS) ▷

The castle of Yedikule was built in Byzantine
times. It stands beside the Sea of Marmara
(called the Propontis by the Ancients) on
its European shore at the southern edge of
Istanbul. Its walls incorporate the triumphal
arch built in AD 380 by the Emperor
Theodosius I, and many imperial triumphal
processions passed through it subsequently.
Today it is known as the Golden Gate.
Mohammed II Fatih rebuilt this Byzantine
citadel after his conquest of the city, reinforcing
its defences and adding more towers to make
the entire structure into an impregnable state
treasury. The scratched inscriptions on the
walls of the east tower show that it was later
used as a prison. Prisoners of war, nationals of
countries at war with the Ottoman Empire
and the crews of captured ships were all left to
rot at Yedikule. Sultan Osman II himself was
imprisoned, and subsequently executed, there
after being deposed in 1622 by mutinous
janissaries.

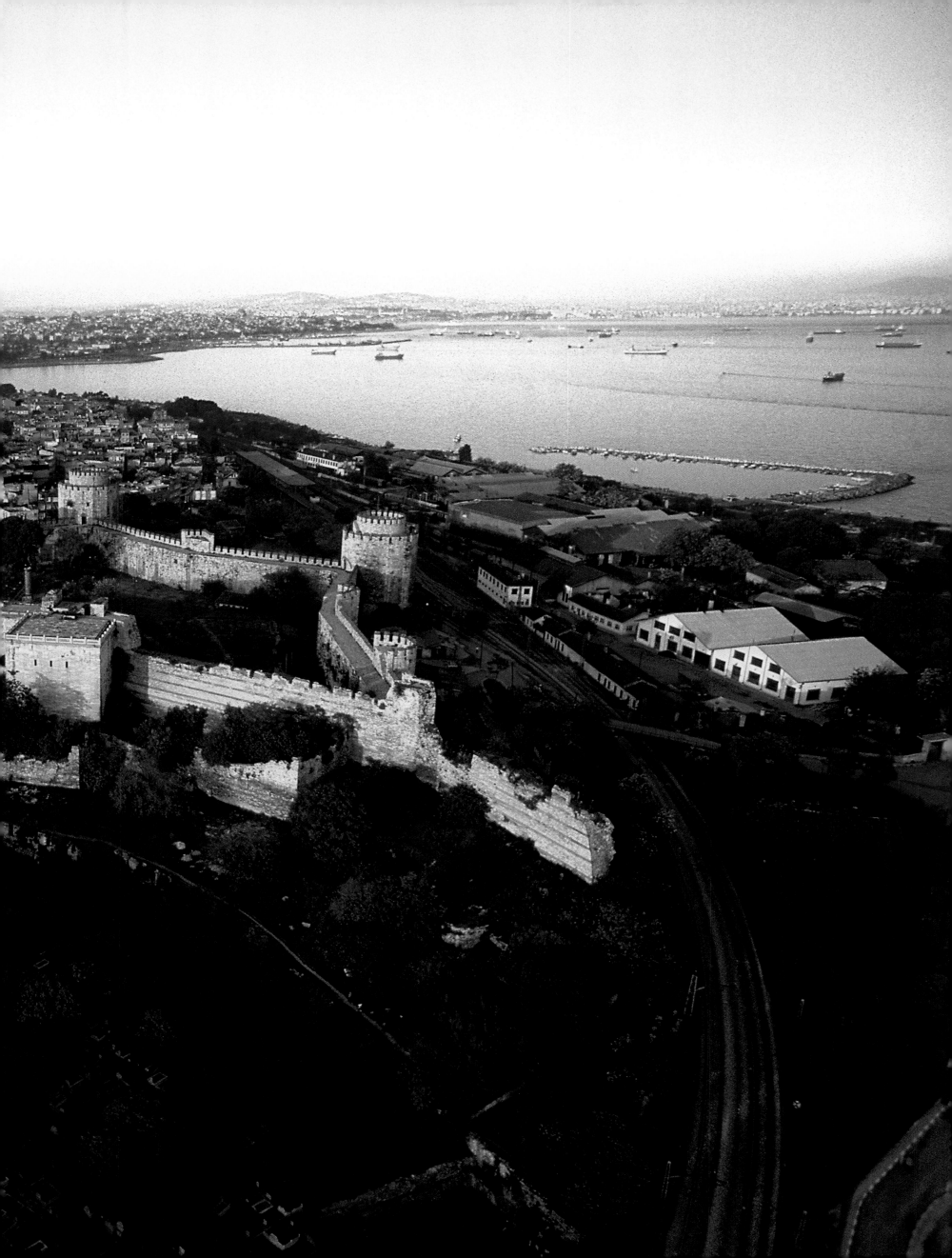

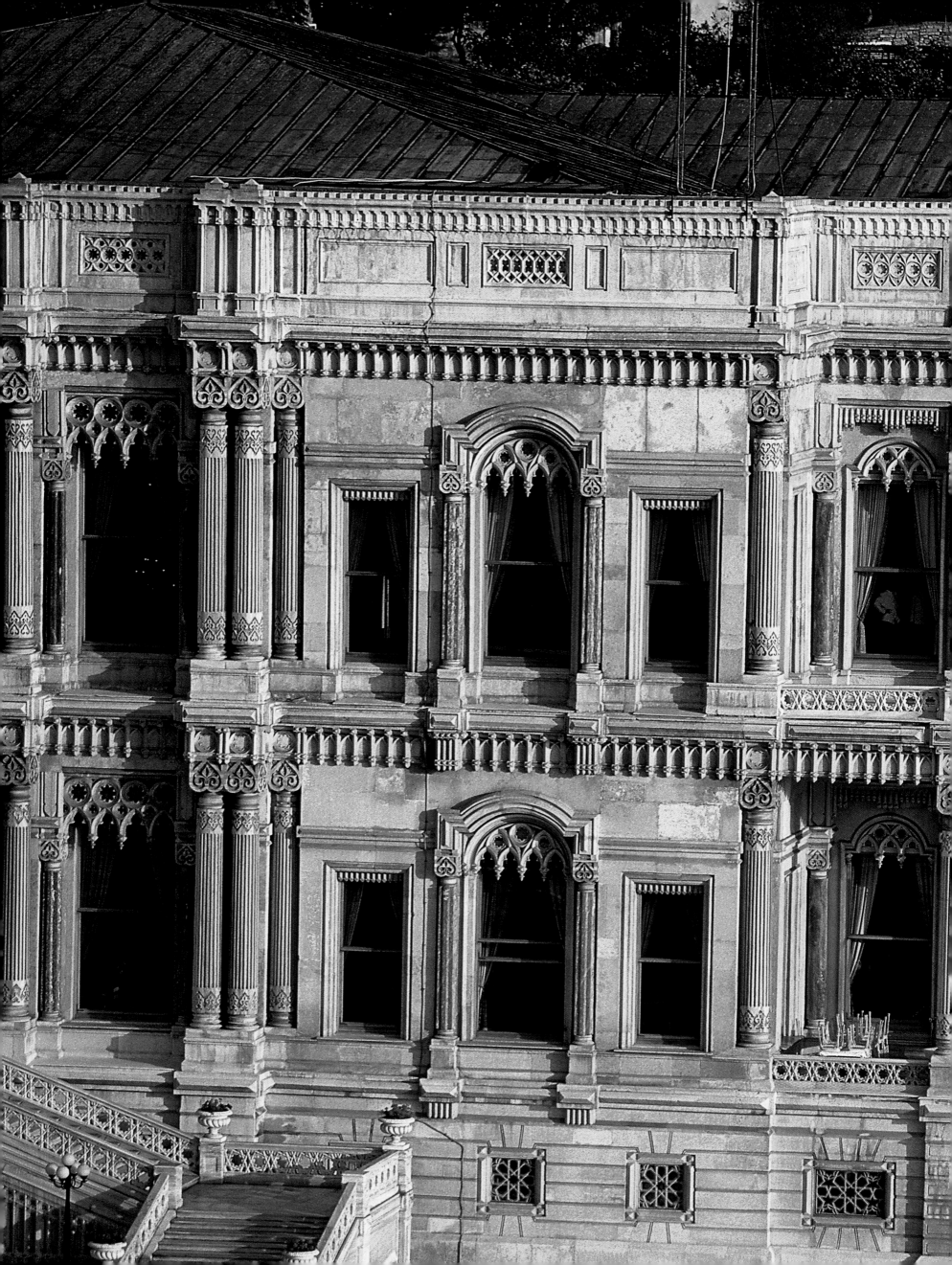

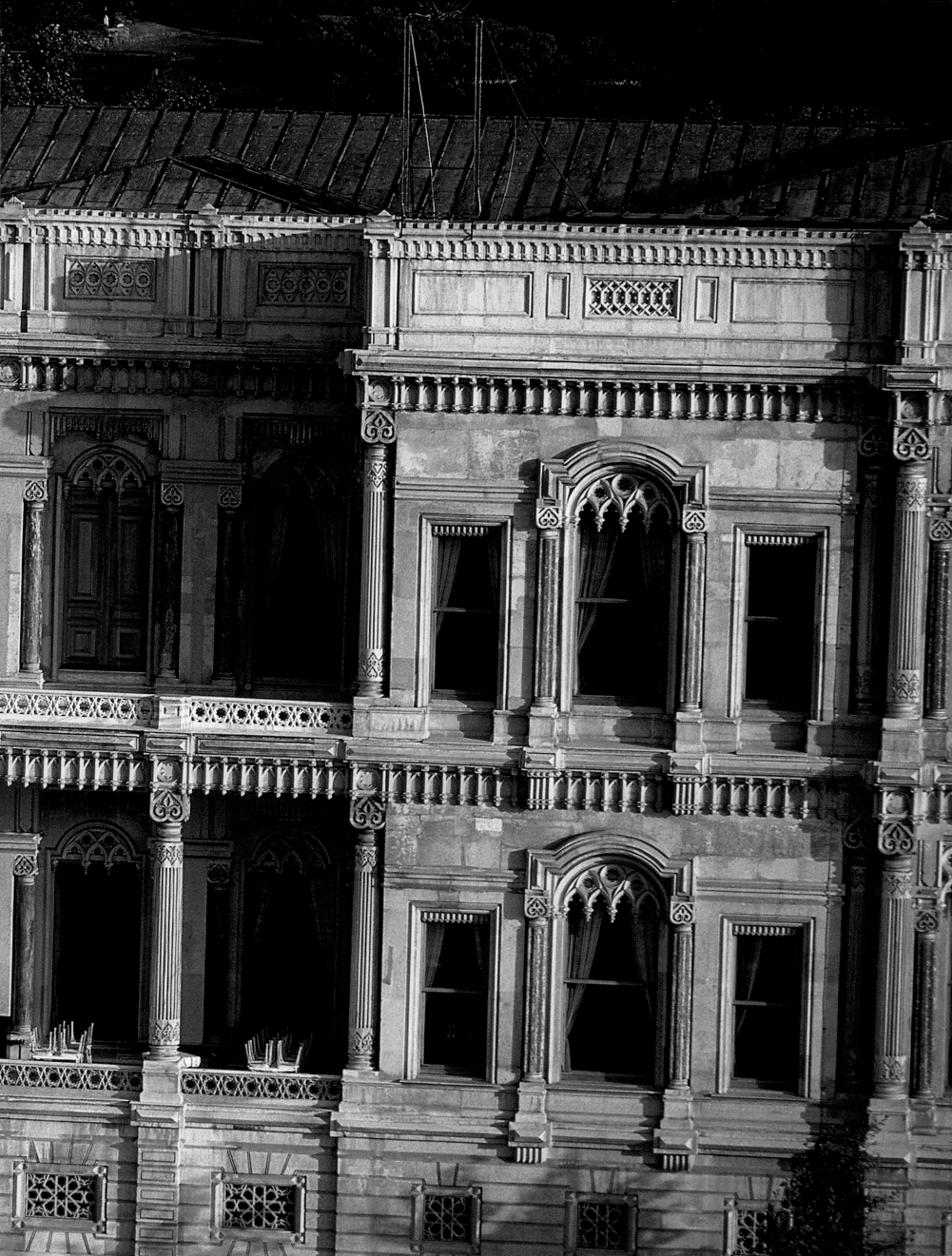

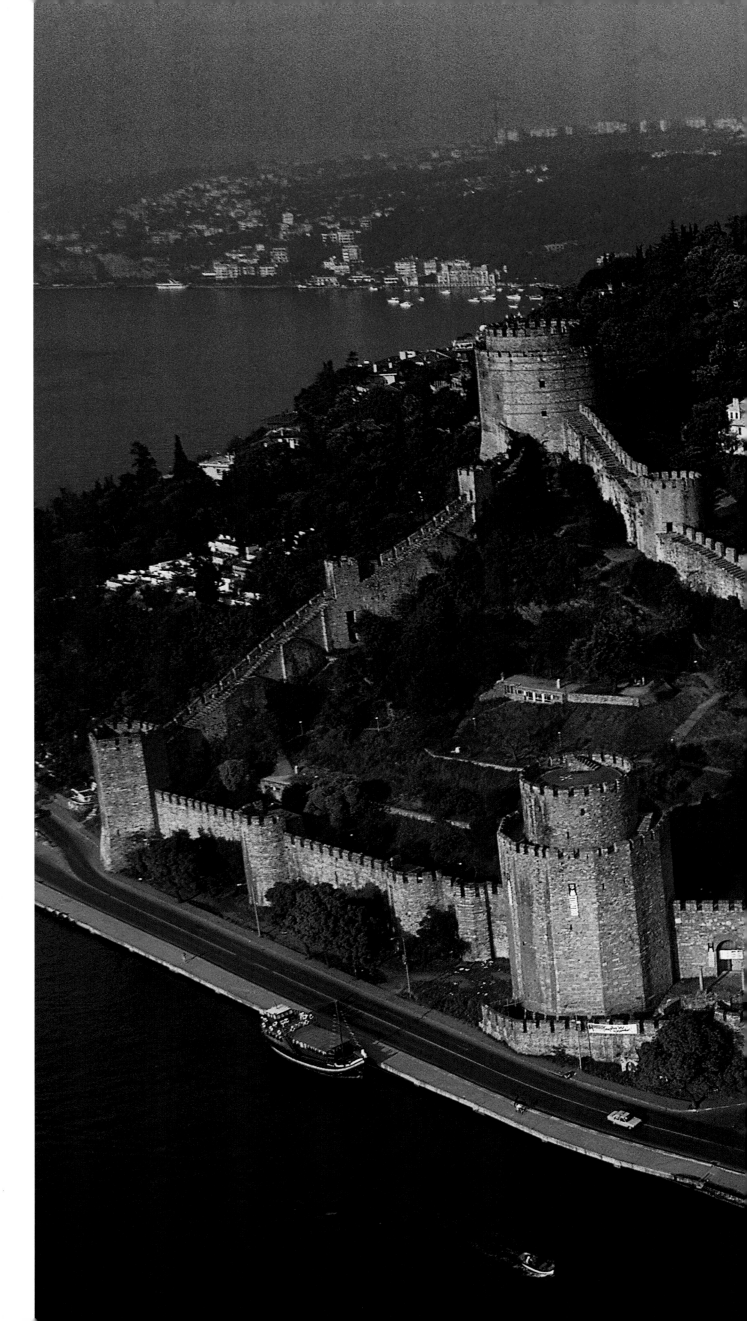

ISTANBUL
ÇIRAGAN SARAYI
(PALACE OF TULIPS)

The Çiragan Sarayi was built by the architect
Nigogos Balyan for Sultan Abdul-Aziz in 1870.
The sultan intended that this sumptuous
building on the European shore of the
Bosphorus would surpass its predecessor, the
nearby Dolmabahçe Sarayi, but both came to
symbolize the end of the Ottoman Empire.
The Young Turks made the Çiragan Palace the
seat of their new Parliament, but it was burned
out in 1910. An exact replica was built from
the ruins in the late 1980s, and the building
is now a luxury hotel and casino.

ISTANBUL
RUMELI HISARI
(FORTRESS OF EUROPE) ▷

This fortress on the European shore of the
Bosphorus was built in just over four months
by Mohammed II Fatih a year before he took
Constantinople: it was intended to control the
narrowest part of the waterway and cut off
supplies to the city. It has huge outer walls
reinforced with towers; according to legend,
it took a thousand masons to build it.
The fortress was garrisoned by about four
hundred janissaries charged with patrolling
the channel, but after the city was taken, it
was no longer used.

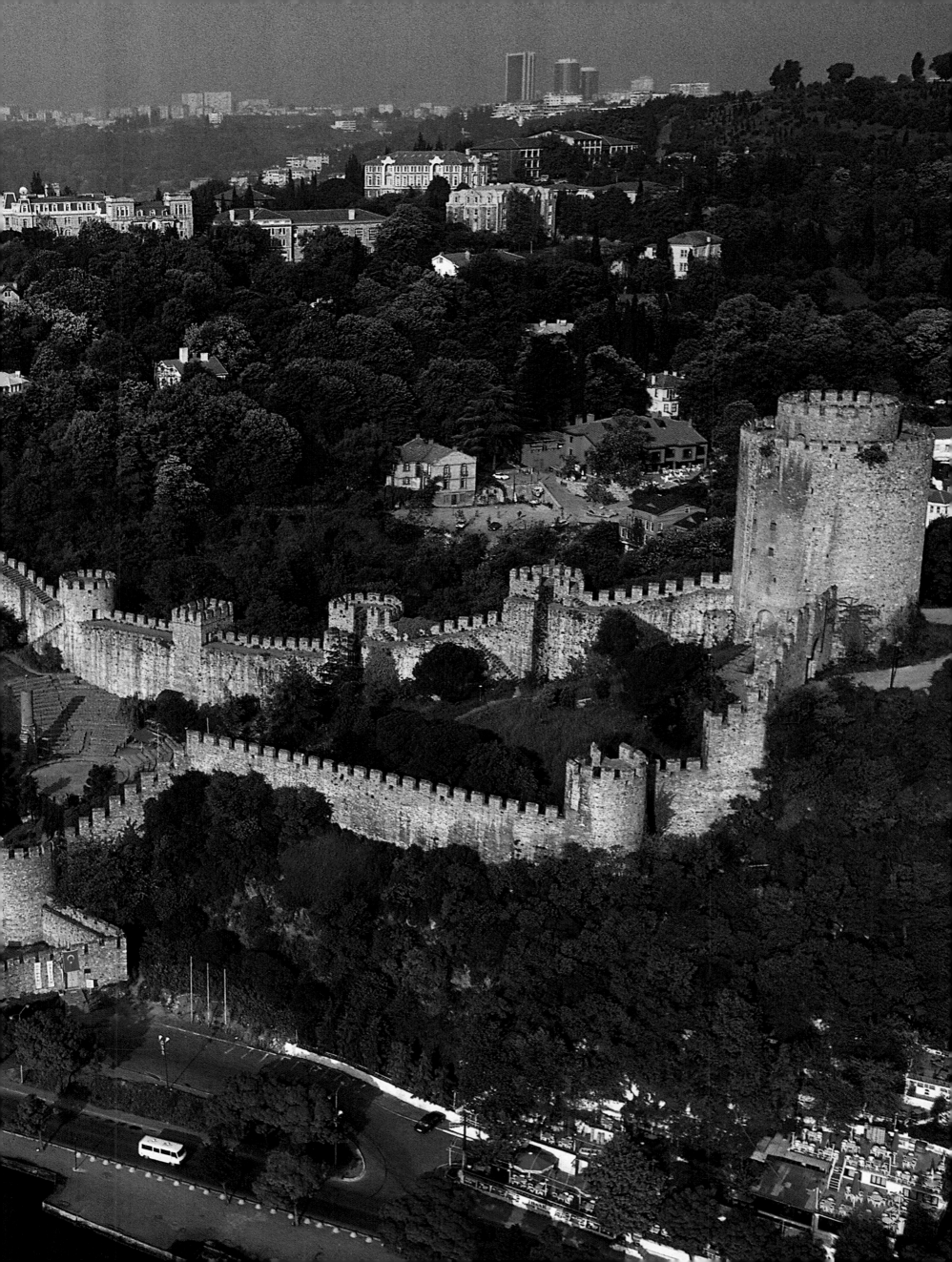

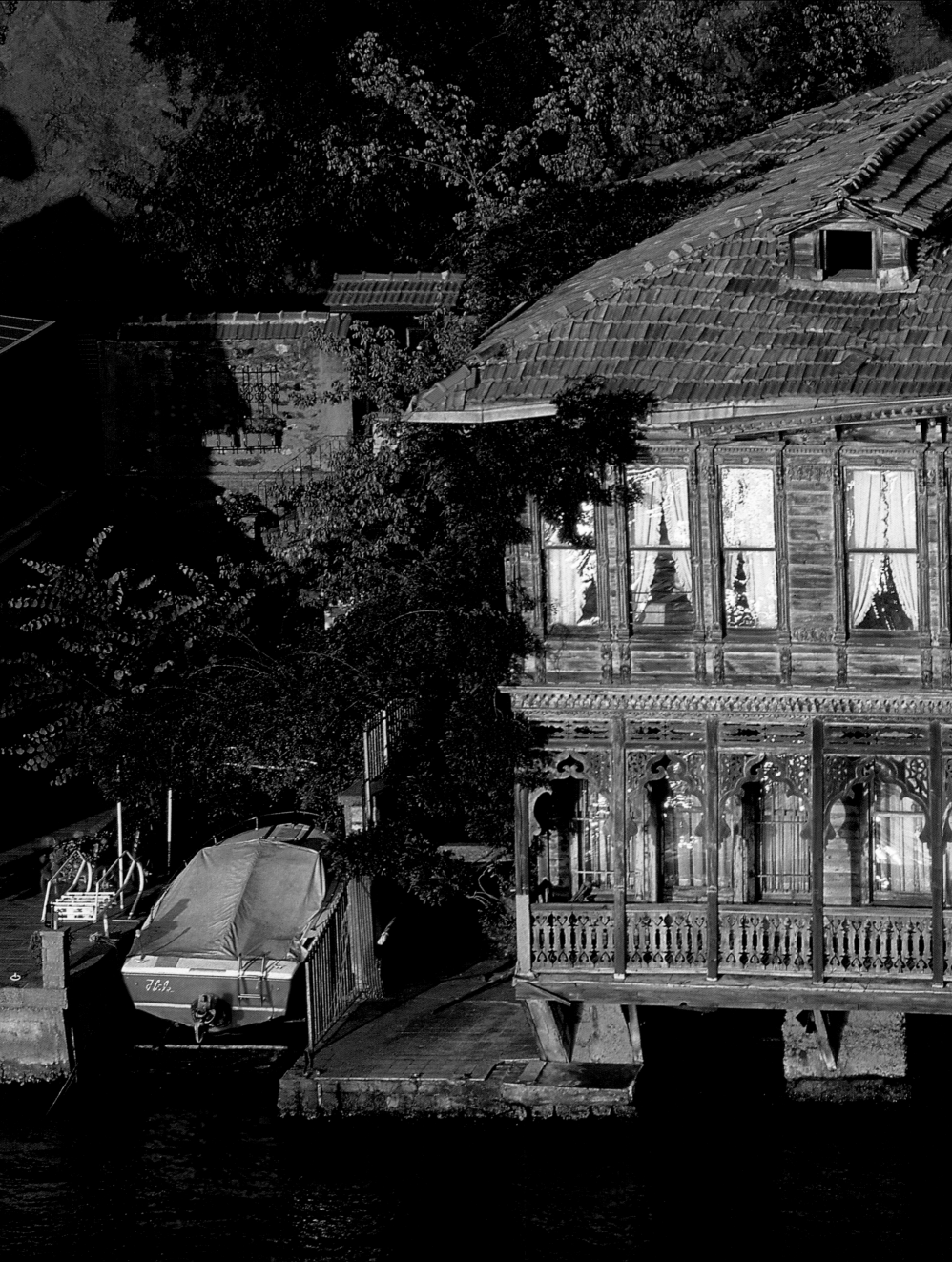

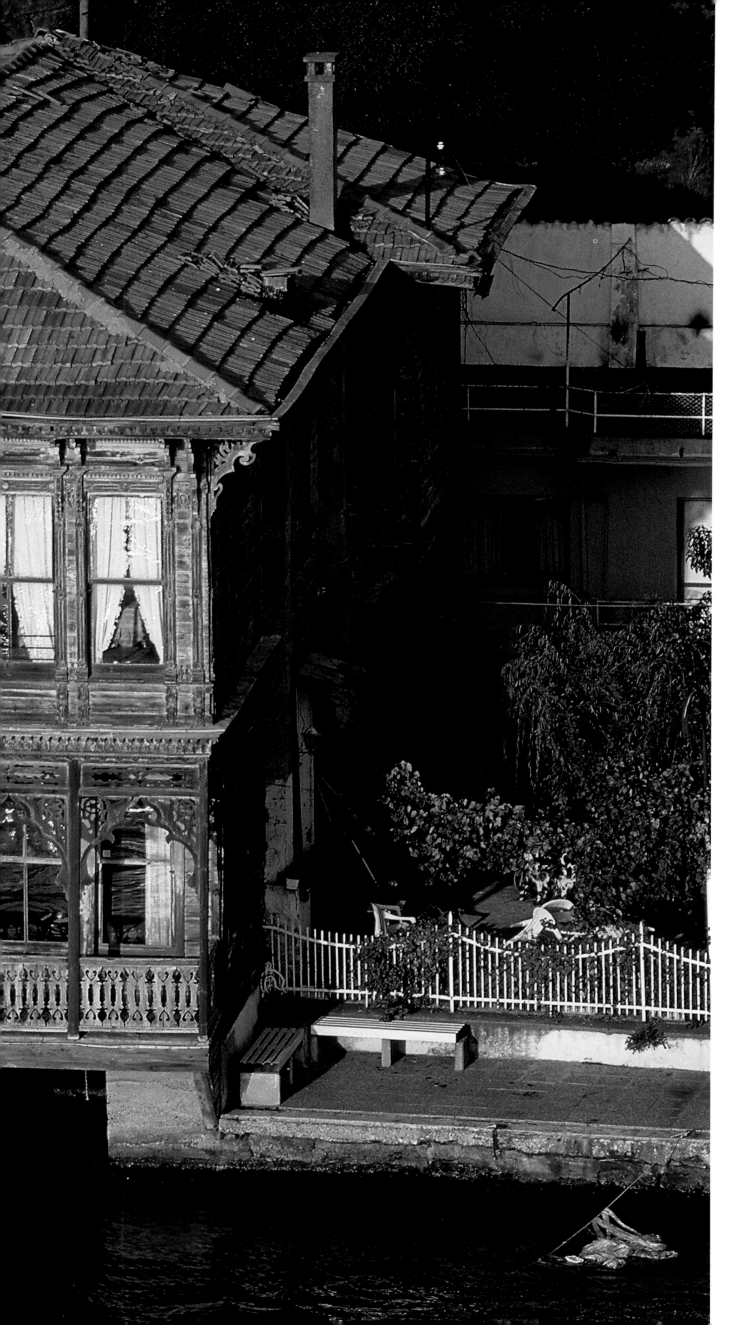

ISTANBUL
HOUSE ON THE SHORES OF THE
BOSPHORUS

The houses of old Istanbul, with their balconies, oriel windows and entirely wooden construction, have an eccentric charm which greatly appealed to Westerners who travelled to Turkey on the Orient Express. The grandest of them, the *konaks*, were the homes of the upper bourgeoisie. Stables and kitchens occupied the ground floors, with the living rooms above, usually looking out both on to the street and over a small garden. The humbler houses of the poorer families adjoined them, and were built in the same way, although less elaborately. Most of them have disappeared, easily falling victim to fires, or simply being abandoned by their inhabitants. Houses in the alleyways near the Nuru Osmaniye are in obviously bad condition, with loose and crooked boards. Even the palatial *yalis* with their many floors and ornamented turrets, scene of the grand receptions given by the powerful during the Ottoman Empire, only survive on the shores of the Bosphorus if they are turned into luxury hotels, and the last of them are prevented from collapse through neglect by an official policy of restoration.

ISTANBUL

ANADOLU KAVAGI

The village of Anadolu Kavagi is crowned by
the Yoros Kalesi (Yoros Castle). It was built in
the 14th century by the Genoese, and all that
remains now is the powerful surrounding wall,
with its towers placed at intervals. It stands on
the Asian shore of the Bosphorus, facing the
Rumeli Hisari on the other side.

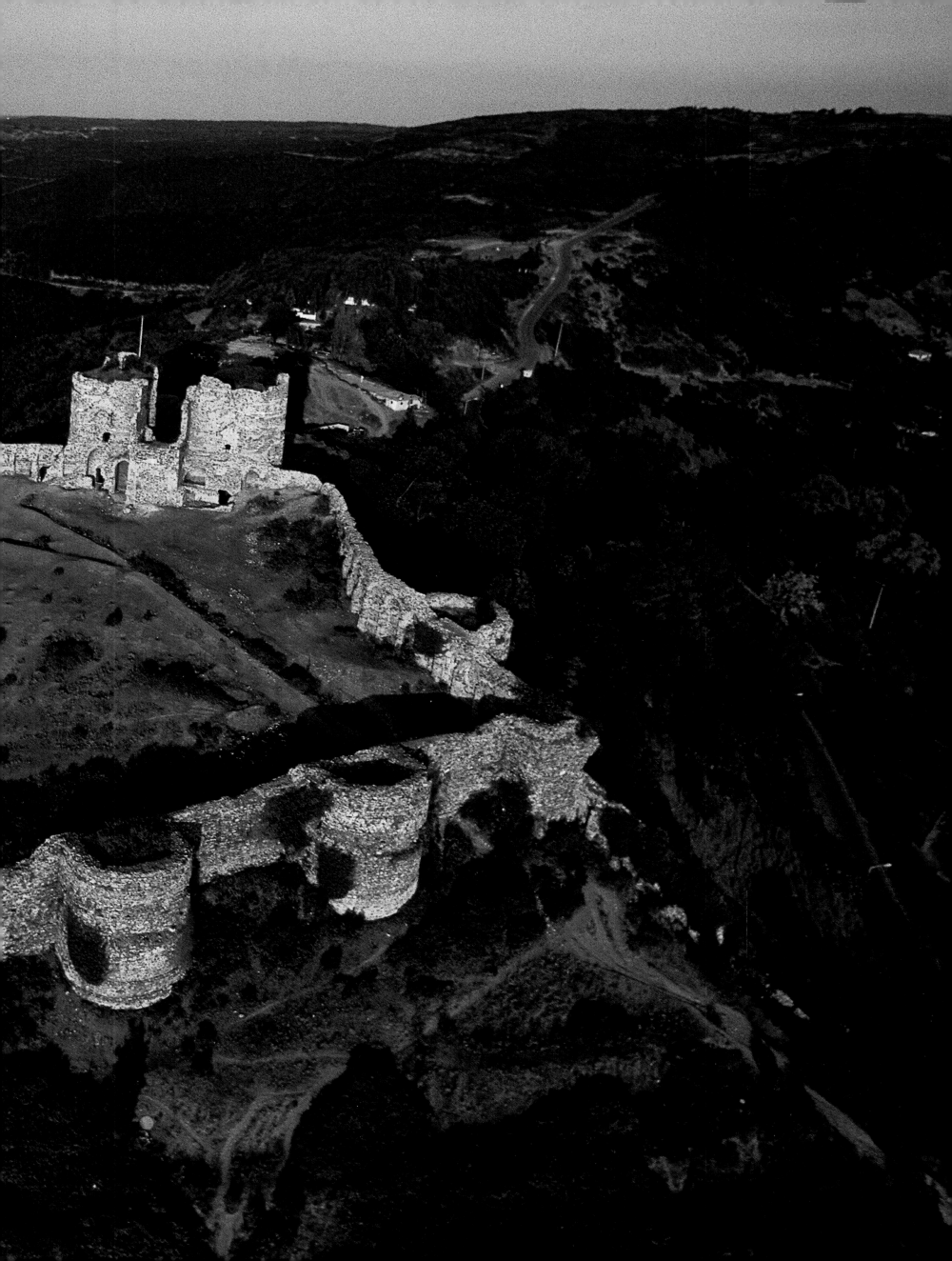

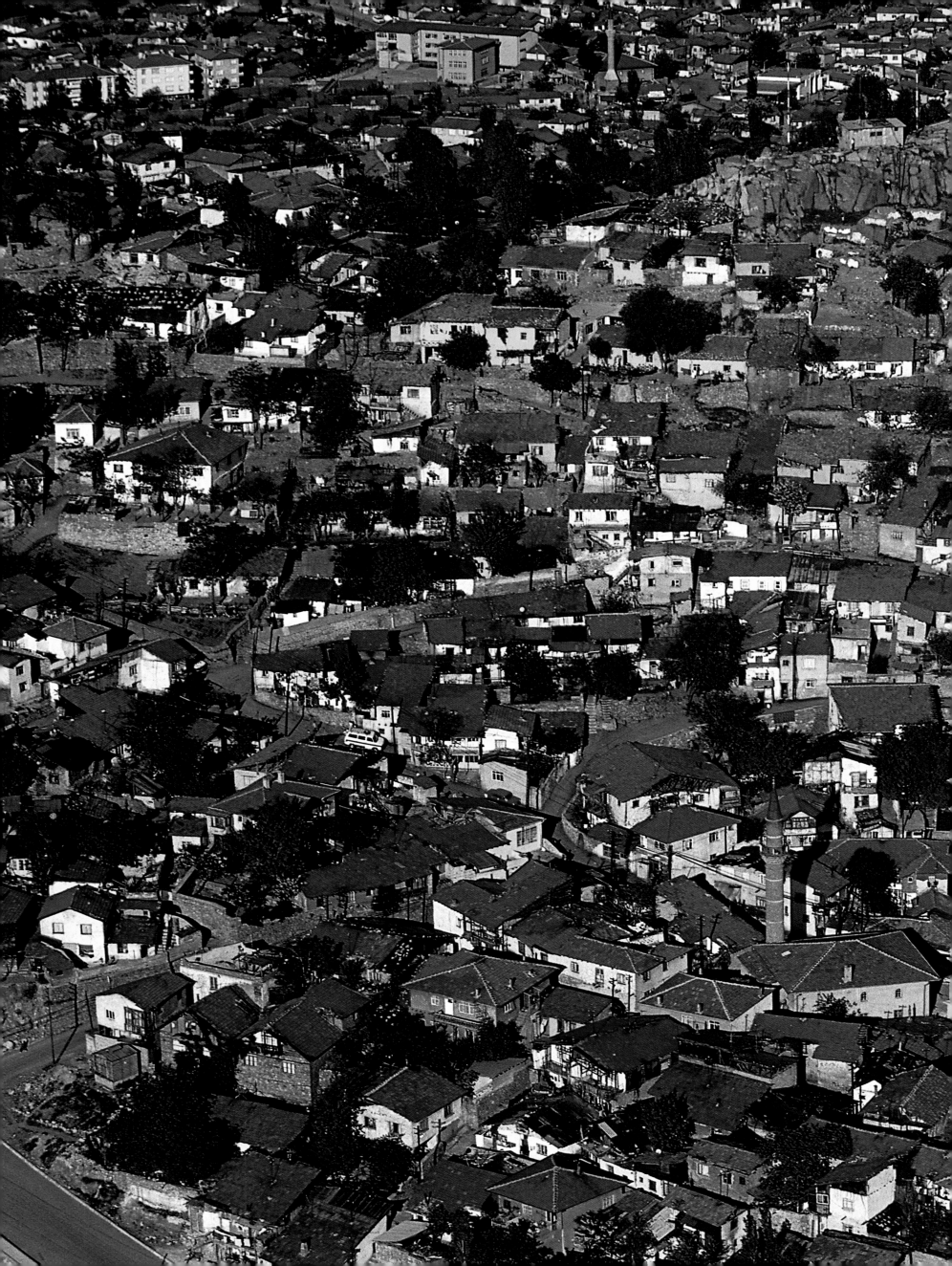

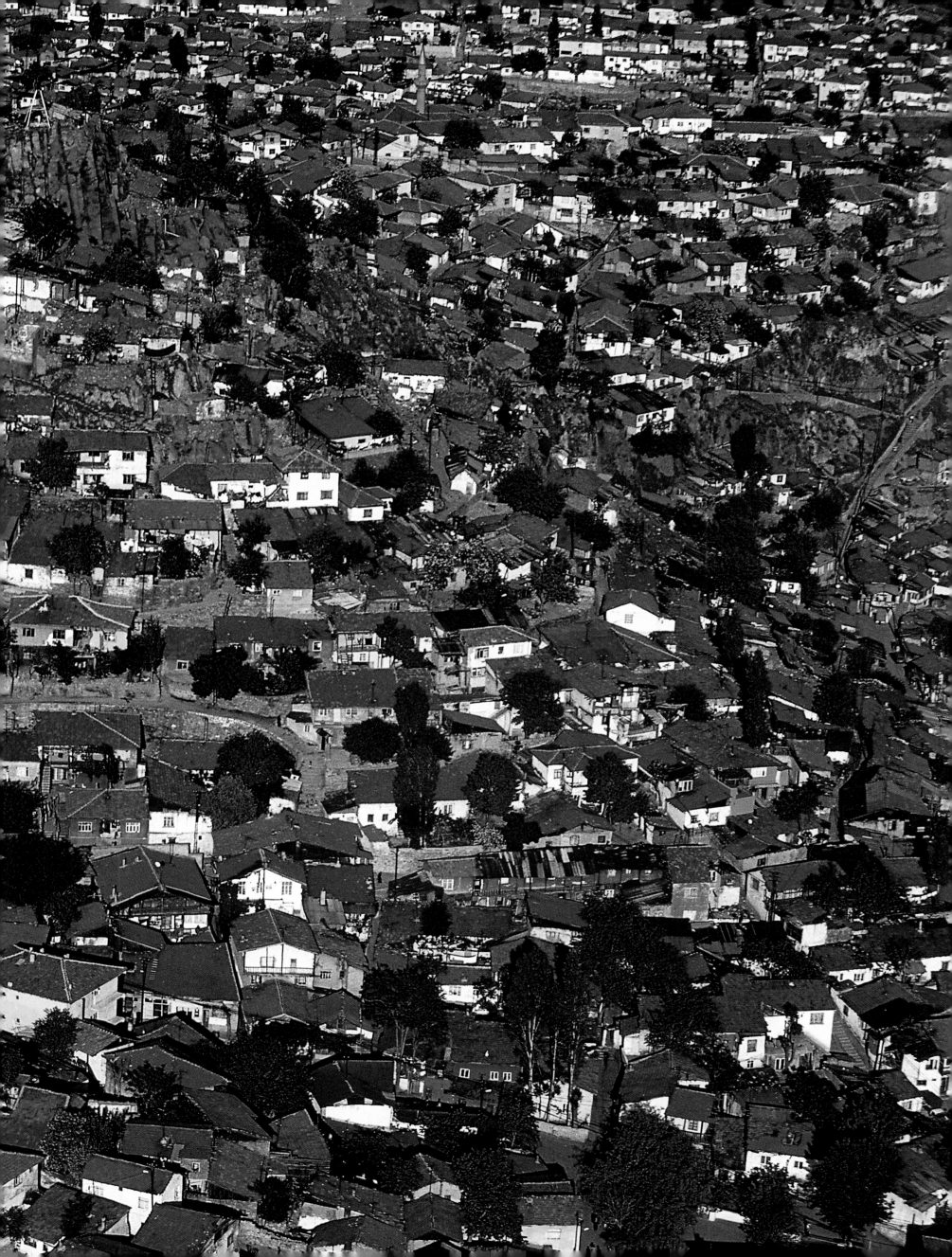

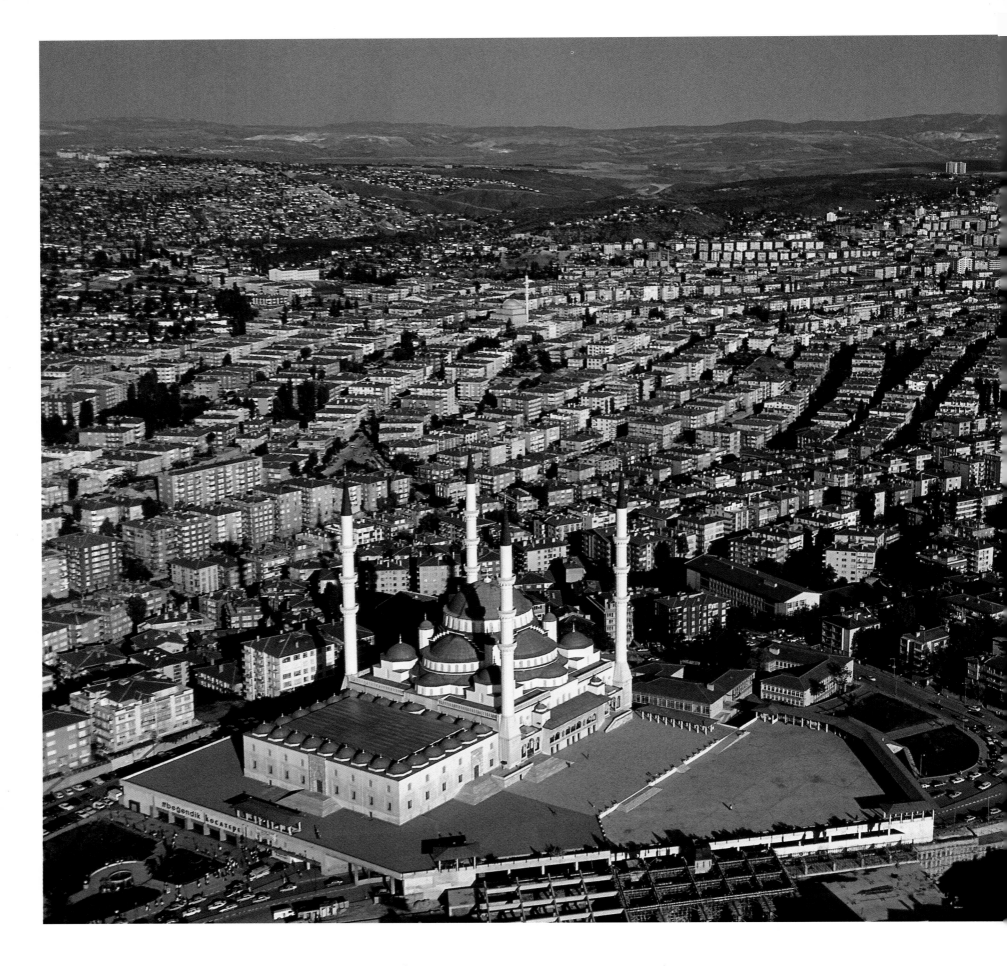

◁ △ **ANKARA**

At the beginning of the 20th century, Ankara was still a relatively unimportant place, spread over two hills and crowned by a Byzantine citadel. Its anonymity was the reason why it was chosen by Atatürk as his administrative capital. It was not historically important (other than having been the scene of a battle in which Sultan Beyazit I was taken prisoner by Tamerlane, dying a few months later in captivity), represented neither Ottoman nor religious power, and was therefore a suitable symbol of the new secular, republican Turkey. The move to Ankara was not universally popular, particularly with the Turkish civil servants and the personnel of foreign embassies, who were obliged to leave the splendours of Istanbul for a tiny city without any particular attraction. Since then, like every other Turkish city, Ankara has experienced an unprecedented population explosion, and now has three and a half million inhabitants. It is rapidly being modernized, and large residential areas are being built. At the same time, outlying areas have become covered with little houses, quickly built and with poor facilities, which seem to clamber up the hillsides.

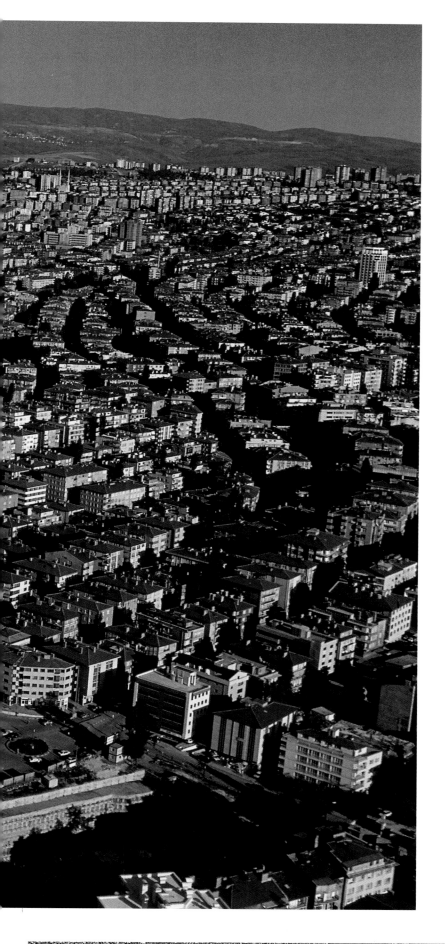

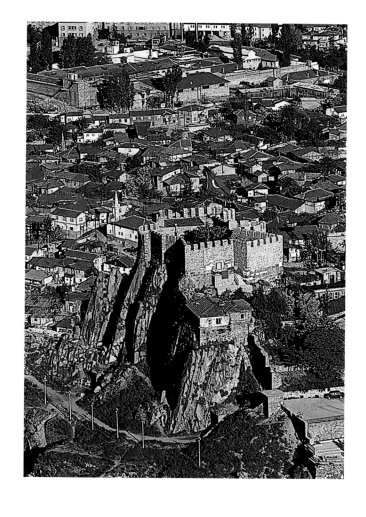

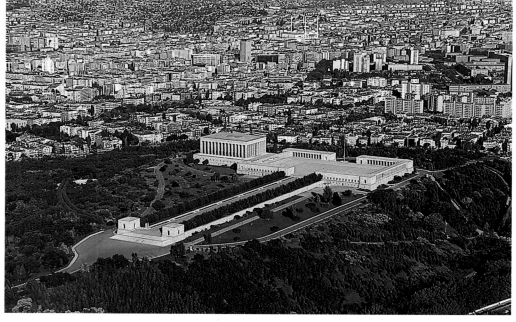

△ ANKARA

**FARMLAND ON THE
ANATOLIAN PLATEAU** ▷

◁ ANKARA
ATATÜRK'S MAUSOLEUM
Although Mustafa Kemal Atatürk died on
10 November 1938, the mausoleum built
on the site of his burial dates only from the
1960s. Around the esplanade are museums
commemorating various aspects of the life of
the man who created the Republic of Turkey.
His cars, clothes and library are on view, and
his successor, Ismet Inönü, is buried close by,
opposite the mausoleum.

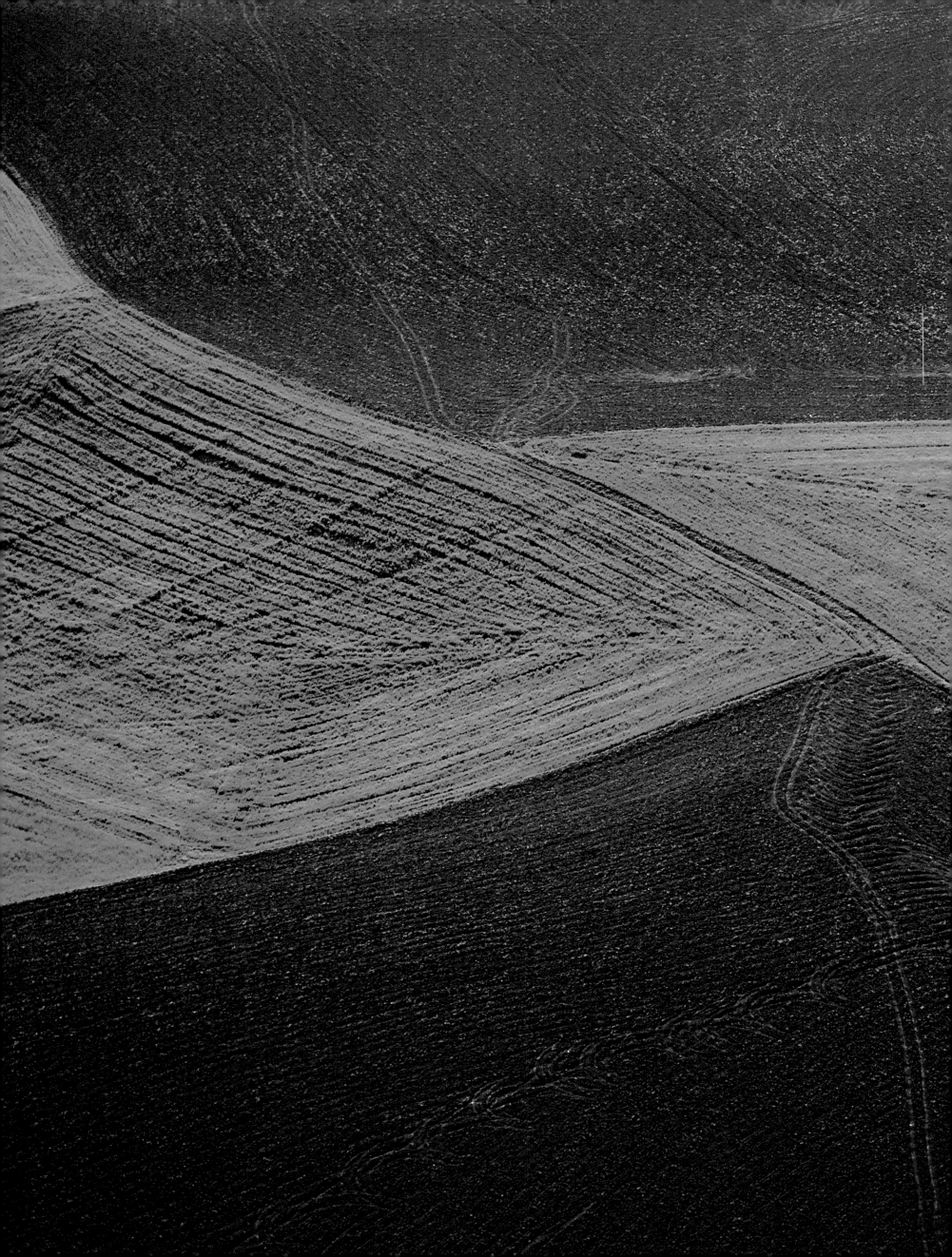

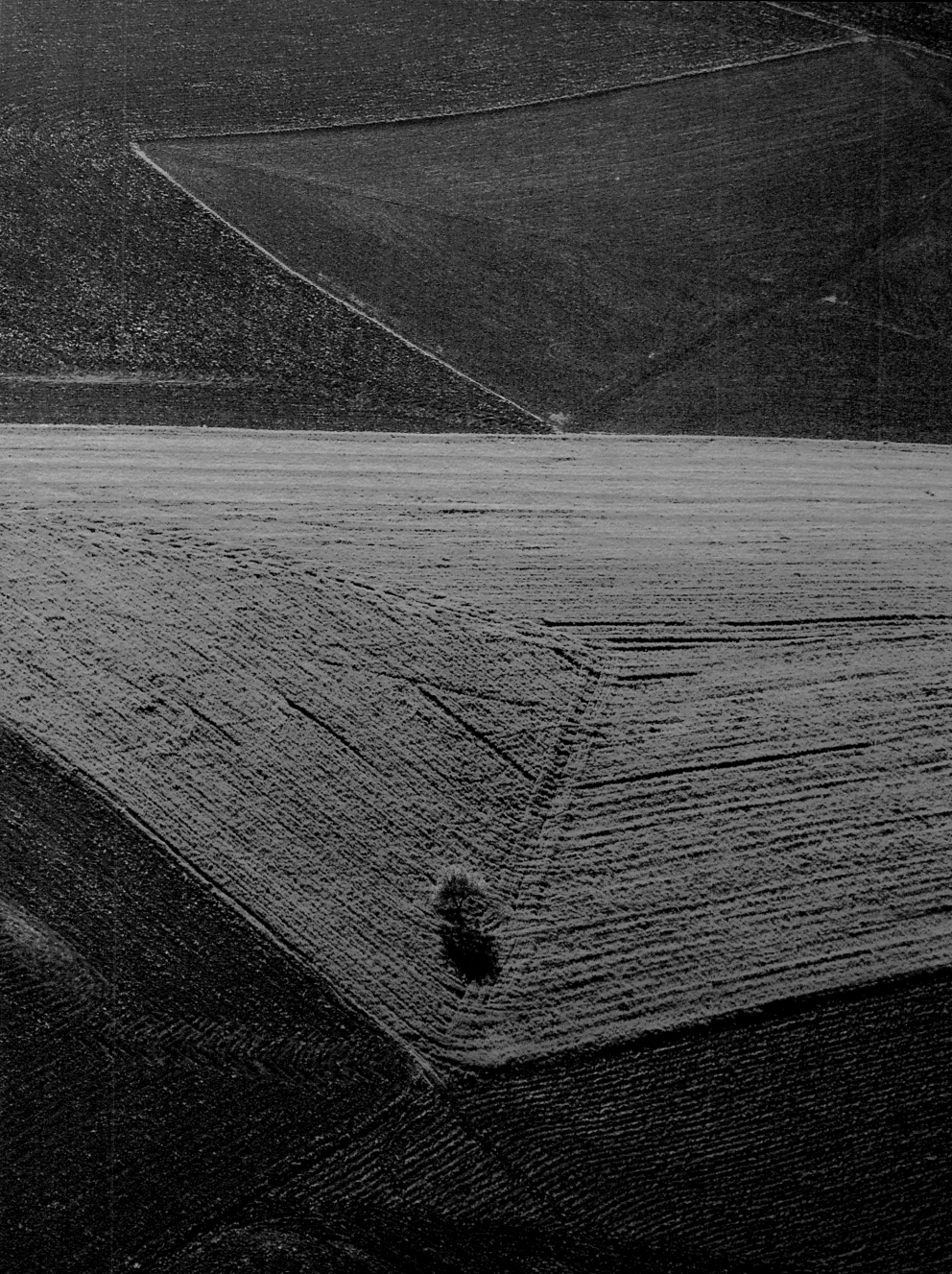

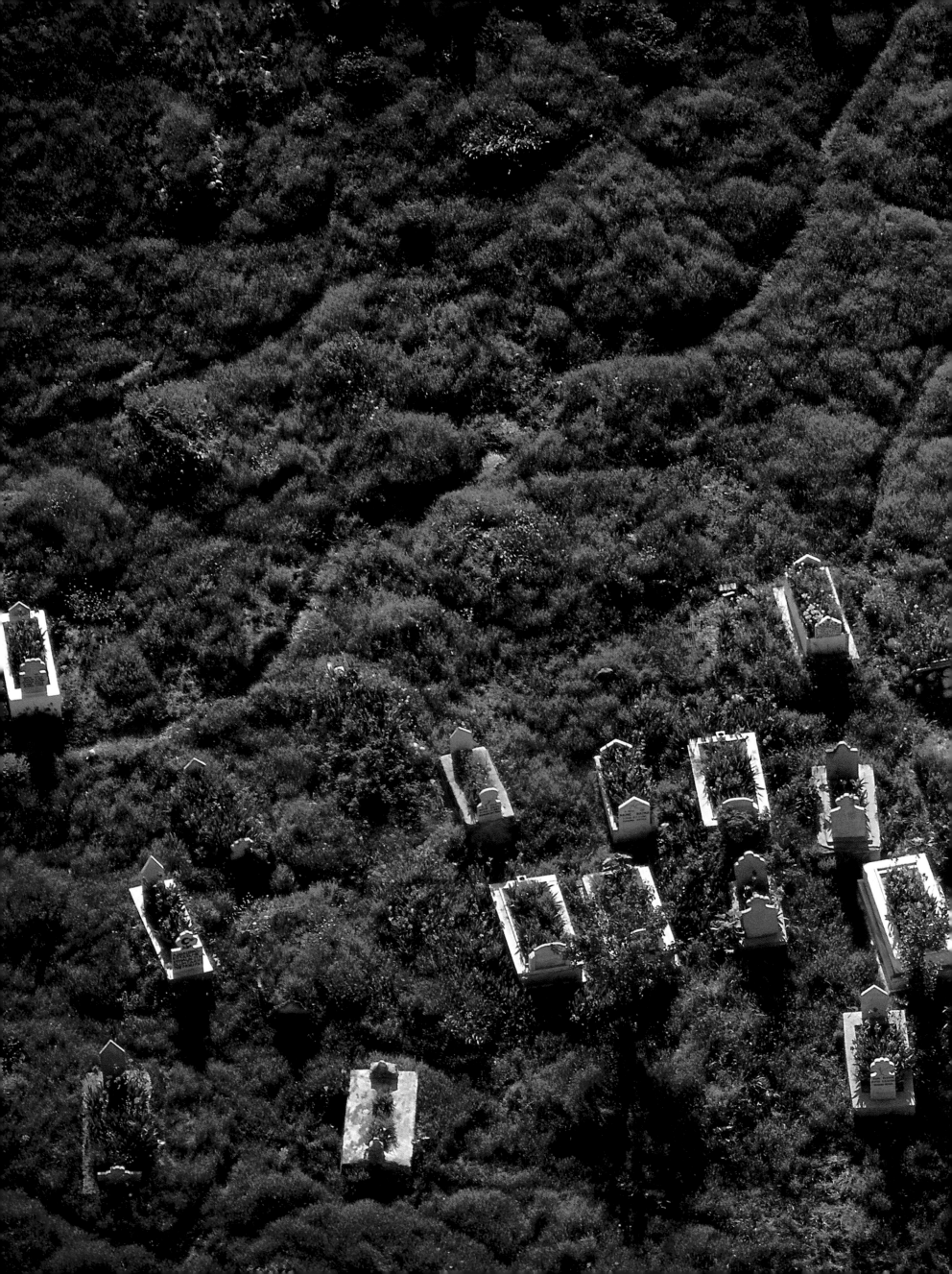

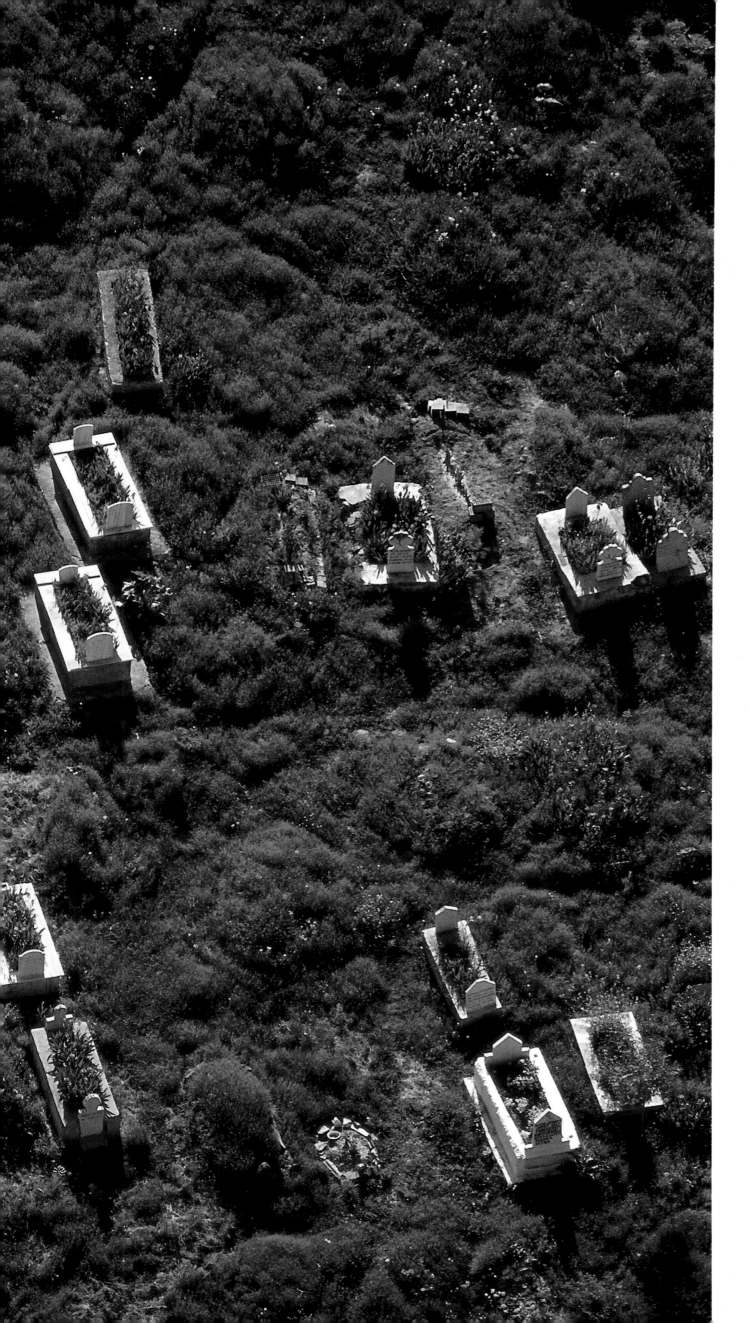

BOGAZKÖY
CEMETERY
Muslim cemeteries are hardly ever laid out in
an orderly or geometric pattern, and are often
very overgrown. Tombs always have two
gravestones, one at the head and one at the
foot. They are inscribed with verses from the
Koran or a religious maxim, the name and date
of death of the deceased, and sometimes his or
her profession.

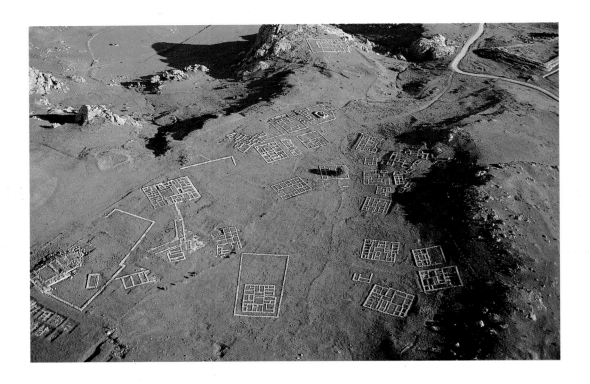

△ **BOGAZKÖY**

SITE OF HATTUSHASH ▷

The city of Hattushash was the capital of the Hittite empire. It was probably founded as early as the 17th century BC, when King Hattusilis I settled there, and lasted until the 13th century BC. Part of it was built on an acropolis, with the residential areas below, housing around 35,000 people. Excavations of the ruins began in 1906, uncovering colossal buildings with massive walls of unfired clay bricks built on stone bases. The fortifications, temples and living areas were all built in this way; the town was defended by immense, double-walled ramparts six kilometres (almost four miles) long and reinforced by towers. Five hundred years later, the Greeks believed it to be the work of a vanished race of giants.

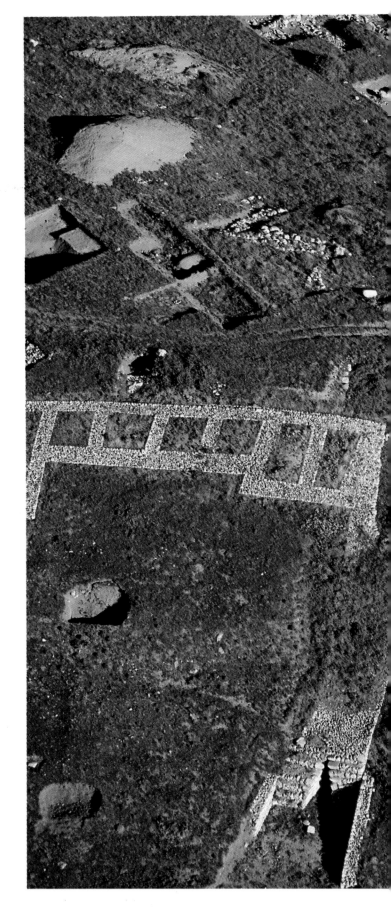

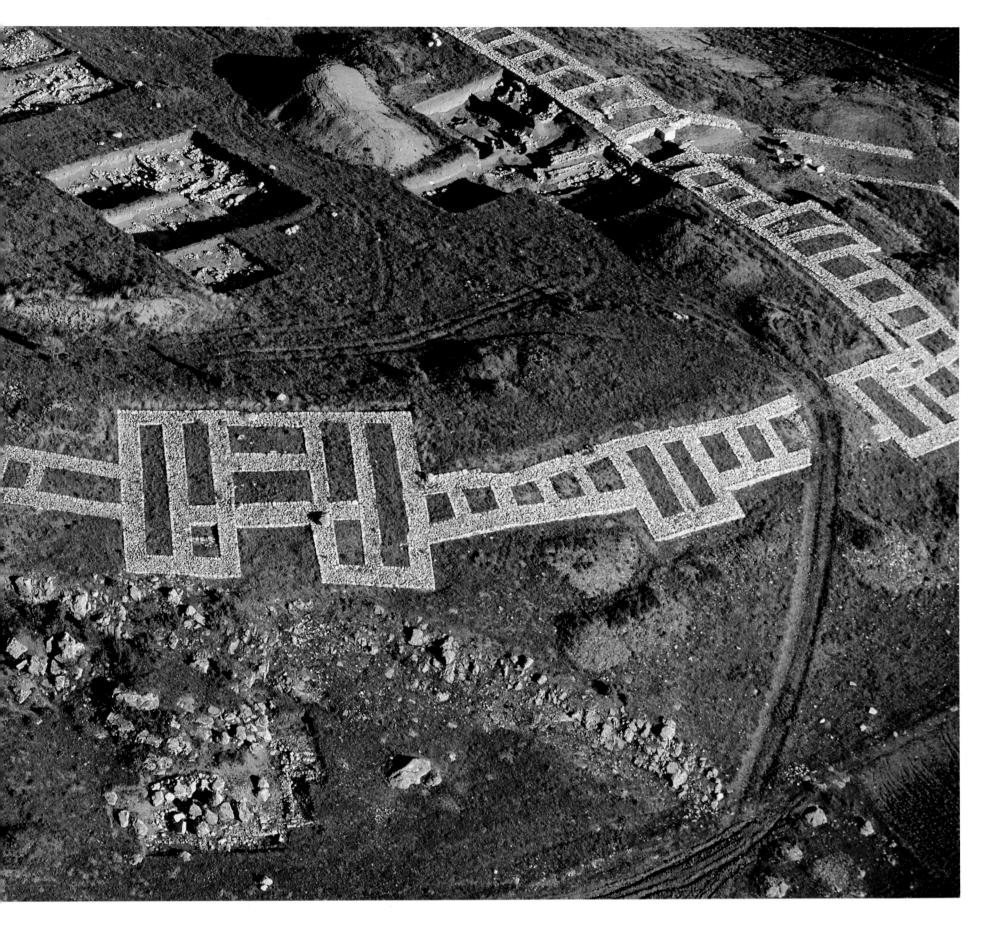

BOGAZKÖY

TEMPLE ▷

The temple dedicated to the storm god Teshub and the sun goddess Arinna – 160 metres (525 feet) long and 135 metres (443 feet) wide – is in the lower part of the town and is the most impressive of all the temples unearthed on the site of Hattushash. It was a vast complex which included not only the shrine, but a number of storerooms, warehouses with buried earthenware jars still in their original places, kitchens and living quarters; thousands of tablets with cuneiform inscriptions have been found there. All that remains is what was built in stone, the brick having crumbled away long ago. Monolithic blocks show where the doorways and thresholds used to be, and were clearly also used in the shrine for the placing of offerings, as pedestals for the statues of the gods, or were carved out for use as washing bowls.

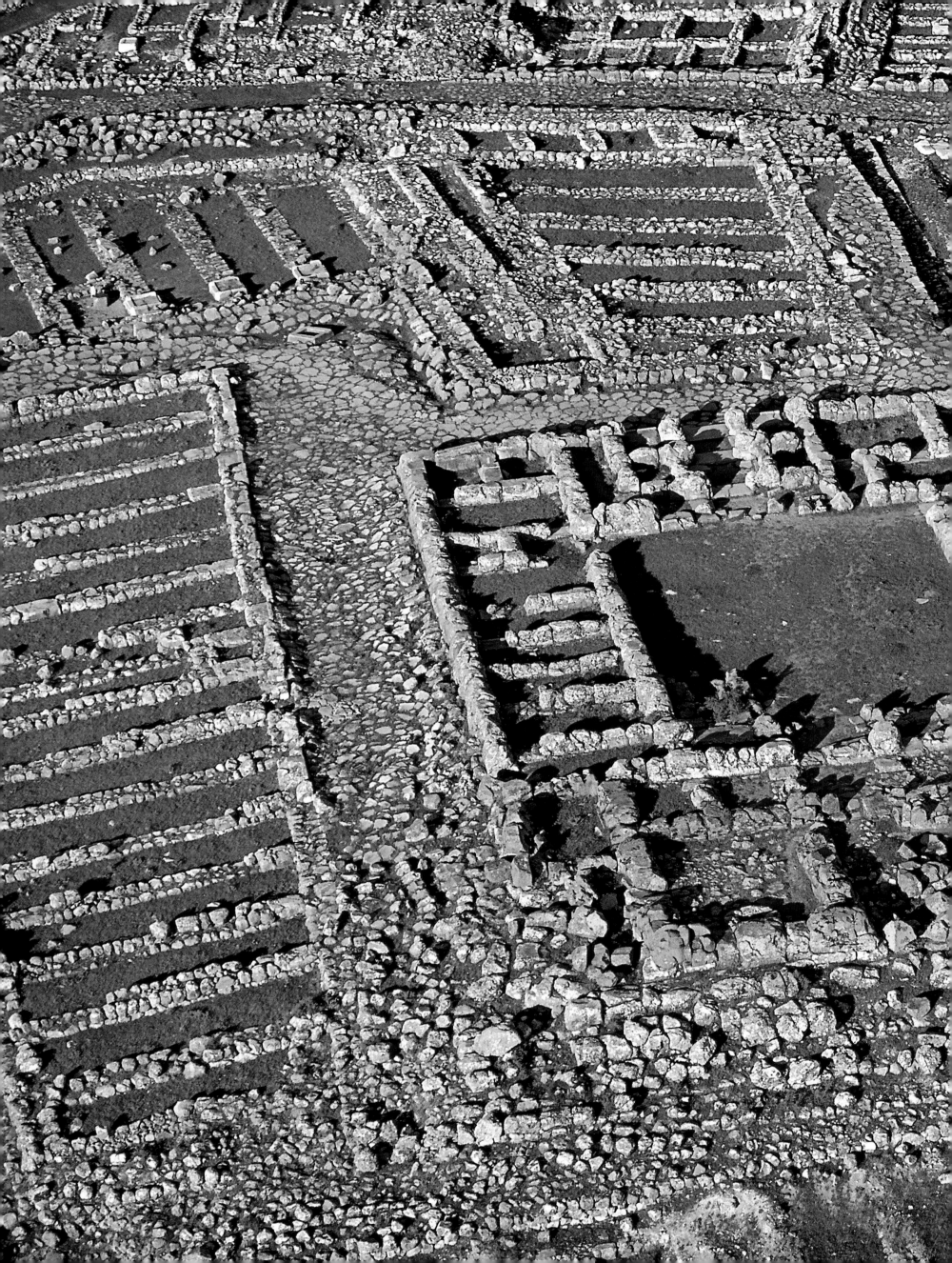

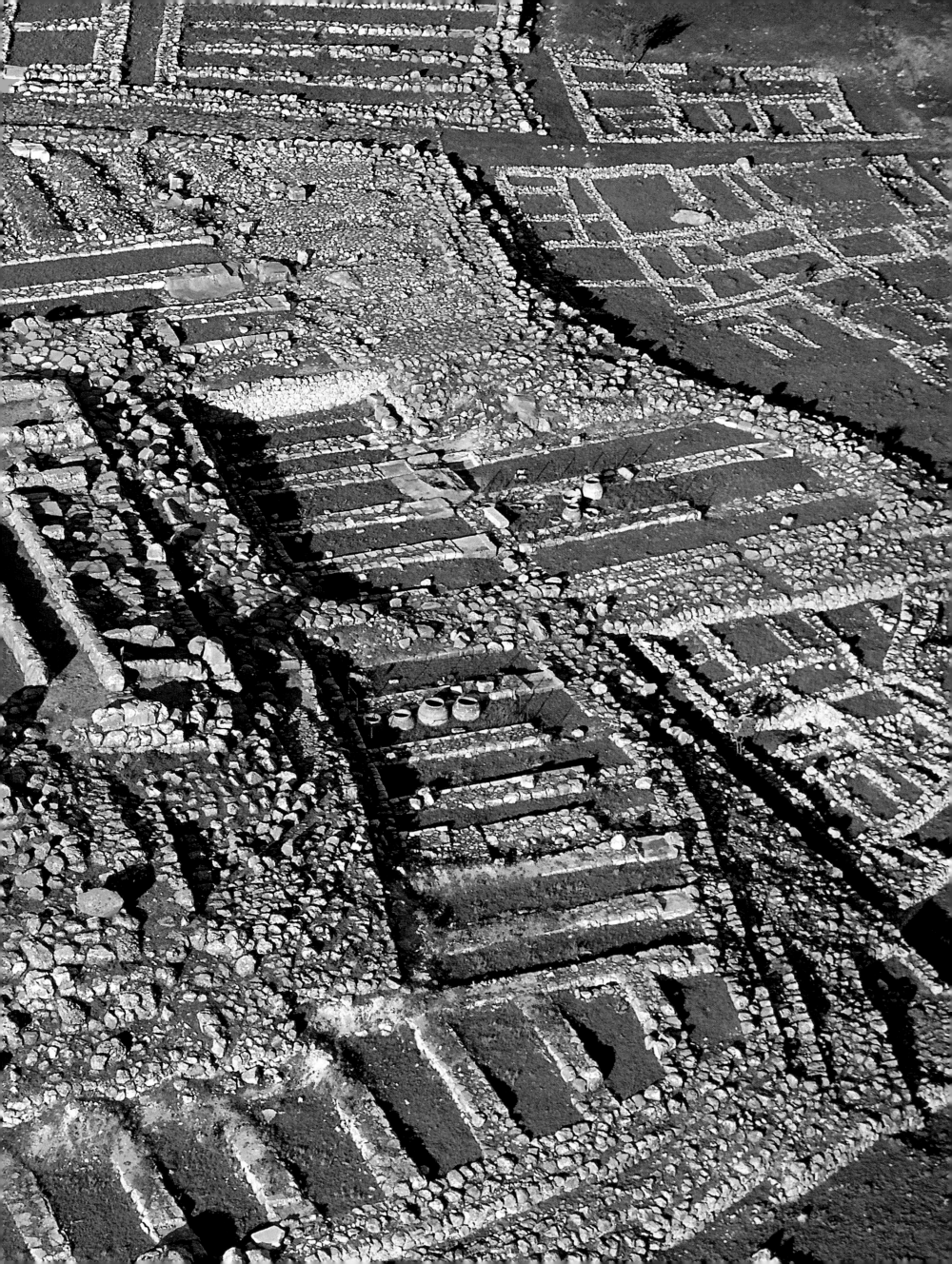

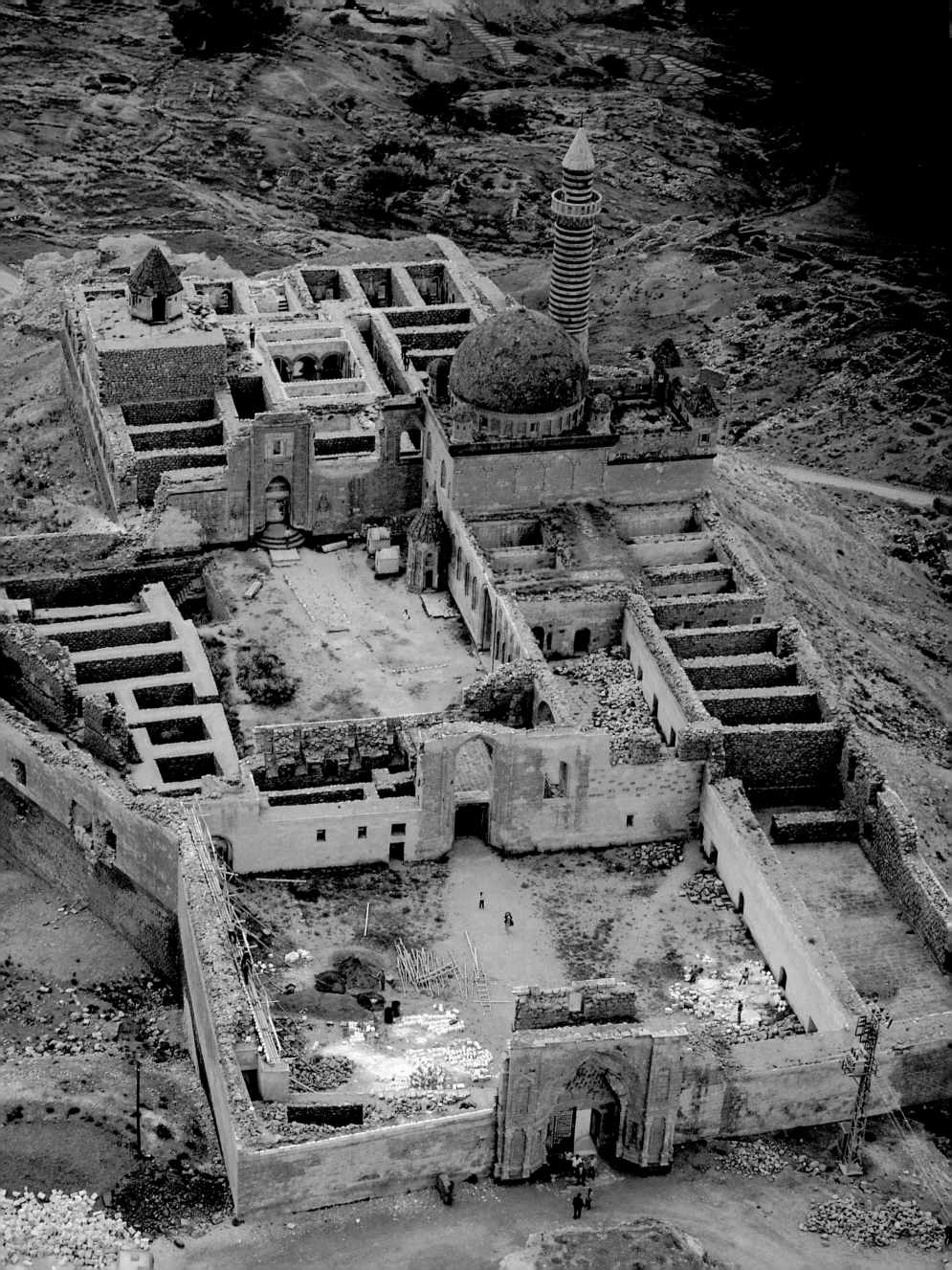

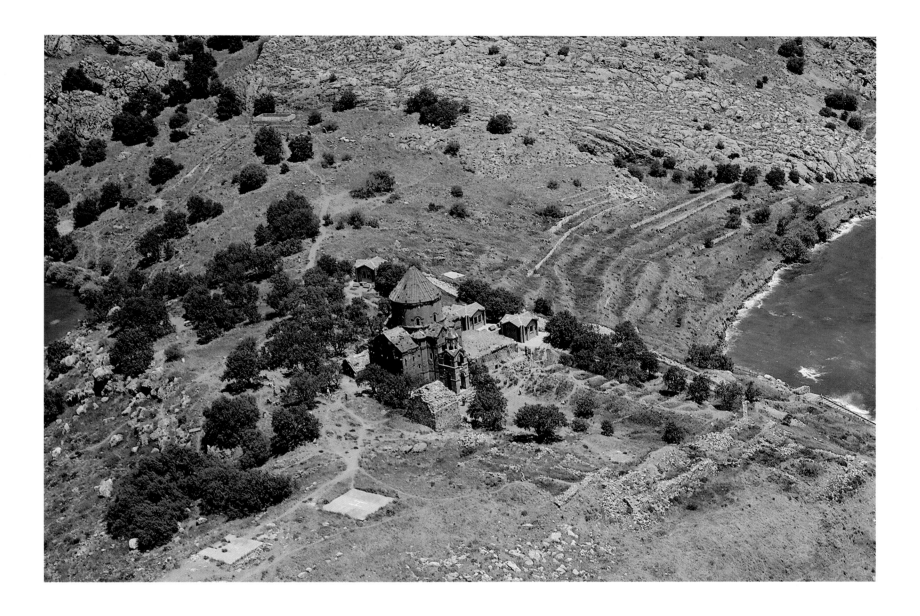

◁ DOGUBAYAZIT
ISHAK PAŞA SARAYI

Standing on high ground to the south of Dogubayazit, the palace of Ishak Pasha was the impregnable residence of a Kurdish ruler; he began building it at the end of the 17th century and it was completed by his son, who gave his own name to the building. Its position allowed him to control the region, and particularly its caravan routes. The group of buildings forms a harmonious whole: the mosque, the *türbe* of Ishak Pasha, the library, as well as the vast courtyards and halls of the palace itself, with its harem of twenty-four rooms, audience chambers and reception halls, its kitchen, hammams and many outbuildings. The main entrance to the whole complex is a splendid gateway enriched with sculptures, though the original doors covered in gold leaf are now in the Hermitage Museum in Saint Petersburg.

△ AKHTAMAR

The island of Akhtamar at the southern end of the salt lake Van Gölü (Lake Van) is an exceptionally beautiful place. Hidden away there is the Church of the Holy Cross by the architect Manuel, built in AD 921 for the Artsrunid King Gagik of Vaspurakan. It is generally agreed that it represents one of the earliest examples of Romanesque art. It is a well-proportioned design, centrally planned with a cupola over the crossing, supported by a polygonal drum, and with a pyramidal roof. Bays, cornices, mouldings and friezes provided scope for abundant decoration, with a mixture of floral, zoomorphic and anthropomorphic motifs: there are animals of all kinds, some in heraldic pairs, full-length realistic figures, horsemen, and scenes from the Scriptures. The whole is a masterly mixture of Christian and Muslim, Byzantine and Turkish influences; we can identify Adam and Eve, David and Goliath, Abraham about to sacrifice his son Isaac, as well as a seated caliph and archers on horseback.

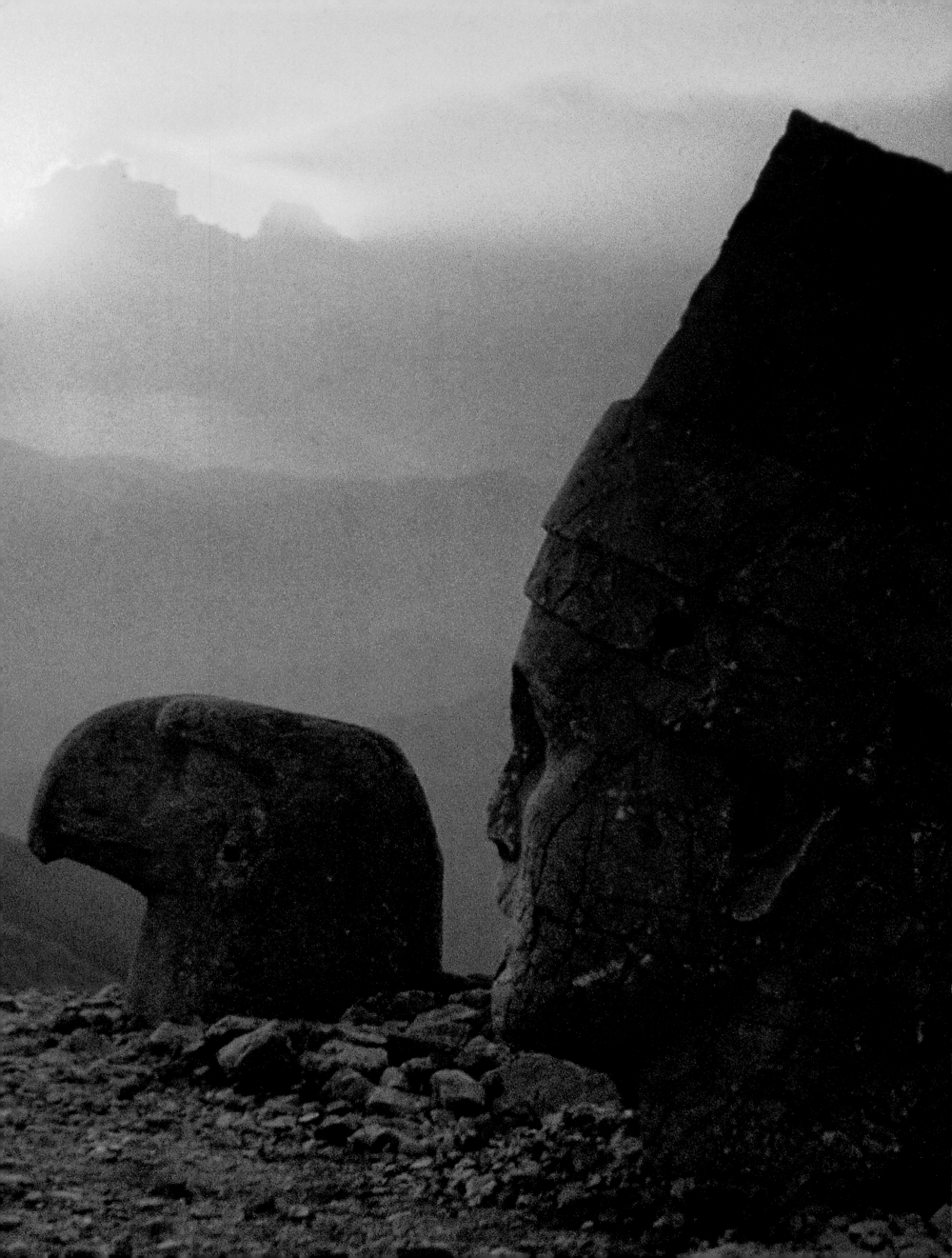

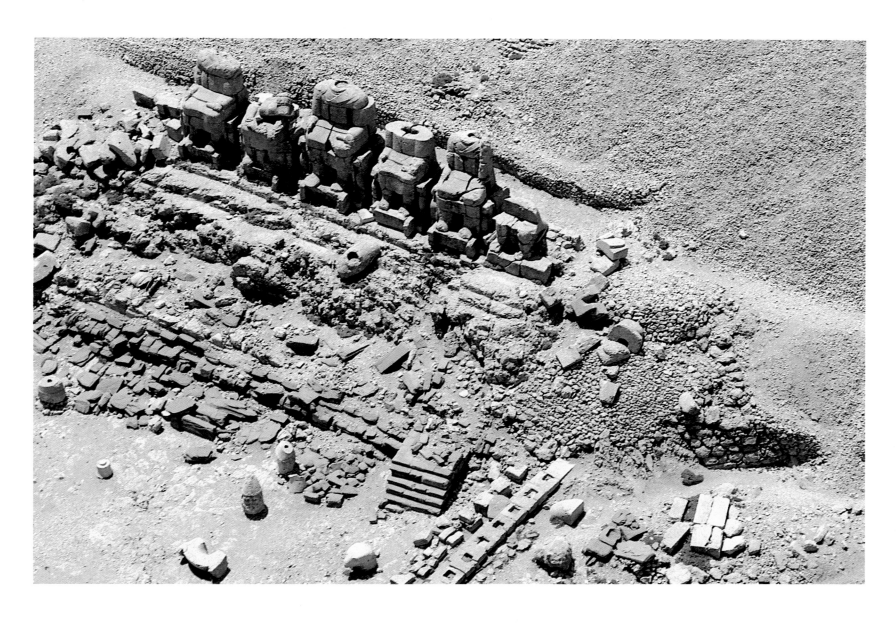

NEMRUT DAGI

Antiochus I Epiphanus (the Illustrious), who reigned from 62 to 34 BC, traced his descent from Darius and the Achaemenides through his father (the Parthian Mithridates Callinicos) and from Alexander the Great through his mother Laodicea, a Seleucian princess. He therefore embodied the two great civilizations of Asia Minor, the Persian and the Greek – or so he claimed: this ancestry has not been proved. On Nemrut Dagi, or Mount Nemrut, the highest mountain (2,150 metres/7,050 feet) in the Comneni kingdom, he constructed a 50-metre (165-foot) high artificial mound, which was destined to be his burial place. Excavations have not yet succeeded in finding his *hieroteseion* (sacred tomb), but the two rows of five gigantic statues which mark its site to east and west remain. These nine-metre (thirty-foot) high figures of seated gods have lost their heads through earthquakes and the elements: they rolled to the ground, and for two thousand years have gazed inscrutably at Persia on one side and at the Roman Empire, source of Antiochus' power, on the other. Two lions and two eagles frame these statues of Apollo, Tyche, Zeus and Hercules, and Antiochus himself sits enthroned in the middle.

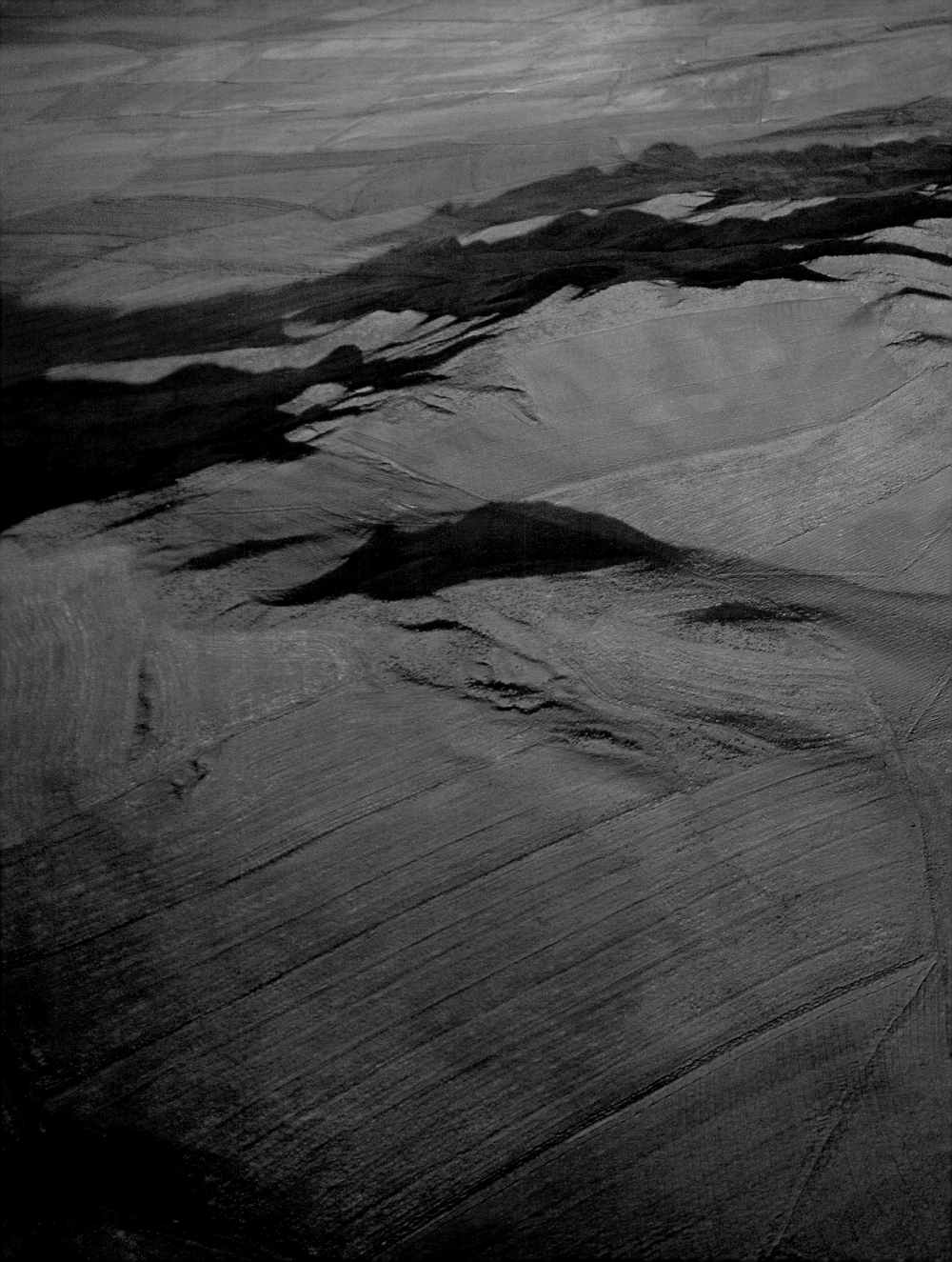

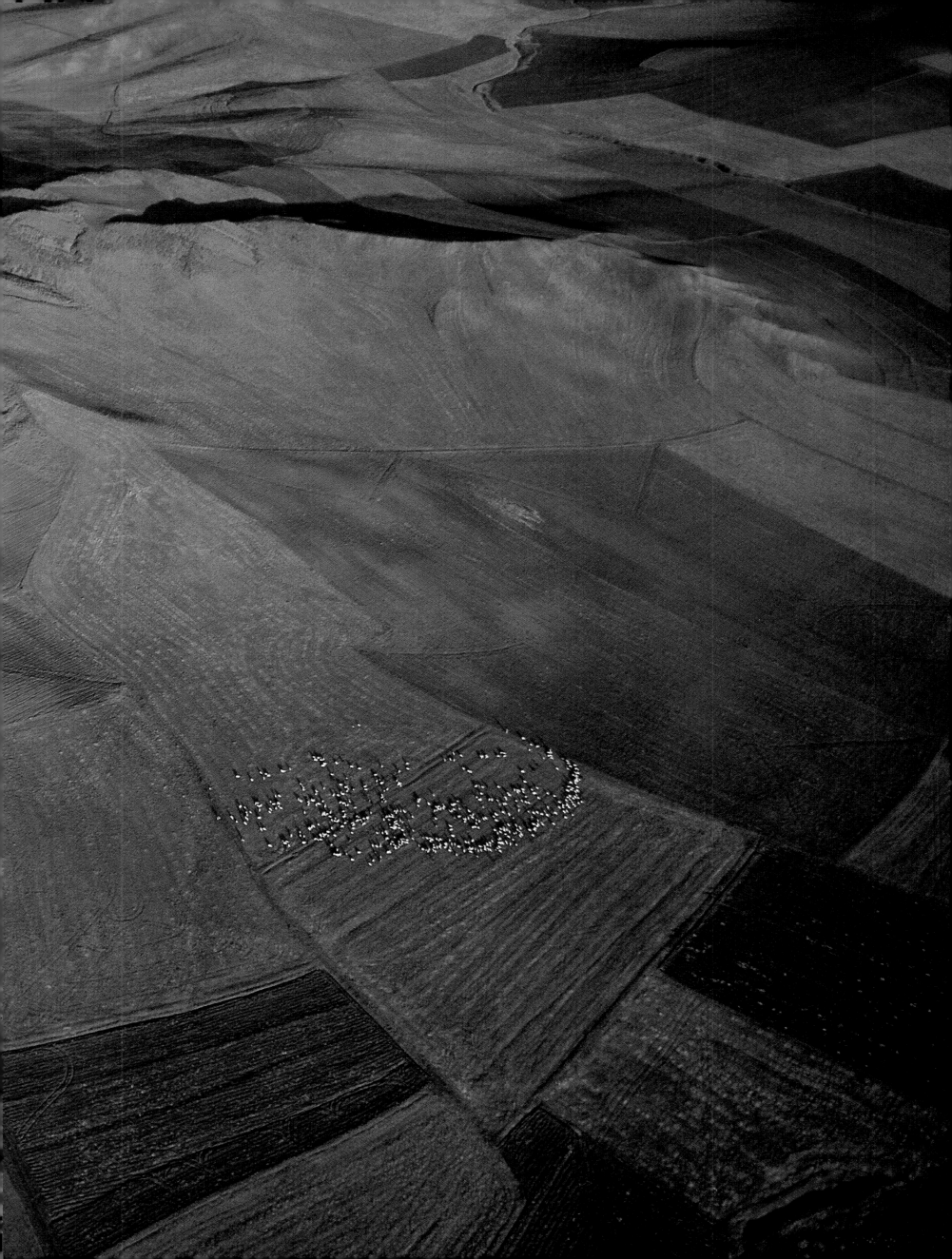

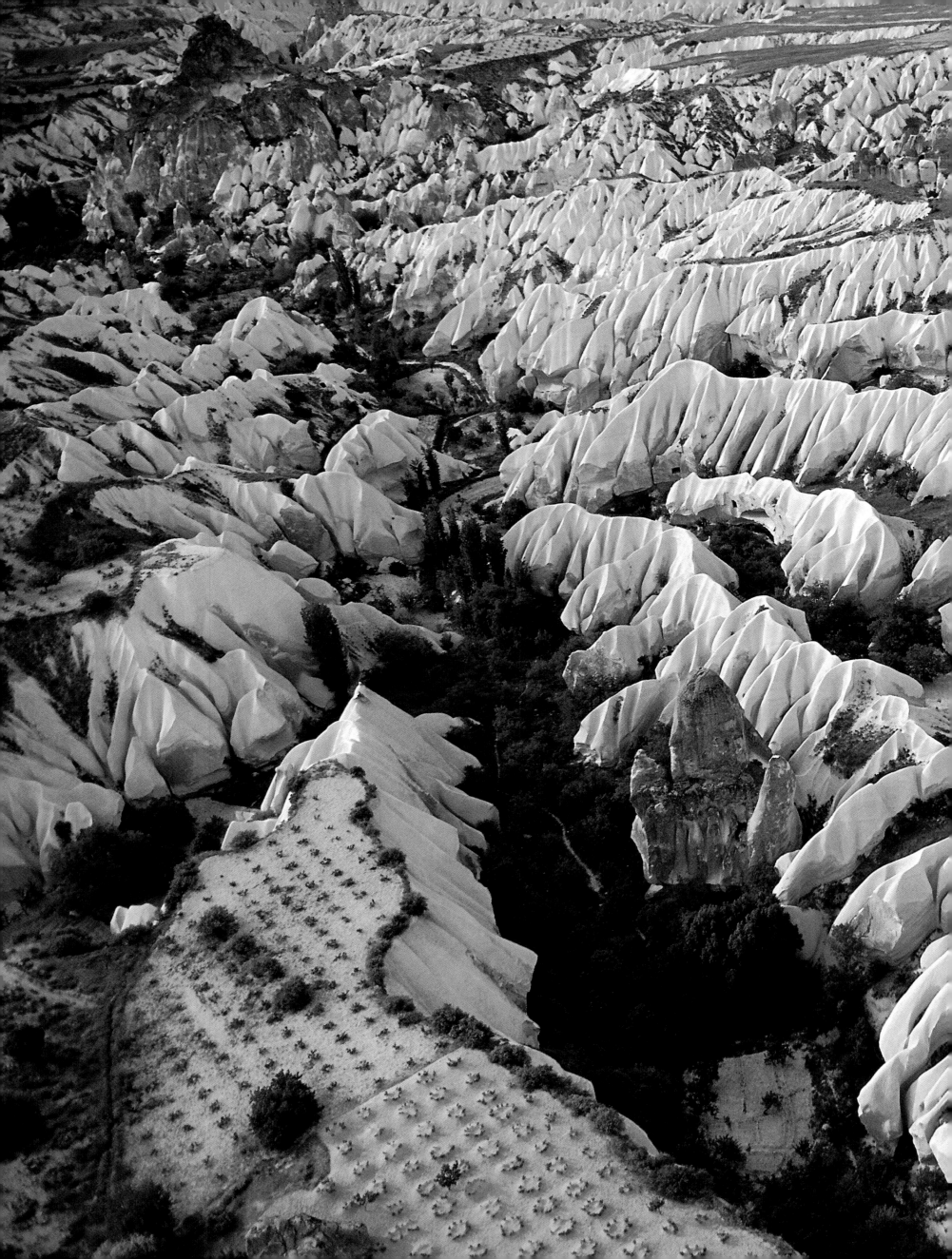

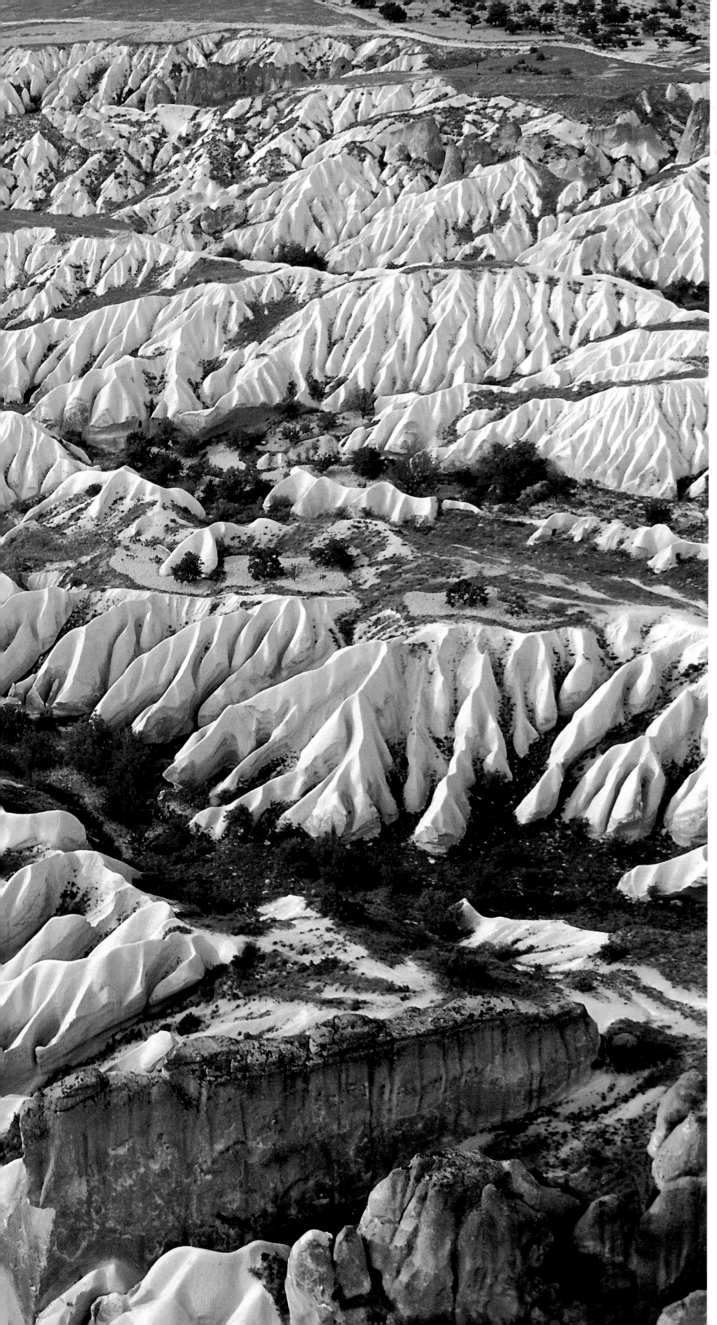

◁ ◁ **CAPPADOCIA** ▷

Cappadocia is a world apart – a lunar
landscape, with an ever-changing light,
mountain peaks, extraordinary needle- and
cone-shaped geological formations, deep valleys
and vertiginous drops; the earth can be ochre,
pink, blood red, blinding white, mauve, or
bright yellow; there are little fertile enclaves
where vines will grow. The whole is a vast
patchwork of bright colours, a mysterious maze
dominated by two tall volcanoes permanently
capped with snow – Hasan Dagi (3,268
metres/10,820 feet) and Erciyes Dagi, the
Greek Argeus (3,917 metres/12,850 feet).
The unique natural conditions are the result
of volcanic action and the erosion of the fragile
tufa which covers most of the ground. Hence
the 'fairies' chimney stacks' and other strange
formations, which astonished European
travellers, but which had long been used as
shelters by people in search of a safe refuge.

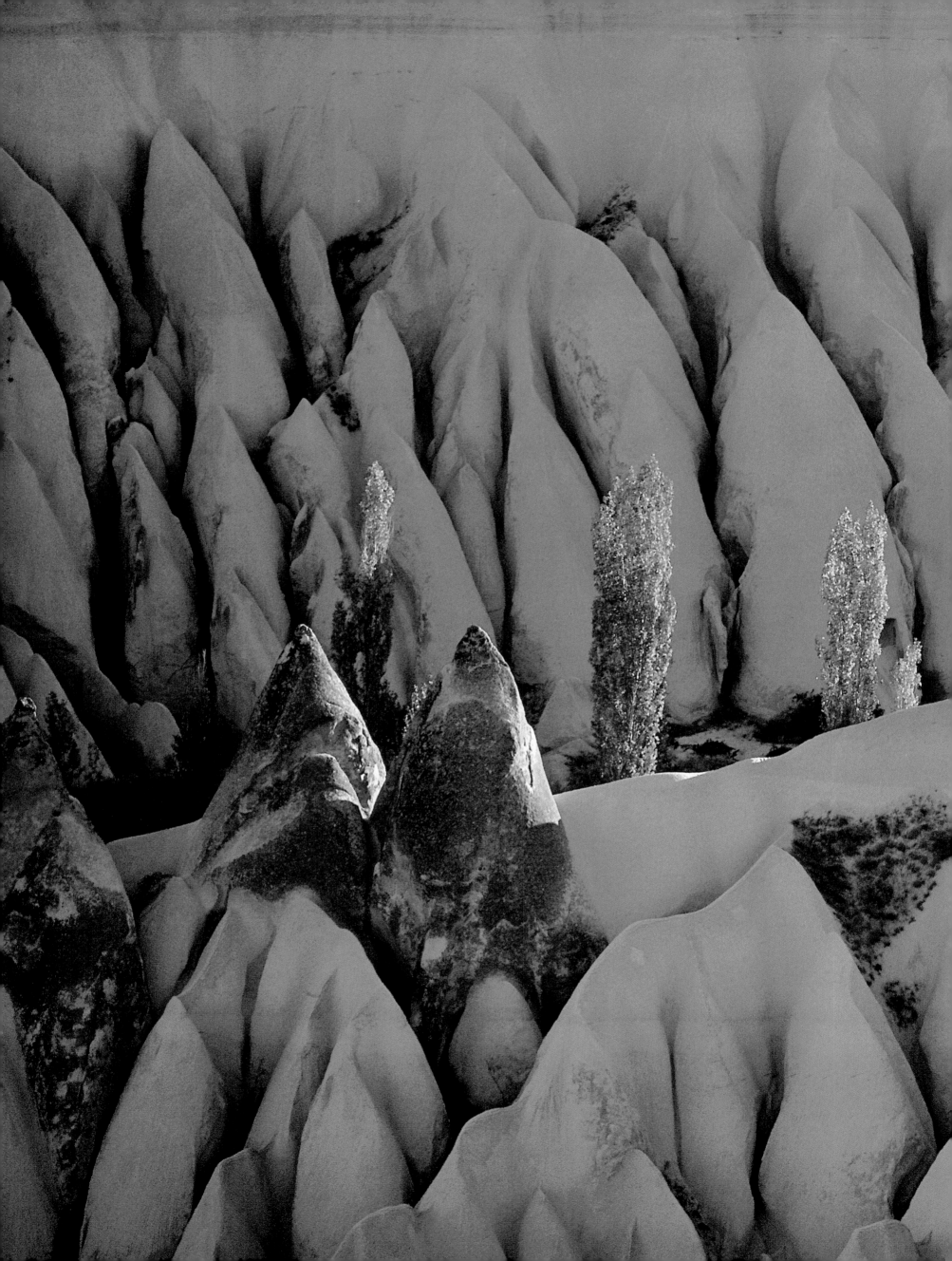

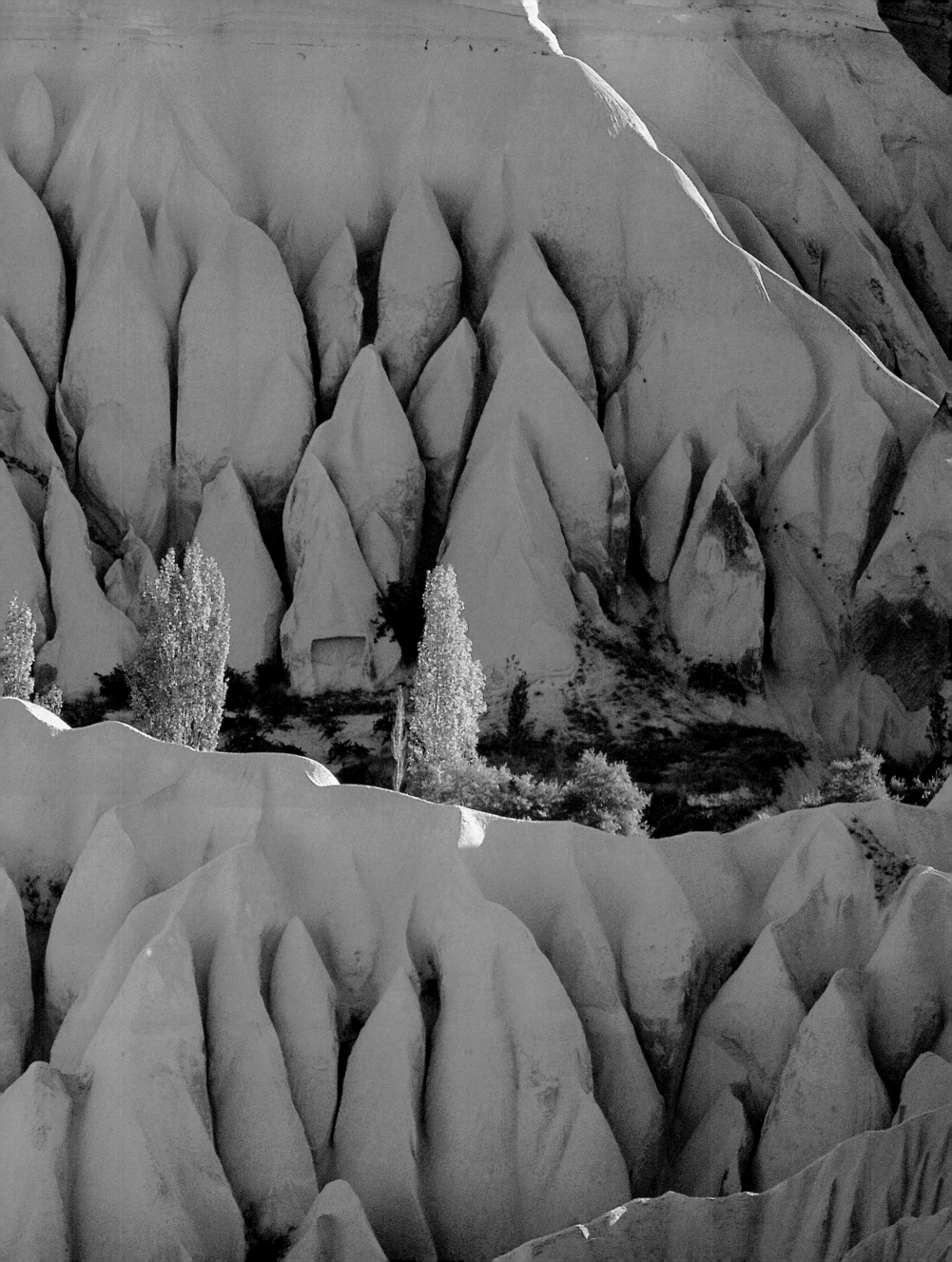

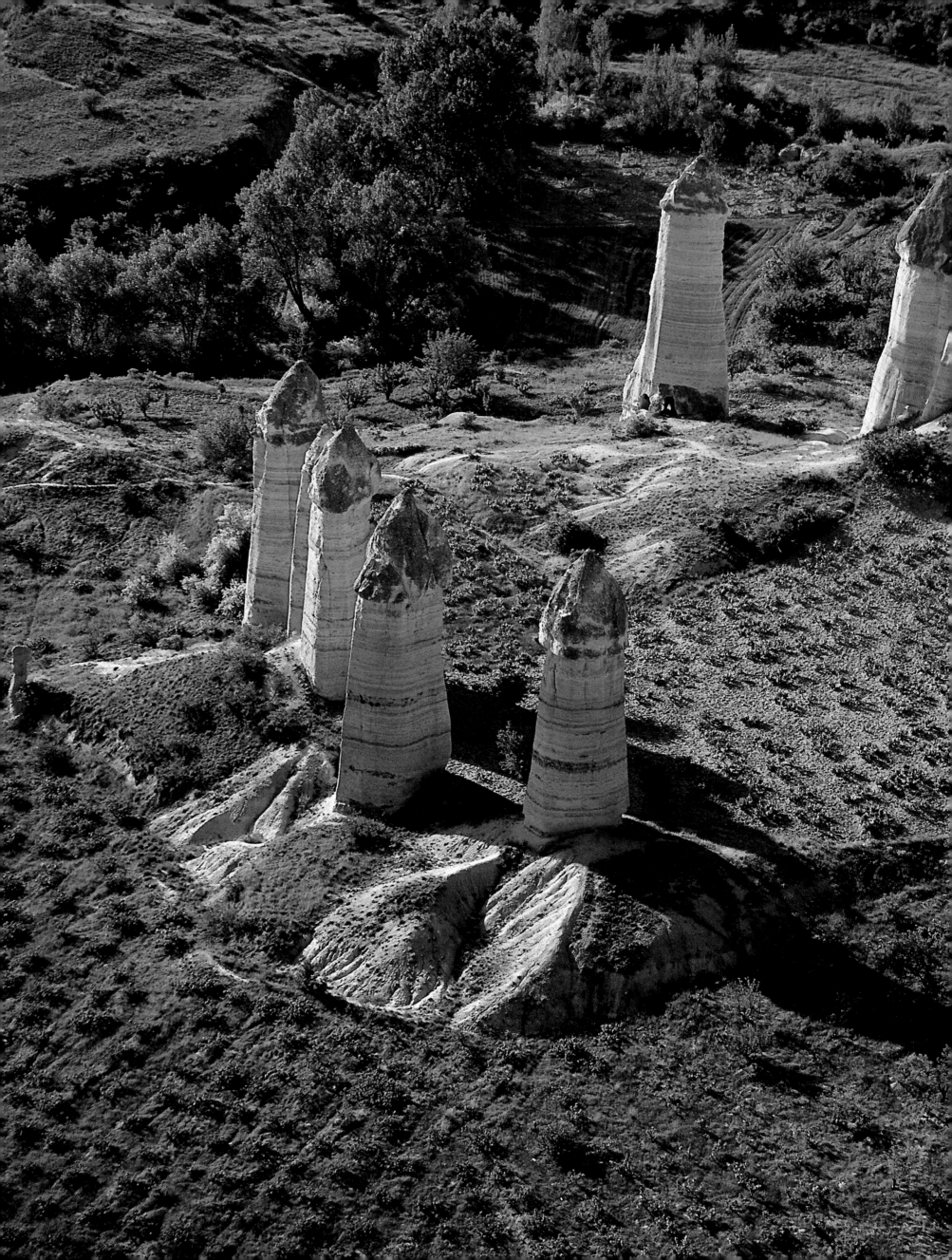

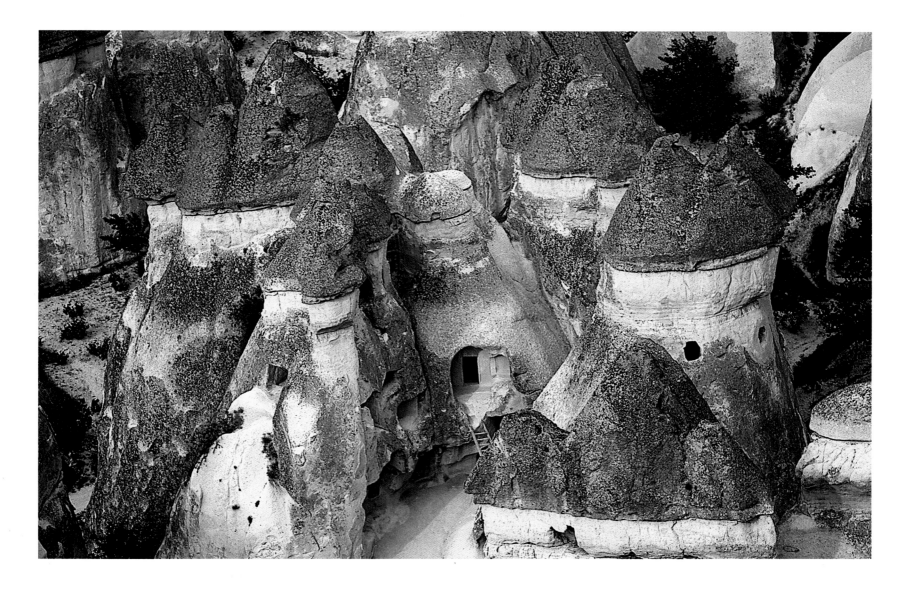

◁ △ CAPPADOCIA ▷

There have been human settlements in this area for centuries. The natural rock caves were easy to enlarge and carve into passageways, even with crude implements, as the substratum is extremely soft and easy to work. Anchorites lived here from the earliest Christian times, carving out the first rock chapels or making use of existing pagan shrines. A large number of the chapels which have survived – about 360 in all – have still got their remarkable decorations, of which the mural paintings are the most impressive.

Most of the chapels date from the 11th century, but it is estimated that some could be as early as the 5th, and even the most recent were made no later than the 13th century. The ones in the Peristrema valley are the most important; there are at least fifteen between Belisirma and Ihlara, including the Yilanli Kilise (Church of the Serpents), the Agaç Alti Kilisesi (Church under the Tree) and the Kokar Kilise (Fragrant Church); at Göreme and the surrounding area, there are nearly fifty, about half of which today form part of an open-air museum; they include the Tokali Kilise (Church of the Knot), the Karanlik Kilise (Dark Church), the Elmali Kilise (Church of the Apple), the Çarikli Kilise (Church of the Sandal) and the Sakli Kilise (Hidden Church). As well as these, there are important sites at Çavusin, in the valleys of Güllü Dere and Kizil Çukur at Soganli – the most important being the Karabas Kilise (Church of the Black Head). They have been classified as world heritage sites by UNESCO.

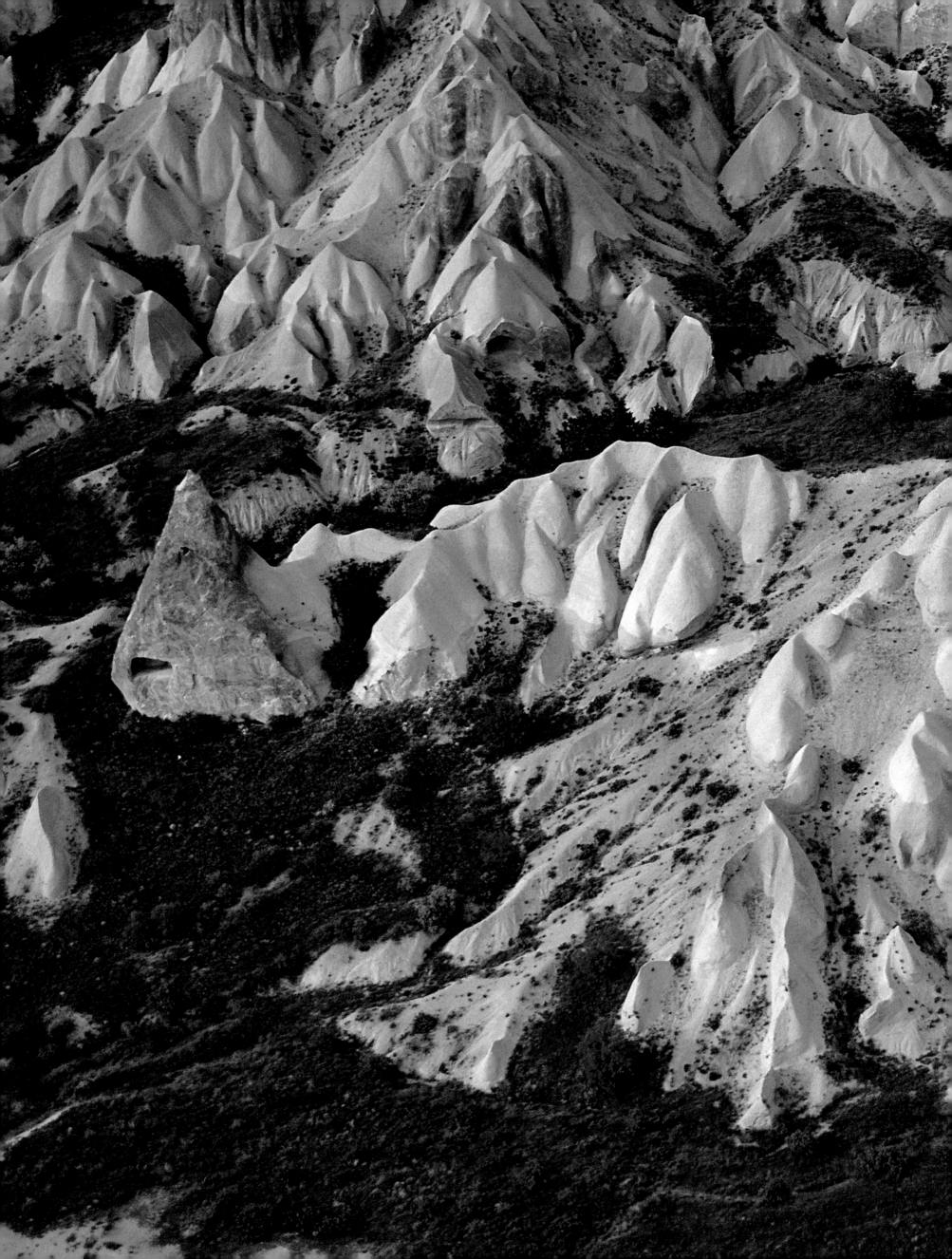

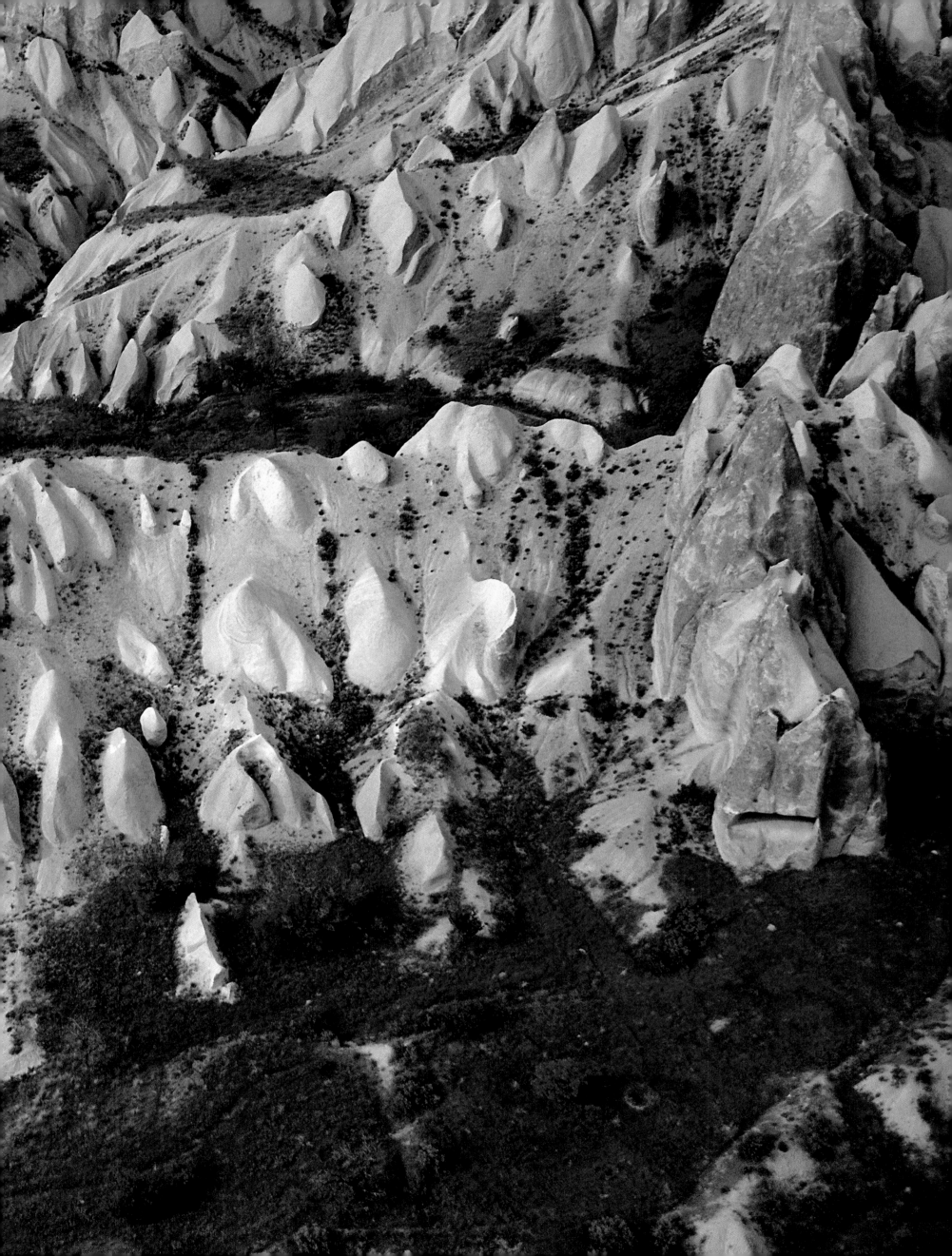

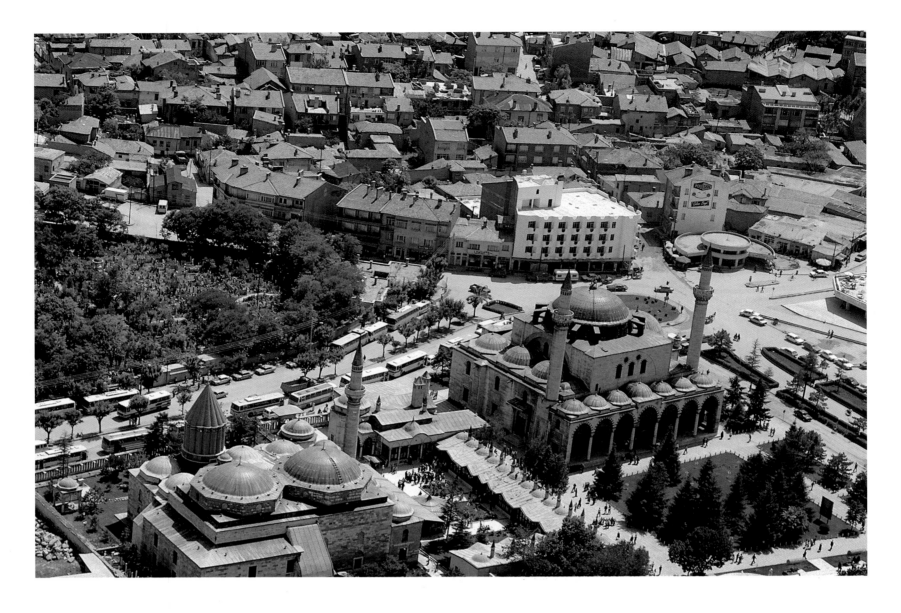

KONYA

TEKKE OF MEVLANA

Konya was an important Seljuk city (the Iconium of the ancients), and the home of Jalal-ud-din Rumi (1207–1273), one of the greatest poets of his time writing in Persian. He was also one of history's most eminent mystics, founding the order of the Whirling Dervishes. His disciples gave him the name Mevlana, which means 'our Master'. A *tekke,* or convent, was built over his tomb in the Ottoman period. Konya is the holy city of Sufism, and today, in spite of the fact that the order was dissolved by Atatürk, the people remain proud of the *tekke,* the mosque and the hall where the dervishes (or *mevlevis*) used to perform their whirling dance until they fell into an ecstatic trance, as well as the mausoleum of Mevlana with its distinctive ribbed tower entirely covered with green glazed tiles. Since the dissolution of the order, the *tekke* has been made into a museum of Islamic art, but large numbers of pilgrims still come here to pay homage to the great Sufi master.

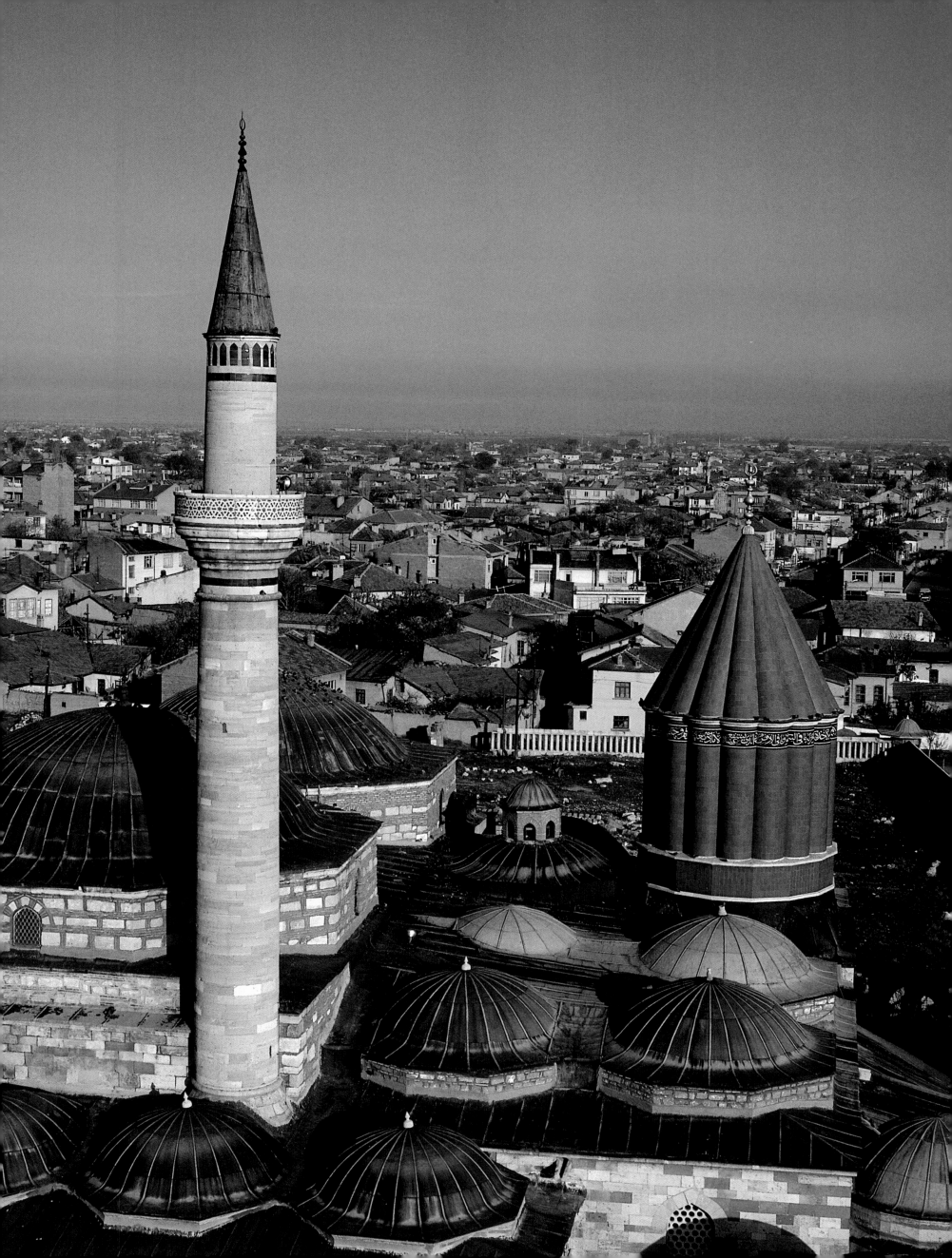

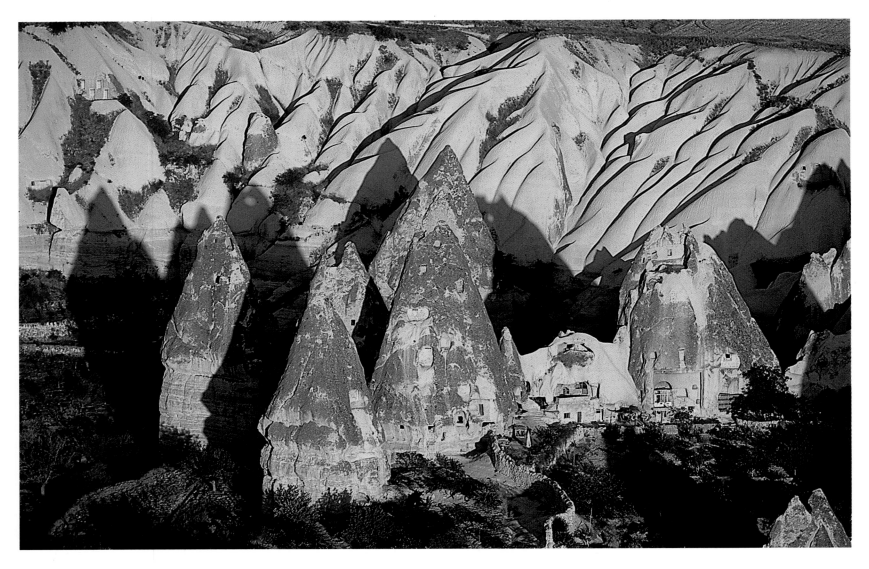

CAPPADOCIA

Xenophon described the subterranean cities of Cappadocia as early as the 4th century BC: 'The entrance is like the mouth of a well, but the rooms themselves are spacious. People get down to them with ladders.' Complete underground towns are hidden away in this region, such as Derinkuyu, which covers an area of several kilometres, or Kaymakli, created between the 5th and 10th centuries, and Mazoköy. At least one hundred of them have been recorded, sometimes built on ten levels; as refuges, they were capable of hiding large numbers of people during an invasion or enemy attack. The inhabitants defended themselves by rolling enormous boulders across the entrances to the labyrinthine corridors. They had fresh-water wells, ventilation shafts, emergency exit tunnels, places to sleep, shrines, silos, presses, drinking troughs and shelter for their animals – in fact, everything they needed to survive for a long time underground. It is thought that the Hittites had already developed a large number of these settlements long before the Christian era.

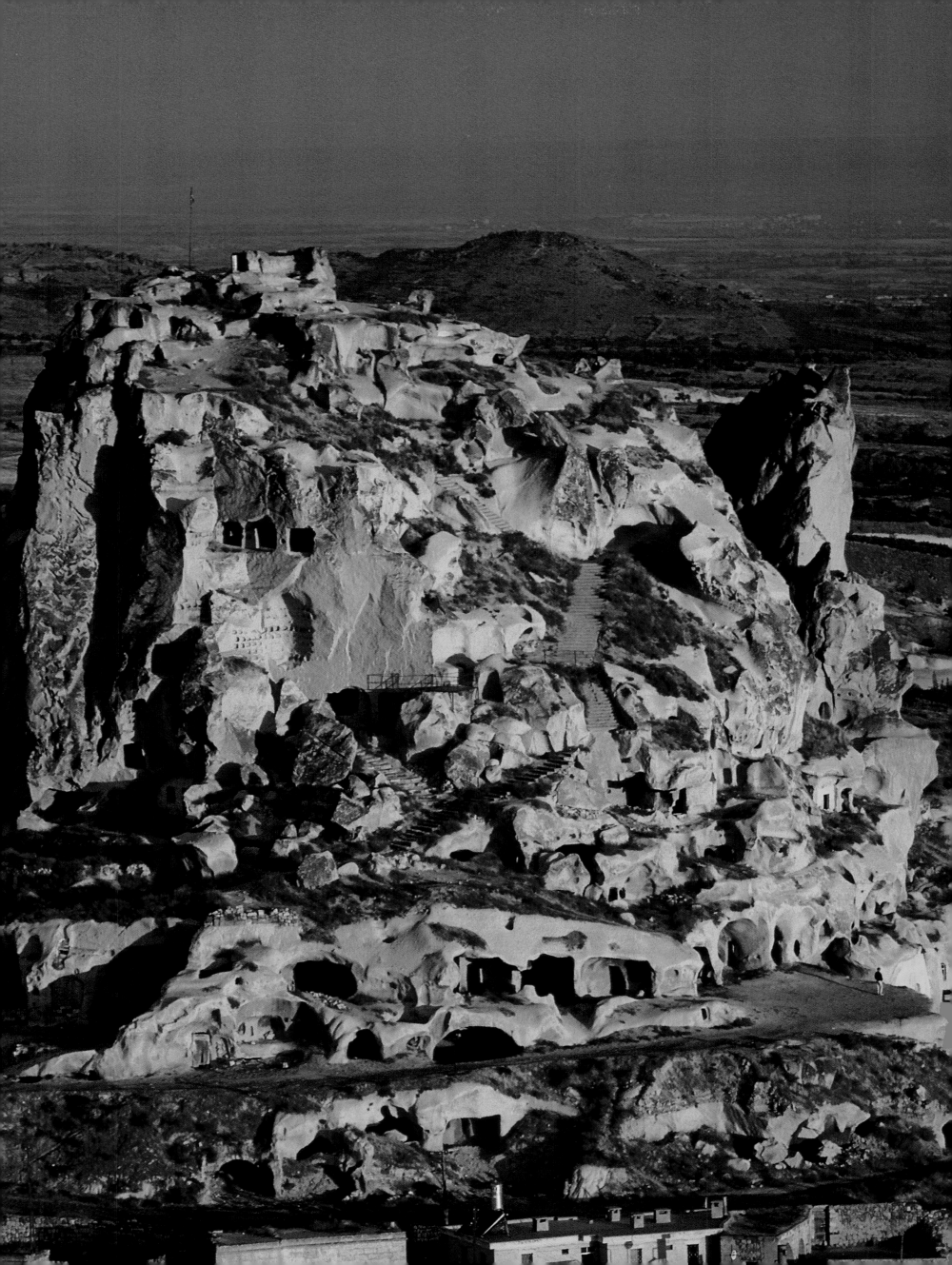

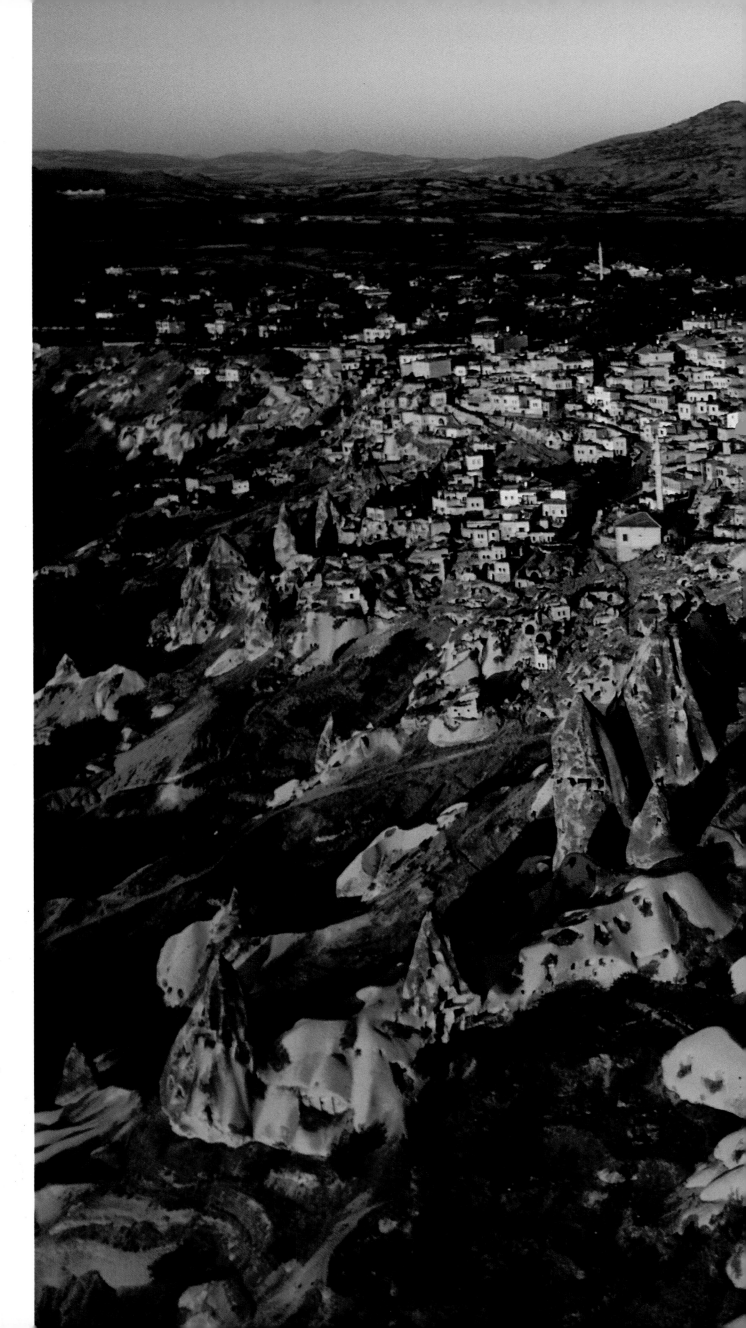

◁ **UÇHISAR** ▷

This is a typical Cappadocian village whose
livelihood is based on agriculture, but it is also
increasingly dependent on tourism. Uçhisar's
most striking feature is an enormous rocky
outcrop, around which the flat-roofed modern
houses cluster, some of which are dug out of
the tufa they stand on. The peak itself, however,
once a citadel riddled with inhabited cells, no
longer serves as a refuge, and nowadays is no
more than a splendid empty shell.

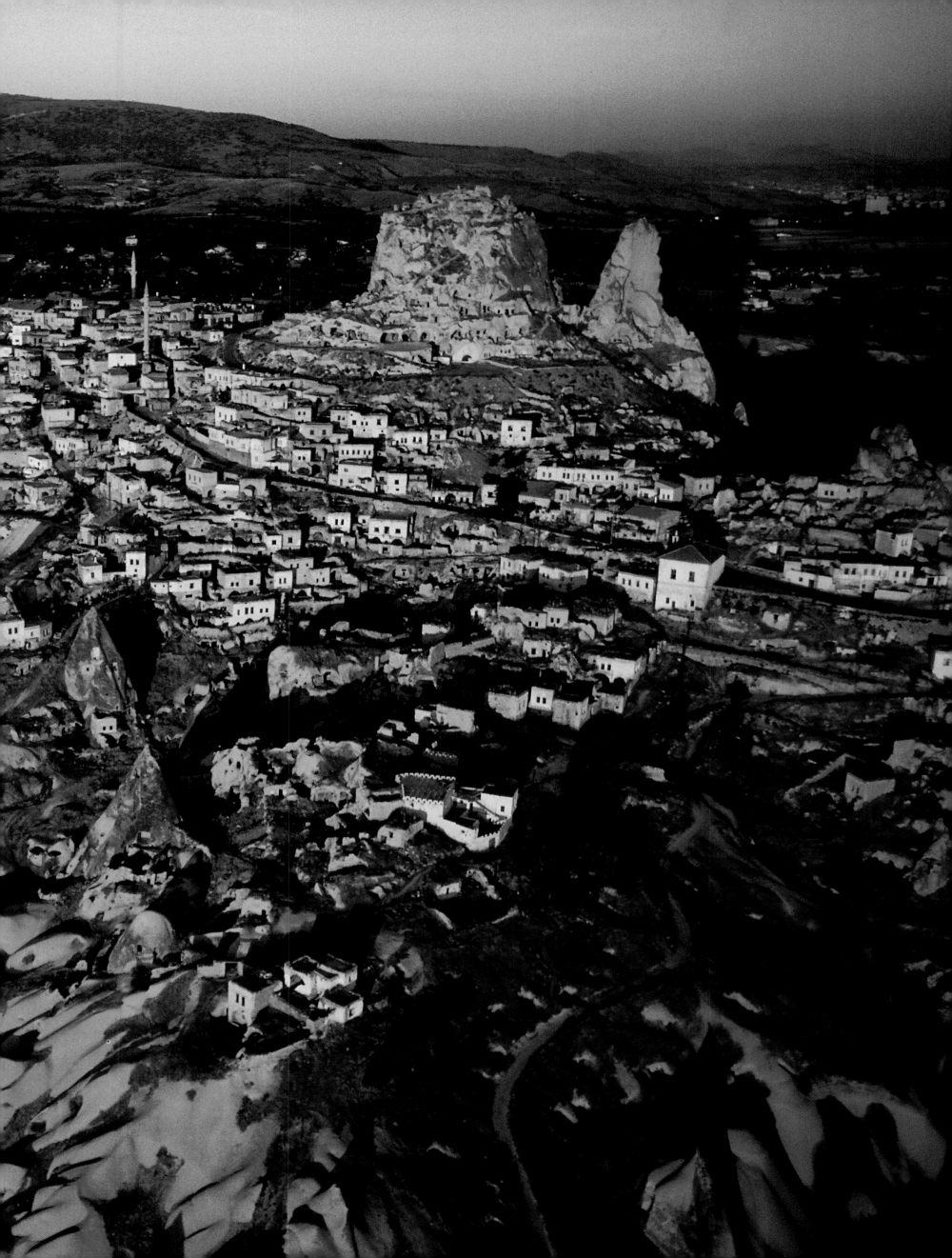

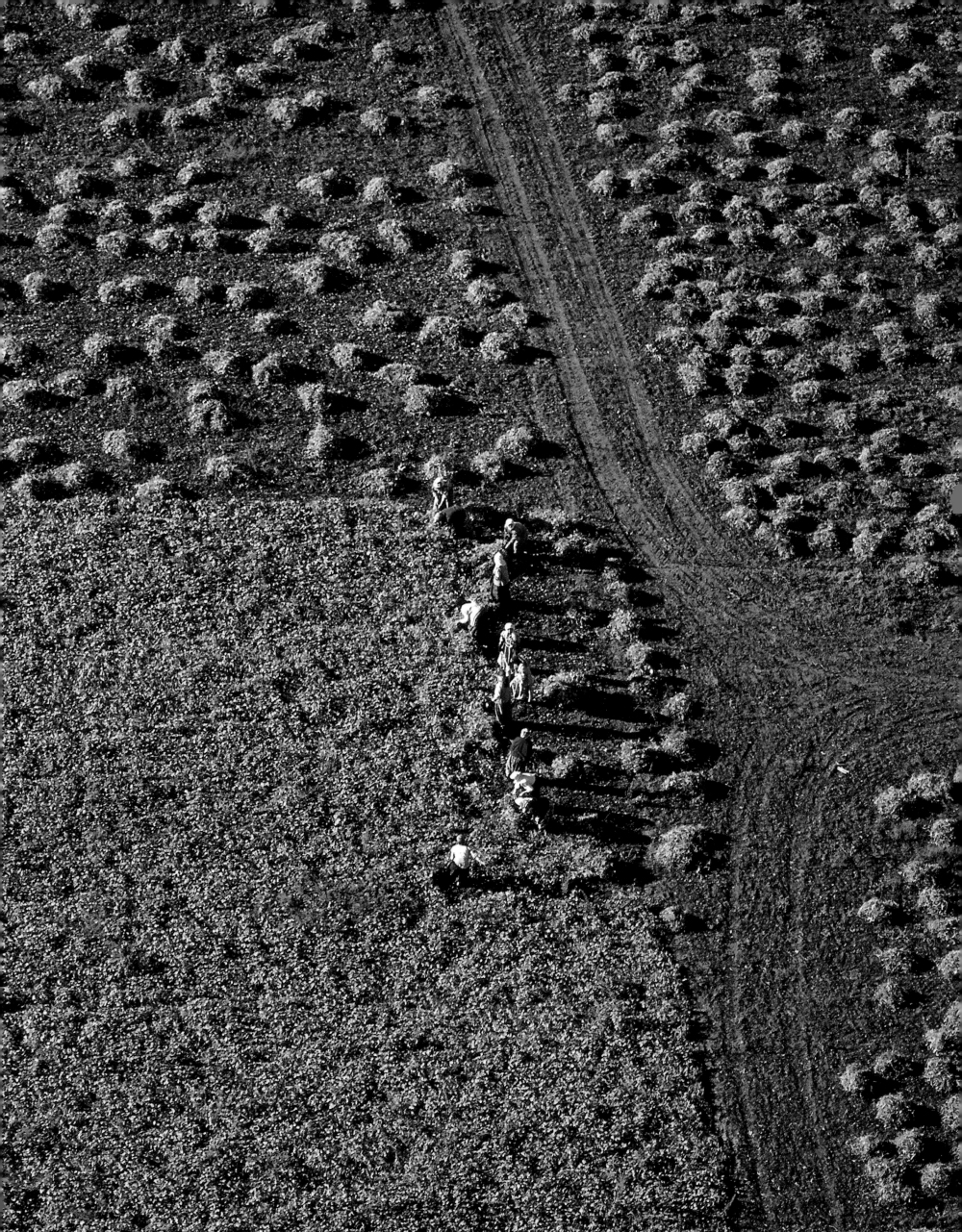

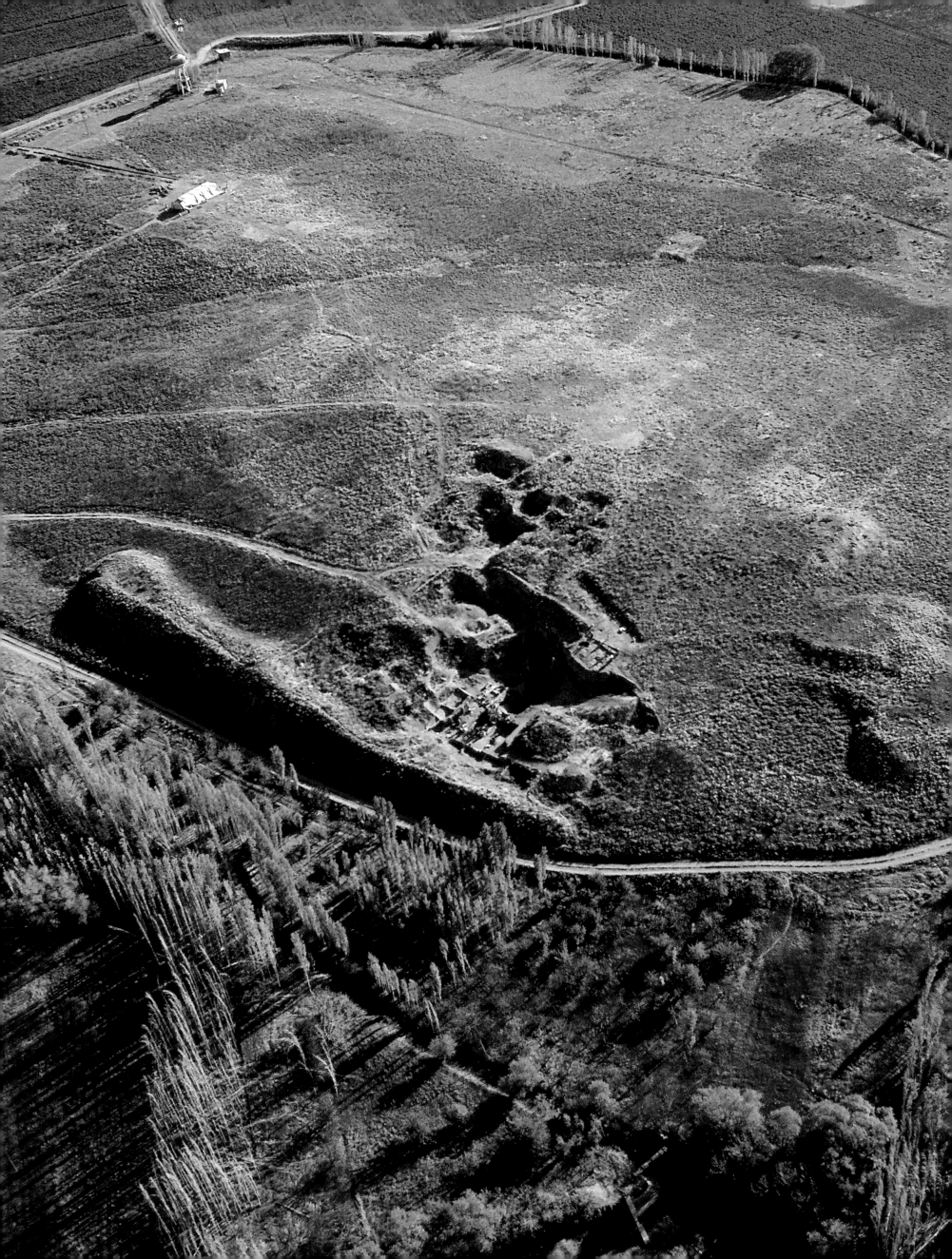

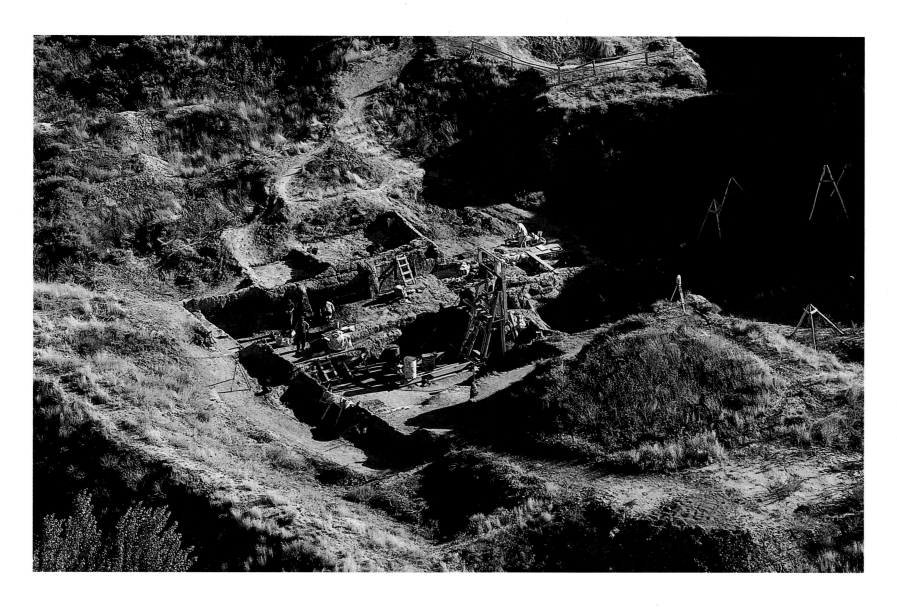

◁ △ **ÇATALHÖYÜK**

These are the remains of one of the oldest urban settlements in the world, and show the inhabitants' progression from a nomadic to a settled agricultural life. Excavations at Çatalhöyük have been able to identify twelve layers of dwellings on this spot between 6500 and 5500 BC, spread over nearly thirteen hectares (thirty-two acres). Excavations have taken place here since the 1960s, and the site has yielded evidence of the amazing diversity of Neolithic civilization; dwellings and places of worship were built of earth and decorated with reliefs, made of bunches of reeds soaked in mud, and polychrome wall paintings. One of them is the earliest known depiction of a landscape in the world, dating from about 6200 BC, and it shows what is probably the eruption of the nearby volcano, Hasan Dagi. There are no side entrances to these dwellings – access was through the roof by means of a portable wooden ladder.

Terracotta figurines of earth goddesses, often shown giving birth, have been found here, evidence of a fertility cult. Burials have been excavated under the floor of the dwellings, where skeletons, stripped of their flesh, were buried with a quantity of funeral offerings. Women's tombs included toilet articles and jewelry made of alabaster, bone, copper and wood. The settlement appears to have been abandoned around 5500 BC and re-established a little further away, at a site that has not yet been excavated.

VOLCANIC CRATER ▷

The Arabo-African geological plate, which is moving northwards, meets the stable Eurasian plate on the Anatolian plain and has always been liable to violent tectonic pressures and disturbances, resulting in multiple geological faults. Earthquakes are a fact of life there, and volcanic eruptions are not unusual. Central Anatolia is dotted with a string of volcanoes, covering more than twelve per cent of Turkish territory. Büyük Agri Dagi (the Mount Ararat of the Bible), 5,165 metres (almost 17,000 feet) high, last erupted in June 1840; Ericyes Dagi (Mount Argeus to the Ancients) is a permanently snow-covered volcano.

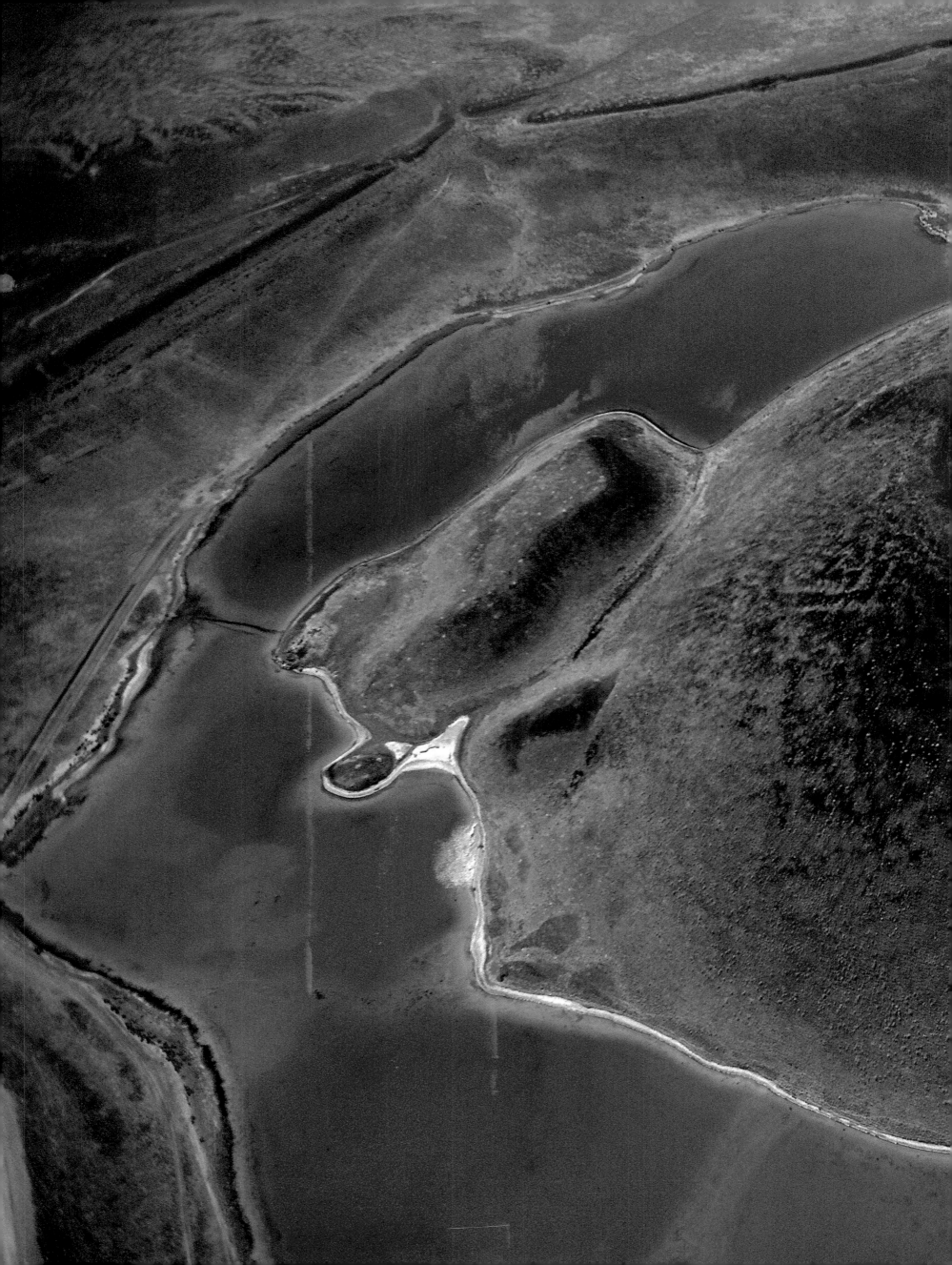

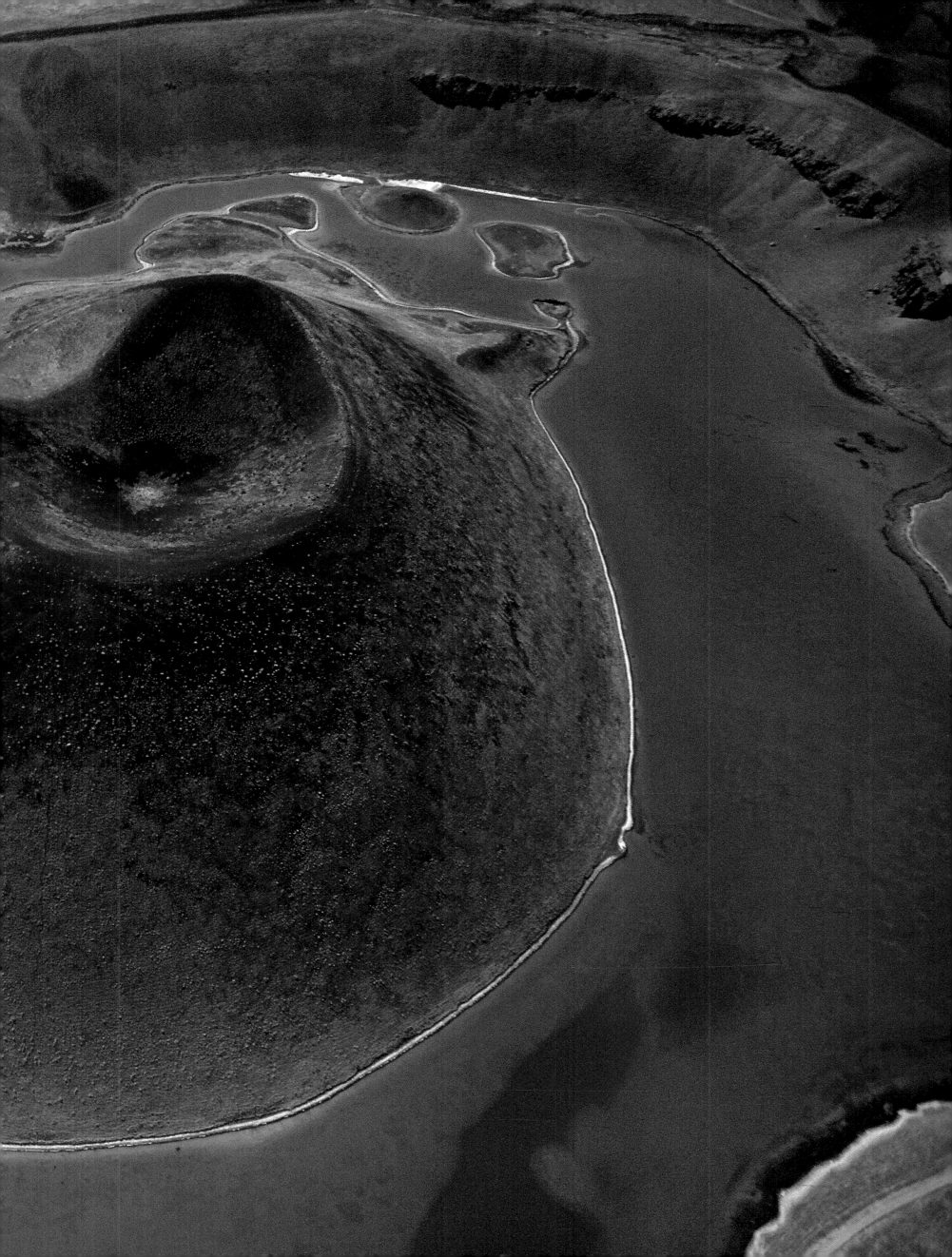

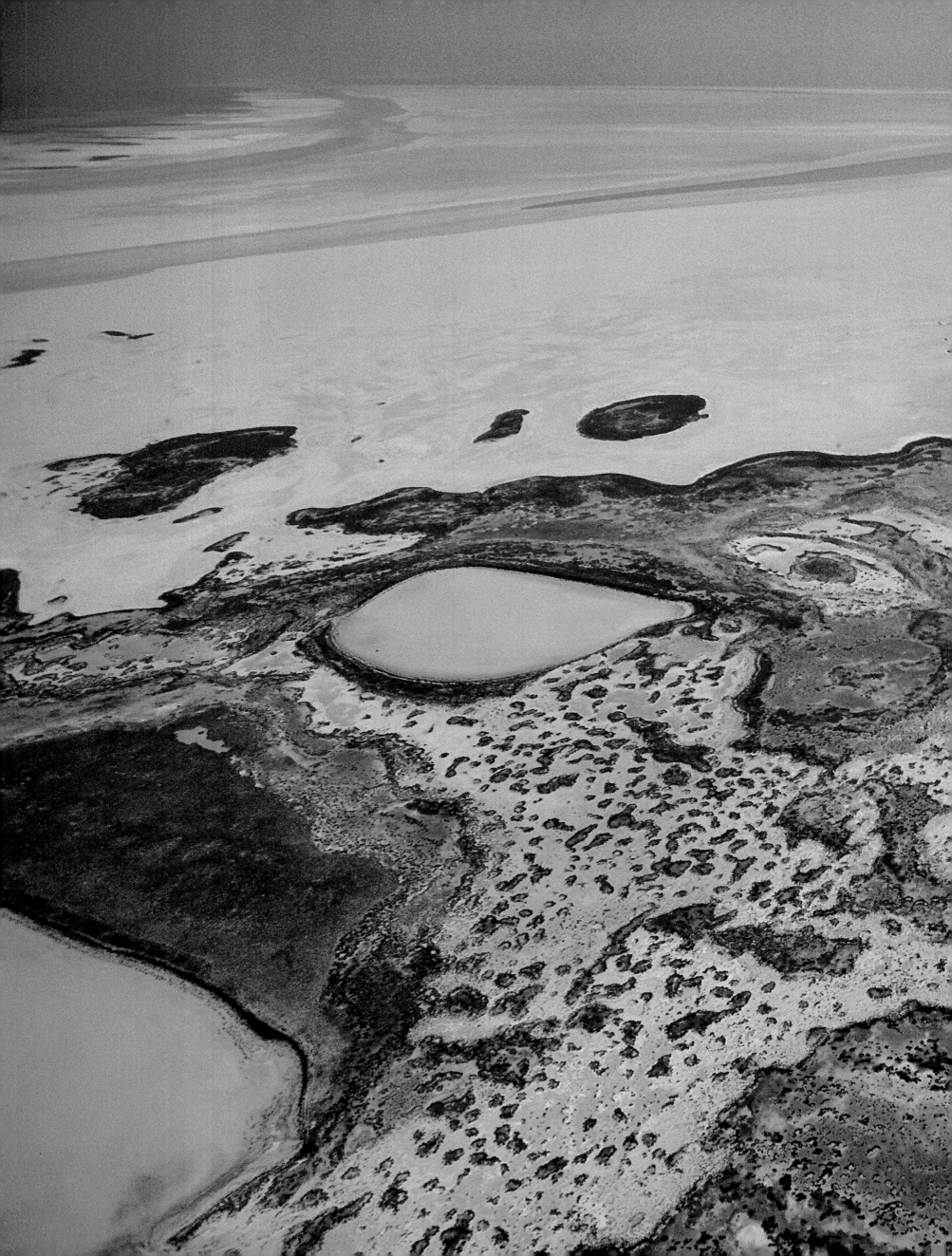

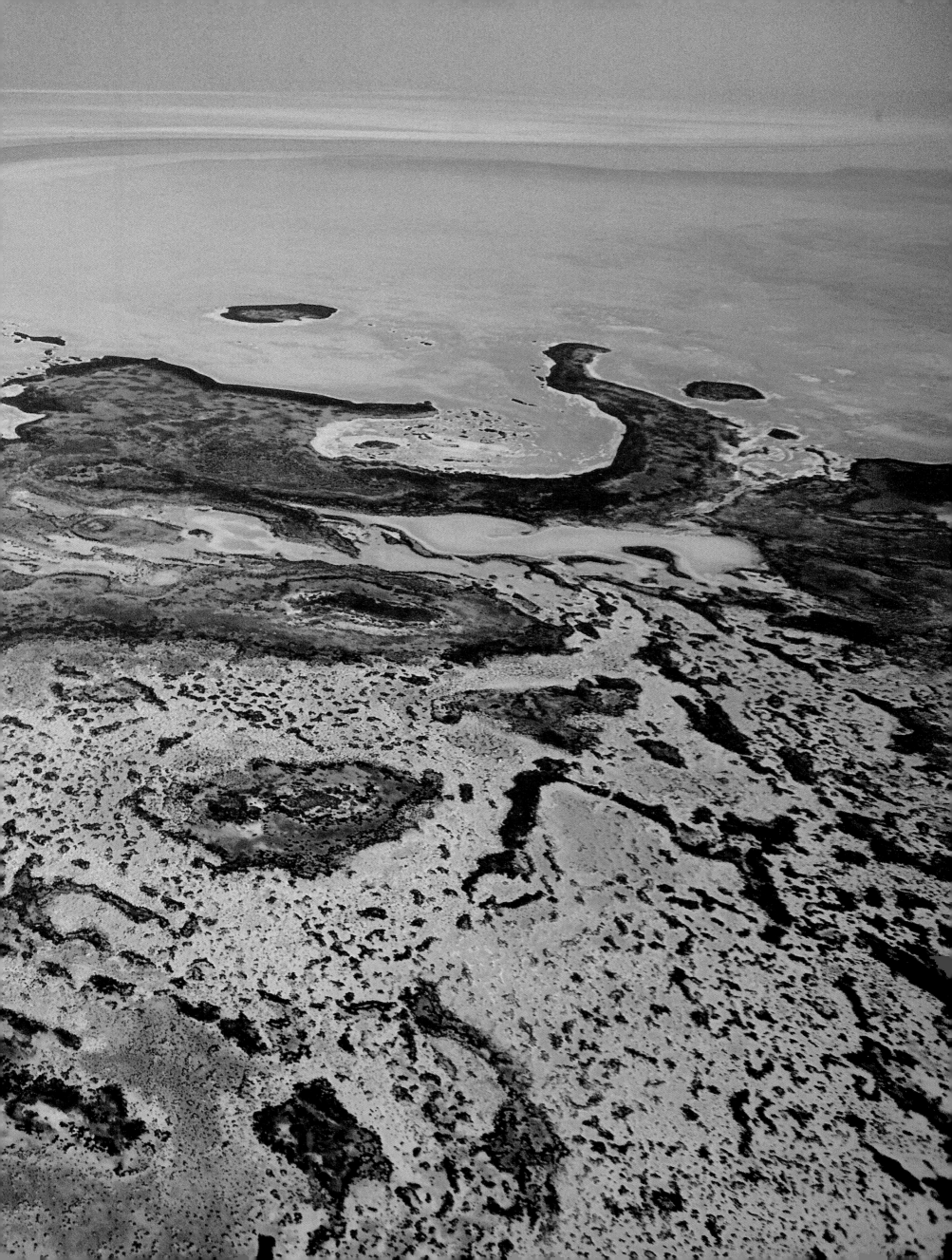

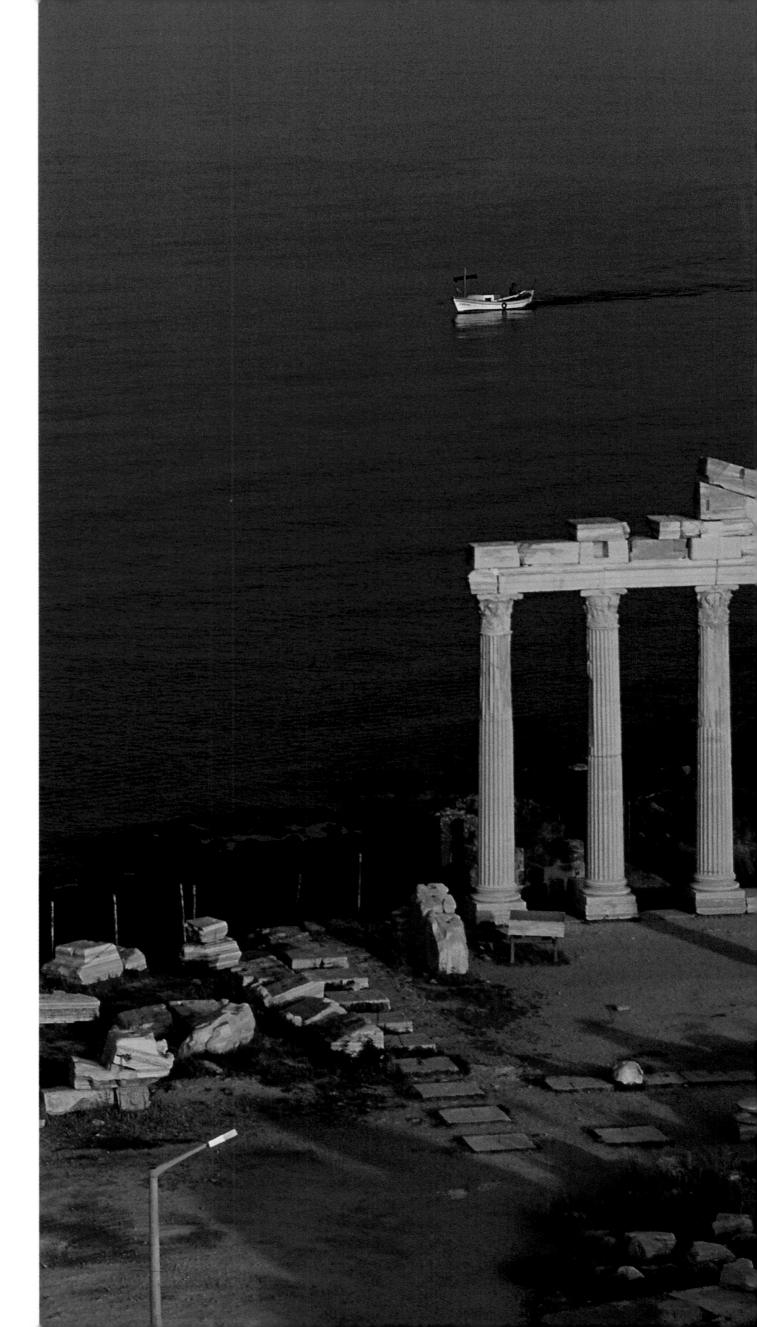

KONYA
TUZ GÖLÜ (GREAT SALT LAKE)

The Tuz Gölü fills a huge depression to the southeast of Konya, the sacred town of Sufism. It is subject to dramatic changes in water level, which has always prevented its exploitation. In summer it is a series of swamps with deposits of salt, whereas after the rains it is transformed into an immense lake stretching as far as the eye can see.

SIDE
ARCHAEOLOGICAL SITE ▷

This was one of the most important cities of ancient Pamphylia. The Greek geographer Strabo claimed that it was founded in the 7th century BC as an Aeolian colony – its name means 'pomegranate' in the Anatolian dialect spoken by the known inhabitants of the site from 1400 BC onwards. Uniquely, it has been reoccupied in recent times, for example by Turkish refugees from Crete at the end of the 19th century, who settled there among the ruins. In the first century BC particularly, and until Pompey intervened, Side was used as a pirates' hideout and as a port for the slave trade – a far cry from being the focus of packed crowds of tourists, as it is today. There are vestiges of ancient buildings to be found in the heart of the modern city as well as on the outskirts, including a nymphaeum, agoras surrounded by colonnades, temples, a necropolis, thermal baths, parts of aqueducts and, most importantly, a perfectly preserved Roman theatre of the 2nd century, capable of seating 15,000 spectators – a reminder of the city's past splendour. Other Byzantine-period remains are evidence that this was one of the first Christian urban settlements in Asia Minor.

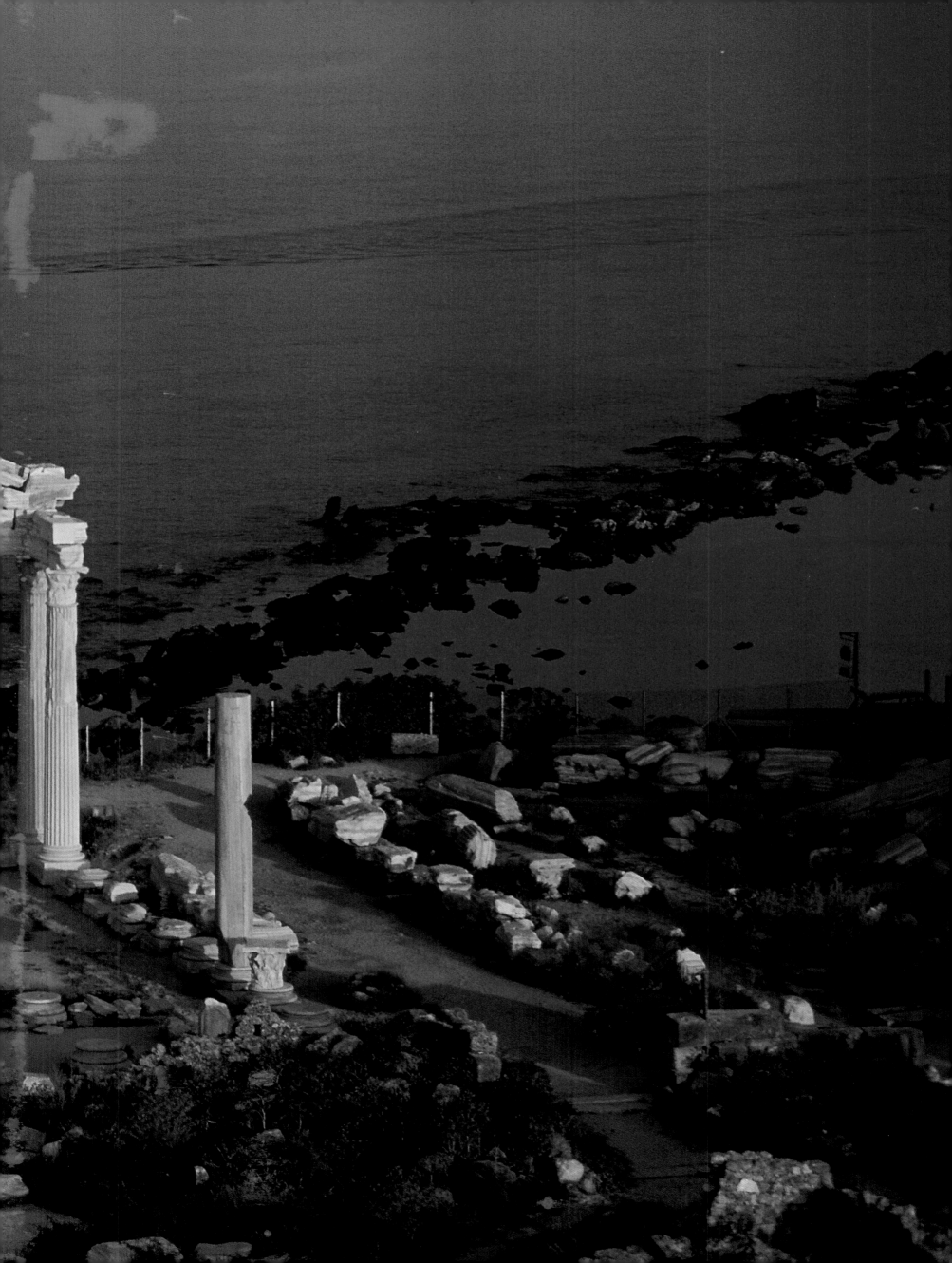

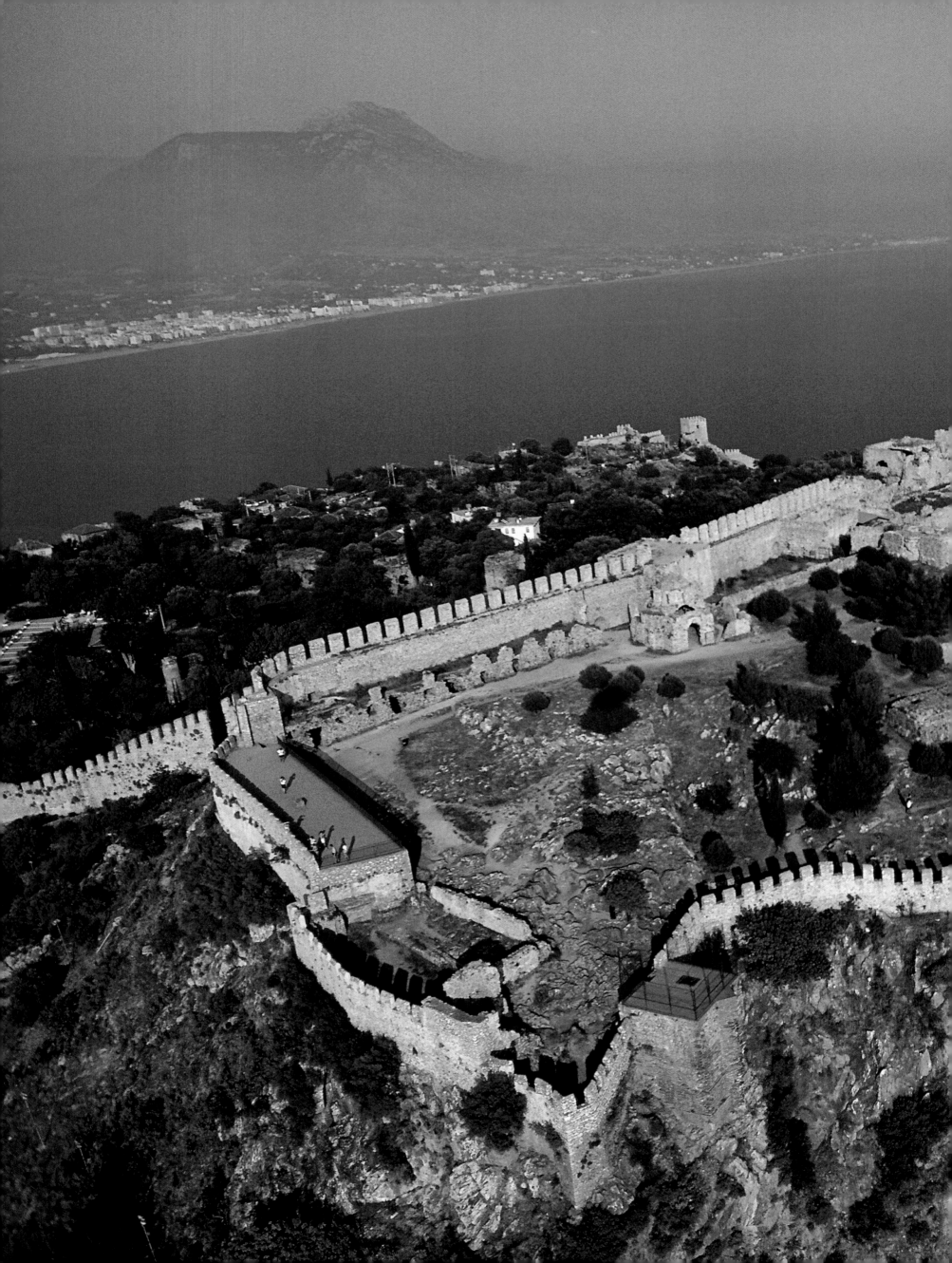

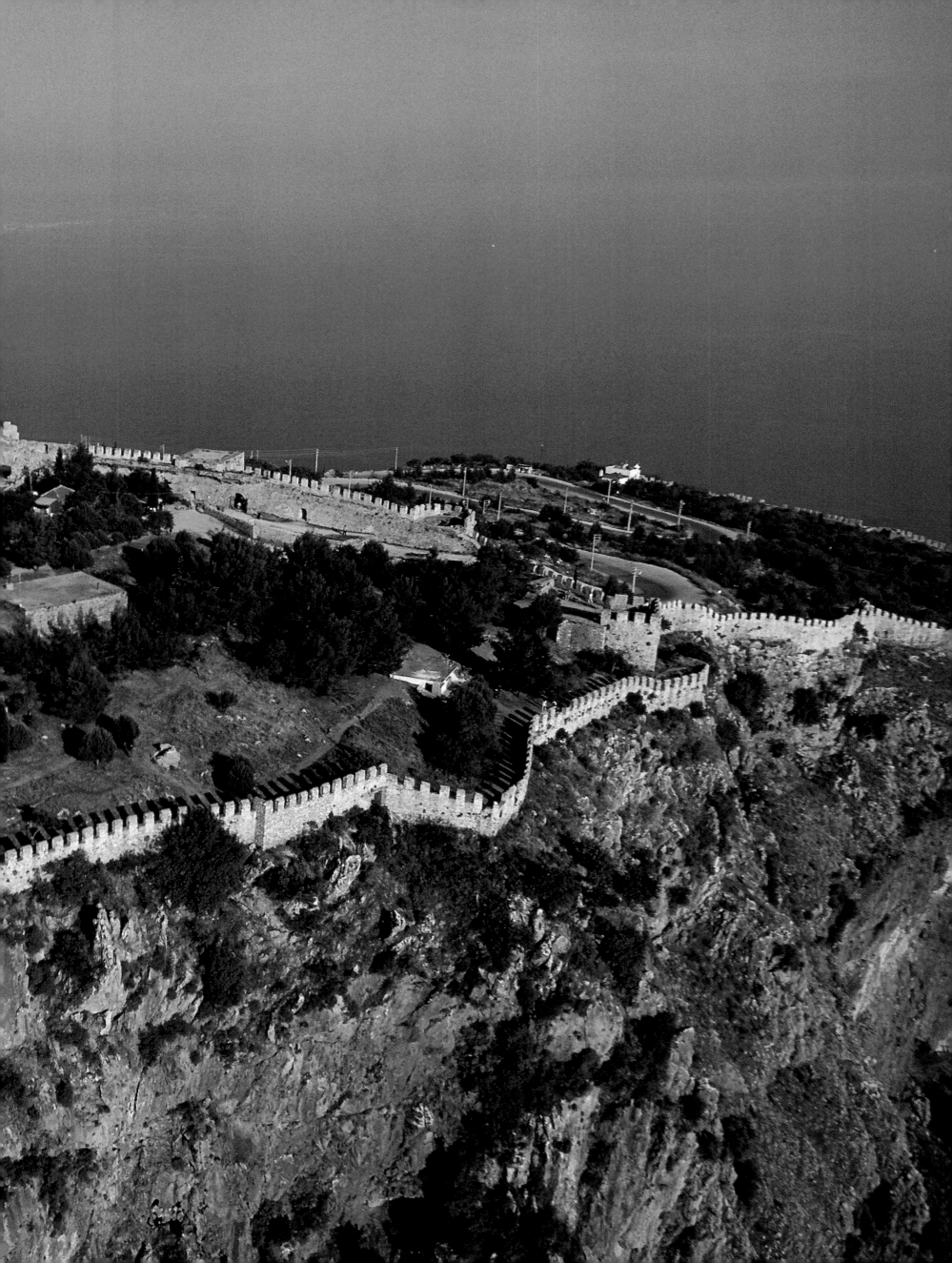

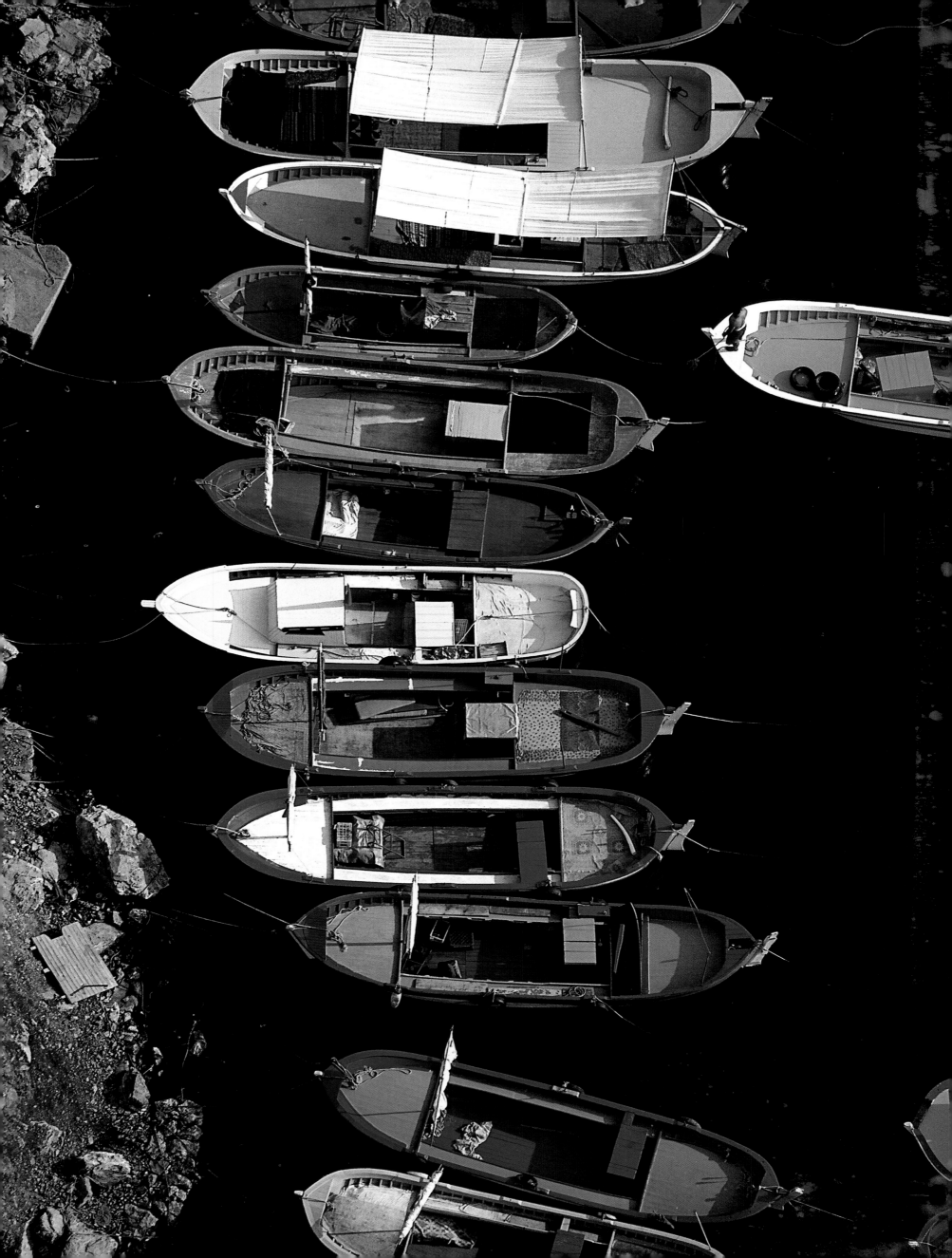

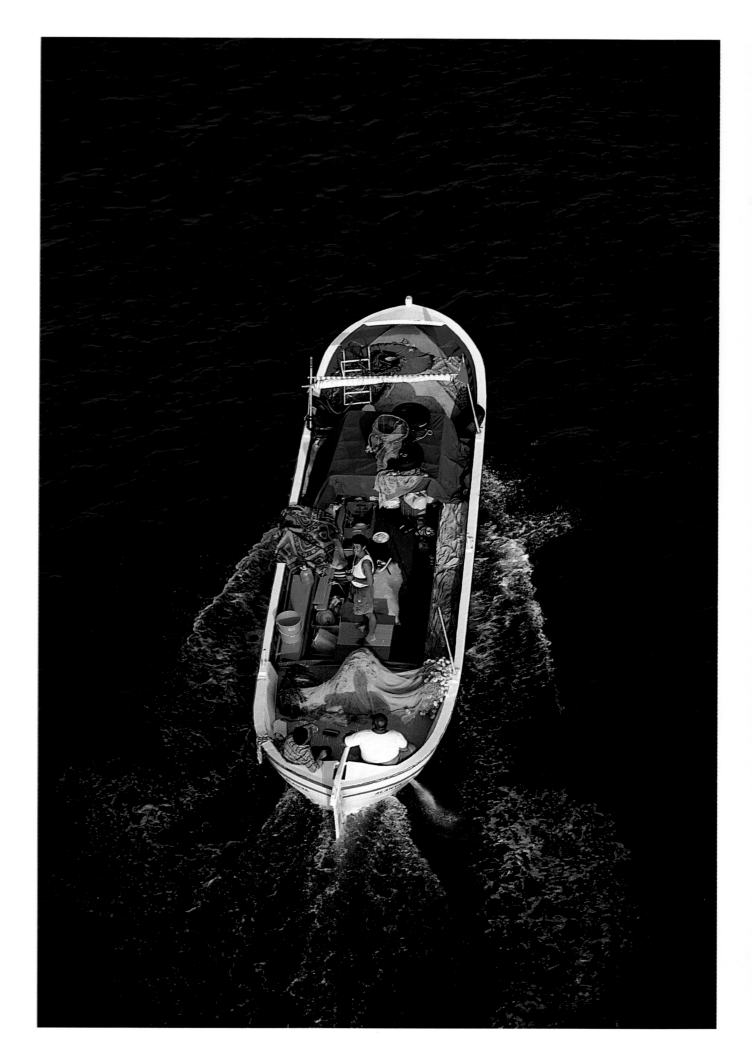

ALANYA KALESI (FORTRESS OF ALANYA)

Seven kilometres (more than four miles) of crenellated ramparts, punctuated by 146 towers, encircle the fortress built on the heights of Mount Alanya which dominates the port. It contains remnants of ancient warehouses (*bedesten*) and a covered market, as well as a mosque, the Süleymaniye Camii, and a caravanserai. The citadel itself (Iç Kali) is powerfully defended by three keeps. There is a small Byzantine church dedicated to St George in one of the courtyards, right on the edge of the cliff. This spot is called Adam Atacagi, or 'the place where men are thrown to their death'; condemned criminals were indeed thrown from here to be crushed on the rocks below. The story goes that the only hope of reprieve was to succeed in throwing a stone into the sea; needless to say, this required almost impossible skill.

All the fortifications – walls, towers and keeps – as well as the port's arsenal, were built by the Seljuks during the 13th century.

ALANYA ▷

Fishing boats in the harbour.

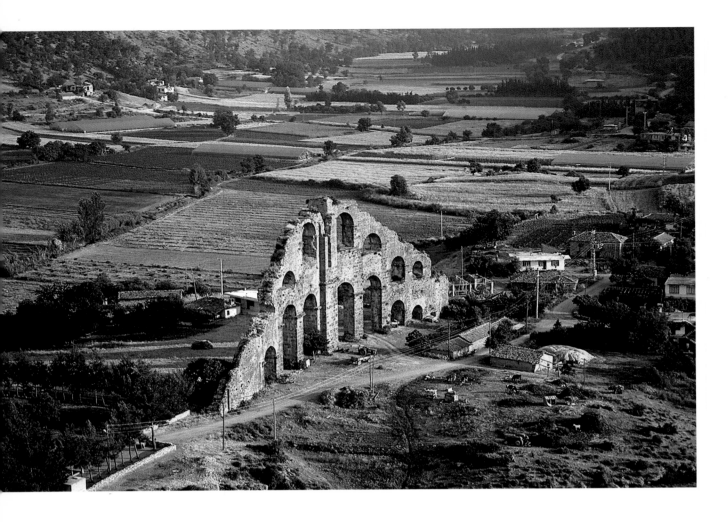

△ **ASPENDOS**
AQUEDUCT

This magnificent structure, dating from the
2nd century AD, brought water to the town.
It was one of the largest aqueducts built by
the Romans in their eastern territories.

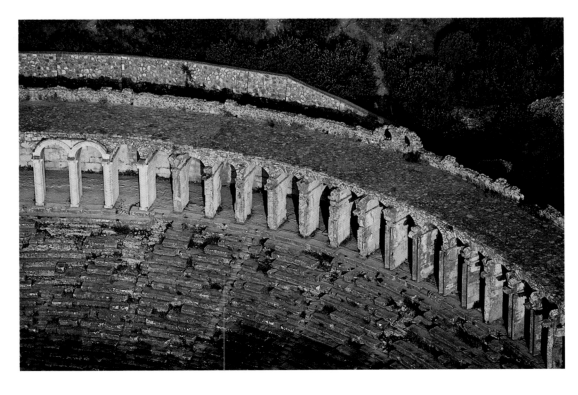

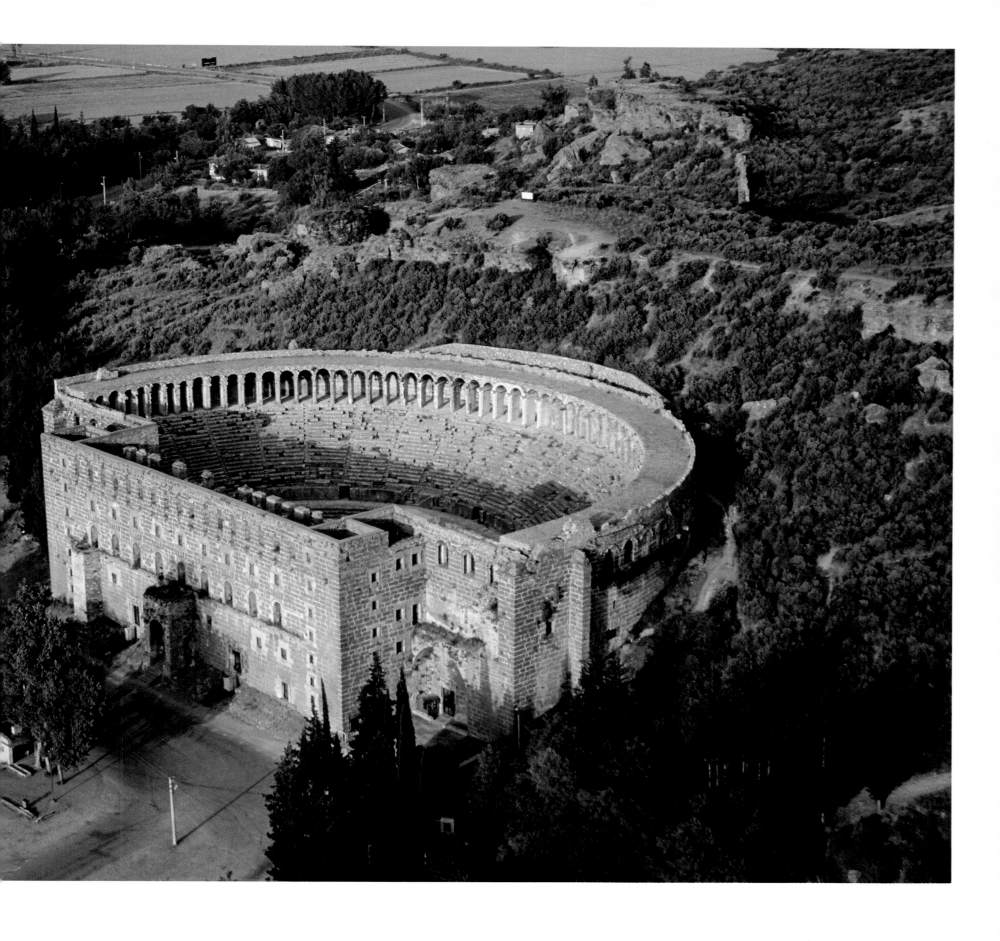

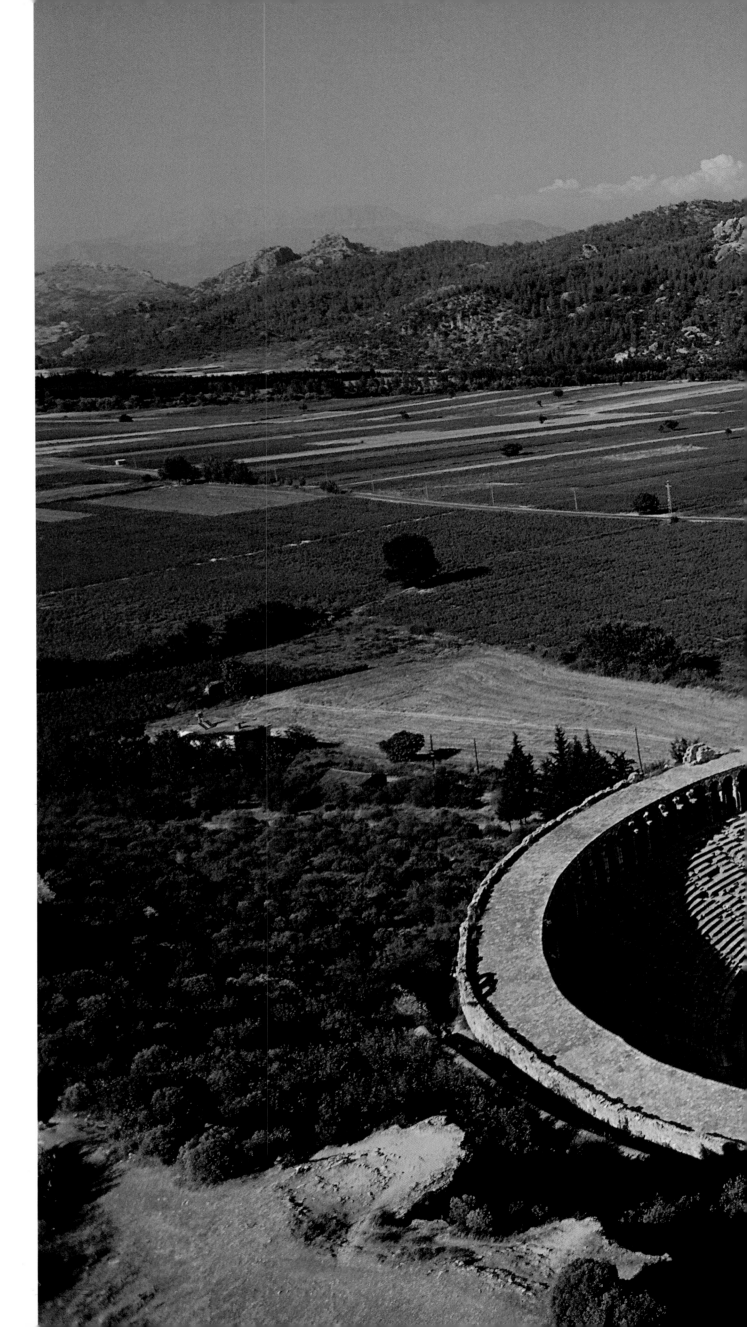

◁ ASPENDOS
THEATRE ▷

The Roman theatre at Aspendos is probably
the best preserved of all those built in
antiquity. Only a few decorative features have
disappeared, such as the marble panels which
covered the inside surface of the *scenae frons*.
The theatre is remarkable for still possessing
this immensely high wall behind the stage, as
well as the Roman-style gallery or ambulatory
at the top of the tiered rows of seats, and all
the vaulted passageways (vomitories) behind
them. It was erected in the reign of the Roman
emperor Marcus Aurelius by the architect
Zeno, but is nevertheless very much in the
Greek tradition, if only because it is built
into the slope of a hill: this indicates that the
builders, although showing in the theatre's
foundations that they were familiar with barrel
vaulting, had been concerned to respect local
architectural traditions. It was able to seat
15,000 spectators.

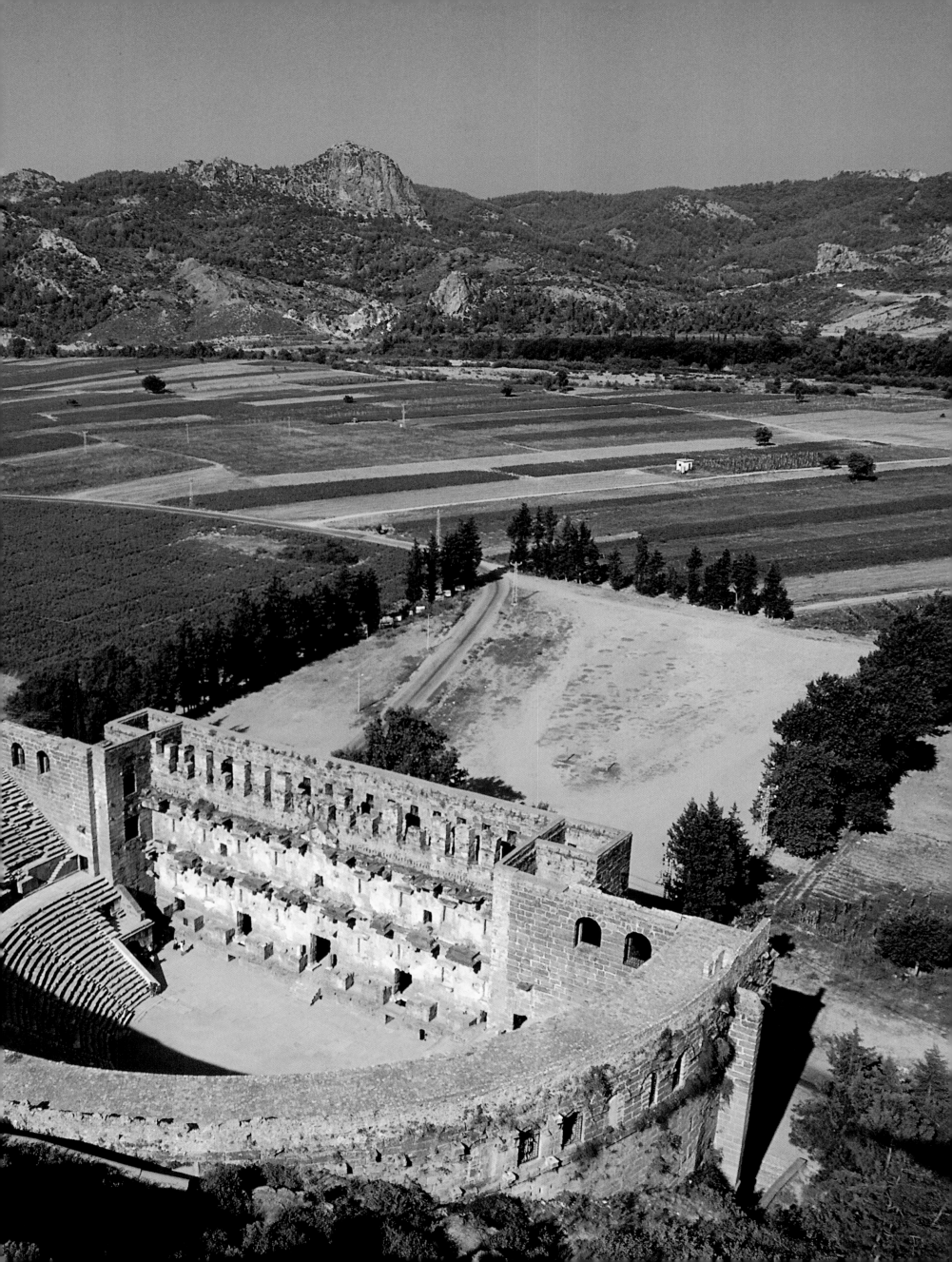

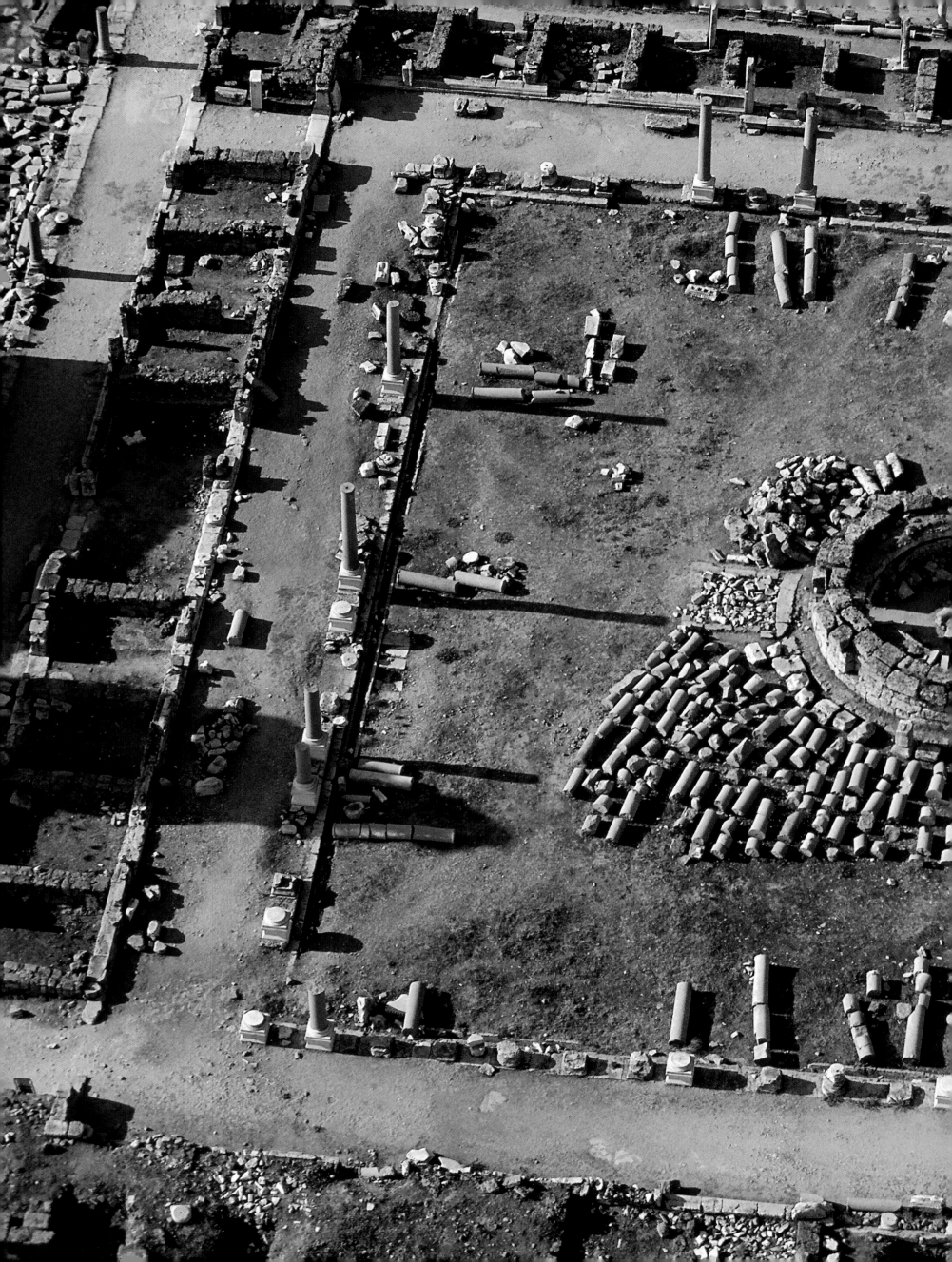

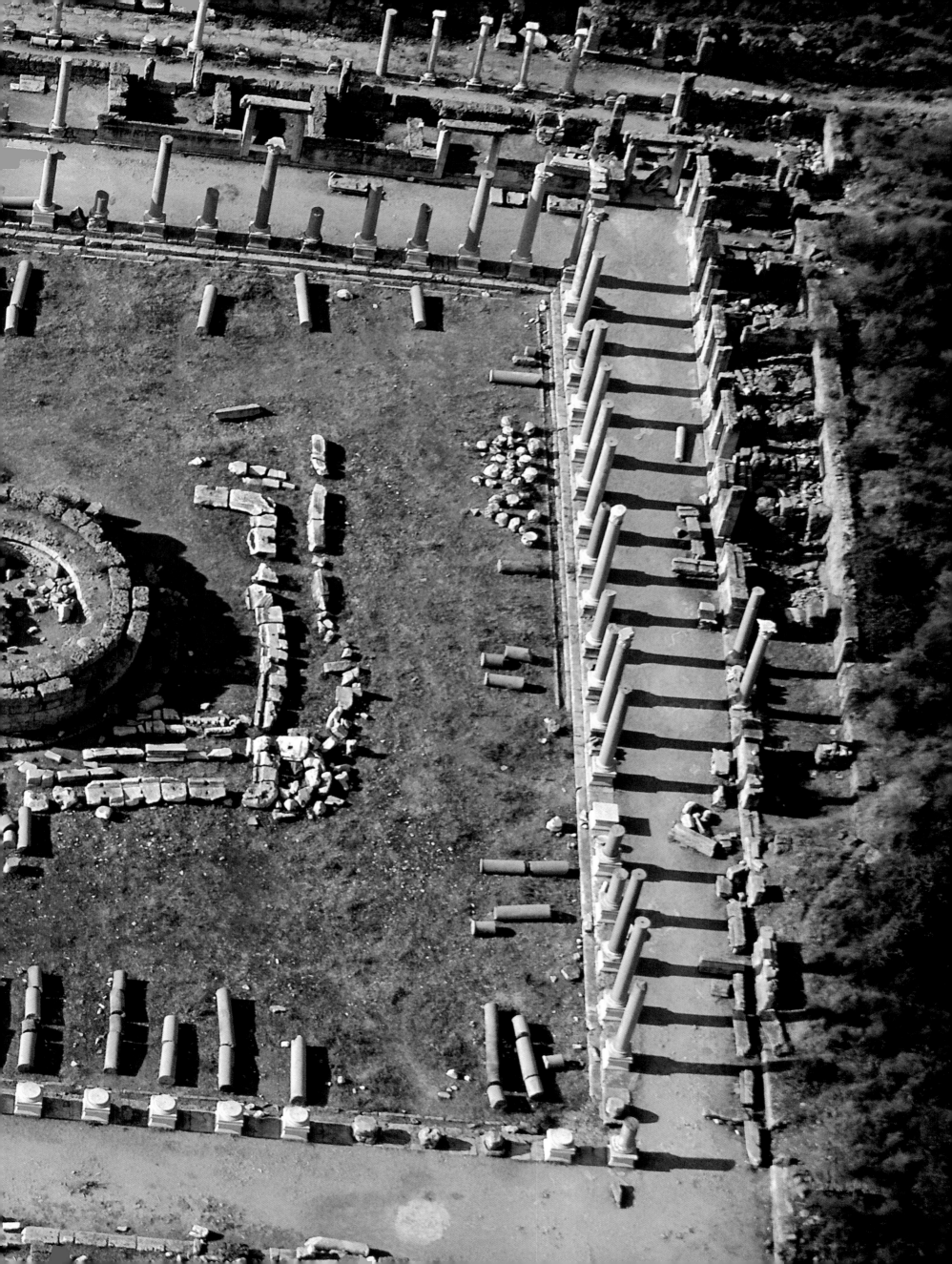

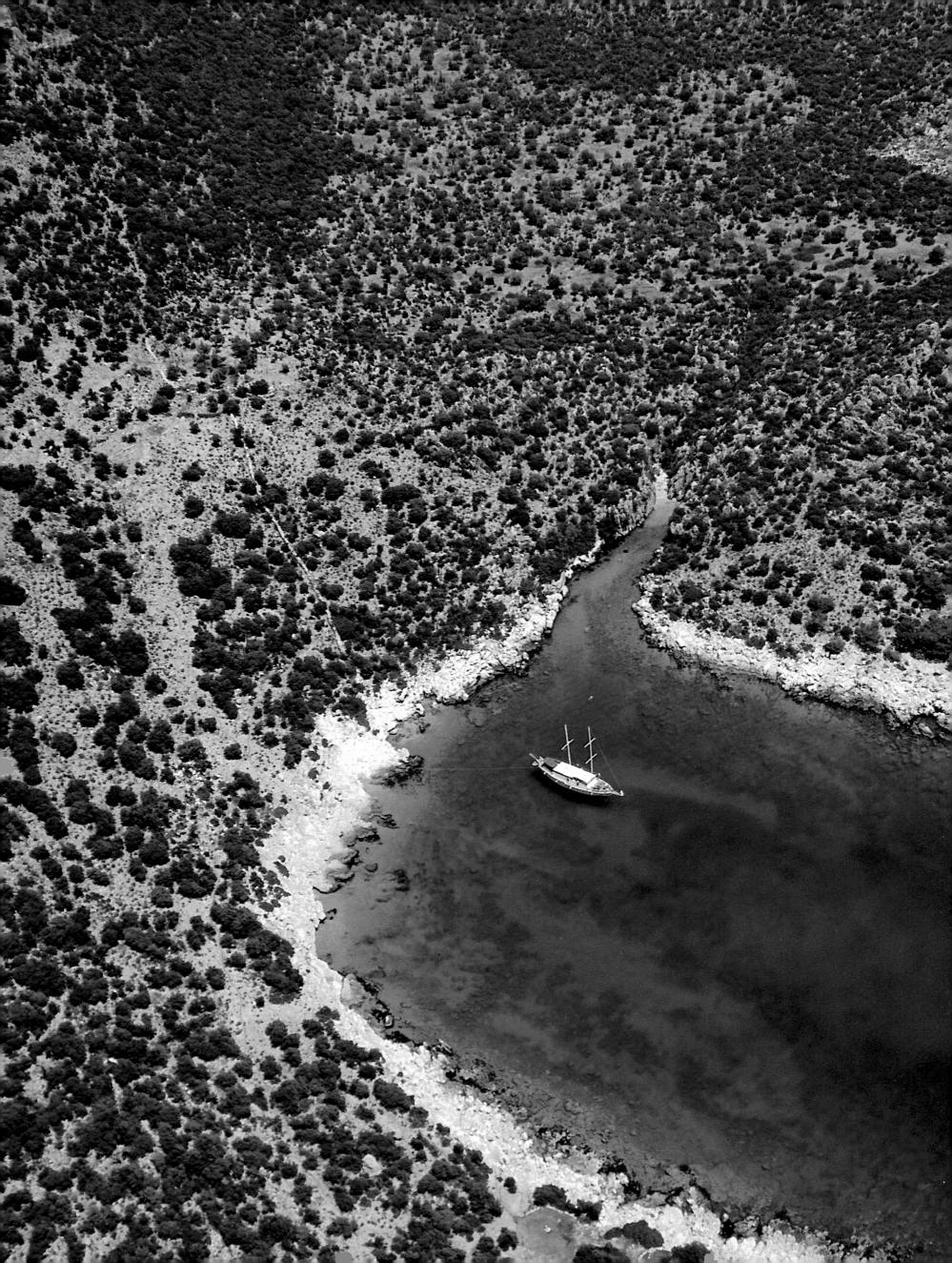

◁ ◁ **PERGE**

ARCHAEOLOGICAL SITE

The ruins of the ancient Perge are still evocative of one of the most prosperous cities in Pamphylia. The inhabitants claimed descent from the seer Calchas, who accompanied the Acheans to Troy, as well as from Mopsos (grandson of Tiresias), seer of Apollo's oracle at Claros, to the northwest of Ephesus. Statues of them, and of other seers and gods, stood on the walls of the horseshoe-shaped formal square near the fortified entrance gate of the city, known as the Hellenic Gate. The square was built by Plancia Magna, a wealthy priestess of the goddess Artemis Pergaia, who lived at the beginning of the 2nd century AD. The temple of Artemis, then famous throughout the Mediterranean lands, has so far not been found.

Alexander the Great easily took the city, which at that time had no protective ramparts, and spared it from reprisals. However, most of the monuments on this site date from the Roman period: the 2nd-century stadium is one of the best preserved of all surviving ancient stadiums. It is 235 metres (770 feet) long and 35 metres (115 feet) wide, and could seat 12,000 spectators on its twelve rows of seats. The nearby theatre, dating from the end of the 2nd century, had 15,000 seats; its *scenae frons* is still standing, and is decorated with reliefs depicting the story of Dionysus. The surrounding wall, towers, arches, thermal baths, agora, arcaded street, nymphaeum and palestra are all evidence of the power of the Roman city. Standing above it all is the acropolis, currently overgrown and awaiting future excavation programmes.

◁ **IDYLLIC COASTAL SCENERY BETWEEN KAS AND MYRA** ▷

103

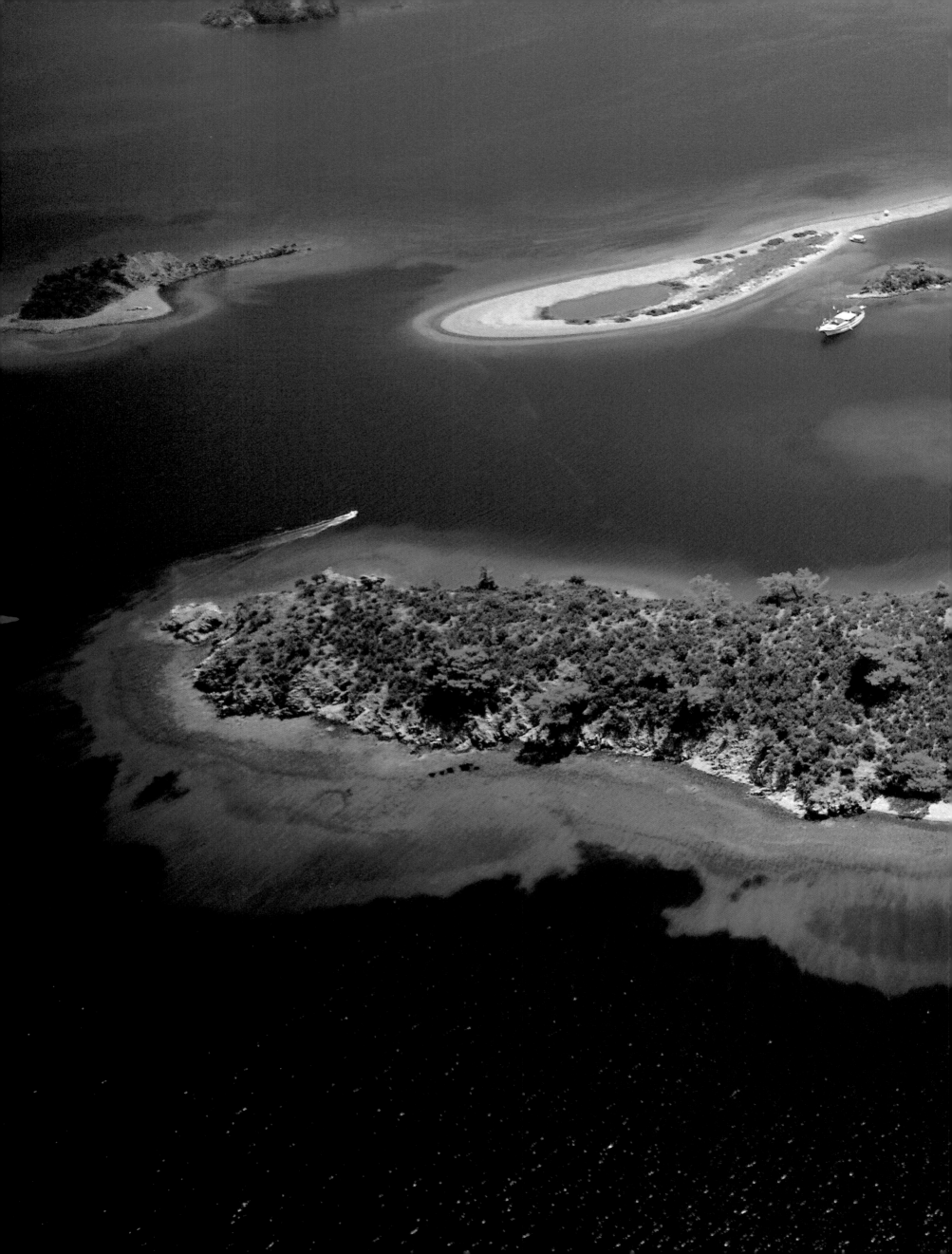

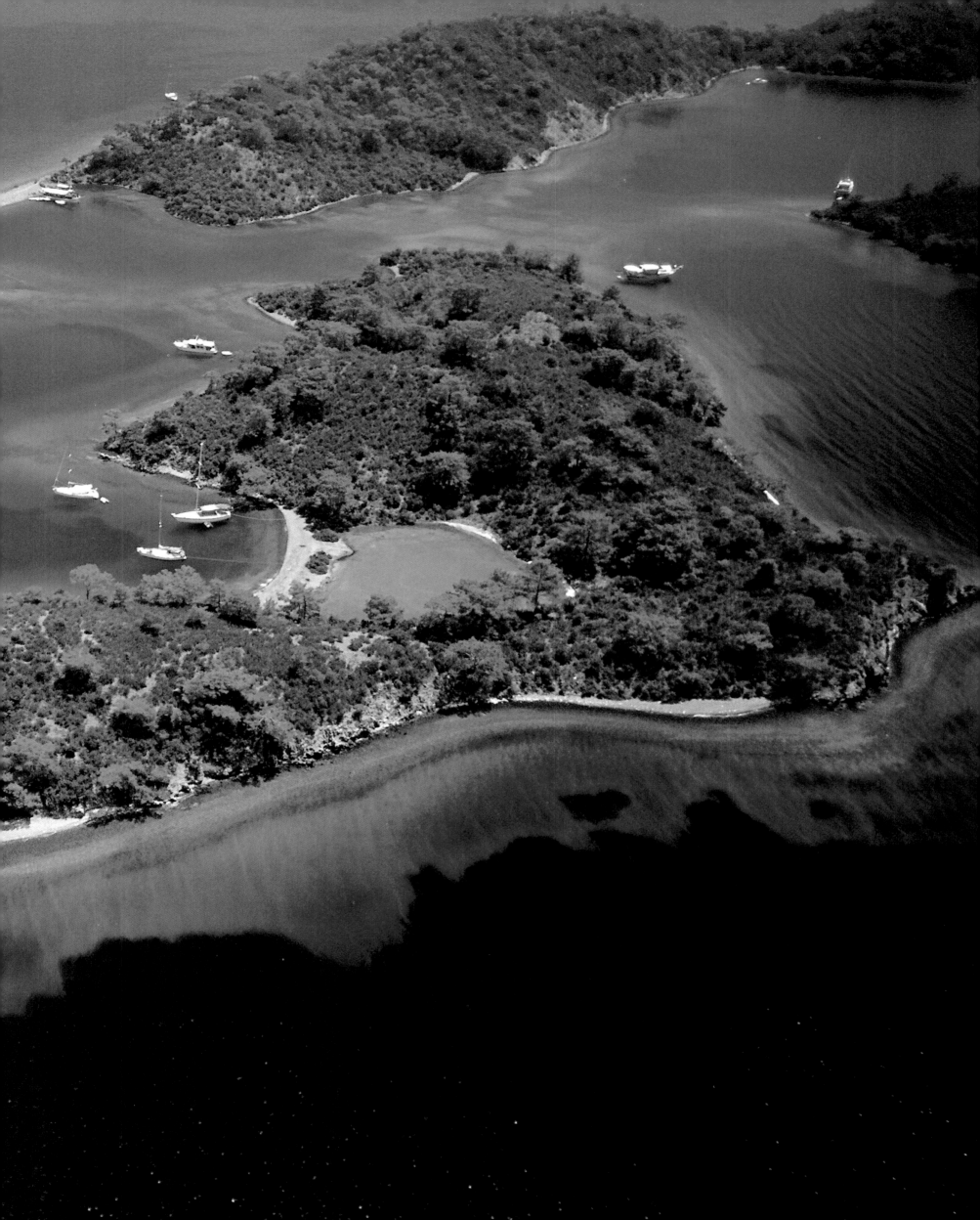

PHASELIS
ARCHAEOLOGICAL SITE

Not far from the town of Antalya, founded by
Attalus II, King of Pergamum, stand the ruins
of the ancient city of Phaselis, submerged in
luxuriant vegetation. Though not the most
interesting site in the region, its position on
the shores of the Mediterranean in a beautiful
wooded setting gives it a magical atmosphere.
A theatre, thermal baths, agoras, the port,
ramparts and necropolis are the principal
features – some of the ruinous structures can
only be seen from the air.

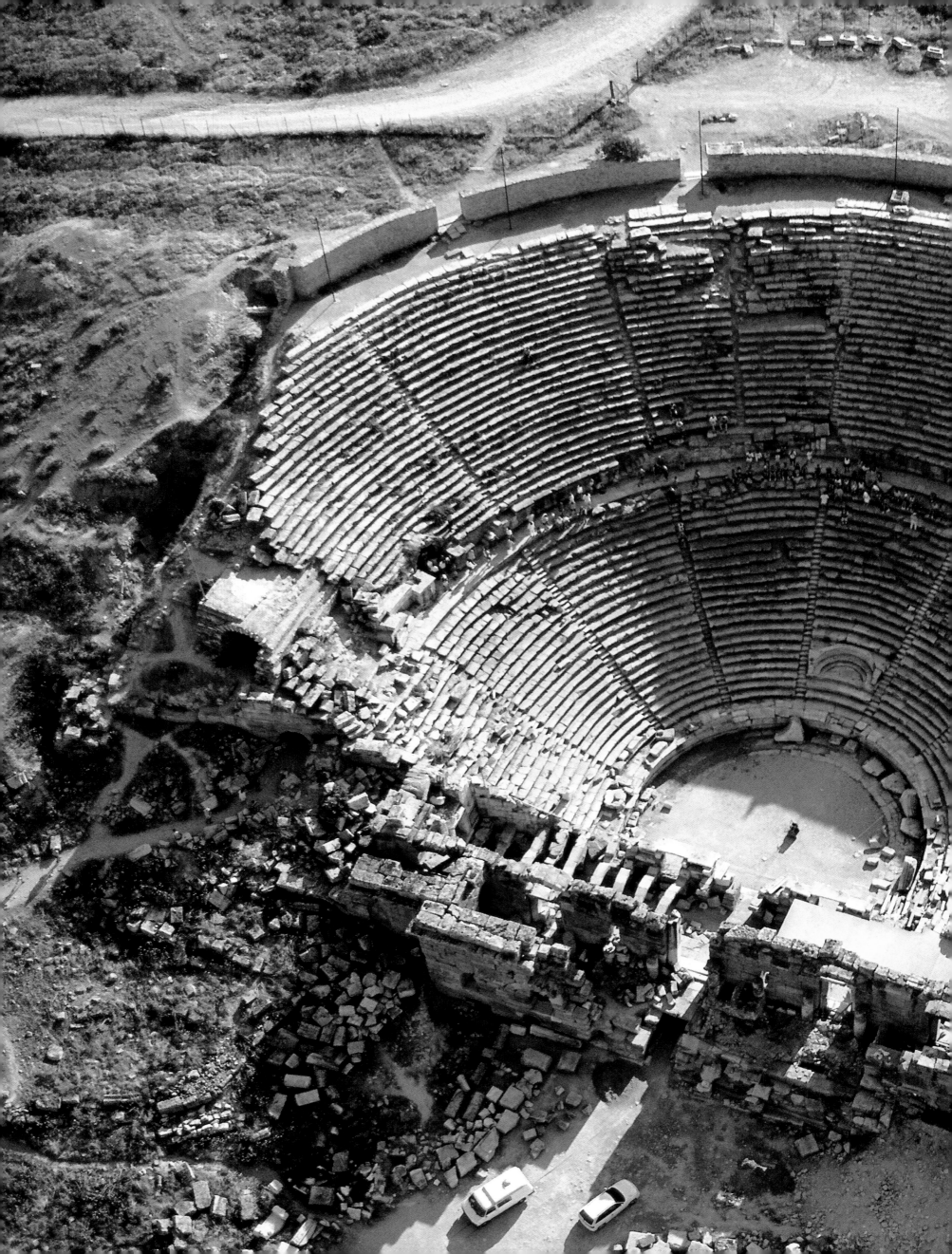

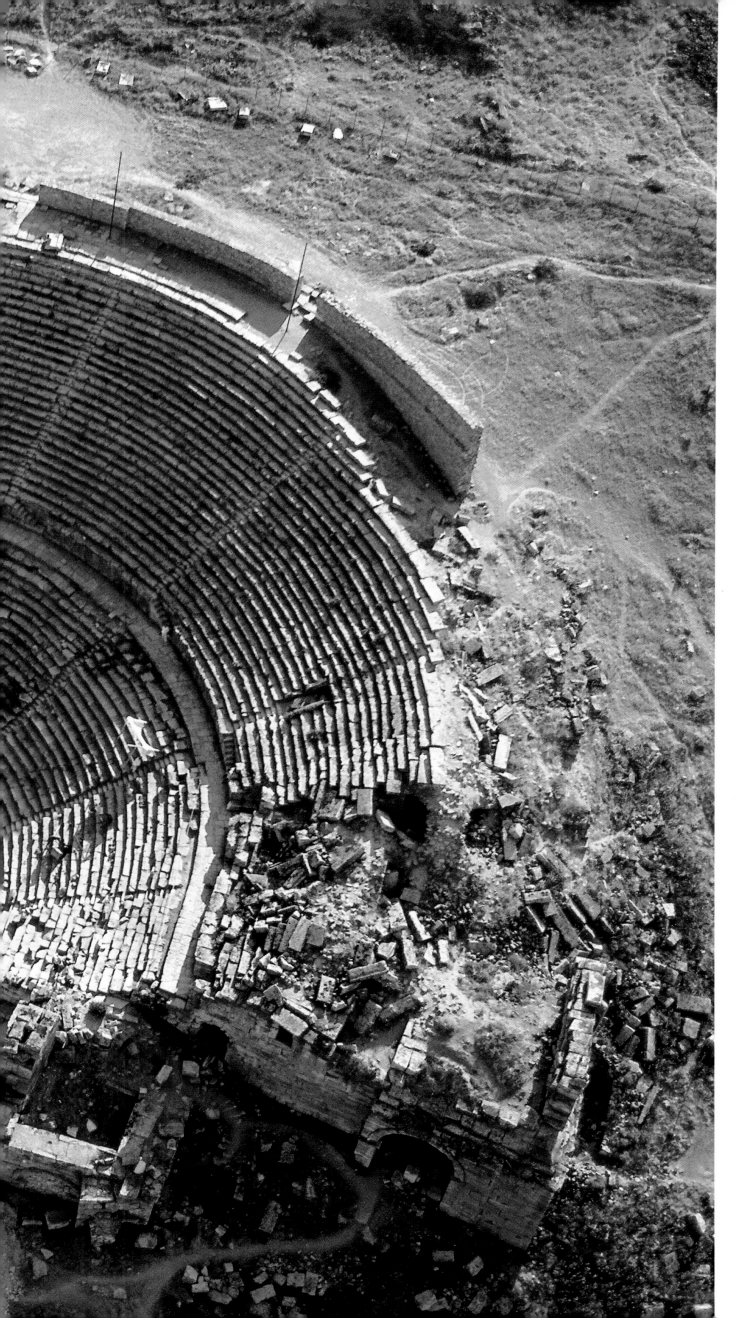

◁ **PAMUKKALE**

THEATRE OF HIERAPOLIS

The theatre of Hierapolis was built in the first century AD, in the reign of Hadrian. It is unusually well preserved, as it has undergone restoration work several times: a century after its construction, in the time of Septimius Severus, the auditorium (*cavea*) was completely rebuilt; further important work was done in the 4th century; and in modern times repairs have regularly been carried out. The structure is entirely supported by the hillside, and was built to seat 25,000 spectators. It is notable for the very richly ornamented *scenae frons*, with fluted column shafts, bas-relief friezes decorating the entablatures, as well as mythological scenes in high relief, all adding up to a monument of great sophistication. Every summer it is the setting for the Pamukkale festival.

PAMUKKALE ▷ ▷

The name Pamukkale means 'cotton castle', and its unreal whiteness certainly gives the effect of being covered with that material. Springs of hot calcareous water have trickled from one stalactite-rimmed ledge to another, creating this white natural phenomenon, which has attracted large numbers of visitors since antiquity. Hierapolis was built nearby in the 2nd century BC by Eumenes, king of Pergamum. The remains of thermal baths can still be seen, as well as the theatre restored in the reign of Septimius Severus, a temple dedicated to Apollo, which was a renowned shrine, and a vast necropolis. The later Byzantine town was equally impressive, with its cathedral built to a basilican plan, probably at the beginning of the 6th century, and a 5th-century octagonal building, which may be St Philip's martyry.

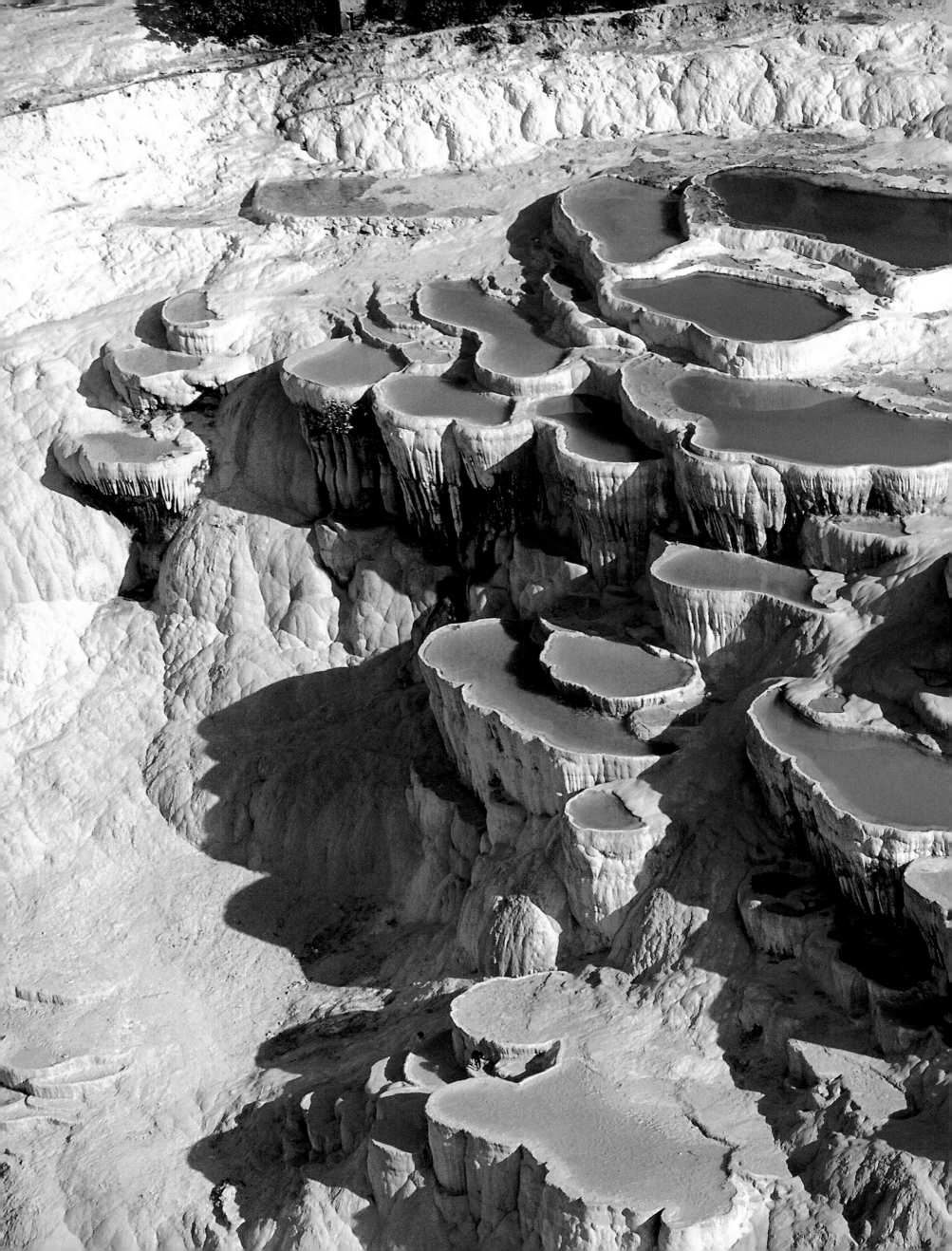

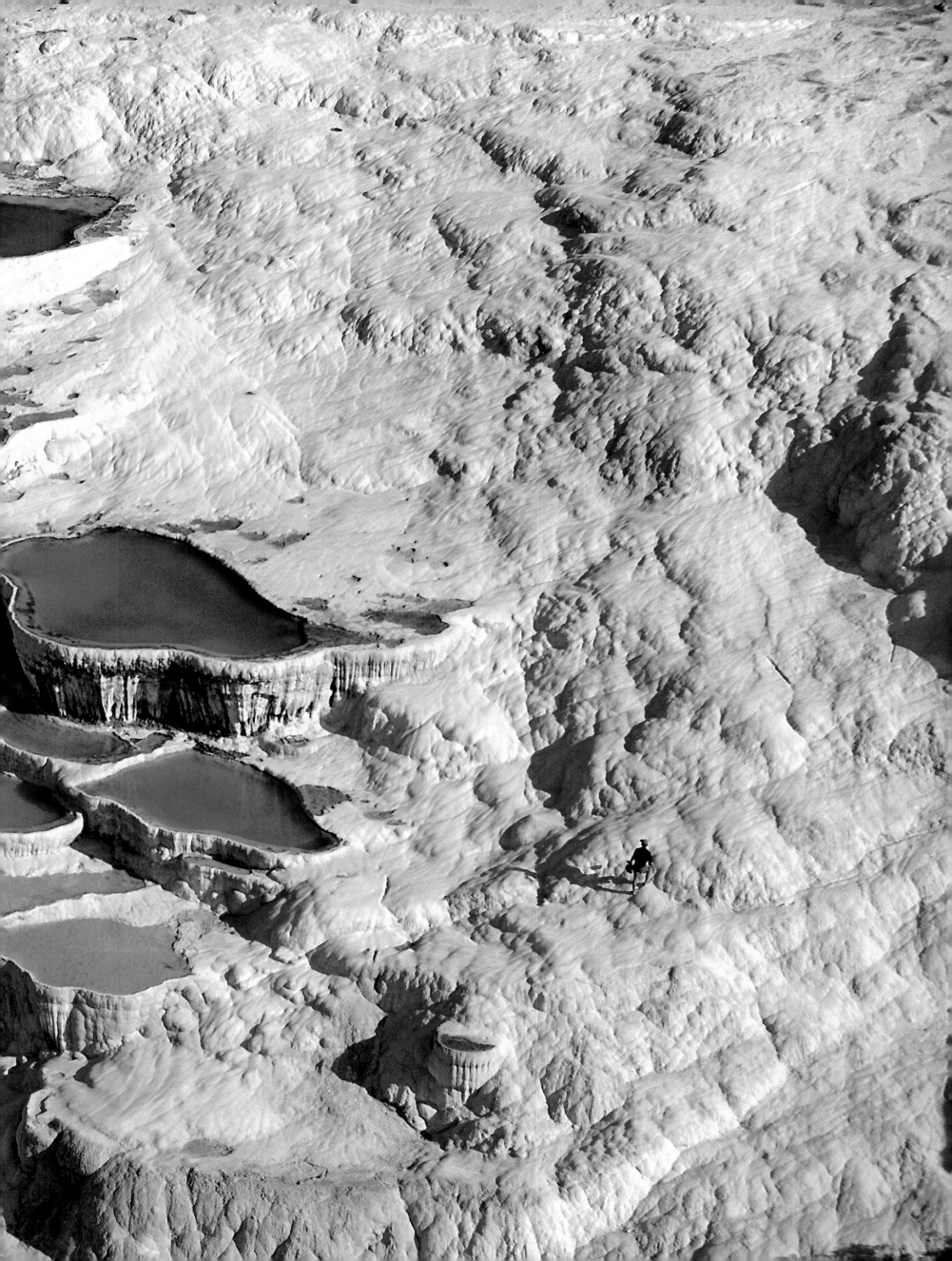

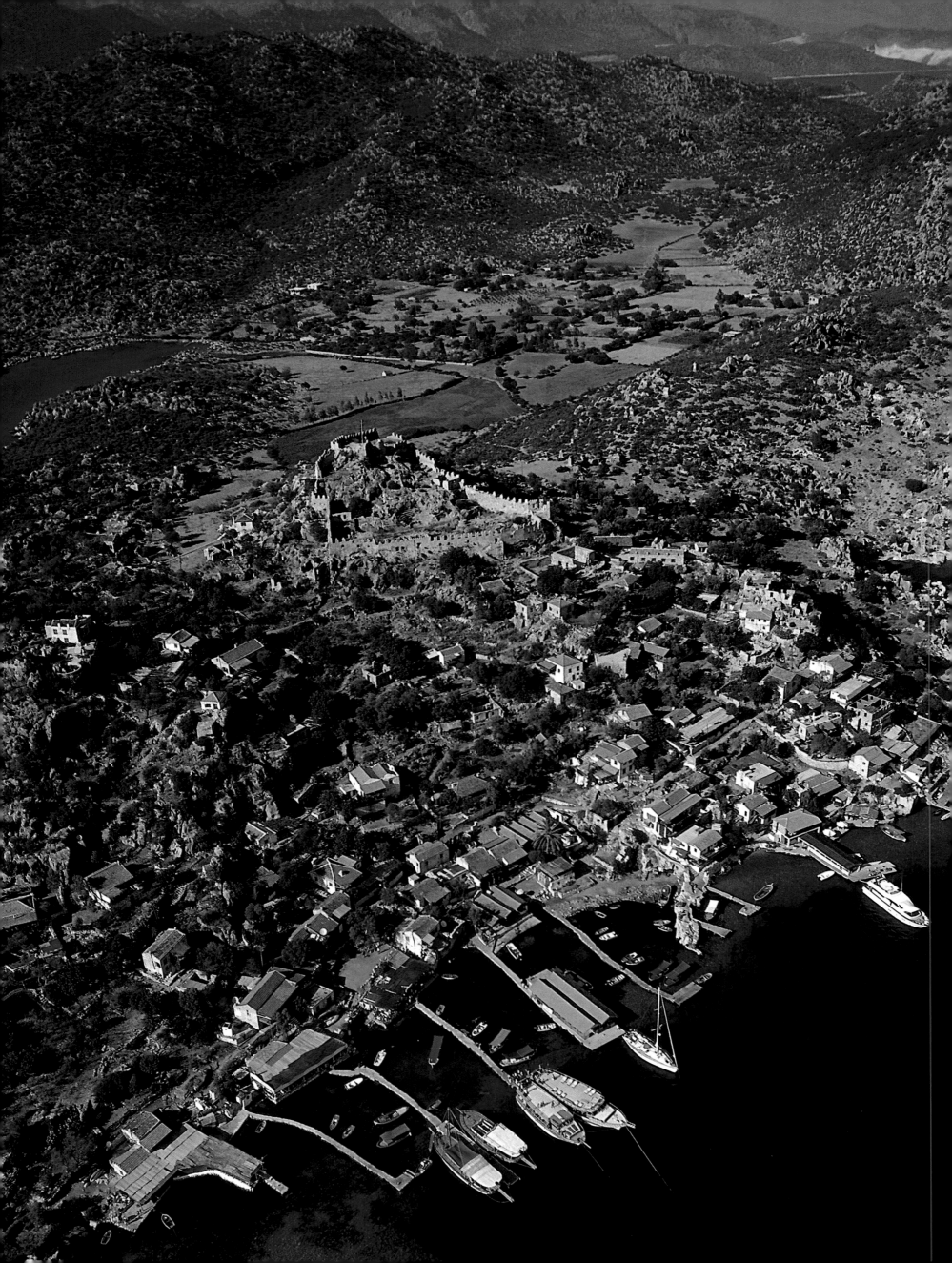

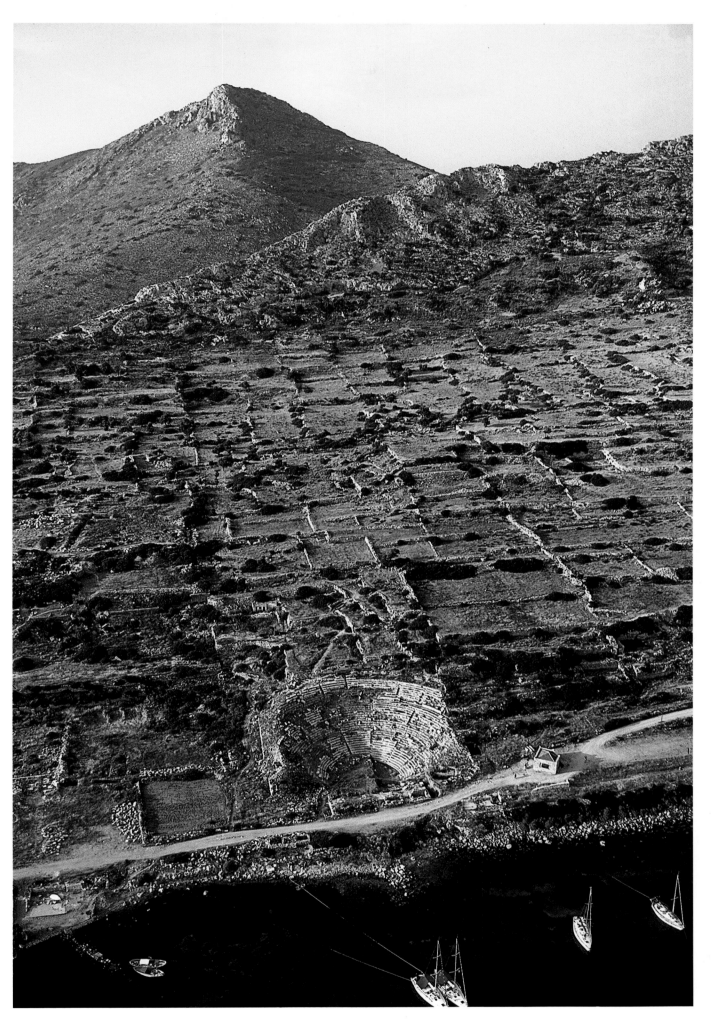

UÇAGIZ ◁

Uçagiz is situated opposite Kekova Adesi (the island of Kekova) in a picturesque setting in one of Turkey's loveliest bays. In the 8th century BC it was already settled by the Lycians, who recognized the many natural advantages of a coast with innumerable inlets and inaccessible cliffs, with sheltered moorings extensive enough for a fleet of ships. The island of Kekova and the many other islets scattering the strait ensured effective defence against any potential invasion from the sea. Nowadays, fishing and the trade in crayfish are the seaside town's most valuable assets.

DATÇA
CNIDUS ▷

Today, Cnidus is known for its wonderful position on the sea and for the remains of the ancient city, built on the orthogonal ground plan advocated by Hippodamus of Miletus. But the feature that the town was most renowned for has long since disappeared: the statue of Aphrodite sculpted by Praxiteles, showing the naked goddess about to enter her bath. It was the first statue of a naked woman produced in the Greek world, only the male gods being represented unclothed before. All the sailors putting in to port made a point of going to the temple of Aphrodite Euploia, where the statue stood, to gaze at her perfect form. Cnidus was the birthplace of the astronomer Eudoxus, who computed the length of a calendar year as 365¼ days, and of the architect Sostratus, who built the lighthouse at Alexandria.

HARVEST TIME SOUTH OF BODRUM ▷ ▷

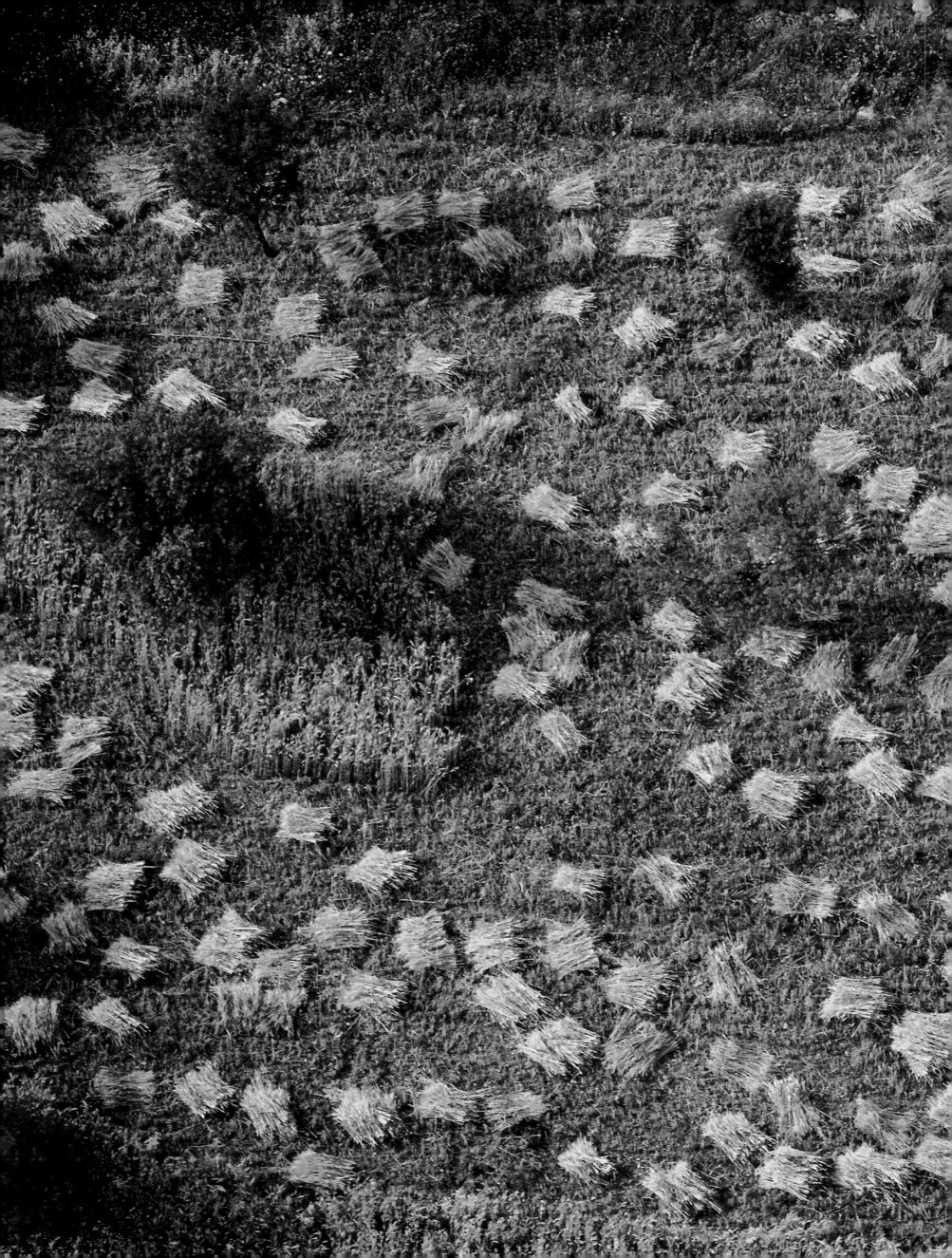

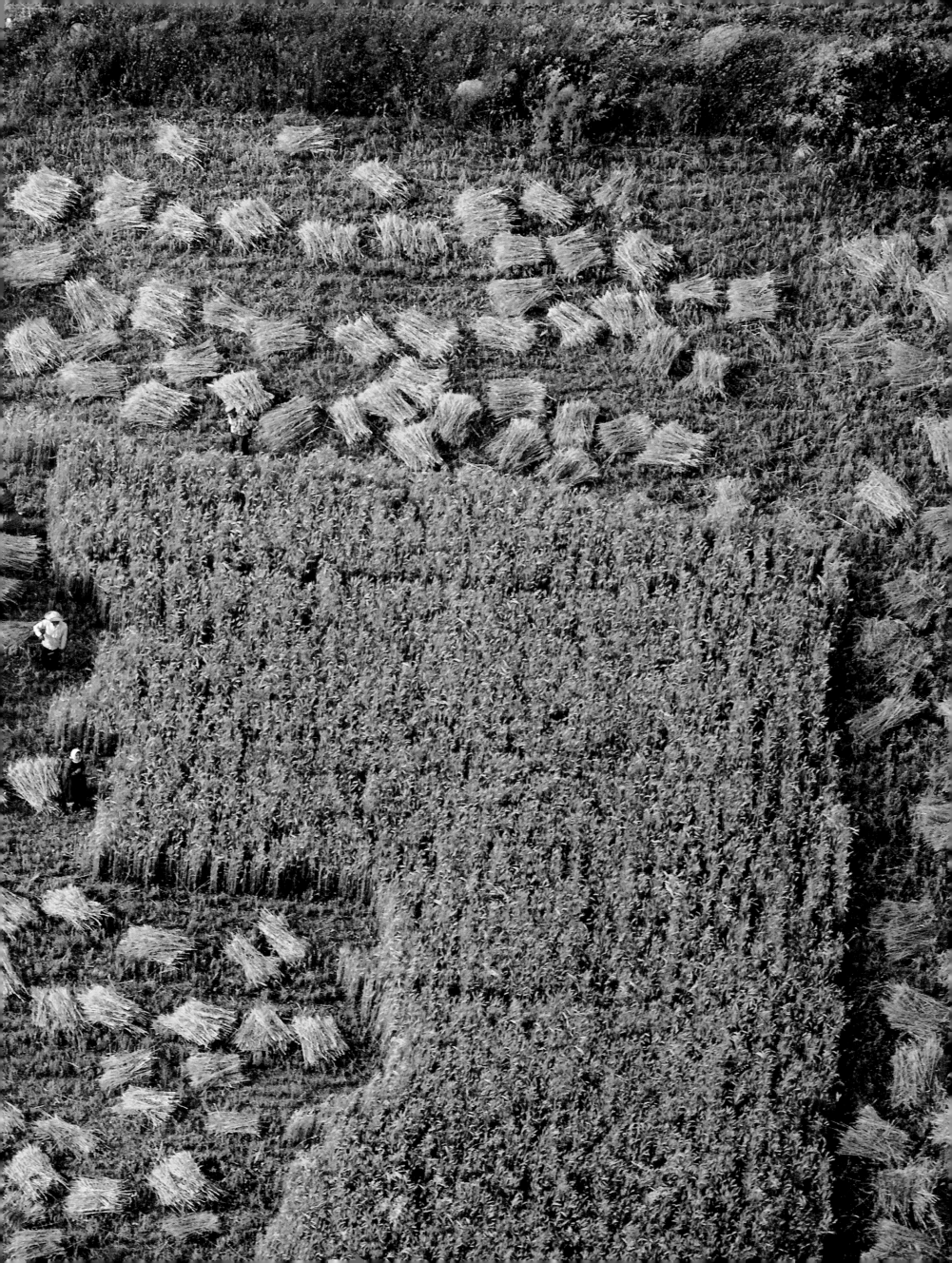

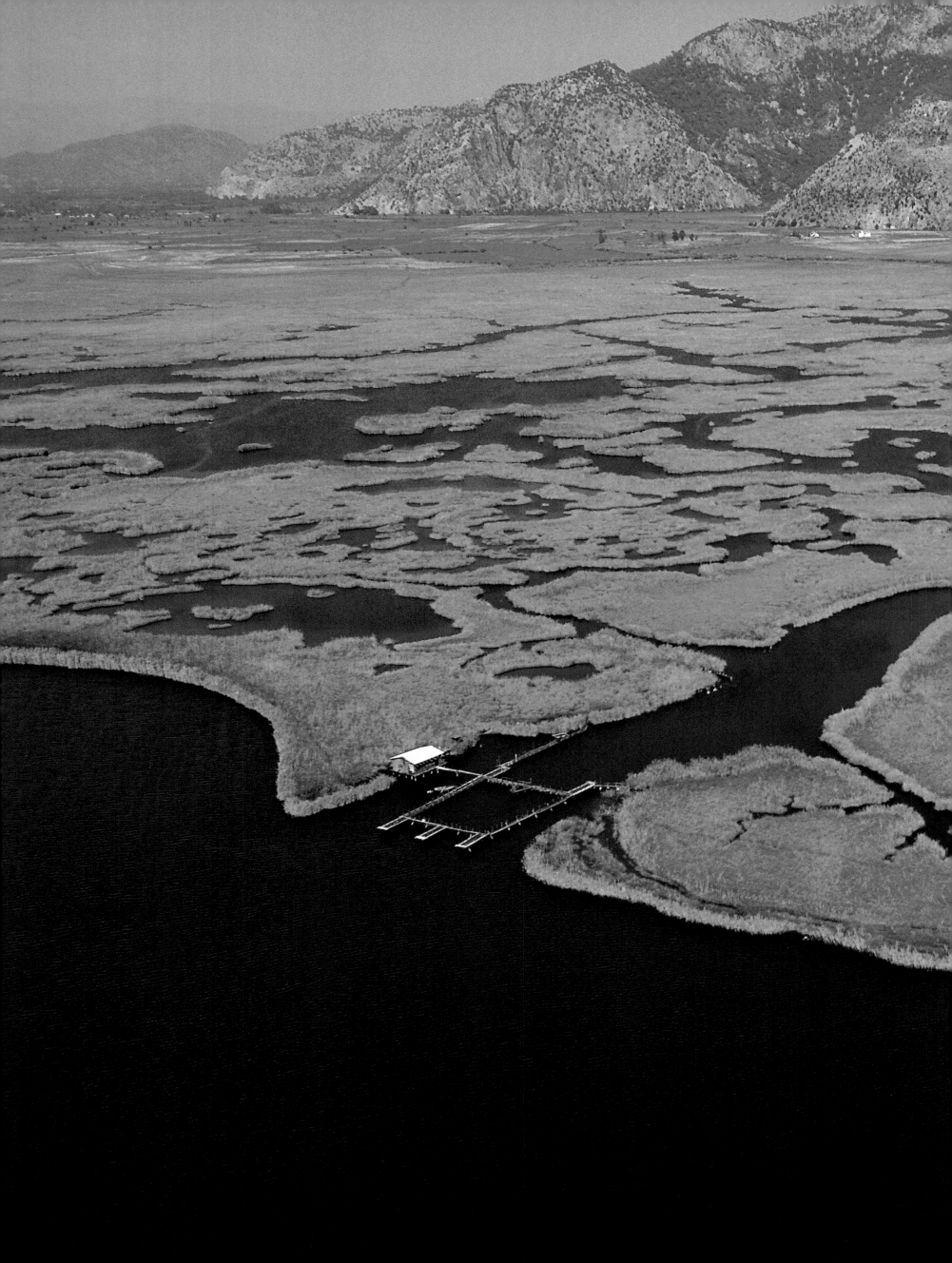

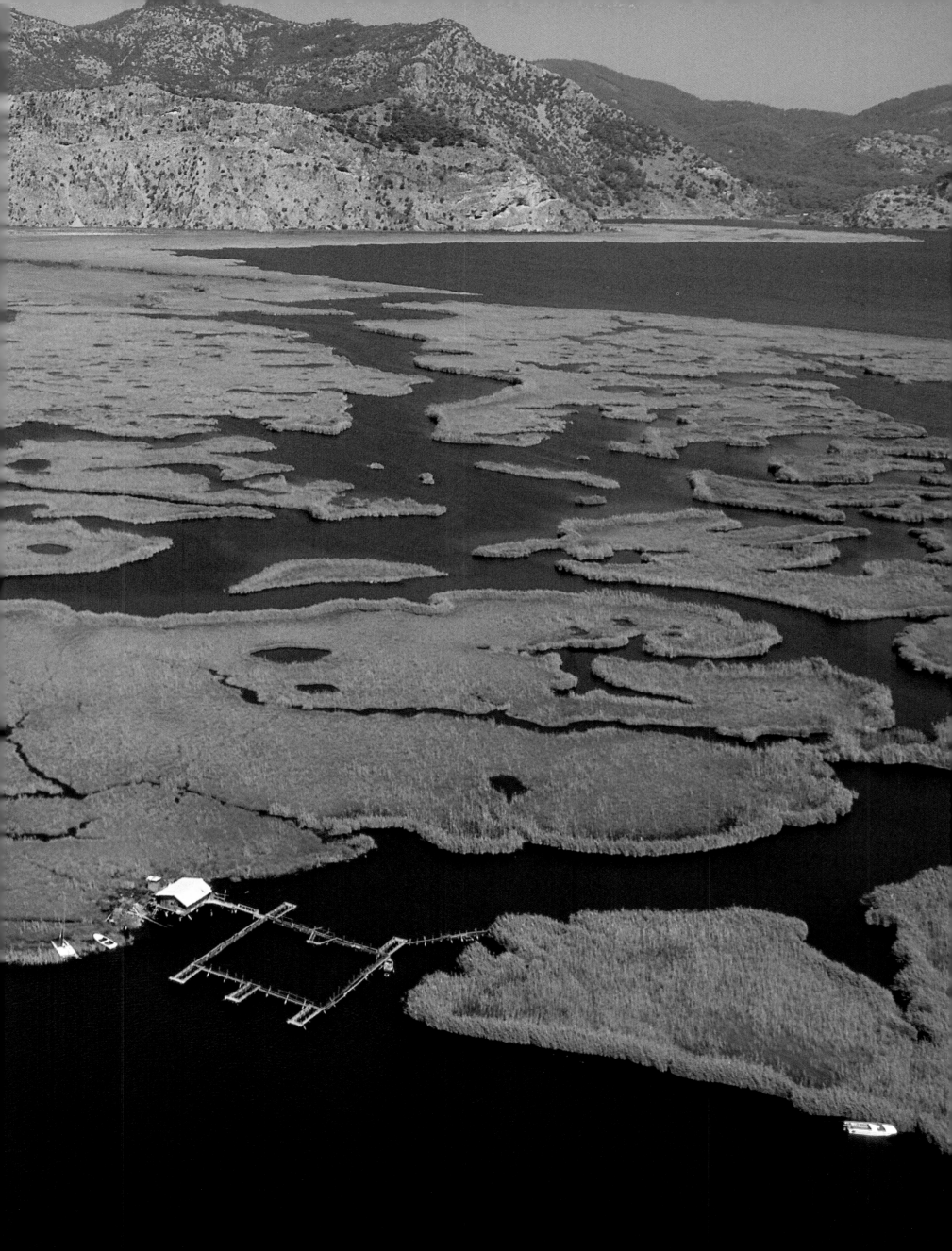

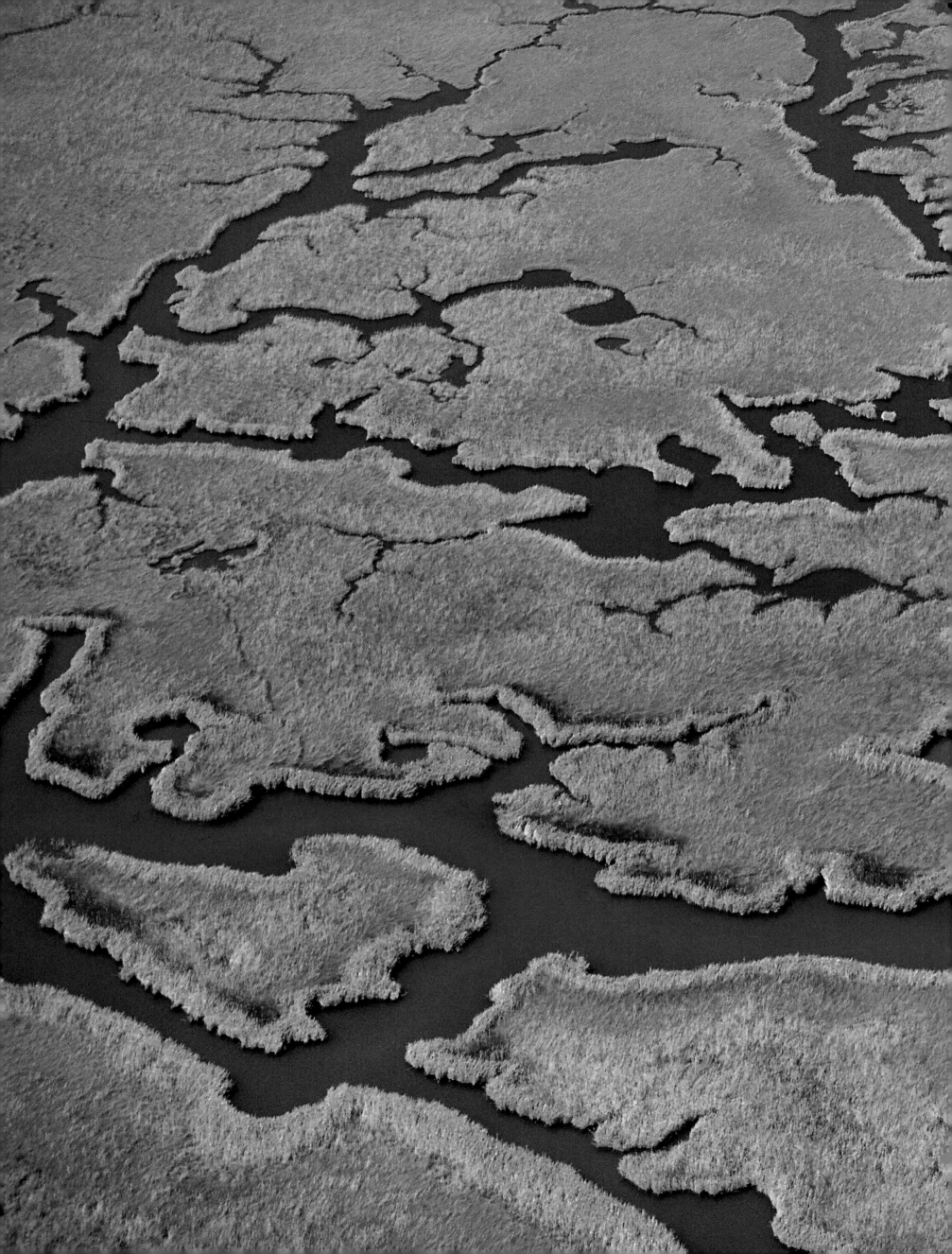

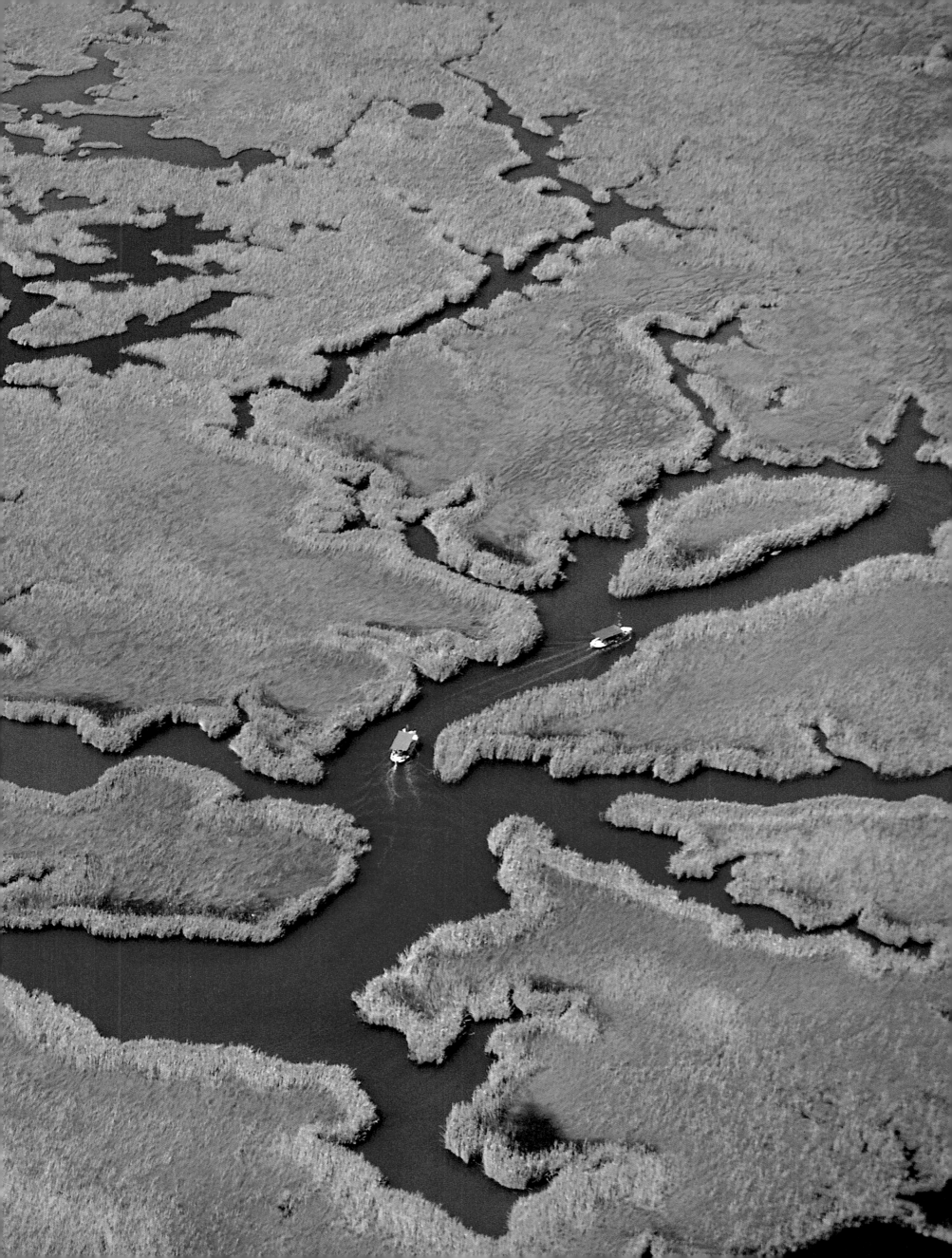

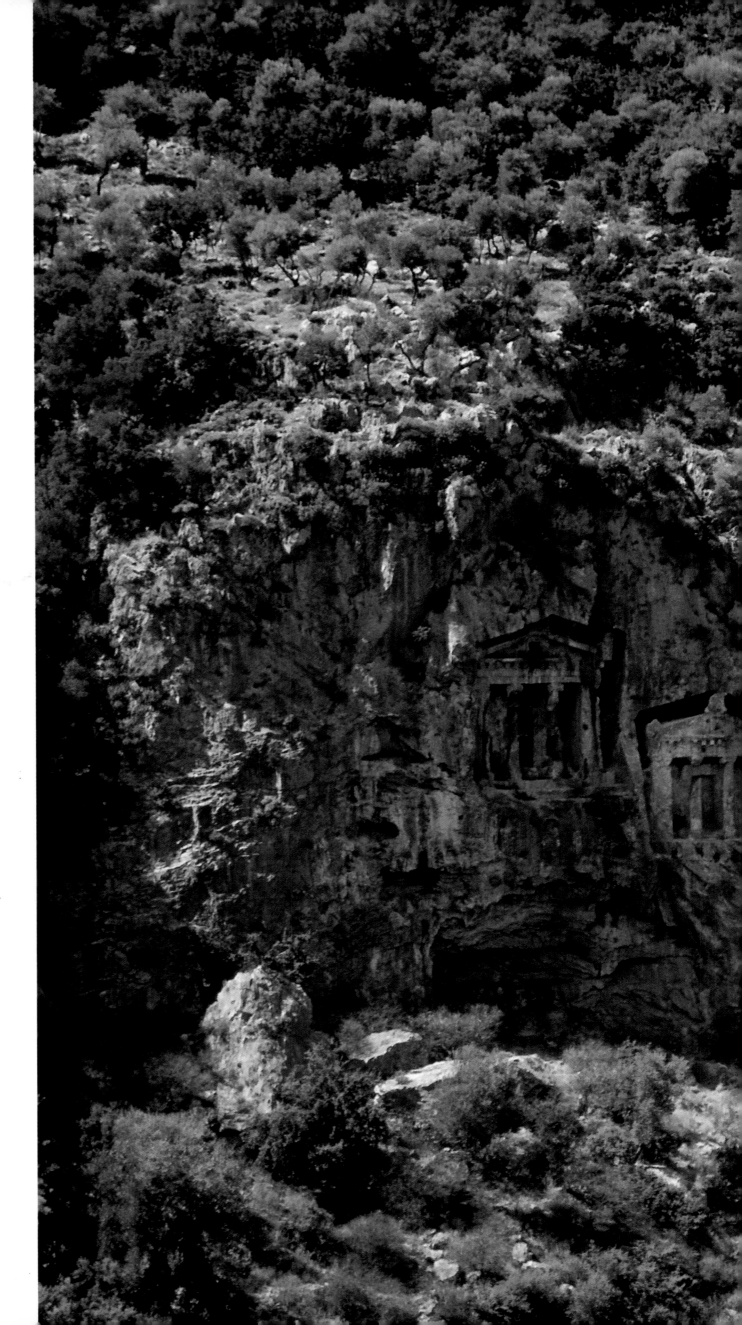

KAUNOS

MARSHLAND

Kaunos is strikingly situated beside the lake
of Köycegiz, much used by fishermen and
a favourite haunt of bird life; the lake is
dotted with little reed-covered islands and is
particularly delightful. The ancient Kaunos
is noted for the Lycian rock tombs, with their
temple façades carved out of the sheer cliffs,
which still survive after nearly twenty-five
centuries. The acropolis, ramparts, portico,
thermal baths, temples and theatre are
reminders that this was one of the most
important cities of ancient Caria, and was
at the peak of its prosperity in the Graeco-
Roman period.

KAS

TOMBS ▷

There are innumerable Lycian tombs all
around Kas – the ancient Greek Antiphellos.
Sometimes they are stone sarcophogi, like the
ones to be found in the city itself, particularly
near the port, or they are part of a rock-face
necropolis, like these to the northeast of the
village, carved out of the cliff not far from the
ancient theatre dating from the Hellenistic
period. Many of these Lycian tombs have
façades in the form of Greek temples, faithfully
imitating their tiles and acroteria. They were
the burial places of the humbler people, while
the more powerful were likely to have the
privilege of being buried in an individual
sarcophogus. The little we know about the
Lycian civilization is largely limited to its
funerary art. Although their dead were buried
in stone, the living had houses made of wood
and earth, which have long since disappeared.
As long ago as the 5th century BC, Herodotus
declared: 'The Lycians lived in wood and died
in stone.'

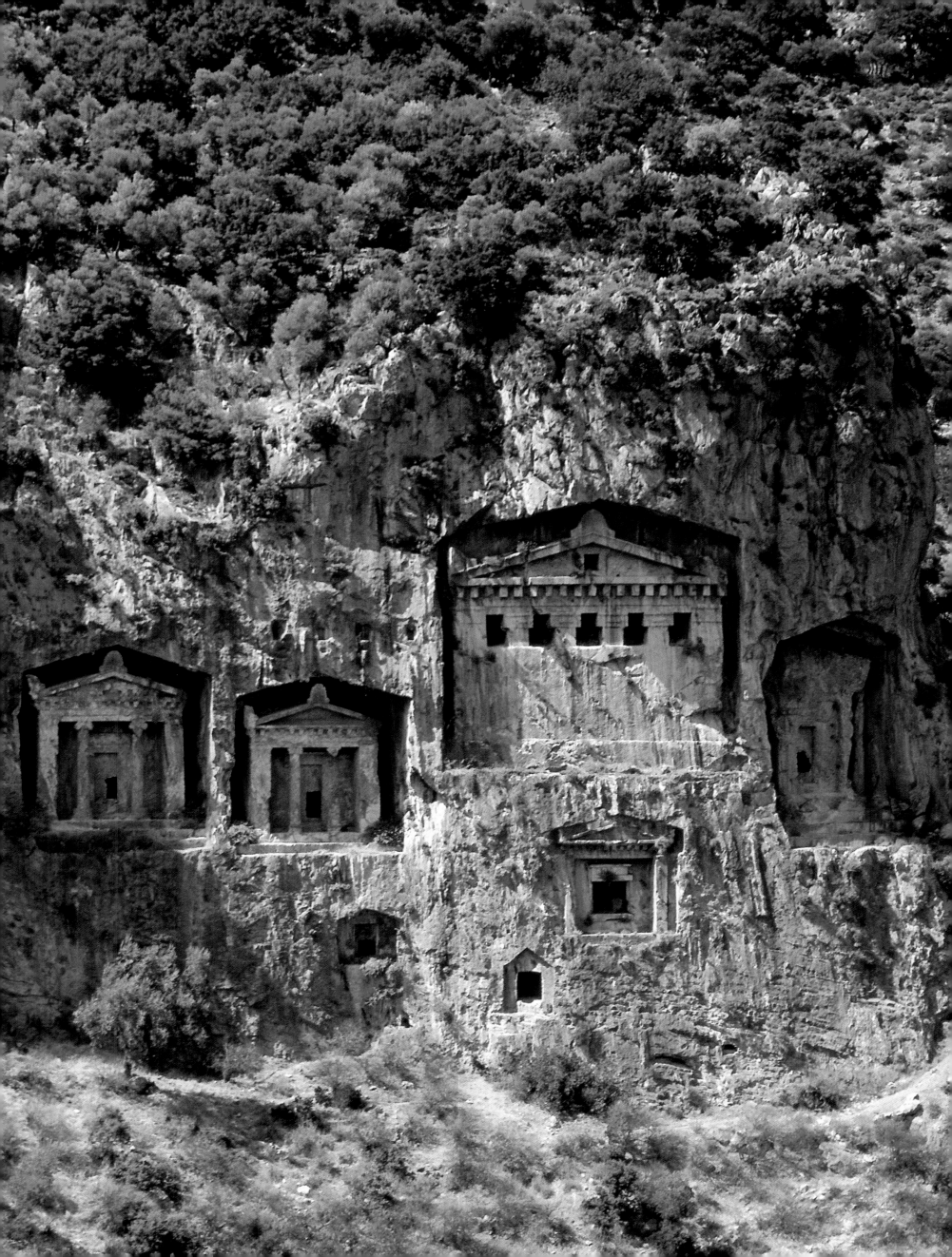

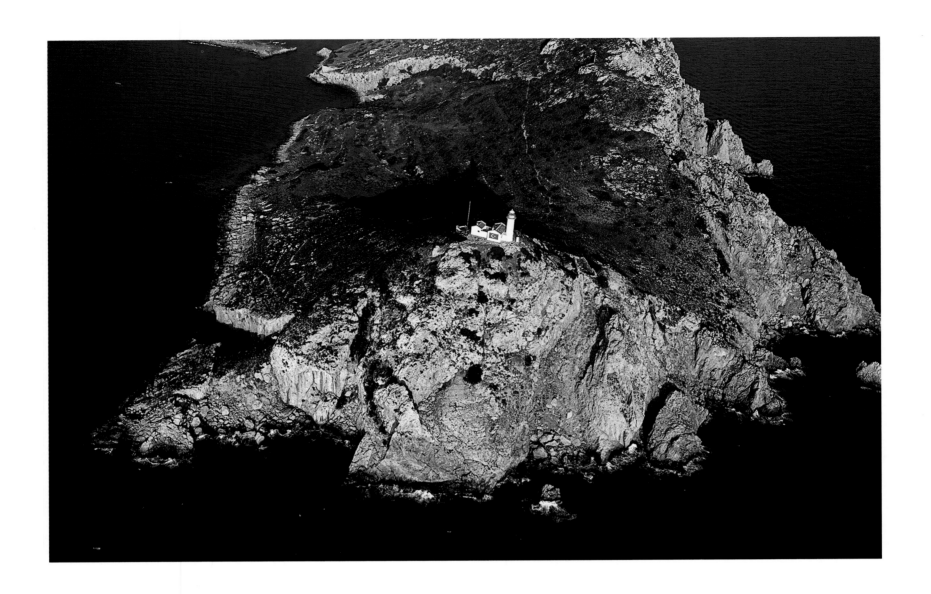

THE COAST FROM DIDYMA
TO FINIKE

The Aegean coast, like the Mediterranean one, has a ragged appearance, with alternating bays and rocky forelands, the shores scattered with reefs and the cliffs riddled with caves. The long peninsulas and innumerable islands and islets of the Aegean give way to a less wild Mediterranean coastline, though still deeply indented almost as far as the outskirts of Antalya. The favourable climate and the areas of marshland – source of molluscs and small amphibians to feed on – attract white storks, which nest and breed there.

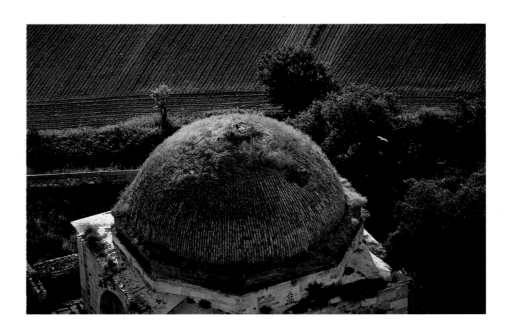

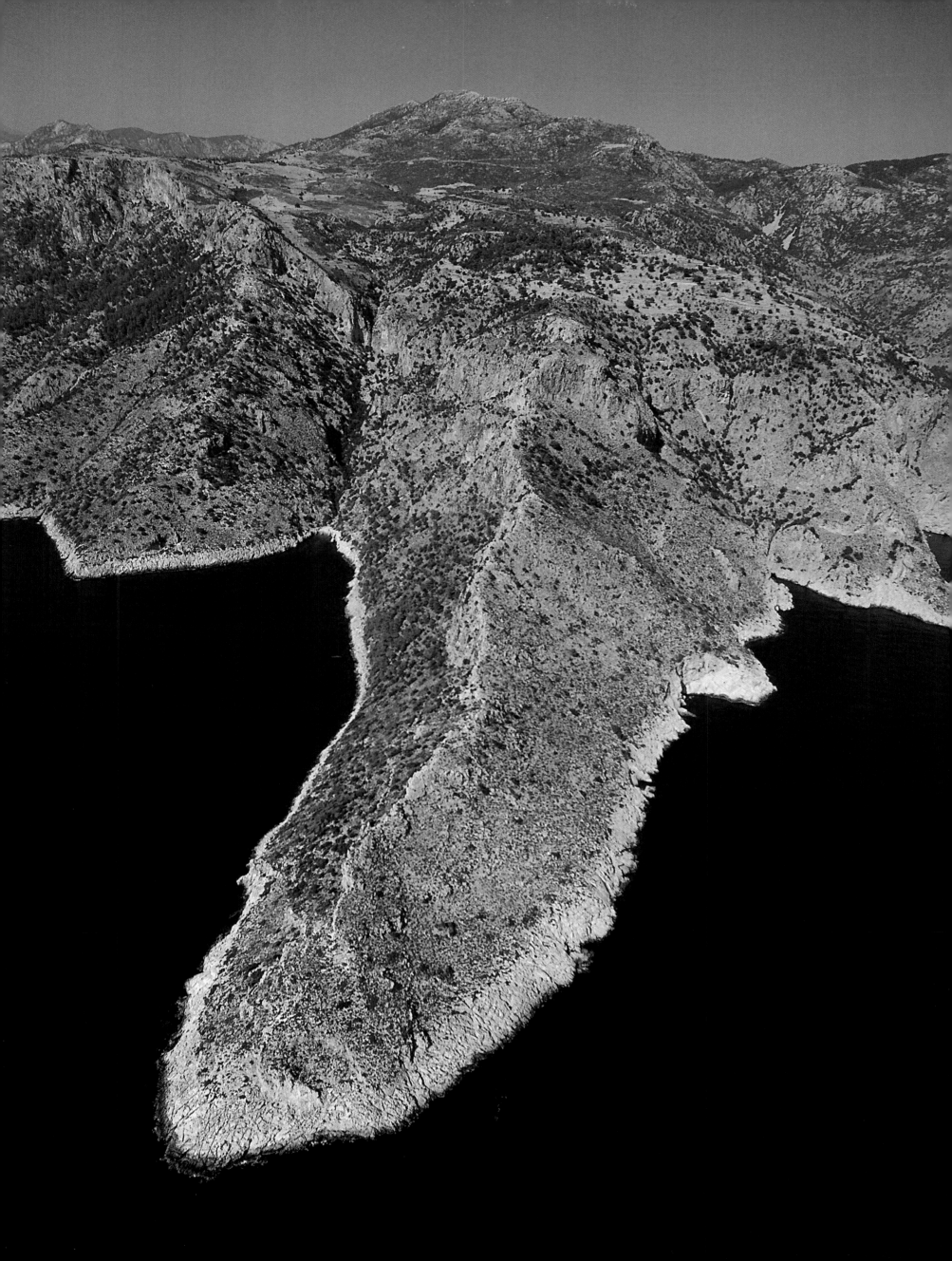

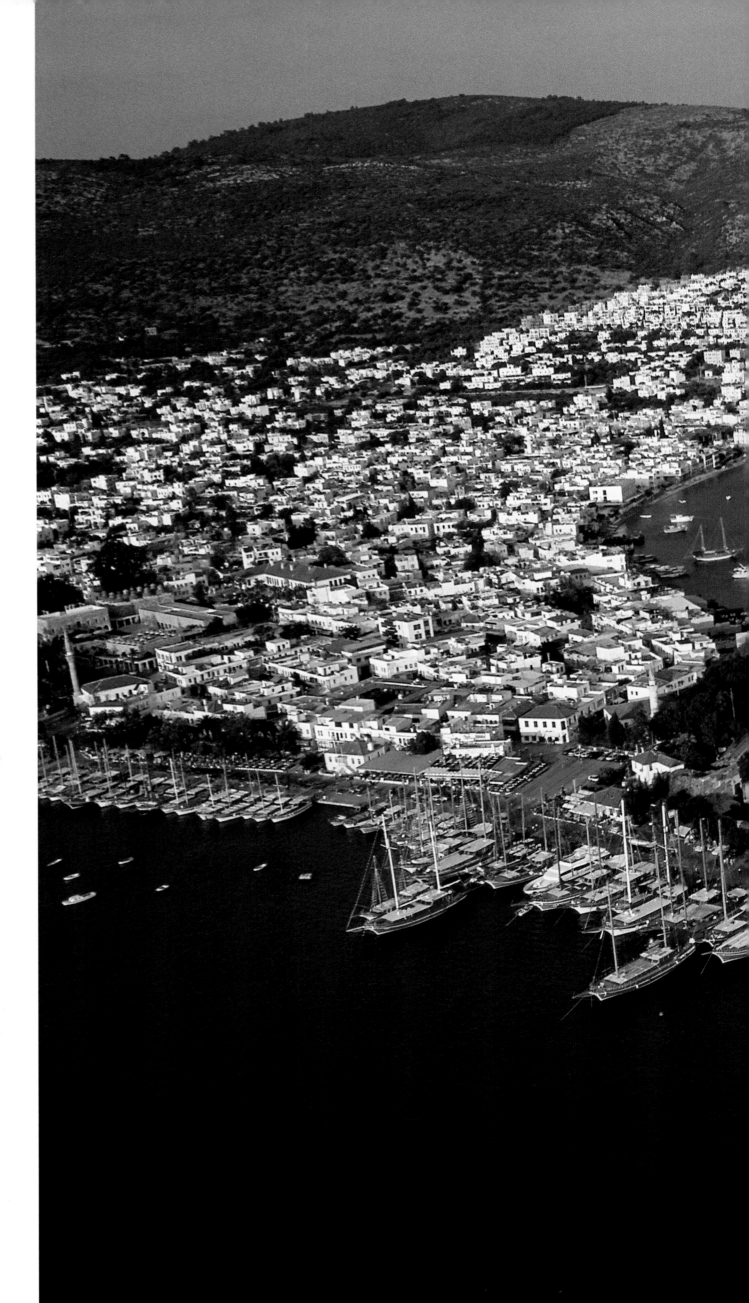

BODRUM
ST PETER'S CASTLE

Bodrum was famous in antiquity as Halicarnassus. The city was the site of one of the Seven Wonders of the World, the tomb built for the satrap Mausolus by his widow and sister, Artemisia. It was on such an exceptional scale that his name became commonly used to describe a monumental tomb, or 'mausoleum'. Unfortunately, little is left of this masterpiece of Ionian architecture. It was built in the middle of the 4th century BC by the architect Pythius (who also built the temple of Athena at Priene) and decorated by the greatest sculptors of the day; but nine centuries later it was used as a quarry to build St Peter's Castle, which has ever since towered over the town and its port. The Knights Hospitallers of St John of Jerusalem began to build this mighty fortress in 1402; they chose the site because it was not far from the island of Rhodes, where they had been installed since 1309. When they left Rhodes on 1 January 1523, after it had been seized by Suleiman the Magnificent, they also abandoned the castle at Bodrum; they finally settled in Malta in 1530, from then on becoming known as the Knights of Malta. Today, St Peter's Castle houses one of the most important museums of marine archaeology in the world.

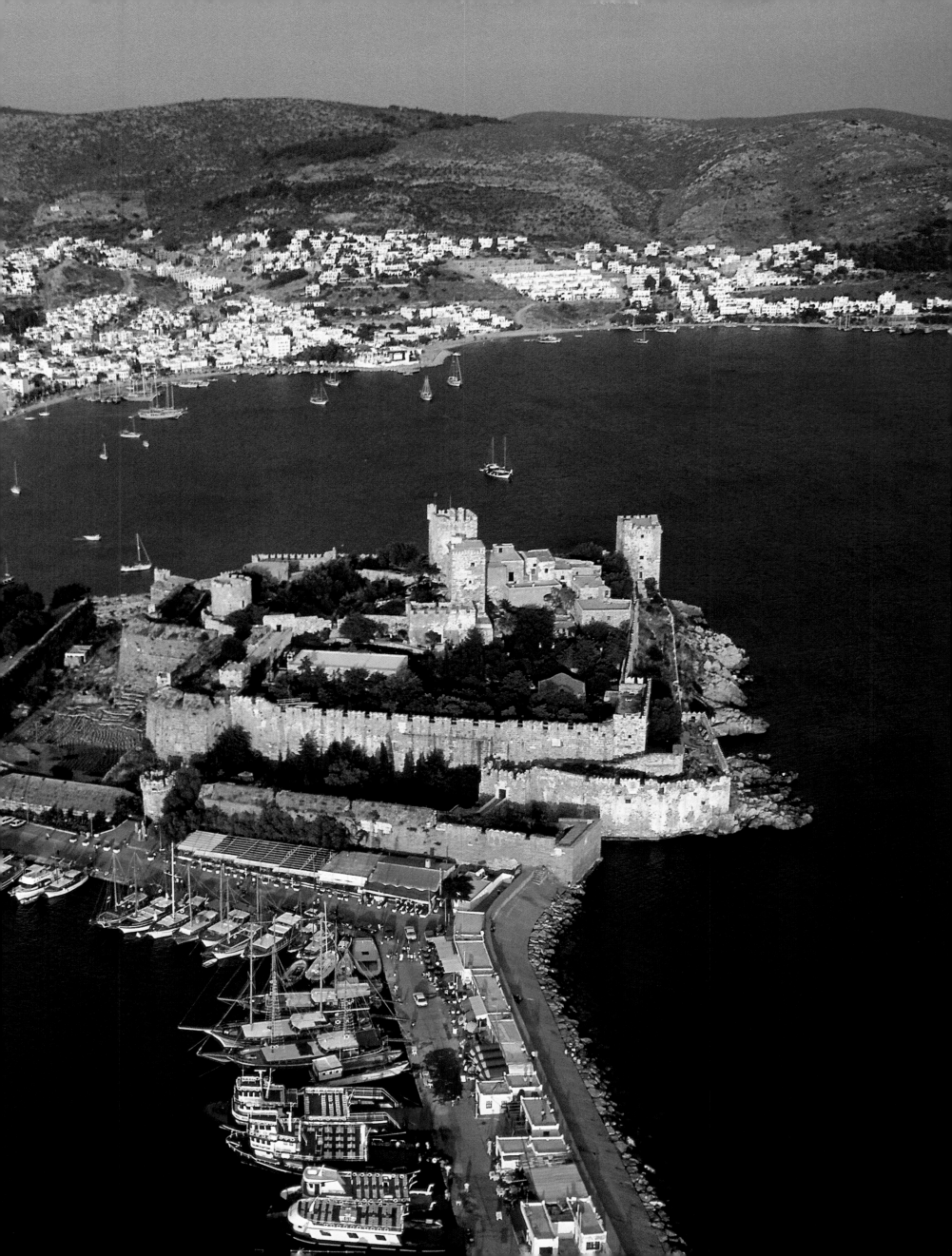

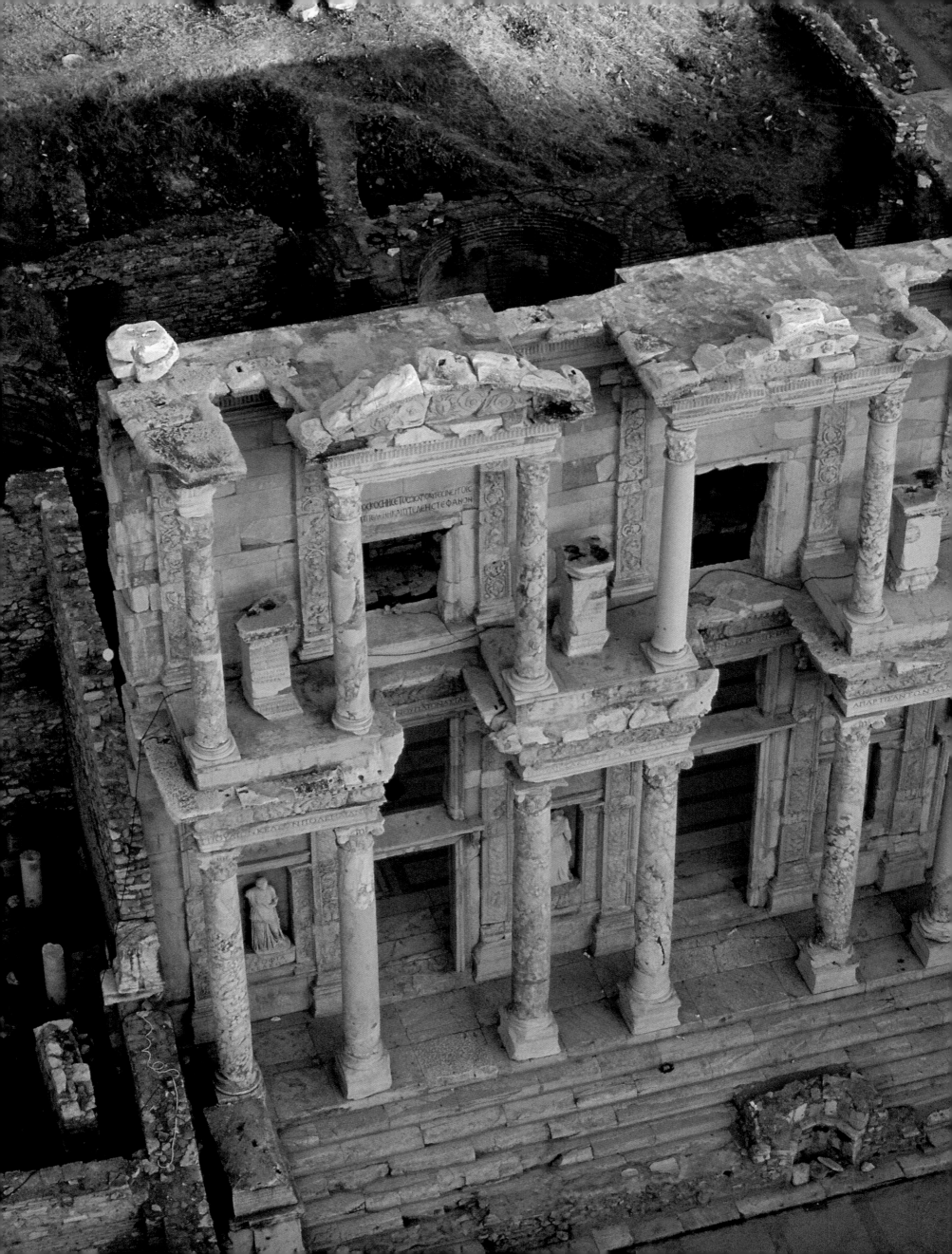

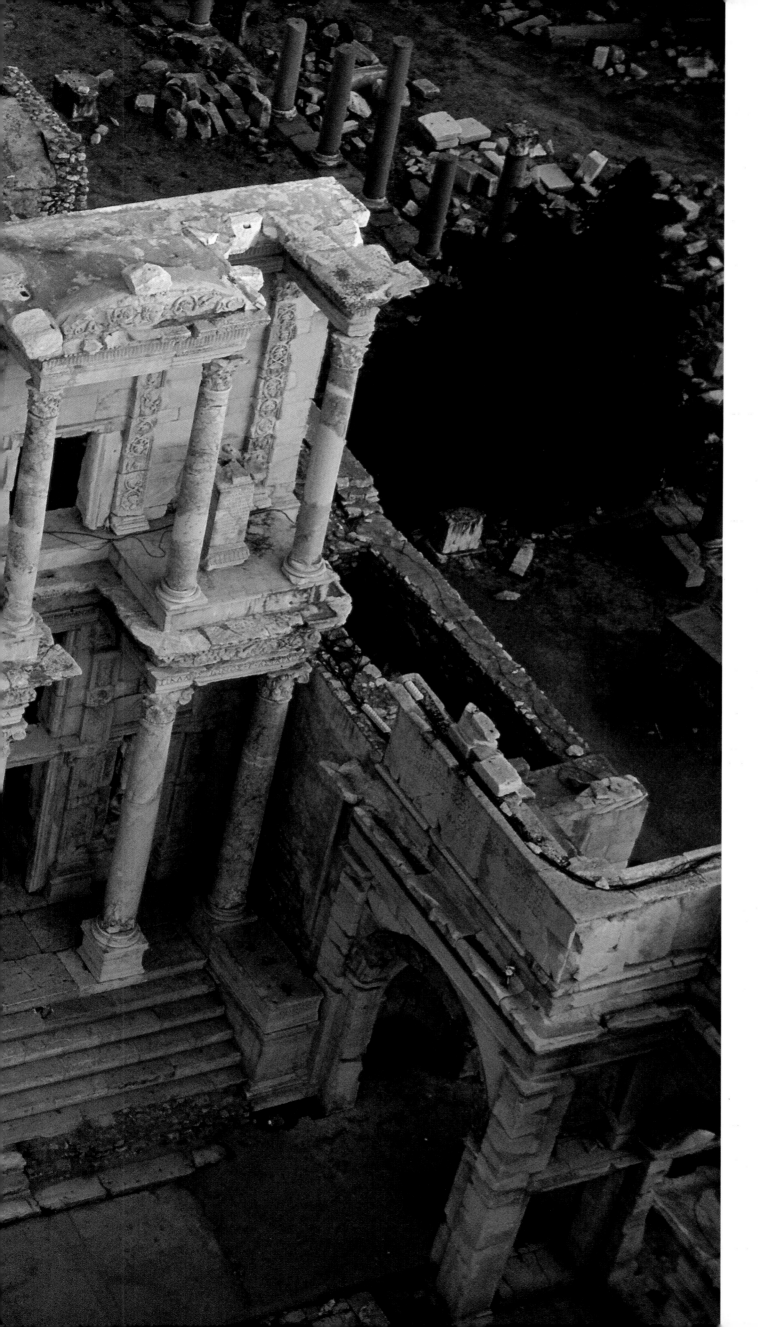

EFES (EPHESUS)
LIBRARY OF CELSUS

One of the principal thoroughfares of the ancient city, the Marble Avenue, leads up to this architectural jewel, the most striking of the remains at Ephesus. It was built between AD 110 and 135 by Julius Aquila, who dedicated it to the memory of his father, Celsus Polemaenus of Sardis, a Roman senator and proconsul of Asia; he is buried here in a white marble sarcophagus. The imposing two-storey façade, nearly sixteen metres (fifty-two feet) high, has been reconstructed using the fallen stones. The four statues standing in the niches are copies of the originals, which are now in the Kunsthistorisches Museum in Vienna. The library was the third most important in the ancient world after those at Alexandria and Pergamum. It housed twelve thousand scrolls, which were burned in AD 263 when the Goths invaded Ephesus.

To the right, the gate of Mazeus and Mithridates leads to the agora, the city's central market, which is enclosed by a double arcade which used to house a large number of booths.

129

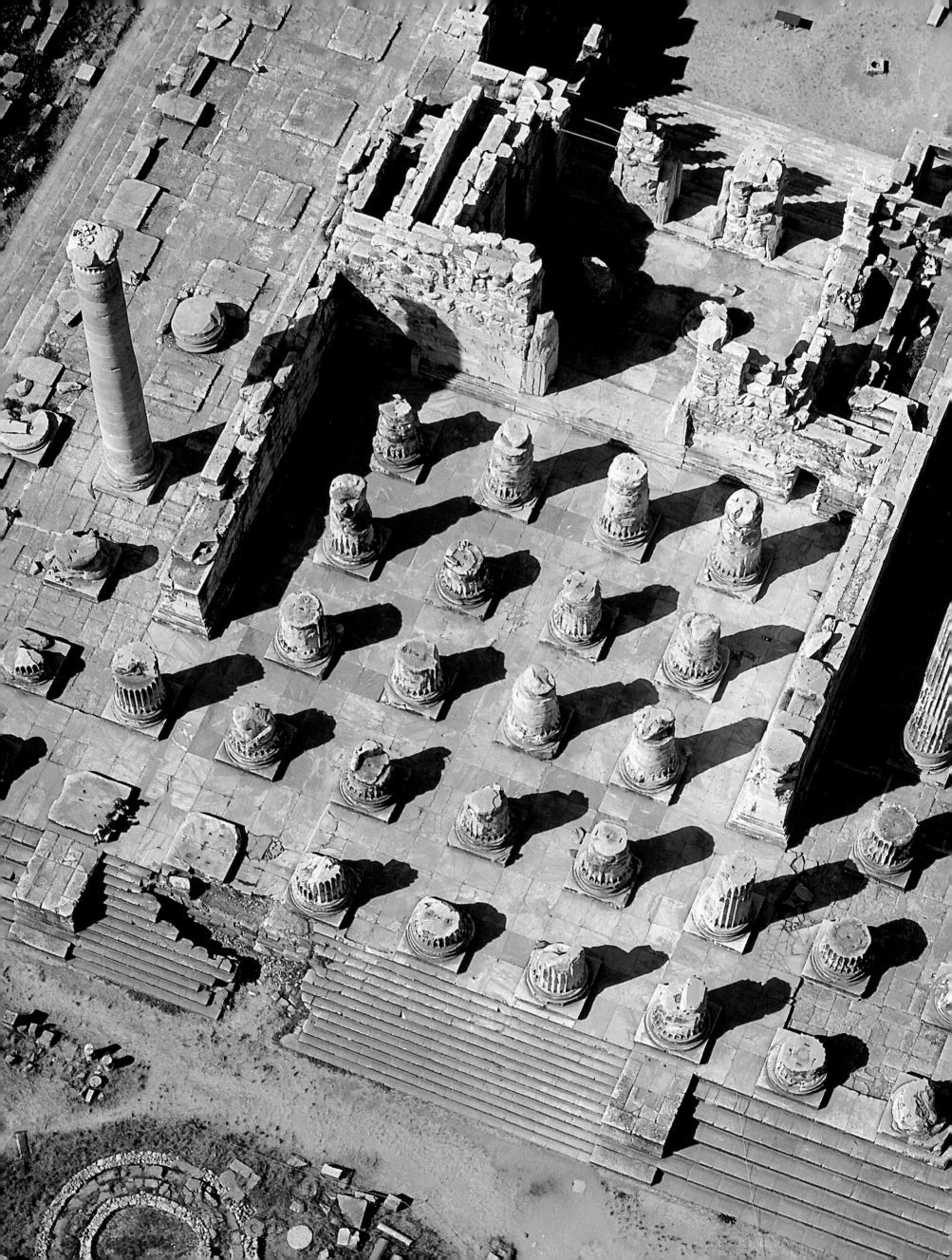

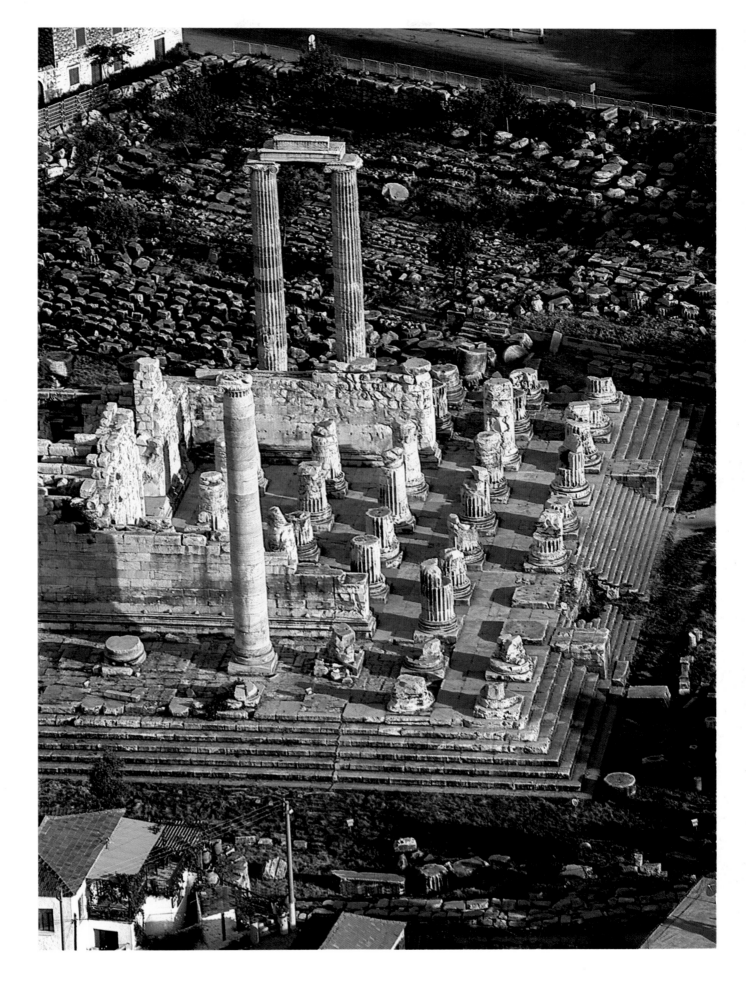

◁ **DIDYMA**

TEMPLE OF APOLLO ▷ ▷

Didyma never developed into a city, although
its shrine was famous throughout the Greek
world, particularly among the Aegeans.
Pilgrims gathered there in large numbers
to consult the oracle, which was almost as
renowned as the one at Delphi. Here victory
over the Persians was predicted for Alexander
the Great, and here, two hundred years earlier,
the king of Lydia, Croesus, learned that a great
empire would be destroyed if he attacked Persia
– although the oracle carefully avoided telling
him that this great empire would be his own.

This dipteral, or double-colonnaded, Ionic
temple is dedicated to Apollo, and was rebuilt
on the orders of Alexander himself. On his
arrival, the sacred spring, which had long
before dried up, began to flow again. This
was one of the most impressive shrines in the
Hellenistic world, even though it was never
quite completed during five hundred years of
intermittent building work, lasting until the
arrival of Christianity.

131

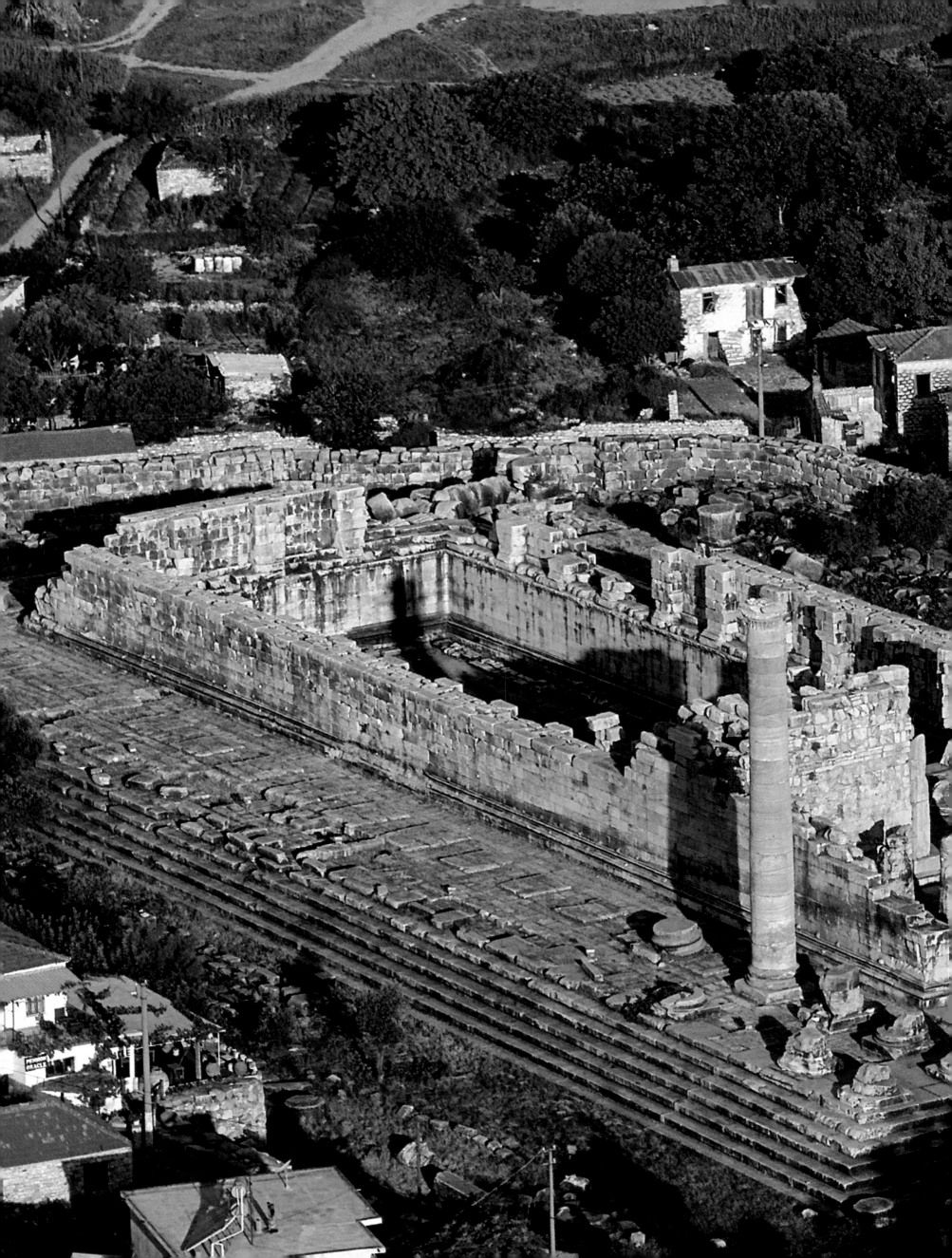

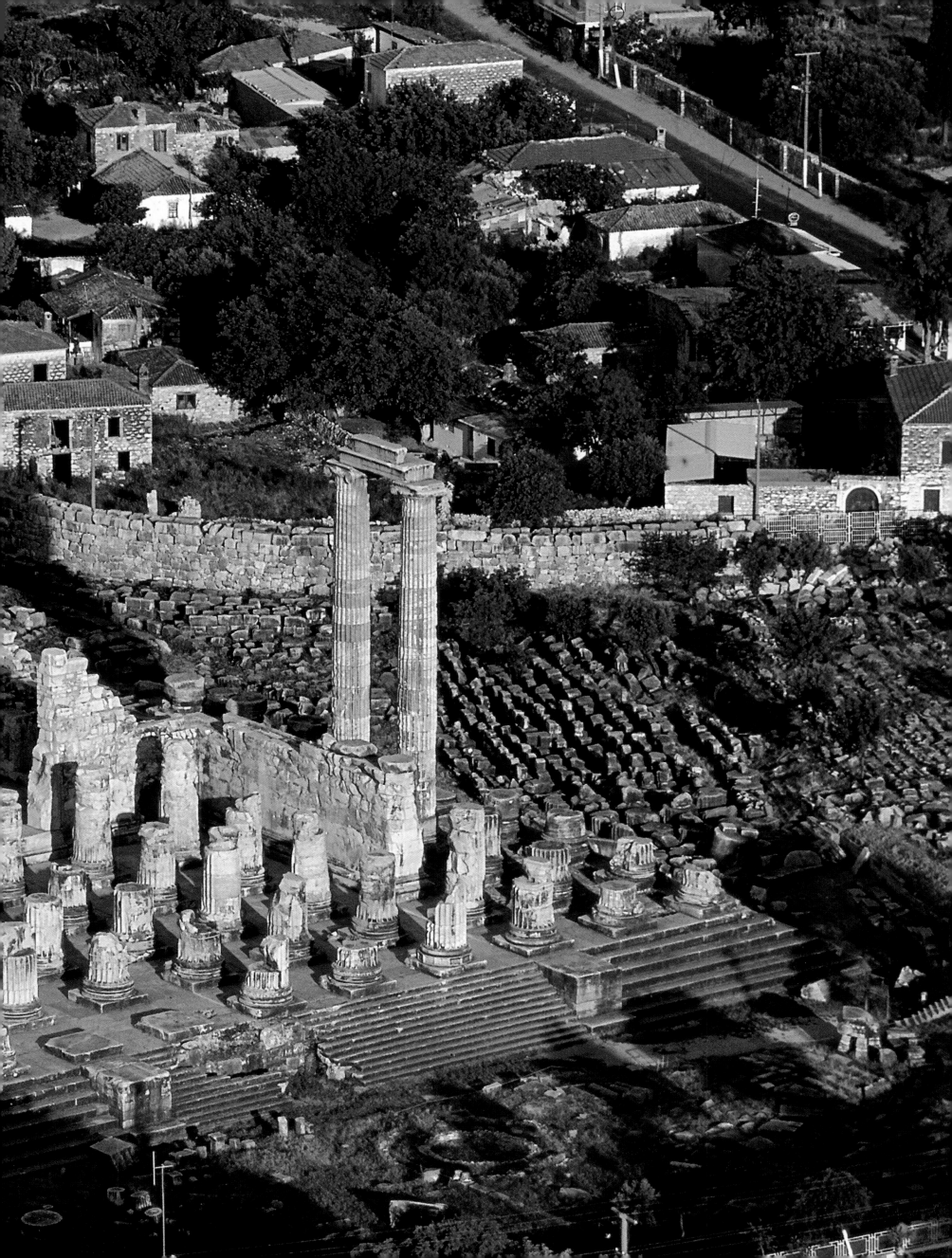

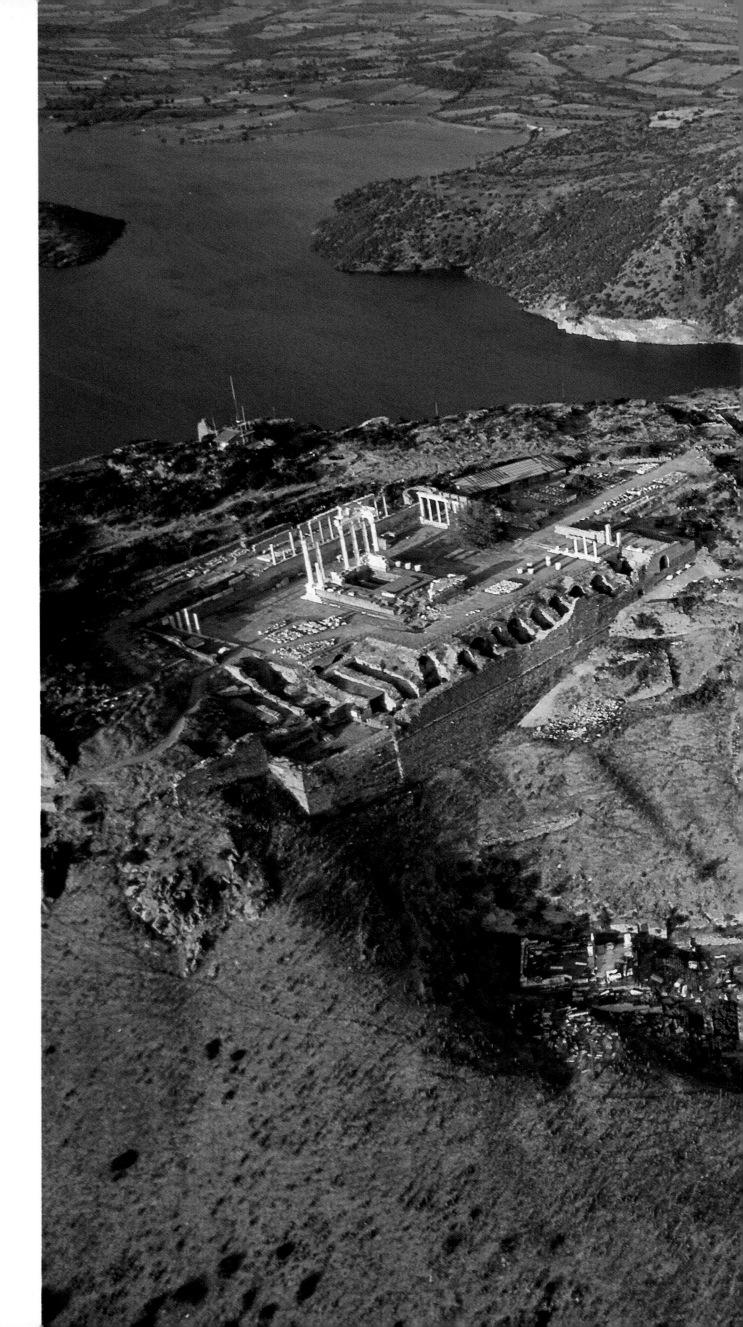

BERGAMA (PERGAMUM)
ARCHAEOLOGICAL SITE ▷

Sited on an almost impregnable rocky cliff, Pergamum was one of the most important cities of the Hellenistic period, the equal of Alexandria, Antioch and Ephesus. The library contained 200,000 volumes collected by Eumenes II and was the finest in the ancient world after that at Alexandria. In the first century BC, Antony gave it to Cleopatra as a wedding present, and it was transferred to the Egyptian capital: the rival collections were later destroyed there together by fire. Parchment was invented at Pergamum in the 2nd century BC – the name comes from the Greek word *pergamene* meaning 'skin from Pergamum' – because Alexandria blocked the export of papyrus in retaliation for the growing importance of the rival city. In this way, books began to replace scrolls.

BERGAMA (PERGAMUM)
ASKLEPIEION ▷ ▷

Pergamum was also famous in antiquity for the Asklepieion, or sanctuary of Asclepius, which was a centre for a variety of therapies, such as hydrotherapy, heliotherapy and even psychotherapy – dreams were interpreted here twenty centuries before Freud. Mud baths and fumigations, as well as dietary regimes for the sick, were all in general use. Patients were greeted by a warning inscription, declaring: 'In the name of the Gods, death is forbidden to enter.' The Roman emperors Hadrian, Marcus Aurelius and Caracalla all came here to take the waters. In the 2nd century AD, the greatest of Greek doctors, Galen, practised here; his work had a profound influence on European medicine until the 16th century.

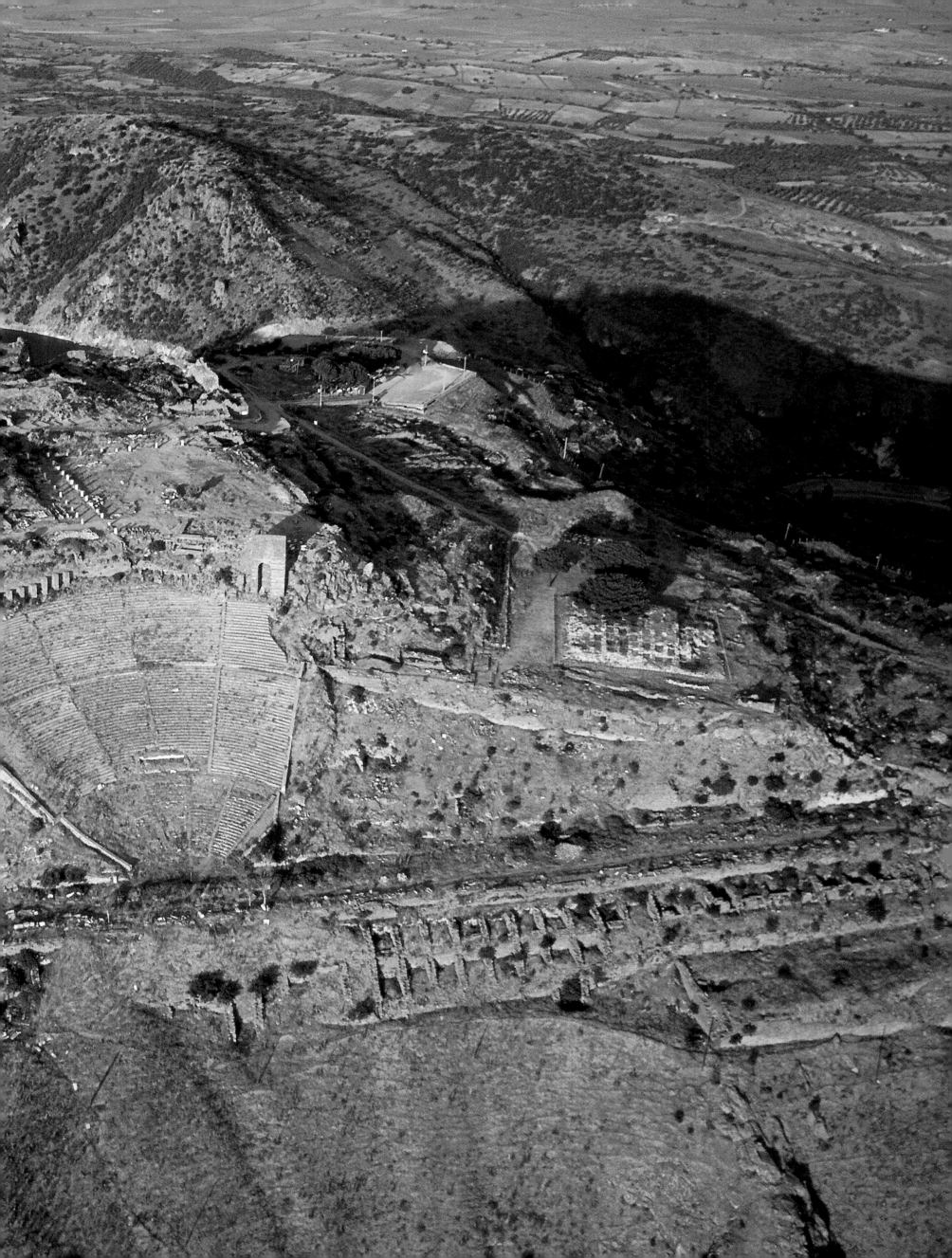

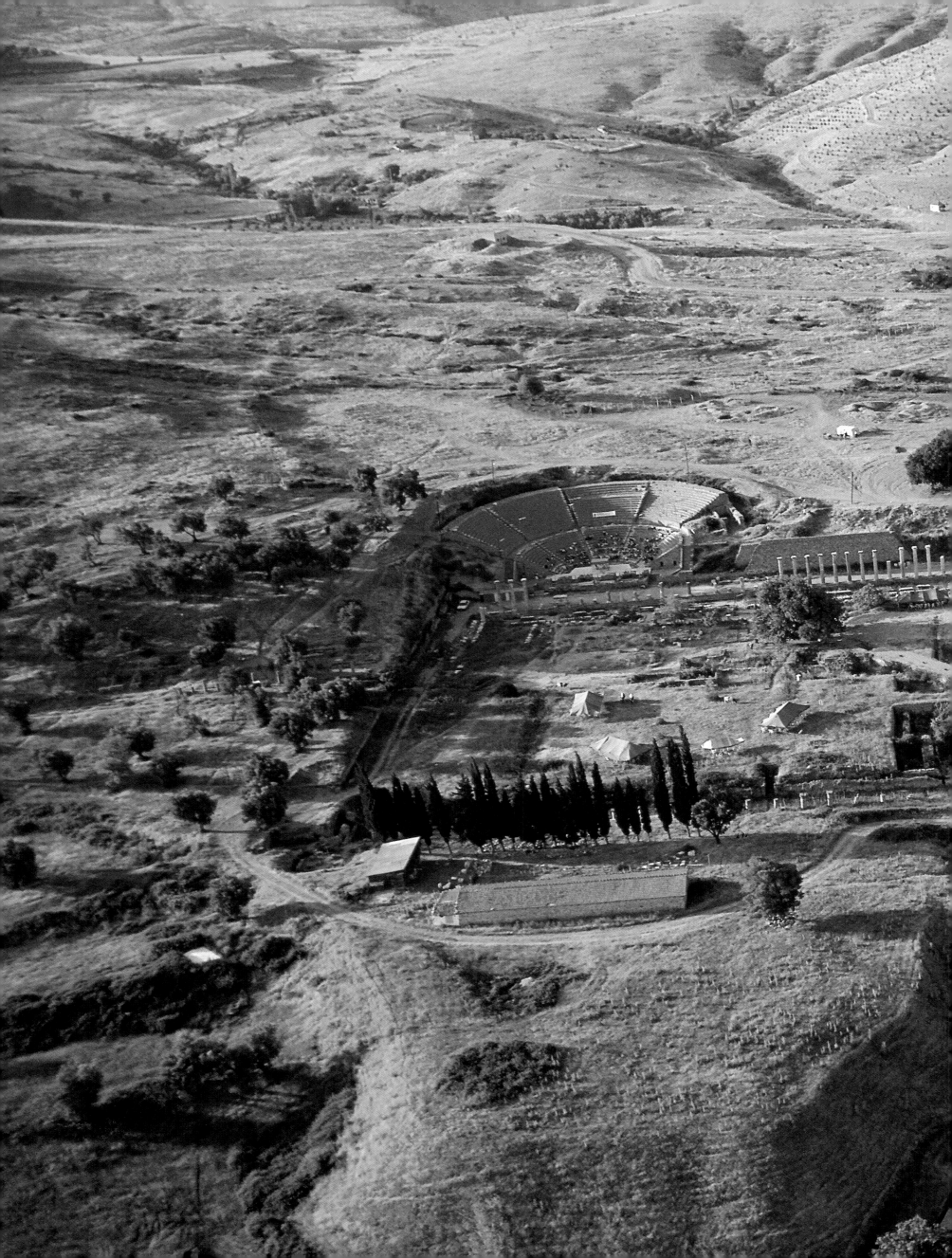

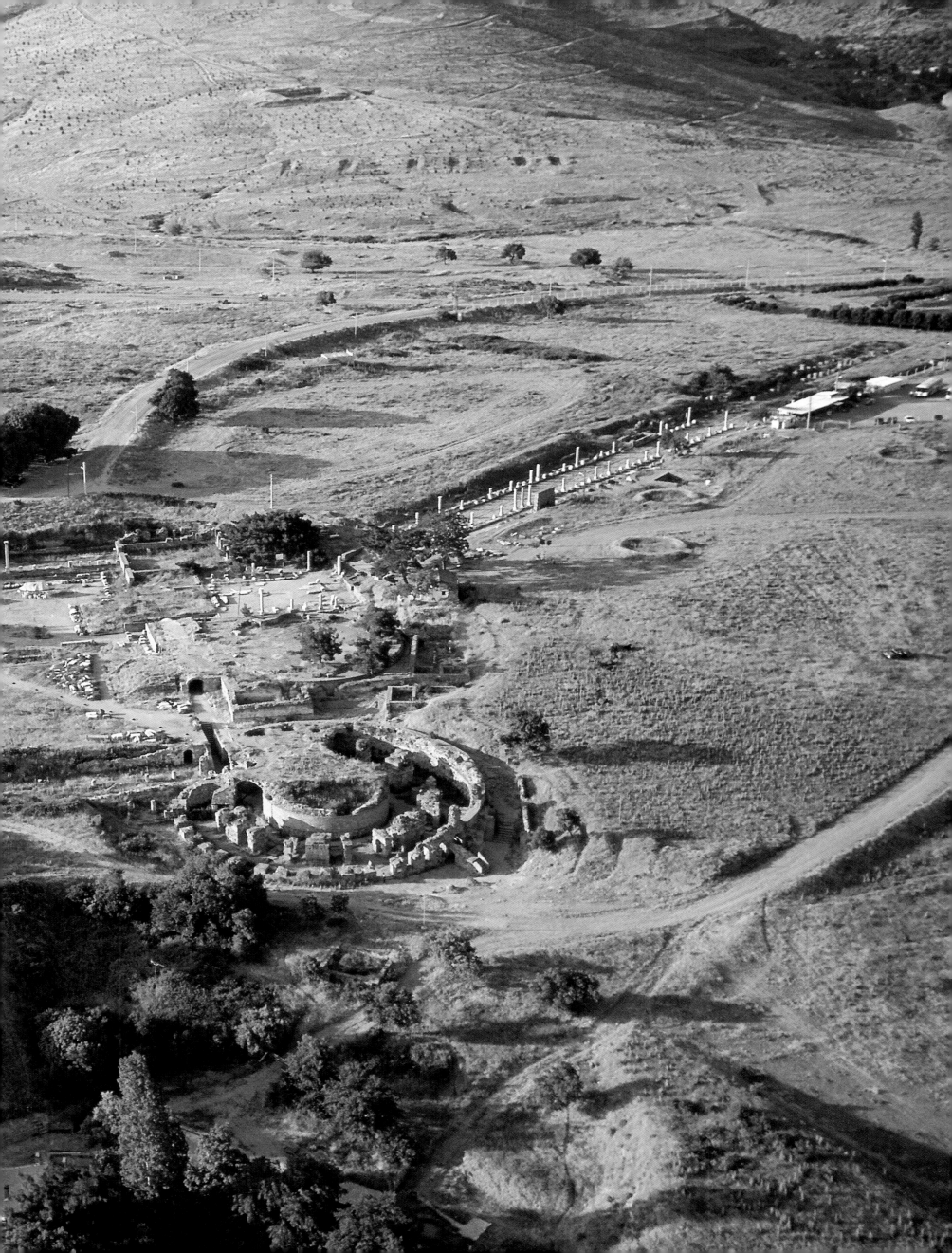

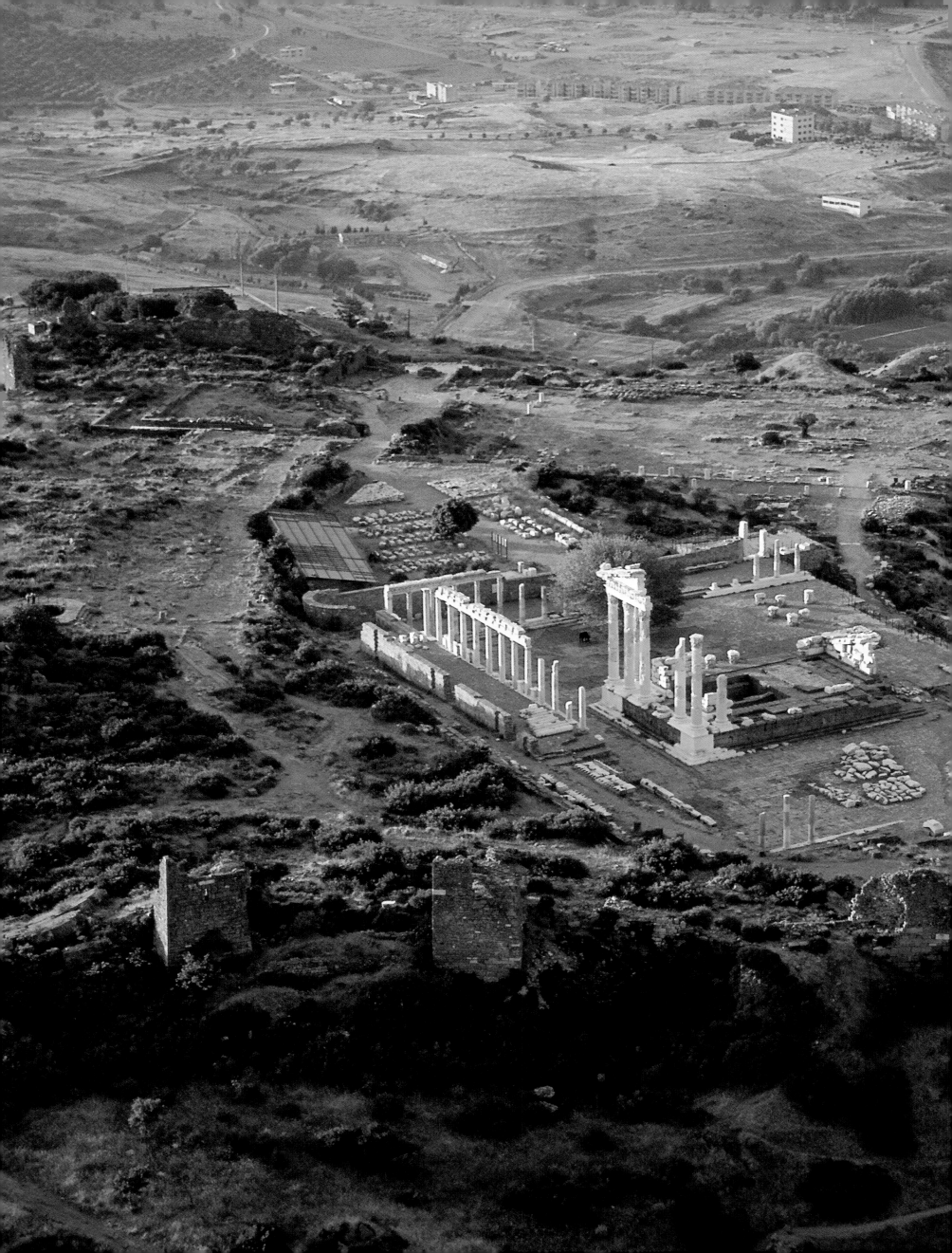

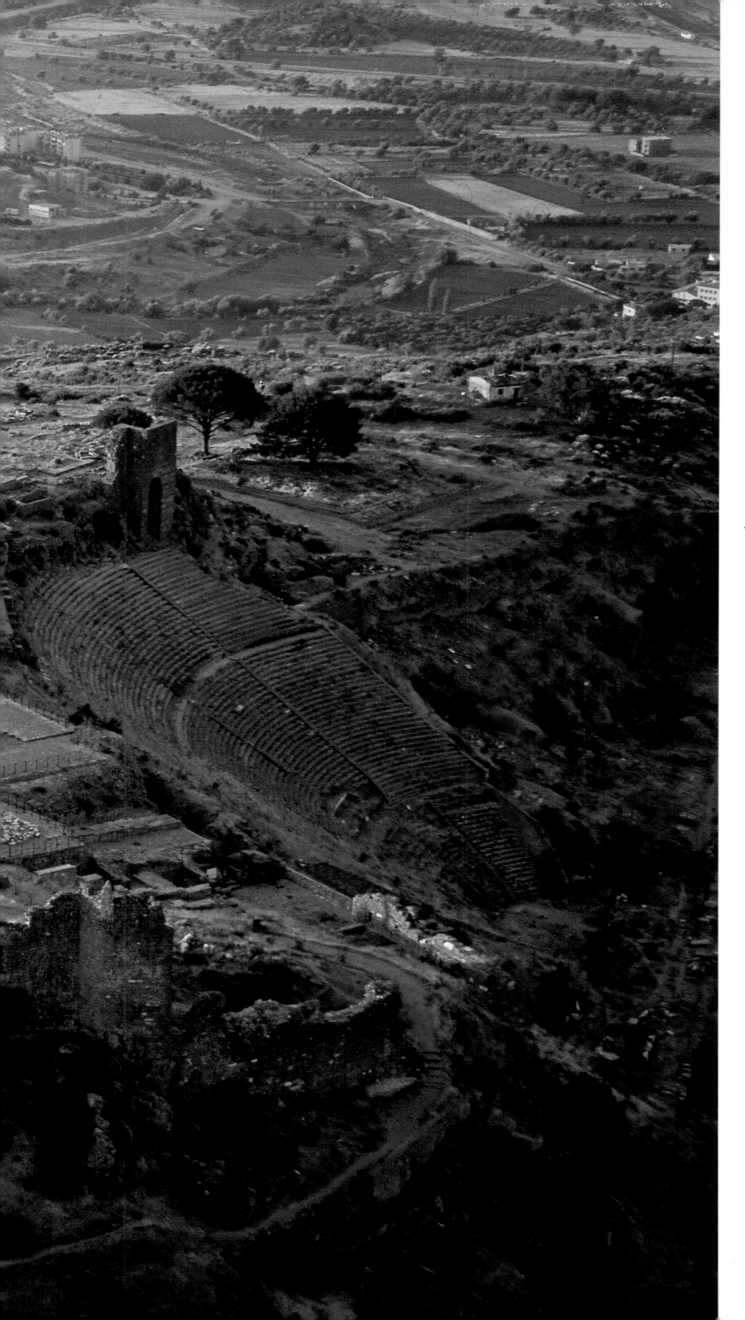

◁ BERGAMA (PERGAMUM) ACROPOLIS

The city's influence was enormous, and began to make itself felt soon after the death of Alexander the Great (323 BC). His generals divided his inheritance, the Macedonian Lysimachus claiming Lydia and Mysia, choosing Pergamum, and particularly its impregnable citadel, in which to secrete his enormous war booty. After his defeat in 281 BC by Seleucus – another of Alexander's generals who ruled in southeast Anatolia – Philetaeros, one of the victorious officers, took over the governorship of Pergamum and began a huge building programme. His successors, the Attalids, continued to enrich the city during their four-hundred-year rule. The last of them, Attalus III, bequeathed his possessions to Rome in AD 133, and Pergamum became the Roman Empire's capital in Asia Minor.

This rich history can be clearly traced in the acropolis perched on its eyrie, covered with monuments, shrines, thermal baths, palaces and agoras, as well as a theatre with remarkable acoustics, seating 10,000 on eighty rows of seats, with the top row 36 metres (120 feet) above the stage, a gymnasium and an odeum. The entire complex was encircled by protective outer walls, of which only the substructure is left, occasionally pierced by fortified gateways.

LANDSCAPES NEAR BERGAMA ▷ ▷

139

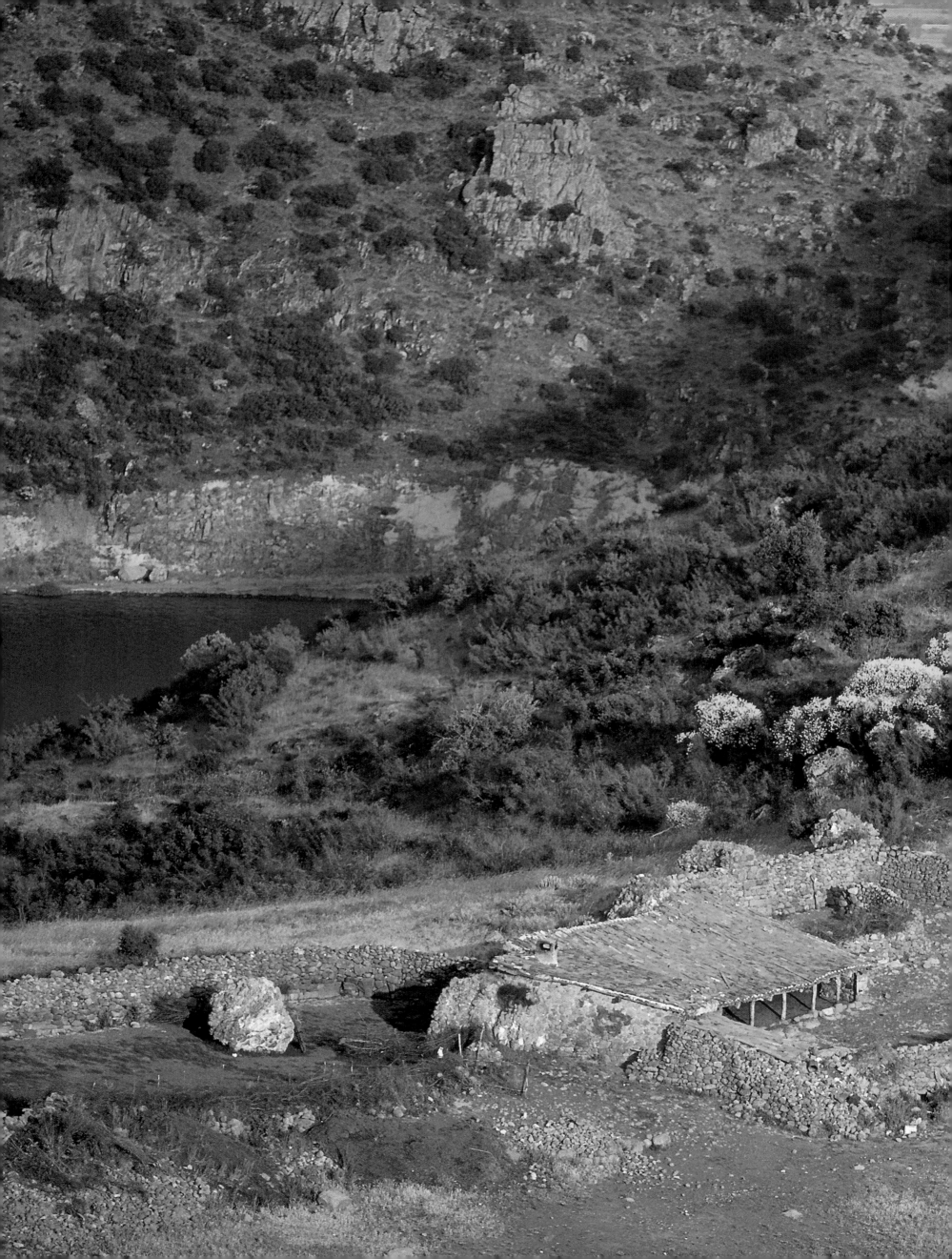

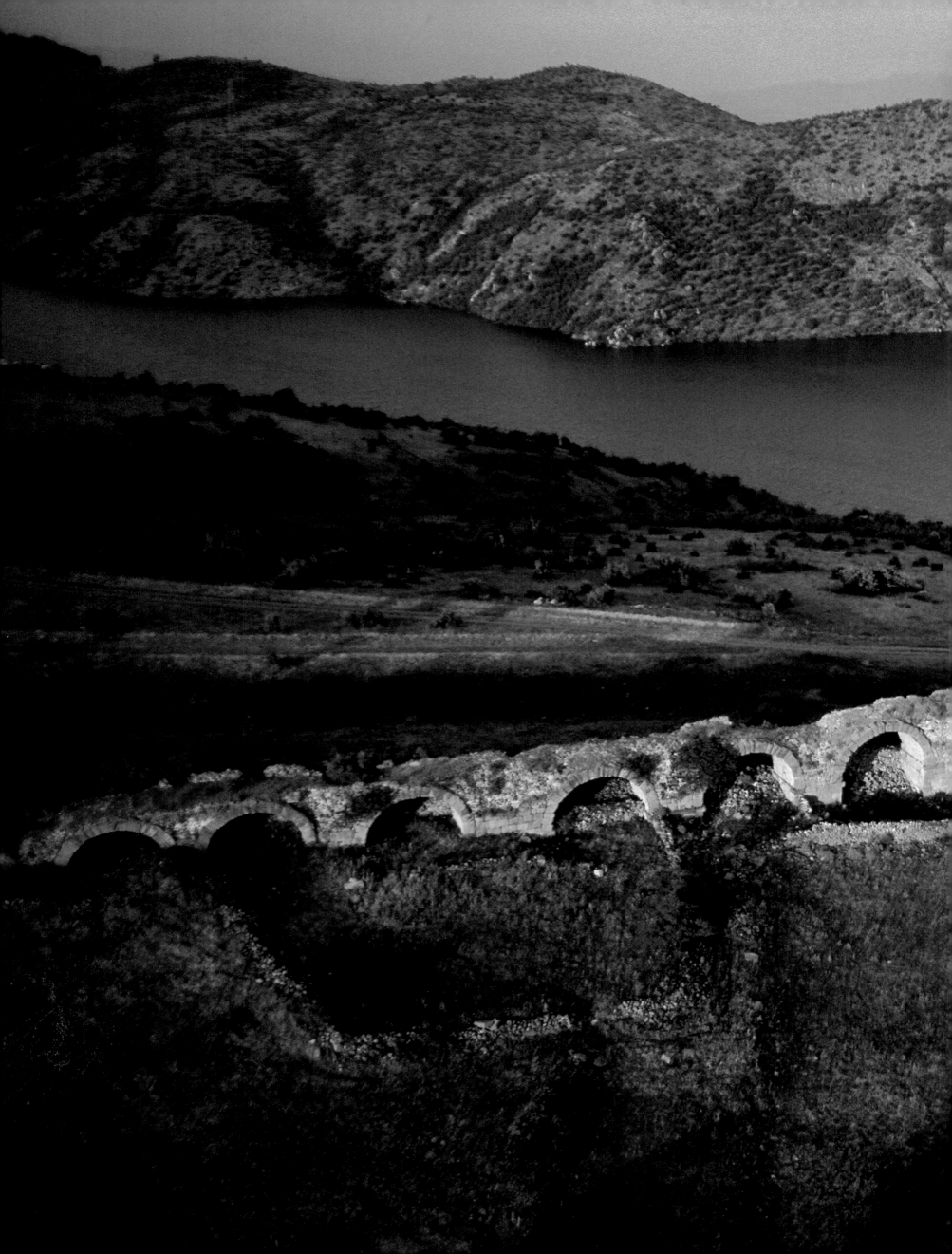

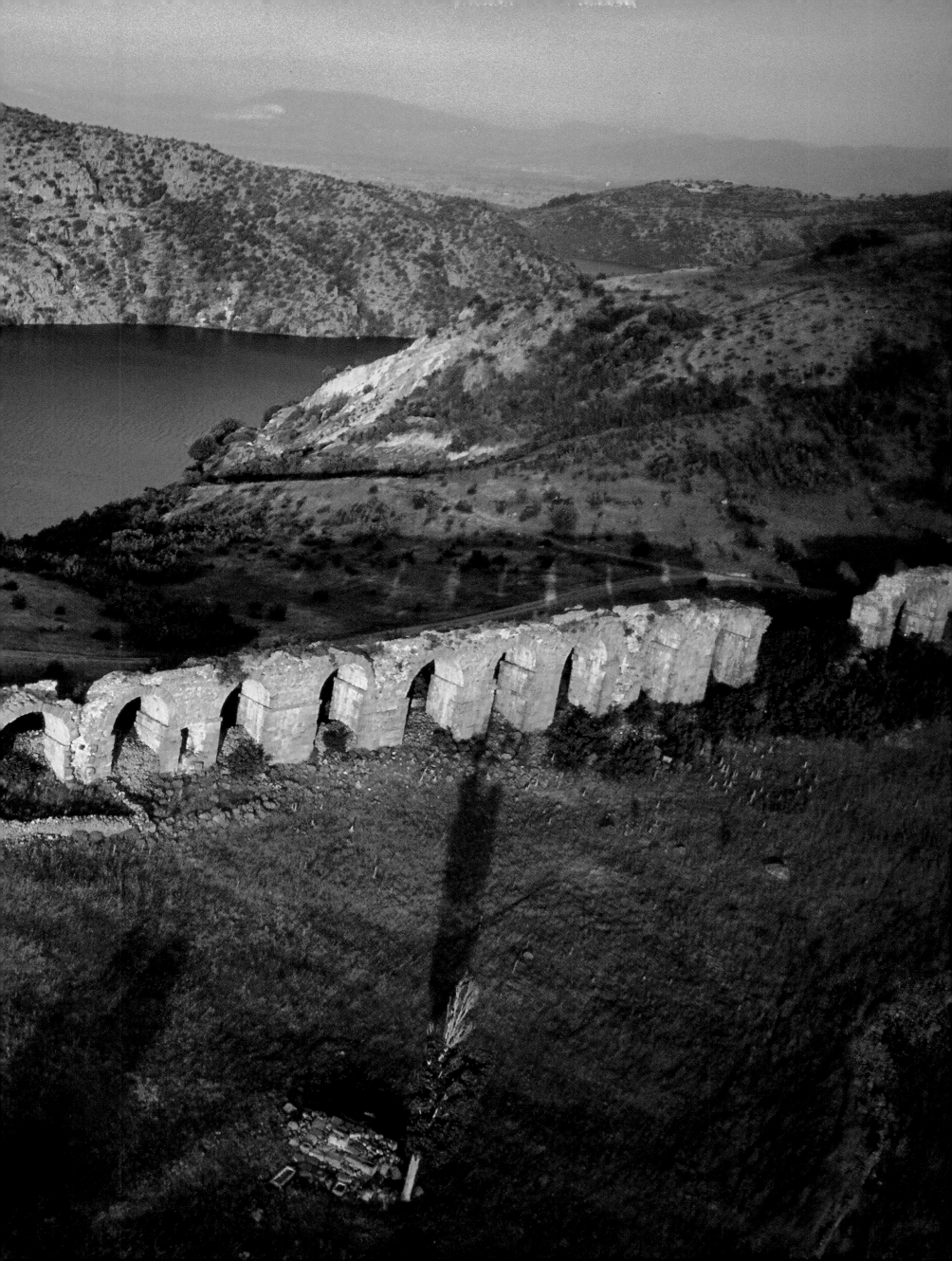

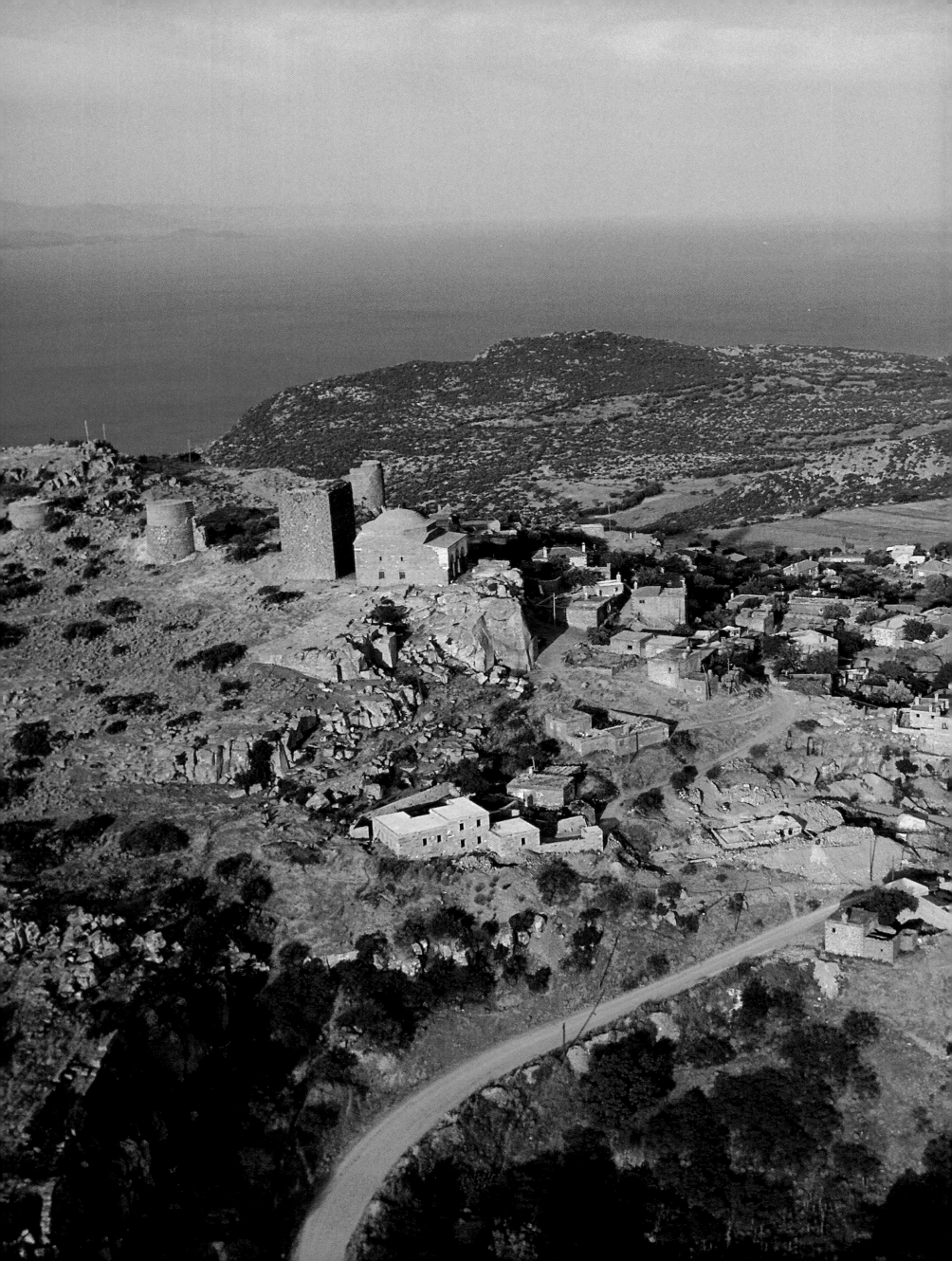

◁ **BEHRAMKÖY**

GENERAL VIEW

Two distinct entities share the Behramköy site, the modern village and the ancient ruins. One of the oldest domed mosques in Turkey survives here, founded in the 14th century by Murad I, but now disused. The remains of the ancient city of Assos include an agora built in the 3rd and 2nd centuries BC, ramparts in regular courses of very high-quality construction, an impressive fortified gateway, a gymnasium, the remains of a theatre and, overlooking the sea, the ruins of the temple dedicated to Athena. Assos was the birthplace of the Stoic philosopher Cleanthes, a disciple of Zeno, around 330 BC, and Aristotle taught here for three years from 348 to 345 BC, after being summoned by Hermeias, a disciple of Plato.

BEHRAMKÖY

ASSOS ▷

The temple of Assos faces out to sea and the island of Mytilene (called Lesbos by the ancient Greeks), whose inhabitants were the founders of the city. The temple, dedicated to Athena, was built on the acropolis during the 6th century BC, and is therefore one of the oldest in Asia Minor. It was of the Doric order, as can be seen from the reconstructed capitals, and originally had an Ionic frieze, which is now preserved in the Archaeological Museum, Istanbul.

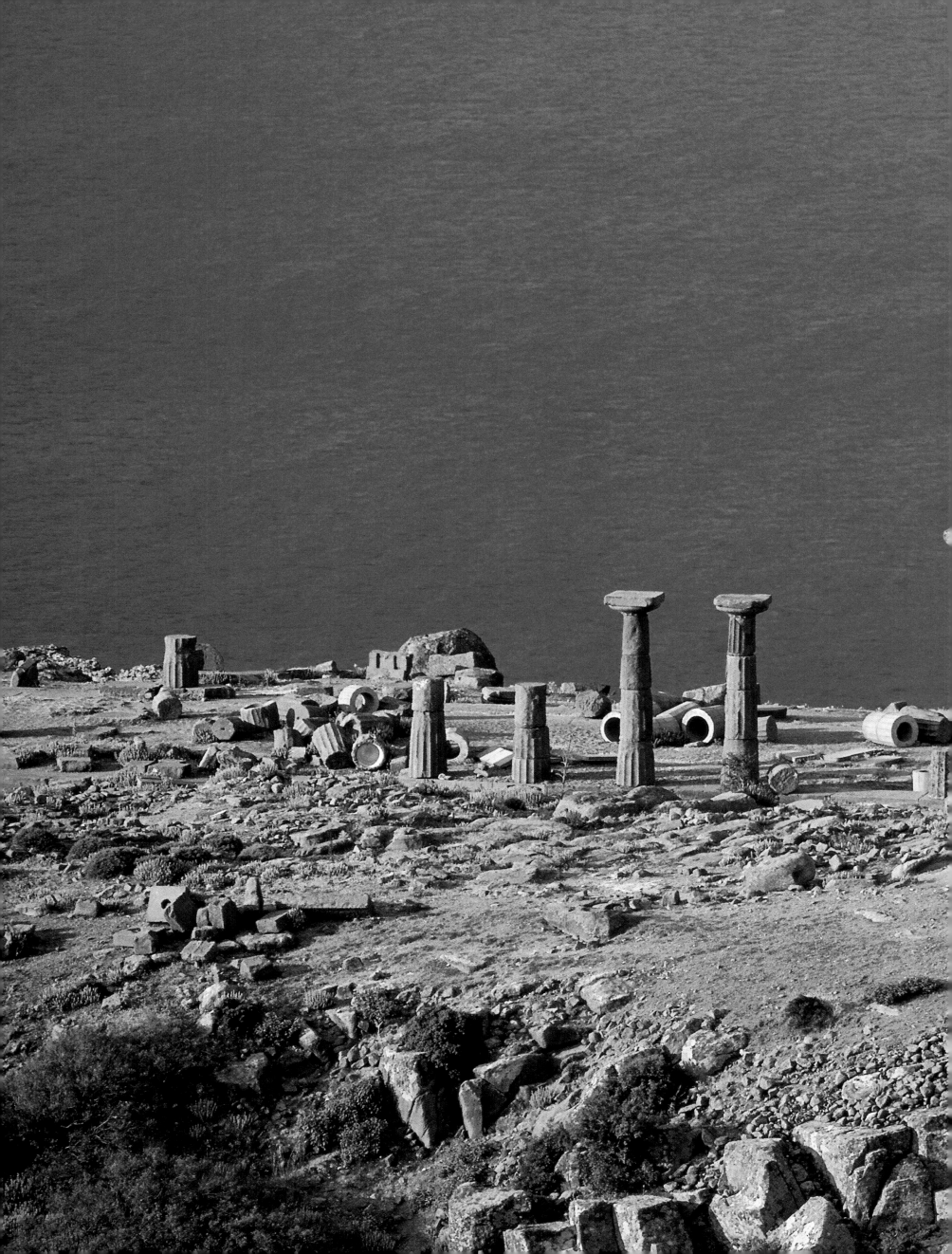

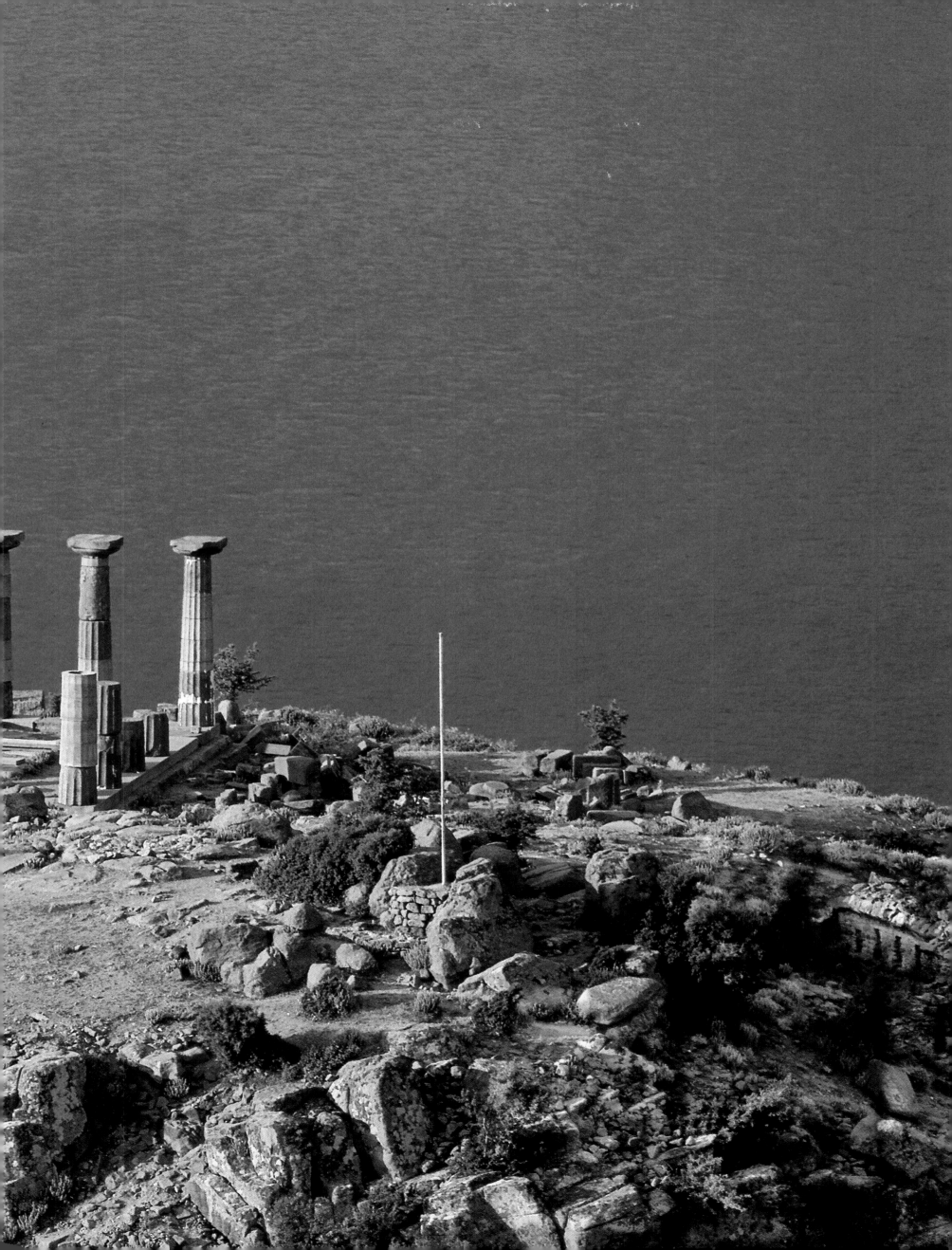

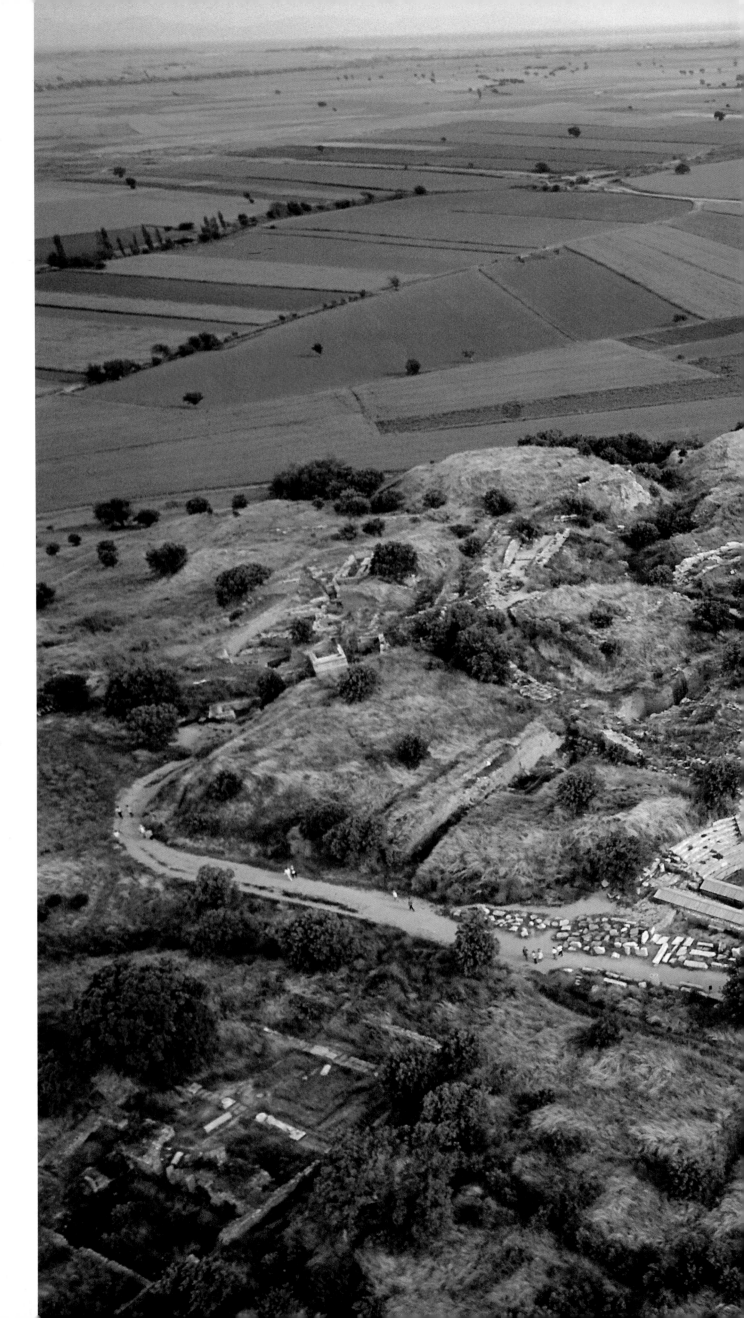

ÇANAKKALE

TRUVA (TROY) ▷

Only an archaeologist who has made a close study of the mound at Hissarlik could find his way around this vast site. Heinrich Schliemann, who discovered it in the 1870s, claimed that it was the site of the city of Priam celebrated by Homer. Since then serious doubts have been raised, and excavations have revealed the different strata in all their complexity. Some consider that Troy VII, or perhaps Troy VIIa (which was destroyed by fire), could well be Homer's Ilium, although it is also often denied that this could be the site of the Trojan War. However, there is no doubt that there has been human habitation on the site from at least 3000 BC until AD 350. Alexander the Great, anointed with oil in homage, made sacrifices to the gods and visited the tomb of Achilles there in 334 BC. Julius Caesar himself came in the first century BC to trace his ancestors, claiming that he was directly descended from Aeneas.

It is here that Schliemann discovered what he called Priam's Treasure, buried near a slope paved with limestone flags in the layer known as Troy II (which, in fact, dates from perhaps a thousand years before the Troy of the Iliad). Several thousand objects in gold, silver, electrum and copper – some showing signs of burning – among them goblets, bowls, weapons and jewels of extremely fine quality, including an outstanding diadem, were found. Together they represent one of the most extraordinary archaeological finds there has ever been. The treasure was thought to have been irretrievably lost when it disappeared from the Berlin bunker where it was stored towards the end of the Second World War, but it is now kept securely in the Pushkin Museum in Moscow.

KILITBAHIR

FORTRESS ▷ ▷

The village of Kilitbahir, standing on the European shore of the Dardanelles, with Çanakkale on the Asian side, is remarkable for its powerful citadel built in a trefoil shape. Kilitbahir means 'the key to the sea' – the citadel stands in a commanding position at the narrowest point of the strait leading from the Sea of Marmara to the Aegean. It was built in the reign of Mohammed II Fatih between 1462 and 1463, at the same time as the sultan was building the Sultaniye Kalesi at Çanakkale on the opposite shore, with the intention of gaining complete control of the strait.

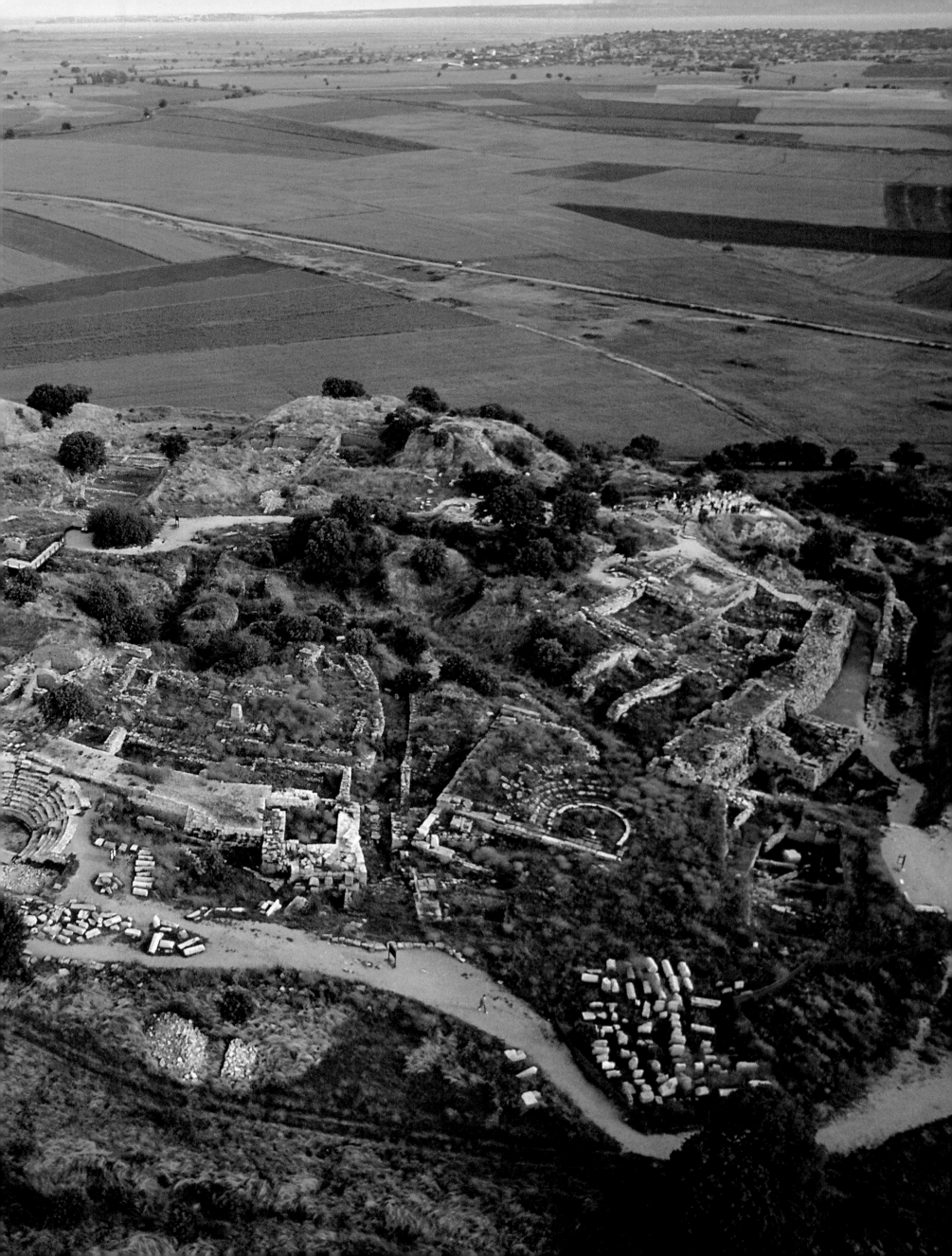

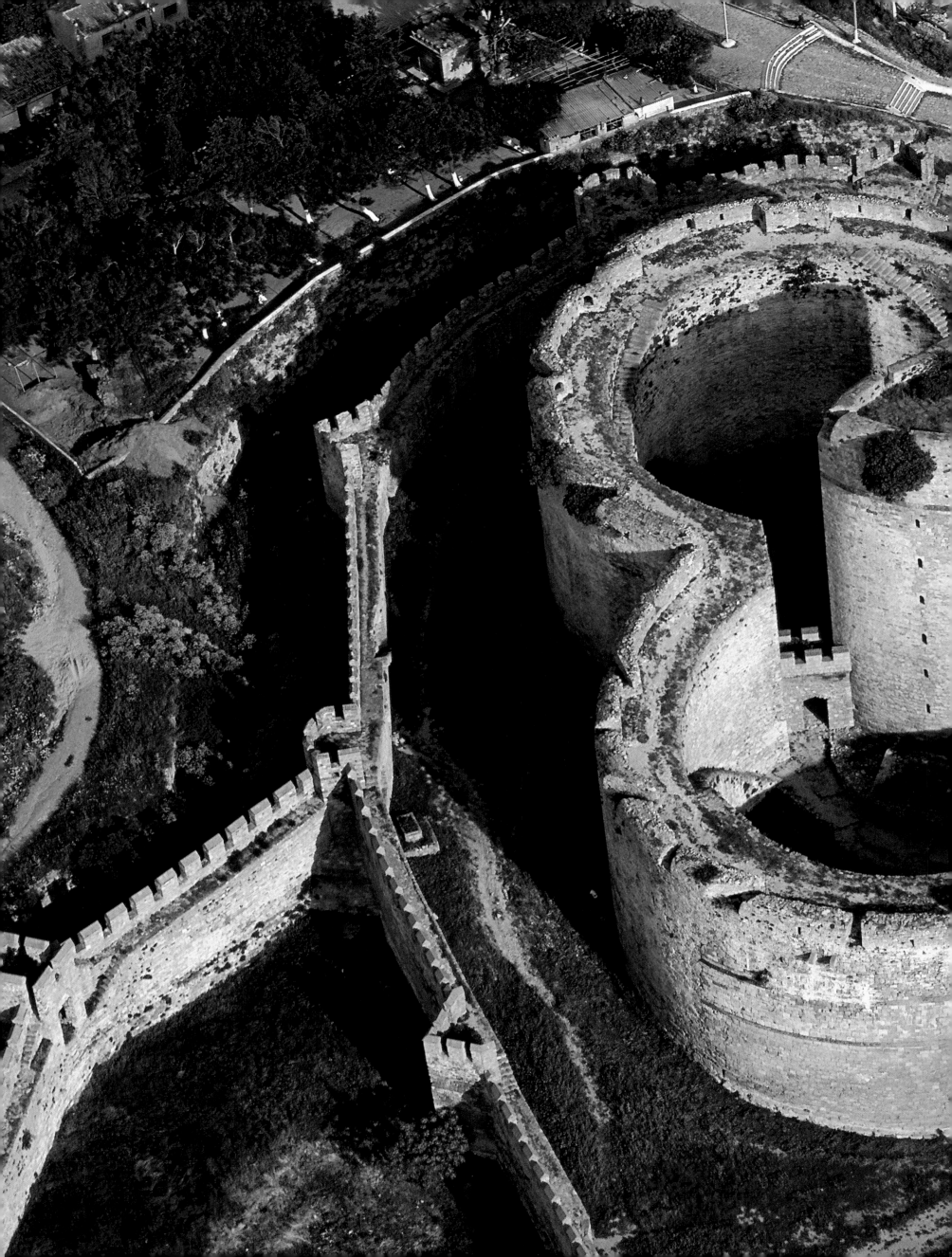

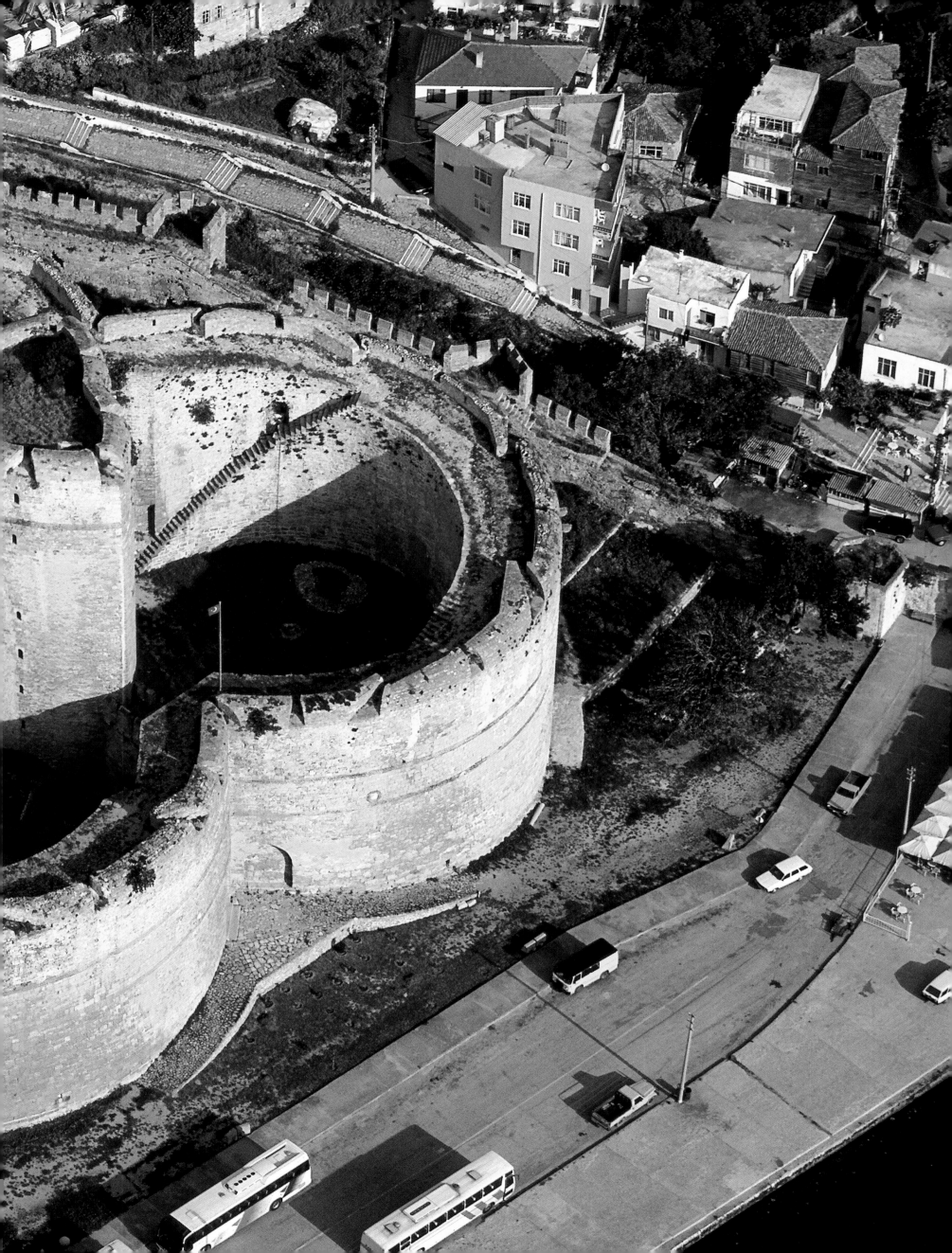

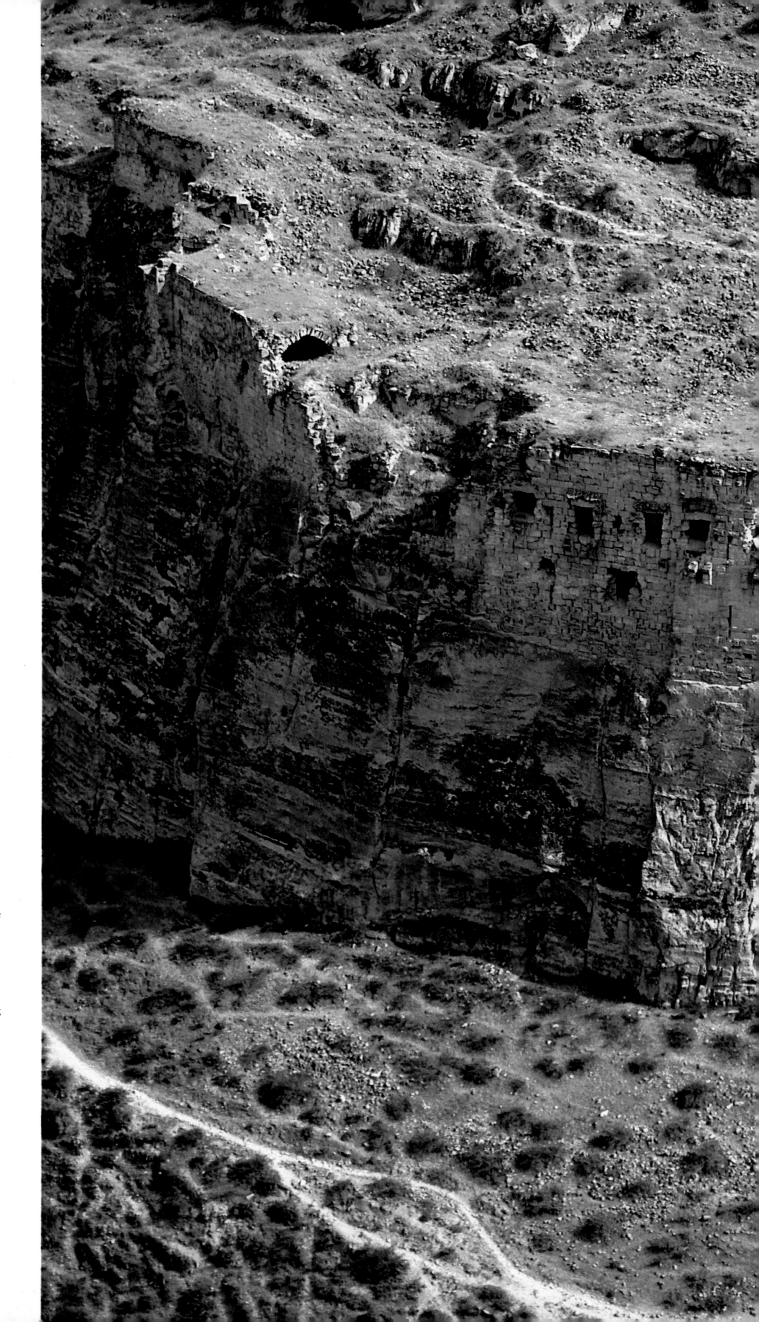

RUM KALESI
(ROMAN FORTRESS) ▷
This breathtaking site above a cliff-face pitted
by cave dwellers and seemingly suspended over
the River Euphrates (Firat Nehri) stands on the
right bank of the river some thirty kilometres
(twenty miles) north of Birecik. It has been
given the name Roman Fortress, and certainly
has an air of impregnability. The Ottomans
readily applied the word 'Roman' to everything
that existed in Anatolia before their arrival,
especially imposing buildings, without any
regard to historical truth.

SIDE ▷ ▷
Fishing boats in the harbour.

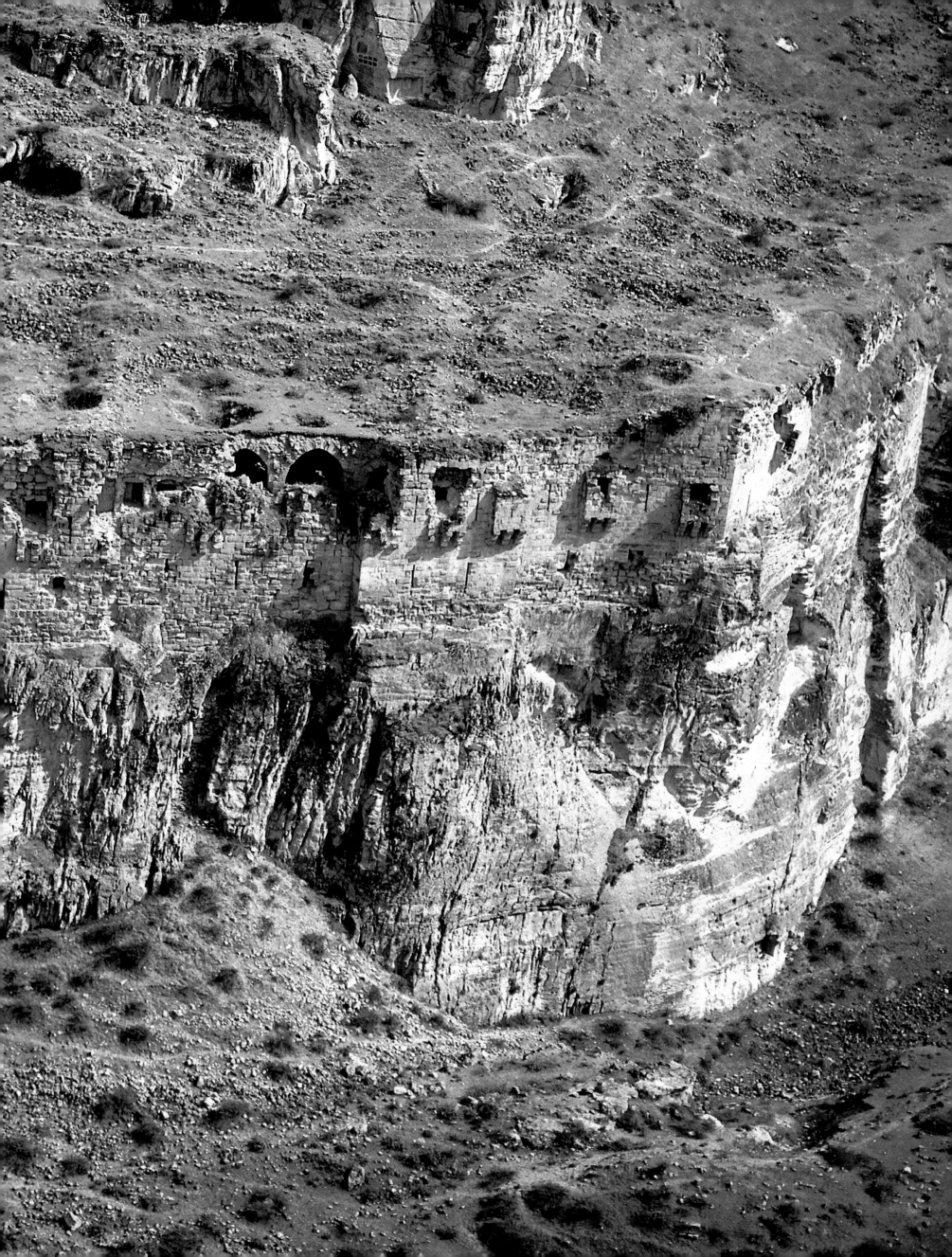

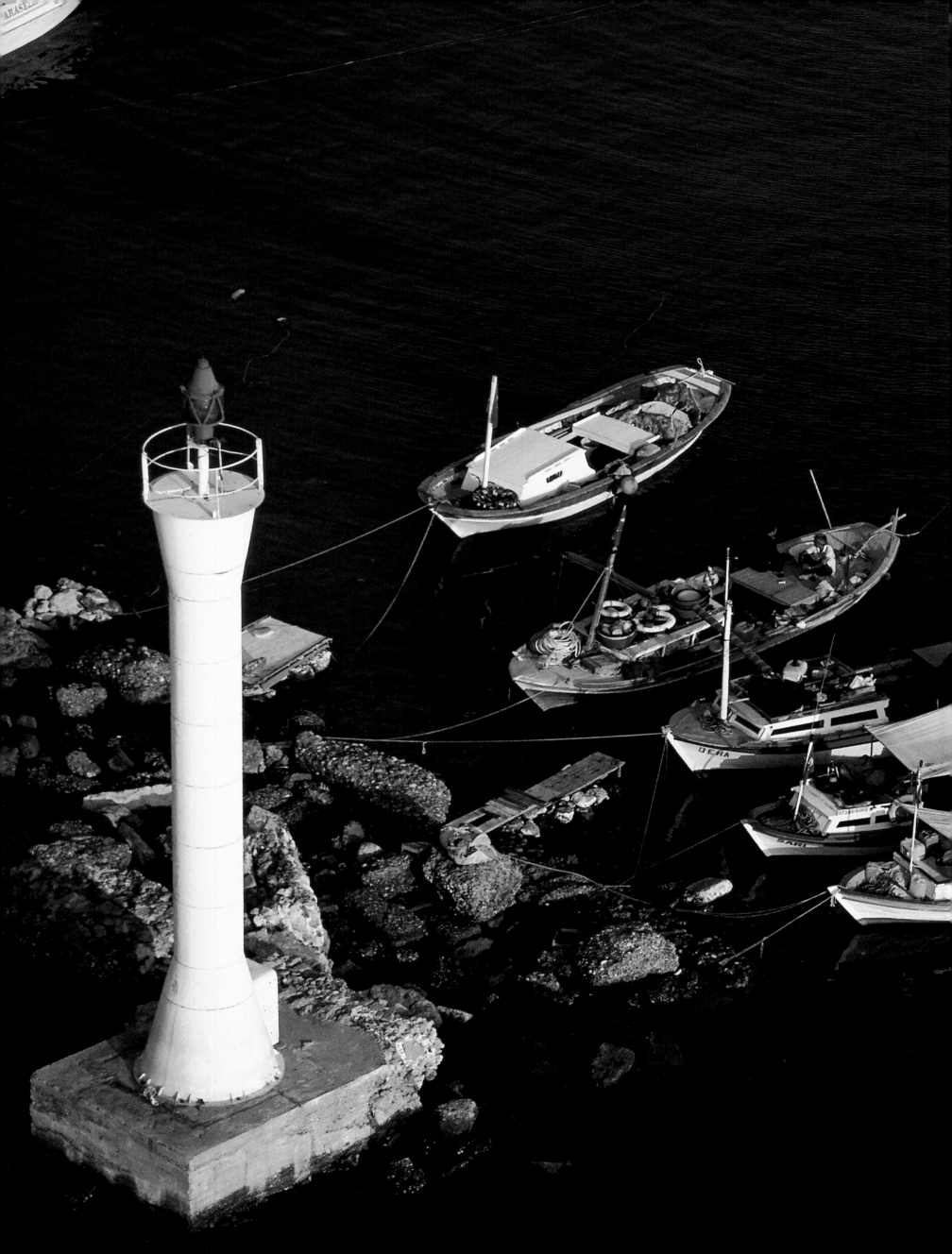

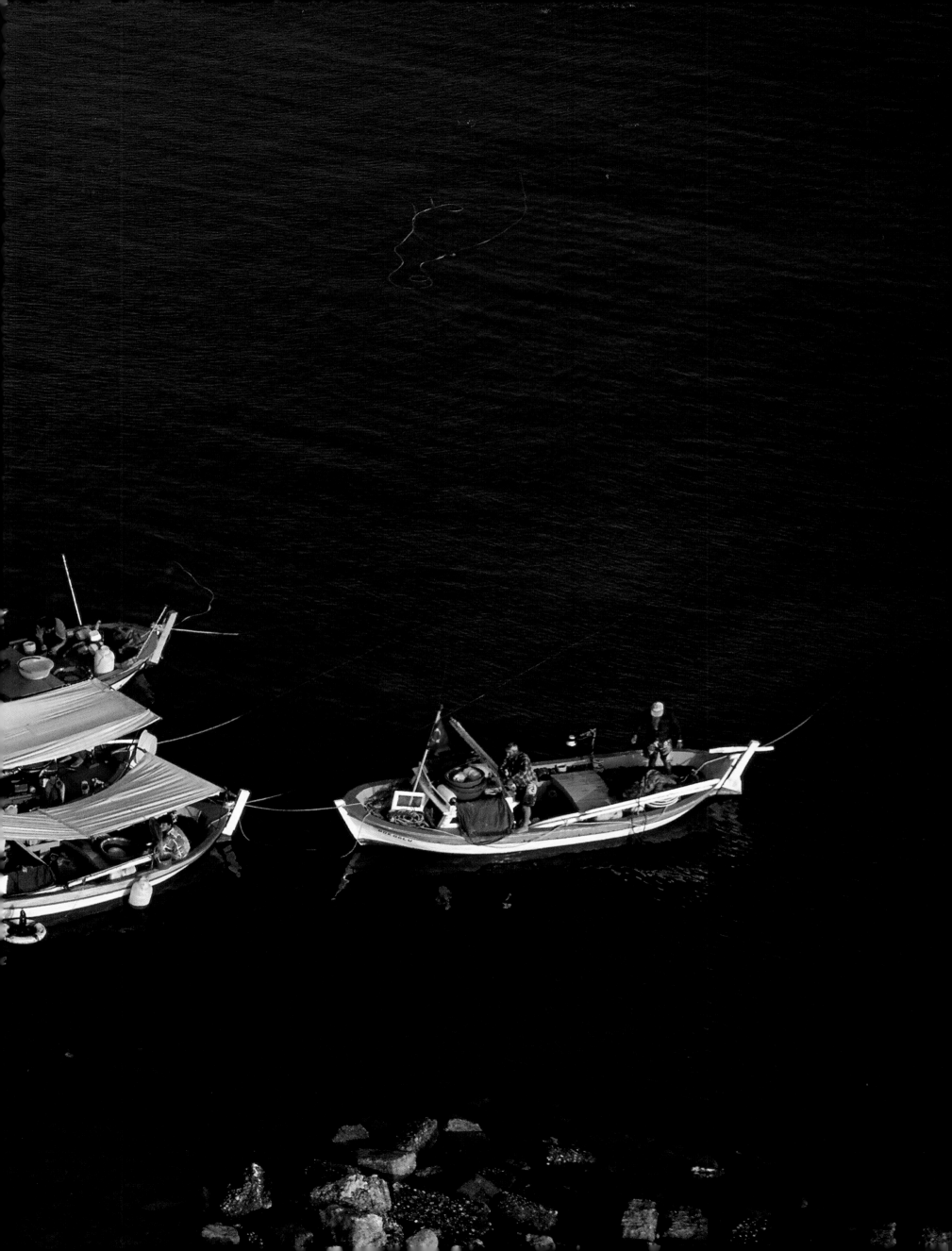

YANN ARTHUS-BERTRAND thanks
CLUB MED and all the village headmen in Turkey, as well as
Henri de Bodinat and Sylvie Bourgeois,
MACH AIR and Mr Izmet Öztürk Ali, Mr Seçal Sahin, Mrs Karatas Gulsah,
TURKISH AIRLINES and Mr Demirci Bulent,
Hélène de Bonis, coordinator of this publishing project
and her assistant Frank Charel.
The photographs in this work are distributed by
Altitude / Hoa-qui.